"*Tinseltown* is entertaining enough                          it an essential addition to any respectable bookshelf of L.A. history."
—*Los Angeles Times Book Review*

"Mann tells his story expertly. . . . When it's all over, Mann has argued so ably for his killer-candidate that he finally may have put this controversy to rest." —*Washington Post*

"[Mann] brings the early days of the movie industry to sparkling life on the page, whether he's evoking Los Angeles' demimonde or explaining how the era's scandals drove the film industry toward protectionism in the face of morality campaigns." —NPR, "The Best Books of 2014"

"*Tinseltown* does a fine job of parceling out its complex plot, and its author brings early Hollywood to life with the flair of a popular historian." —*Wall Street Journal*

"Mann spins this yarn with all the suspense and intrigue of a Dashiell Hammett novel. From beginning to end, the engrossing true tale will keep you guessing." —*Out* magazine

"Many readers will come away from this stellar and gripping true-crime narrative utterly convinced by Mann's solution to the unsolved 1922 gunshot murder of William Desmond Taylor, president of the Motion Pictures Directors Association, in Hollywood. Mann (*Hello, Gorgeous: Becoming Barbra Streisand*) hooks the reader from the start, describing the discovery of Taylor's corpse by his valet in a prologue that reads like fiction. The author then provides the backstory with an engrossing and comprehensive look at the birth of the motion picture industry and the highs and lows it faced in the early 1920s. . . . Mann has crafted what is likely to be a true-crime classic." —*Publishers Weekly* (starred review)

"Mann has a James Ellroy–like grab-you-by-the-lapels style."
—*Quivering Pen*

"[A] gripping true-crime narrative. . . . Mann expertly juggles the various threads of the narrative to a satisfying conclusion that is sure to please both true-crime and film-history enthusiasts." —*Booklist*

"Author William J. Mann paints a striking portrait of Los Angeles in the Roaring Twenties--a sparkling yet schizophrenic town filled with party girls, drug dealers, religious zealots, newly minted legends, and starlets already past their prime; a dangerous place where the powerful could still run afoul of the desperate." —TCM.com

# TINSELTOWN

ALSO BY WILLIAM J. MANN

*Hello, Gorgeous: Becoming Barbra Streisand*

*How to Be a Movie Star: Elizabeth Taylor in Hollywood*

*Kate: The Woman Who Was Hepburn*

*Edge of Midnight: The Life of John Schlesinger*

*Behind the Screen: How Gays and Lesbians Shaped Hollywood*

*Wisecracker: The Life and Times of William Haines*

# TINSELTOWN

MURDER,

MORPHINE,

AND MADNESS

AT THE DAWN

OF HOLLYWOOD

# WILLIAM J. MANN

HARPER

NEW YORK · LONDON · TORONTO · SYDNEY

# HARPER

A hardcover edition of this book was published in 2014 by HarperCollins Publishers.

TINSELTOWN. Copyright © 2014 by William J. Mann. All rights reserved. Printed in the United States of America. No part of this book may be used or reproduced in any manner whatsoever without written permission except in the case of brief quotations embodied in critical articles and reviews. For information, address HarperCollins Publishers, 195 Broadway, New York, NY 10007.

HarperCollins books may be purchased for educational, business, or sales promotional use. For information, please e-mail the Special Markets Department at SPsales@harpercollins.com.

FIRST HARPER PAPERBACKS EDITION PUBLISHED 2015.

Library of Congress Cataloging-in-Publication Data has been applied for.

ISBN 978-0-06-224219-8

22   OV/LSC   10 9 8 7

FOR MY FATHER, WILLIAM H. MANN, 1925–2013

*There's something wrong at Hollywood*
*The cause, O let us seek!*
*There's something wrong at Hollywood*
*No scandal yet this week.*

<div align="right">

—LOUISVILLE (KY) TIMES, *February 22, 1922*

</div>

# CONTENTS

*Part Two:* **HUNTING, HUSTLING, AND HIDING**

*Part Three:* **CLOSING THE CASE**

# PREAMBLE TO INTRIGUE

This is the story of a murder, of a single hollow-point bullet that traveled upward through a man's rib cage, piercing his lung and lodging in his neck, after being fired by an unknown assailant ninety-two years ago on a cold Los Angeles night.

This is also the story of three beautiful, ambitious women, all of whom loved the victim and any of whom might have been his killer, or the reason he was killed. It is also the story of one very powerful man, who saw the future of a very profitable industry hanging in the balance and kept the truth about the murder obscured and camouflaged for nearly a century.

In many ways, this is also the story of the American dream factory, which was just being born in 1920—a time when the movies were still young and their power still taking people by surprise. It is the story of the clash between old and new, between tradition and innovation, between those who would have censored the movies and their facility to spread new ideas and those who were determined to bring about a new world of freedom, technology, power, and illusion.

I have not fictionalized these events. All scenes described come from primary sources: letters, telegrams, police reports, production records, FBI files, and contemporary news accounts. Nothing has been created for the sake of enhancing the drama, and I do not venture unbidden into the minds of my subjects. When I write "How terribly she missed him" or "Zukor seethed," these descriptions are based on interviews or memoirs by the subject in question, wherein such feelings, attitudes, or motivations were disclosed or can be deduced. Anything within quotations comes from direct sources. Full citations can be found in the notes.

And in a nod to 1920s orthography, *clue* is herein spelled *clew*.

—*WJM, New York*

# PROLOGUE

# A COLD MORNING IN
# SOUTHERN CALIFORNIA

## FEBRUARY 2, 1922

### 6:20 A.M.

Headlights punctured the early-morning darkness of the coastal highway between Los Angeles and Ventura. As the Pacific Ocean crashed against the beach, a solitary motorcar sped up the highway in the northbound lane.

Streaks of pink lightened the sky as the vehicle emerged from the shadows—an expensive touring car, its leather top folded down. Traveling at a dizzying speed—perhaps as fast as sixty miles an hour—the car likely originated in Los Angeles, where such flashy automobiles were popular among the movie people.

By the time it reached Ventura, the roadster was thirsty for fuel. As the sun peeked above the treetops of the coniferous forest surrounding the little town, the vehicle pulled off the highway and into a filling station. Dozing inside his office, the attendant opened his eyes to spot a shiny car idling beside the pumps. He was surprised to see that the driver was a woman, and a beautiful one at that, wearing an evening dress and a fur coat. Her hair was in disarray from the wind.

"Give me all the gasoline and oil my car will take," the woman told the attendant when he hurried to her side. Her face was pale and drawn, and the attendant saw her biting at the fingertips of her gloves. As he filled the car's tank, he thought the woman seemed "anxious and restless to be on her way."

Having paid with a bill, the driver screeched out of the station without waiting for change. The attendant stared after her. The incident was

unusual enough that he made a mental note of all the details, just in case someone came asking.

Someone would.

Six miles up the road, another motorist, this one heading south, spotted the speeding car. As the two vehicles neared each other, the second driver became alarmed. The touring car was heading directly at him, its driver seemingly oblivious to his presence. Finally, at the last possible moment, the southbound driver veered off the road as the touring car zoomed past in a cloud of dust.

Not once did the woman at the wheel look back. She continued at breakneck speed, her hair flying in the wind, toward her northern destination.

That was, if she had any destination at all.

**7:00 A.M.**

If he hadn't hurried, Henry Peavey might have been late, and today of all days he didn't want to disappoint his employer. Peavey's workday officially began at seven thirty, but he'd gotten an early start this morning because he had an extra stop to make. Mr. Taylor, who suffered from frequent heartburn, had asked his faithful valet to pick up a bottle of milk of magnesia for him on his way to work. Peavey paid for such purchases out of his own money, and Mr. Taylor always reimbursed him. No receipt was ever necessary. Mr. Taylor would simply ask how much Peavey had "spent to keep him comfortable" and then gratefully hand over the amount in cash.

Such an arrangement would have made it easy to pull some fast ones on Mr. Taylor, but his valet wasn't likely to engage in such shenanigans. Until coming to work for Mr. Taylor, Peavey had lived a rather hardscrabble life. As valet to William Desmond Taylor, one of the leading film directors in Hollywood, Peavey had landed a very good gig. He wasn't about to jeopardize that—especially not after everything he and Mr. Taylor had been through these past few days.

Hurrying out of his $5-a-week lodging house on East Third Street, Peavey sashayed down the block to the Owl Drug at the corner of Fifth and Los Angeles Streets. Henry Peavey, it must be understood, never walked anywhere. He swished; he swayed; he swung his hips. At the

Owl Drug, he traipsed through the aisles of elixirs and syrups, his many scarves fluttering, his hands in constant motion. At the counter he paid $1 for the blue magnesia bottle and a handful of peppermints.

Medium height, slightly overweight, Henry Peavey would turn forty years old in a month's time, but he looked younger. He possessed a certain je ne sais quoi, a love of life that was entirely his own. He wore bold ties and colorful knickers with striped socks. If he was sometimes the object of stares on the trolley or catcalls on the street, Peavey didn't care. When someone called him a name, he was apt to spin around, arms akimbo, and sass them right back.

The trolley ride to the fashionable Westlake district, where Mr. Taylor lived, took only a few minutes. Clutching the bottle of milk of magnesia inside his coat, Peavey stepped off the running board and braced himself against the chilly air. Temperatures had been in the low forties at five o'clock that morning and hadn't risen much in the last couple of hours. Peavey hurried past the Mission Revival houses that lined Alvarado Street. No, he definitely did not want to be late to work today. Not after all Mr. Taylor was doing for him.

The valet's troubles had begun several days earlier, after leaving Mr. Taylor's house at the usual time, an hour or so after sunset. As he sometimes did when he was feeling a little frisky, Peavey had wandered down the block to Westlake Park instead of hopping back on the trolley to Third Street. There, an undercover policeman had appeared as if out of nowhere. The Los Angeles Police Department didn't like Negroes in the park, let alone Negro queens wearing loud clothes making passes at other men. Cruising the parks was one of the very few options for gay men looking to meet each other, especially gay men of limited means like Henry Peavey. But such fraternization was actively discouraged by the LAPD, and so Peavey had been hauled down to the station, where he'd been booked on charges of vagrancy.

It was Mr. Taylor—dear, shining, sterling Mr. Taylor—who'd put up bail, and who'd promised to appear in police court this afternoon on his valet's behalf. Peavey hoped that Judge Joseph Chambers might look a little more leniently on him with a man of Mr. Taylor's reputation standing beside him. After all, Mr. Taylor was one of the most important movie men in America, the head of the Motion Picture Directors Association. His newest film—aptly titled *Morals*—was playing

in theaters all across the country. If Mr. Taylor requested it, the judge might reduce the charges against Peavey. He might even dismiss them altogether.

In his many years of service, Peavey had "worked for a lot of men," he'd say, "but Mr. Taylor was the most wonderful of all of them." Certainly he felt fortunate that a man like William Desmond Taylor was standing up for him now, in Peavey's time of need, and after only six months on the job. Some bosses wouldn't do half as much for employees who'd given them many years of loyal service. But Mr. Taylor was a man among men, Peavey had come to believe.

Shortly before seven thirty, he arrived at Alvarado Court, the complex of eight semiclassical structures on the corner of Maryland Street, where his employer lived. Each building was divided into two duplex apartments, with pyramidal hipped roofs capping the white stucco facades. Boxwoods grew outside each apartment, and in the center of the courtyard, behind a line of date palms, an unfinished white-marble-columned pergola reflected the pink morning sun.

Walking through the courtyard, Peavey passed the homes of several other movie people. On his left was the bungalow of Edna Purviance, frequently Charlie Chaplin's leading lady, most recently in the smash hit *The Kid*. Directly in front of him, at the end of the courtyard, resided Douglas MacLean, a popular actor Mr. Taylor had directed in two films costarring Mary Pickford, the biggest star in Hollywood. Less than a year ago, Peavey had arrived penniless on the train from San Francisco. Now he stood on the edge of a very glamorous world.

Reaching the last unit on the left side of the courtyard, number 404B, Peavey hurried up the three shallow steps to the door. As he did every morning, he retrieved the rolled newspaper from the stoop. The milkman had left a bottle of milk, but for now Peavey let it be; he had his hands full with the paper and the magnesia, and he needed to prop open the screen door with his shoulder as he fumbled for his key.

Suddenly it occurred to Peavey that something wasn't quite right. As he slipped the key into the lock, he noticed that all of the lights in the apartment were blazing. Was Mr. Taylor already up? Had he been reading all night? Peavey knew this sometimes happened. As a busy director, Mr. Taylor never had enough time to keep up with his reading. Not long before, he'd gestured toward a pile of books and told Peavey in

a weary voice, "I've got to read all these." Such were the demands placed on important men, Peavey understood.

Putting aside his concerns, Peavey pushed open the front door and prepared for his usual morning routine. He would draw Mr. Taylor's bath and give him a couple of spoonfuls of milk of magnesia, then fix his breakfast of two soft-boiled eggs, toast, and a glass of orange juice while his employer was soaking. But as soon as the valet got the door open and glanced inside the apartment, Peavey realized he'd been right to feel uneasy.

He saw Mr. Taylor's feet.

Peering farther into the room, Peavey saw his employer lying on the floor, flat on his back, parallel to his writing desk. His feet were maybe a yard from the door, and his arms were straight at his side. Mr. Taylor was fully dressed in jacket, waistcoat, and tie; he was still wearing his shoes from the night before.

"Mr. Taylor?" Peavey asked.

At the sound of his valet's voice, Mr. Taylor did not stir. He seemed almost stonelike.

"Mr. Taylor?" Peavey asked again.

That was when he noticed the blood under his employer's head.

Henry Peavey screamed. The bottle of magnesia slipped from his hands and smashed on the steps as he turned and ran.

Peavey's screams woke the neighbors. Up and down Alvarado Court, lights went on and window shades snapped up. People looked down into the courtyard to see Mr. Taylor's valet running about like a madman, crying and waving his arms.

Later, it would be said that all of Los Angeles heard Peavey's screams that morning—indeed, that his screams reached across the country and beyond. For the murder of William Desmond Taylor and the hunt for his killer would launch an odyssey of greed, ambition, envy, desire, betrayal, accusation, heartbreak, intrigue, triumph, and revenge. And when it was finally over, Hollywood—and the world it had already begun to shape so profoundly—would never be the same.

But somewhere many miles north, a beautiful woman in an expensive automobile heard nothing at all. She may still have been driving like lightning even then, putting as many miles as possible between herself and Los Angeles. Or she may finally have stopped, pulling over

to the side of the road and slumping over the wheel, running her fingers through her windswept hair and glancing up at her bloodshot eyes in the rearview mirror.

At some point she turned the car around and headed back toward home.

# SUSPECTS, MOTIVES, AND CIRCUMSTANCES

# A MAN CALLED CREEPY

**SIXTEEN MONTHS EARLIER**

Like a cat, the little man with the unblinking eyes moved through the corridors of his company headquarters on New York's Fifth Avenue, fleet of foot and all ears. His employees, clustered around file cabinets or taking refuge in stockrooms, didn't hear him approach. They just turned around, midsentence, and there he was, his beady black eyes fixed upon them. Standing just five feet four, their boss had a narrow face, a sharp nose, and eyes one colleague would describe as "long like an Indian chief's." His name was Adolph Zukor, and he was president of the world's largest and most influential film studio, Famous Players–Lasky.

But his employees called him Creepy.

On the morning of Thursday, September 2, 1920, the forty-seven-year-old movie chief watched silently as his staff scurried back to work. Rarely did Zukor speak to his underlings. He communicated mostly through a glance, a stare, a frown. When he did utter words, his voice was soft, precise, and deliberate. Today, as always, Zukor wore an expensive but understated bespoke suit and a gold pocket watch. He enjoyed conjuring an illusion of old money, though the cauliflower ear on his left side suggested rougher, more humble beginnings.

Soundlessly Zukor made his way to the elevator, where the operator knew better than to speak to the boss unbidden. The only sound as they ascended eight floors was the low metallic creaking of gears and pulleys.

Striding into his elegant mahogany office, Zukor could look out over a commanding view of New York's midtown. Across the street gleamed the white marble of the new public library. Beyond that, the iron of the Sixth Avenue elevated railway rusted in the dewy morning air. And in the far distance, Zukor's keen eyes made out the theaters he owned in Times Square. Every month, it seemed, there were more of them. One day, the film chief vowed, he'd own every single movie theater in the country. And after that, the world.

When all his dreams were realized, he'd rule over his empire from an office much higher than the eighth floor.

In New York in 1920, it was all about height. New skyscrapers were going up all the time, competing with each other to reach the clouds. The diminutive Zukor had decided he wanted to join the sky-high club. A year earlier he'd spent $4.4 million for the old Putnam Building, which ran the entire west side of Broadway between Forty-Third and Forty-Fourth Streets. The block had belonged to John Jacob Astor, one of America's richest men from one of its oldest aristocratic families. But Astor had gone down on the *Titanic*, and now the block belonged to Zukor, a Jewish immigrant from Hungary who'd come over in steerage. Zukor was planning to spend another half a million to turn Mr. Astor's building into a palatial skyscraper, raising the roof ten, eleven, or maybe even twelve stories.

Such stature mattered to Zukor, who'd been forced to stand on a box to peer into the kinetoscopes in his arcades when he'd first started out in show business seventeen years before.

In the years since, Zukor had accomplished a great deal. But his achievements were nothing compared to what he had planned.

This morning, as always, his newspapers had been carefully laid out for him by his secretary. Zukor read as many as he could lay his hands on—all the New York papers, of course, along with selected others from around the country. Glancing down at the headlines, he frowned, no doubt displeased by what he read.

#### ROB. HARRON SHOT—FILM STAR IN CRITICAL CONDITION
##### MOVED INTO PRISON WARD AS POLICEMAN
##### PLACES HIM UNDER ARREST

This was not good. Robert Harron might not have been one of Zukor's employees, but a scandal at one studio could affect them all. The film industry had hit a difficult patch these last several months. Revenues were down; calls for censorship were up. With mounting concern, Zukor read the account of Harron's troubles. The popular young actor had been staying at a hotel on West Forty-Fifth Street. He claimed he'd dropped his pistol as he was unpacking his trunk, and accidentally shot himself in his chest. What made the situation worse was that Harron's gun had been unlicensed—a serious crime in New York under the Sullivan Act. That was why Harron had been clamped in the prison ward at Bellevue Hospital.

No, not good at all. These silly, imprudent actors. Didn't they know how much was at stake?

Zukor knew.

He knew exactly how much they all stood to gain—right down to the cent—and how much they all might lose.

Seventeen years earlier the film business had been a jumble of careening, colliding, freewheeling interests, with dozens of companies in various cities, all of them risky, unstable ventures. Now the movies were the fourth largest industry in the country, behind steel, railroads, and automobiles, and it was largely Zukor who'd made that happen. He'd risen above the fray to tame and control the tumultuous bazaar, transforming what had begun as a novelty act, hatched up in Edison's lab to display in penny arcades, into an industry worth three quarters of a billion dollars a year. Wall Street, largely wooed and won over by Zukor, was now pumping millions into the movies, with returns of 500 to 700 percent not uncommon.

Of all the studios, Zukor's Famous Players–Lasky was the most profitable, with total assets of $49 million and a net working capital of about $10 million. Once an impoverished orphan from Hungary, Adolph Zukor was now a very rich man.

In that summer of 1920, however, the economic boom that had followed the end of the Great War had been wrenched off course by steel, coal, and railroad strikes. Unemployment was rocketing toward 8 percent. Theater owners were noting declines in their weekly receipts; by

the end of the year, they would post a $20 million loss against the previous twelve months. Famous Players felt the pinch particularly hard. Its stock-market value had just plunged to its lowest point in a year. Adding to the woes was an extraordinarily hot summer, which kept people away from the movies in those days before air-conditioning. "As a consequence," the trade paper *Variety* reported, "film renters are reluctant to sign up for next season."

So it was an extremely inopportune moment to absorb a scandal— like this business with Bobby Harron's gun.

Zukor was quickly on the phone to find out what was up. "Mr. Zukor finds out anything just by picking up the phone on his desk and making a single call," one employee said. No doubt he did just that on the morning he read about Harron's misfortune.

The shooting, Zukor quickly learned, had been no accident. Depressed after being demoted by his longtime director, D. W. Griffith, Bobby had shot himself in despair.

Foolish actors, indeed. Always so emotional, putting their hearts before their heads. If Zukor could have made movies without them, he would have done so gladly.

Now the industry would have to bury any rumors of attempted suicide. Zukor had to hope that Griffith, one of his chief rivals, was up to the job.

As the film chief well knew, the industry had more to fear than the occasional column of red ink. Scandals like Harron's were extremely dangerous. They emboldened those civic reformers and church ladies who saw the handiwork of Satan in the silvery shadow plays that flickered across the nation's screens. Movies glorified sex and sin, these bluenoses charged, and the movie players, with all their affairs and divorces, were agents of the devil. Thanks to the movies, big-city values and the mores of middle America, traditionally kept far apart, were now rubbing up against each other. And the church ladies were going to do something about it.

Five years earlier, the Supreme Court had ruled that motion pictures were not protected by the First Amendment in the same manner as literature and theater. As a result, the country had become infected with a rash of creeping censorship laws. In Ohio, Pennsylvania, Mary-

land, and Kansas, as well as in several US cities, censors were busy cutting or banning films they deemed too sexy or subversive. If such laws continued to proliferate—or worse, if federal censorship was implemented—the fortunes Zukor and the other film chiefs had accumulated over the last decade would be whittled away. Zukor knew it could happen. The Eighteenth Amendment had just been passed, forbidding the sale of alcohol throughout the United States—and the campaign that led to Prohibition had been very similar to the one currently being waged against the movies, and often by the very same people.

Yet Zukor could be thankful for one thing: none of *his* employees was causing any trouble—at least not yet. In fact, he could think of only one person at Famous Players–Lasky whose private antics might prove troublesome if they ever became known to the public.

Much to his secret chagrin, that person was his great and powerful self.

In the industry Zukor was known as a man of supreme self-control, a model of discipline and propriety. But three years earlier, the man they called Creepy had revealed another side of himself.

In the parlor of a house in Woburn, Massachusetts, a buxom young woman tickled the ivories of an upright piano. Zukor settled back into a comfortable chair and lit himself a cigar. A thick, low cloud of gray smoke hung over the room. With Prohibition still two years in the future, the champagne flowed freely. The assembled men, all executives of Paramount, the distribution arm of Famous Players, were in high spirits, laughing and egging each other on.

They all had wives. Zukor had been married for twenty years. There was a time when his wife, Lottie, had entranced him with her "beautiful dark eyes and exquisite skin." Indeed, as a young man, struggling to find his fortune, the young Adolph had courted Lottie with all the passion and determination he now brought to his movie operations. Zukor still adored his wife—no one understood him better—but these days she was fat and fussy, forever bustling off with gaggles of clucking society ladies her husband despised. So it was no surprise that Zukor

accepted the invitation of Brownie Kennedy, a Boston madam, to visit her Woburn home, dubbed Mishawum Manor, with a group of his colleagues.

"The revelries began at once," said one report of the evening, "and continued until long after daybreak. Choice drinks were served throughout the night and many of the girls danced in scant costume." The young women had been recruited from Brownie's well-thumbed red-leather phone book, and the madam "exacted heavy fees" from the movie men in exchange for introductions. The rate depended "largely upon the ability of the guest to pay, with $100 being the average." The women themselves received only a fifth of that.

But they certainly earned their pay. "More than a score of girls, most of them in their teens, and all pretty, kissed every man in the party," the report continued.

With those fierce, staring eyes of his, Zukor zeroed in on one of the prettiest of Brownie's girls. Her name was Eva Lord. Taking her hand, he led the young woman upstairs to a private room, where they might get to know each other. There they spent the remainder of the night.

When the sun finally rose, Hiram Abrams, the president of Paramount, who had arranged the party, paid Brownie $1,050 for fifty-two bottles of champagne and "other services." Sated, tired, and happy, the film executives returned to New York.

That would have been the end of it. But two months later a letter arrived from a Mr. Fred Lord, a garage mechanic from Worcester, Massachusetts. He said his wife's name was Eva, and he charged that Zukor had "alienated her affections."

The elevator boy at the Famous Players office was kept extra busy that night, running nearly a dozen lawyers up to Mr. Zukor's office. The men all looked stricken.

The lawyers gave Zukor the bad news. Other complainants had come forward, including the father of a seventeen-year-old girl. Other Famous Players execs were also being charged, including Abrams and Zukor's partner, Jesse Lasky. Boston district attorney Nathan A. Tufts had all of their names.

Zukor's long eyes narrowed as he took charge. He ordered a battery of lawyers to hop on the next train to Boston to persuade the DA to drop the charges.

Tufts proved receptive. His manner as slick as the pomade in his hair, the DA assured Zukor's lawyers he had "no wish to prosecute innocent men." If the complainants could be "gotten off his back," Tufts insinuated, there would be no prosecution.

Zukor knew extortion when he saw it. But he was desperate. He'd come so far, so fast, gained so much, and he still had a very long way to go. He couldn't allow this stupid little indiscretion to derail all his plans.

Back in New York, one of Zukor's lawyers argued that they should refuse to pay a cent. The complainants had no chance of winning a conviction, he said. But Zukor wouldn't take the risk. He ordered that Tufts be sent his money. A hundred grand sufficed to placate everyone involved, from the aggrieved husbands and fathers to Tufts and his lawyers.

Zukor took one other action. He fired Hiram Abrams as president of Paramount. Abrams had gotten him into the mess by arranging the party, so he had to go. No matter that Abrams had built Paramount into a world-class distributor, he was now a liability. In business, as often in life, Zukor had no room for sentiment.

And so the lesson became clear. Scandal had to be contained at all costs.

When Robert Harron died from his gunshot wound on September 5, Zukor was surely pleased with the way his competitors handled the story. The official spin from D. W. Griffith's publicists was that Bobby had bought the revolver from a homeless man as a kind gesture, and that, as a Catholic, he would never have committed suicide. Bobby's death became a sympathetic tragedy. Had the young man lived, of course—and perhaps been led out in handcuffs in front of a judge on felony charges—the newspaper coverage wouldn't have been so affectionate. For the moment, they all breathed a little easier.

But there would be other scandals, Zukor knew. Perhaps even his own.

If the church ladies ever got wind of Brownie Kennedy, Zukor would have holy hell to pay. The fact that so many of the movie bosses were Jewish already made them suspect in the minds of the reformers, most of whom were evangelical Protestants. The party in Boston—and the money paid to cover it up—would simply confirm the belief that the

movies and the men who made them were debauched and dismissive of Christian values.

In their attempts to slow down, and hopefully reverse, the march toward censorship, Zukor and his rivals had banded together to create a pair of organizations. The National Board of Review scrutinized every film of every major movie studio before its release, suggesting changes to appease local censorship boards. The National Association of the Motion Picture Industry lobbied for legislation beneficial to the industry and against censorship. But what they really needed, Zukor knew, was a human face, a personal first line of defense.

As its champion, the industry required an articulate spokesman who could put forward an intelligent argument against censorship. The ideal candidate would be conversant in all aspects of picture-making and express as much passion in his calls for artistic freedom as he did for the movies' moral responsibilities—a strategy to disarm the industry's critics.

And one more thing: he had to be from Los Angeles. While the studios' headquarters were all still based in New York, it was Los Angeles, and particularly the subdivision of the city called Hollywood, that was fast becoming the industry's center of production. An effective spokesman for the industry couldn't be drawn from the smoke-filled boardrooms of New York. He had to toil in the California sun, socialize with Mary Pickford and Charlie Chaplin, and play a vital part in that place beneath the palms that was already becoming mythical to millions of people around the world.

Not surprisingly, Zukor had such a man on his payroll.

His name was William Desmond Taylor.

The day after Bobby Harron's funeral, Zukor once more glanced down at the newspapers on his desk. There, in headlines bolder than ever, exploded the industry's next scandal—the one Zukor had known was coming, but couldn't have foreseen arriving quite this quickly.

In Paris, the glamorous, top-ranked star Olive Thomas had swallowed poison after a night of carousing in the nightclubs of Montmartre. The church ladies were already grumbling.

Zukor's man Taylor would have his work cut out for him.

# BABYLON

Like a tsunami wave, the rising sun burst over the eastern wall of the San Gabriel Mountains and flooded the verdant plain of the Los Angeles Basin. Golden sunshine spilled across roads and between buildings and through the neat, orderly rows of orange and lemon groves. It rushed in to fill up the natural amphitheater known as the Daisy Dell—soon to become the Hollywood Bowl—and bounced off the shiny aluminum roofs of the movie factories. It warmed up swimming pools, opened the petals of poppies, tanned the faces of highway workers, and chased the prostitutes and drug dealers away from the street corners of downtown. Finally the sun's rays reached land's end, dissolving in a milky haze over the Pacific Ocean.

Just twenty years earlier, this bustling little city had been mostly farmland and alfalfa lots, studded here and there with oil wells in constant genuflection to the earth. With the arrival of the first film producers in the winter of 1907, that began to change. Before the invention of high-intensity arc lamps, movies had to be shot in the open air or in studios with retractable roofs. So the moviemakers had come west in search of light during the dreary eastern winter months. Eventually many of them settled down, opening storefront studios in the land of the eternal sun.

The influx of movie people nearly doubled the population of Los Angeles between 1910 and 1920, from 319,198 to 576,673, making the city, practically overnight, the tenth largest in the nation. In 1910 the census had counted 399 actors and 216 actresses; now there were 2,289 and

1,311, respectively. Directors, scenarists, cameramen, electricians, carpenters, painters, bookkeepers, publicists, managers, and other movie workers numbered thousands more. Although some pictures were still made in New York, more and more producers were basing their studios in Los Angeles. Practically obscure a decade before, the city now found itself the focal point of the world's obsession with the movies.

"The sudden and grandiose rise of the motion picture," journalist R. L. Duffus wrote, had brought about an unprecedented cultural transformation. Thirty-five million Americans—one out of three—went to the movies at least once a week. The "flickers" were "transforming the dress, the manners, the thoughts and the emotions of millions of people," Duffus observed. Fashions, trends, and ideas now flashed across the globe in the twinkling of an eye. "There has never been anything like this before in the history of the human race," Duffus noted. "The motion picture is the school, the diversion, perhaps even the church of the future."

And every day young men and women from small towns all across America stepped off trains and buses into the bewilderness of Hollywood, hoping they might become gods.

Folks back home had told them they were good-looking enough to be in the movies, and so, like those first filmmakers, these beautiful young people had headed west. In 1920, beauty was all you needed to make it in Hollywood. It didn't matter what your voice sounded like, or if you could sing or even act. The camera could take care of that. And so the city was overrun with thousands of beautiful people. They were everywhere: on the trolleys, in the drugstores, outside the studios angling for jobs as extras.

But only a tiny fraction ever fulfilled their dreams. Most of them became hard. Bitter. Their looks faded. Their skin turned to leather under the perpetual sun. Eventually most had to choose between returning home or finding other ways to survive. The newspapers were filled with stories of actors snared in the opium dens of the city's growing red-light district, and actresses caught selling dope from their dressing rooms. The sweet scent of orange blossoms became, for many, the clammy stink of desperation.

# THREE DESPERATE DAMES

On this late summer morning, as the sun reflected off the shiny chrome and mirrored stages of Tinseltown, three beautiful, desperate young women tottered on the brink.

The first of these was Mabel Normand. She was twenty-seven years old, but her friends told her she'd never live to see twenty-eight if she didn't break off a love affair that was destroying her by inches. The affair had started as a lark, full of fun and laughs, but it had ended up wrecking Mabel's health and depleting her bank account—the way romances with cocaine usually ended.

With the city around her waking up, mockingbirds jeering from jacaranda trees, and trolley cars jangling their bells, Mabel knew the only answer was to get out of town. She needed to go home, back to the East, away from all this sunshine and make-believe.

Mabel had been very successful here on the coast. After almost a decade on the screen, her face was one of the most familiar in the world. She was the "Queen of Comedy," sometimes called the female Chaplin. Her latest picture, *The Slim Princess*, had just opened in June. But what Mabel needed more than anything else was a long, deep breath of New York air. It might be grimy, it might be smelly, but it was real—unlike the air out here, perpetually perfumed with coyote mint, as if she were living in some absurd fairy kingdom. Packing the last of her things and locking the door of her apartment at 3089 West Seventh Street, Mabel instructed her chauffeur to take her to La Grande Station, at the corner of Second Street and Santa Fe Avenue. She had a train to catch.

Once, a long time ago, Mabel had liked Hollywood very much. Back then it had been all about laughter and friendship and romance and late-night skinny-dipping in the Pacific Ocean. Now it was only about money and grosses and boardrooms and deceit. How Mabel hated the film colony's artificiality and hucksterism. She could play "the baloney card," as she called it, when she needed to, like the way she knocked three years off her age in her official biographies (the public thought Mabel was twenty-four), or the way she told some interviewers she'd been born in Boston and others Atlanta. But Mabel never played the baloney card for money or power. When she regaled the fan magazines with stories of growing up wealthy and being educated at private schools—or sometimes the opposite, growing up as a destitute orphan scrubbing floors—she was indulging a creative imagination that stretched all the way back to her childhood. Rich or poor, it didn't matter to Mabel. All she had ever cared about was that she never be considered ordinary.

When Mabel was a little girl—on Staten Island, which she rarely admitted—her father, a carpenter, would take her out on a boat and point at Manhattan. Those glittery lights, he'd tell Mabel, were part of a great big world he hoped she'd see one day. Claude Normand had once wished the same for himself. Instead, he lived vicariously through the local theater company for whom he occasionally built sets, imagining the places they saw on tour—Cleveland, Columbus, Chicago, St. Louis—places he might have seen himself if he hadn't been a husband and father stuck on Staten Island.

Mabel's father was a dreamer, and he imparted his dreams to his little girl. But he also taught her more fundamental lessons, such as the difference between right and wrong, and what was worth giving up and what was not. Out into the world, Mabel had carried the twin gifts of her father's imagination and his integrity, and sometimes found it hard to square the two. In the movie colony, there were lots of people with the former but only a few with the latter. Mabel was fine with exploiting herself for her own goals—what was the harm in subtracting a few years from your age or pretending you were born in Boston?—but she drew the line at taking advantage of someone else. That set Mabel apart in Tinseltown, where such behavior was common.

She'd noticed the strange, foreign looks that would cross people's faces when they'd see her drop a dollar into a hobo's hat or hand over a

pair of shoes to an extra. Mabel's generosity was well known. Her boss, Sam Goldwyn, struggling to make his payroll one week, was thunderstruck when his star actress presented him with an envelope containing $50,000 worth of Liberty Bonds. "If they will tide you over," Mabel told him, "you may have them." Such things just weren't done in Tinseltown.

Except by Mabel Normand.

She was always giving, and by the late summer of 1920, she seemed to have given everything away.

As her train steamed through the California desert, the reflection glancing back at Mabel from the window looked nothing like her. Her friend, the fan magazine writer Adela Rogers St. Johns, had been horrified when she'd seen her last. Mabel had looked "harassed," St. Johns thought, "eaten up inside by something that was bitter to her spiritual digestion."

For all its promise of high spirits, cocaine wasn't very flattering to one's face.

Neither was booze. They might be living under Prohibition, but that didn't stop people like Mabel, who had money and connections, from getting what they wanted. Bootleggers were as easy to find in Los Angeles as fresh avocados. As a result, Mabel had one of the "six best cellars" in town, according to the *Los Angeles Herald*. Two of the other five belonged to Mabel's friends Roscoe Arbuckle and William Desmond Taylor, whom Mabel called Billy.

Billy Taylor worried about her. He had no problem mixing Mabel drinks, but he was opposed to her use of drugs, seeing what they'd done to her. Billy promised to do whatever he could to help her break the habit. But first, he said, Mabel had to really *want* to quit.

Did she? Mabel wasn't sure. How could she survive without cocaine in a place like Tinseltown? Could she really "get off the dope," as the saying went?

The answer came soon after Mabel's train chugged into the imposing pink granite structure of New York's Pennsylvania Station. As taxicabs bleated and smokestacks pumped black soot into the air, Mabel wandered happily along the crowded city sidewalks, exulting in being back home, cherishing the realness, the grittiness, the anonymity.

Then, all at once, everything changed. Handing a newsboy a penny,

Mabel stared down at the headline marching across the front page in three-inch black type. Her good friend Olive Thomas had just died in Paris after drinking a solution of mercury bichloride, apparently by accident. Mabel hurried back to her hotel room at the Ritz, where, for the next week, she hid out.

Mabel was devastated by Thomas's death. The two good-time girls had partied together many times, so it was easy for Mabel to imagine her friend's tragic last night. Strung out on cocaine and booze, Ollie had shaken some tablets into a glass, thinking them to be sleeping pills. But in fact they had come from a medicine bottle, prescribed by a French physician to treat husband Jack Pickford's syphilis. Intended to cauterize Jack's sores topically, the mercury had instead burned its way down Ollie's throat, before embarking on the slow, agonizing process of eating through her stomach and other internal organs. The poor woman's death had dragged out painfully for several days.

The sheer horror of it all destroyed Mabel. Her happy homecoming was ruined. The next "accidental death," she realized, might be her own.

Back in Hollywood, in the once quiet but now rapidly urbanizing Bunker Hill neighborhood, in the architecturally incongruous Melrose Hotel, the second desperate woman, twenty-five-year-old Margaret Gibson, did not share Mabel's desire to get out of town. In fact Margaret, whose friends called her Gibby, had overcome great odds in her effort to stay right where she was.

She might not have been as successful as Mabel, or lived in as swanky an apartment—the Melrose was a faded dowager of the 1890s, home to traveling salesmen and small-time movie players—but Gibby wasn't forfeiting her place in this land of dreams, no matter how precarious. Not long before she'd endured a terrible, humiliating night in Little Tokyo, one that had nearly ended her aspirations right then and there. But Gibby had cooked up a scheme in response to that disaster that she hoped would still allow her to make it to the top.

On a late summer day, as the heat rose in shimmering sheets from the sidewalk and the papers in her hands dampened and began to curl, Gibby set out on a round of the studios. On South Grand Avenue she hopped onto one of the Big Reds, the lumbering, noisy streetcars of the

Pacific Electric Railway. Mabel had a chauffeur; Gibby had to ride the trolley. But she was determined to meet with "everyone she knew in the business who might give her a job."

The résumé she carried did not bear the name Margaret Gibson. Instead, the girl with the golden brown hair in the head shots was identified as Patricia Palmer. How easy it had been for Gibby to rewrite her past in this land of make-believe. By replacing Margaret with Patricia, she'd expunged that night in Little Tokyo and reset her clock by six years—from twenty-five to nineteen—giving herself plenty of time to become a top star.

True, there might have been some in the audience who recognized Patricia as Margaret, but they had no way of proving it. The films of Margaret Gibson had largely vanished. Once a movie had finished its run, it was dumped into a vault, where its nitrate base soon crumbled into dust. Only the most exceptional films were ever seen again. So if the newspapers and fan magazines declared that Patricia Palmer was a garden-fresh nineteen-year-old new to pictures, then she was. In Tinseltown the truth was unverifiable, so it could be anything Gibby wanted it to be.

She had come to Hollywood when both were still very young, when movies were made on the cheap and didn't last longer than ten or fifteen minutes. The Vitagraph company had put out a flyer looking for girls for cowboy pictures. Gibby, who'd grown up in the mountains of Colorado, figured she'd be perfect. "Before Western girls are sent to school," she explained, "they are taught to ride a horse. By the time they are graduated, they can ride anything that has four feet and wears hair." No surprise, she got the job.

But there wasn't much of a future in westerns, Gibby soon realized, at least not for women. Playing second fiddle to both the hero and his horse meant she'd never make the big bucks, and the whole reason Gibby had gotten into movies was to get rich. She'd seen the salaries top stars like Mary Pickford were making—unheard-of wealth!—and determined she'd snatch some of that for herself.

Gibby had grown up dirt-poor. Her father had abandoned the family when she was just twelve, after which she and her mother had lived out of the back of a wagon pulled over mountain roads by a tired old horse. They'd made a living singing and dancing in flea-ridden theaters

between Colorado and Kansas. One day Gibby had looked over at her mother and declared, "We are going to have nice things." She had never forgotten that vow.

For a while, Gibby had seemed on course to get what she wanted. She'd played leading lady to Charles Ray in *The Coward*, a smash hit five years ago. But then had come the debacle in Little Tokyo, and most everyone in Hollywood had turned their backs on Gibby after that. Only comedy producer Al Christie had stuck by her, keeping Gibby busy in short comedies, which at least paid the rent at the Melrose Hotel. But a life on the receiving end of custard pies was hardly Gibby's objective. She still wanted to be a star—if not as big as Pickford, then at least of the standing of Mabel Normand or Mary Miles Minter. And why not? Gibby was as pretty as either of them, and had ten times their ambition. Yet she was at that dangerous age—twenty-five—when if she didn't grab the brass ring soon, it would soon be forever out of her reach.

So Gibby rode the trolley to every studio and office where she had a connection. Patricia Palmer's head shots and résumés landed on dozens of desks.

Among her more important connections was William Desmond Taylor, the prestigious Famous Players–Lasky director. Gibby had known Taylor when he'd been an actor at the Vitagraph company. Six years earlier, they'd starred in a quartet of pictures together, Taylor playing the noble hero to Gibby's demure leading lady. They'd been "great pals," one fan magazine reported. Gibby was one of the few who called the aristocratic Taylor "Billy." Now Billy exerted considerable clout at the biggest, most successful studio in Hollywood, and Gibby hoped her old pal would help her out.

Head shots in hand, she headed into the Famous Players plant. It couldn't hurt to ask.

And finally, in one of the city's poshest neighborhoods, Fremont Place off Wilshire Boulevard, where the nouveau riche built sprawling Beaux Arts mansions to trumpet their arrival into society, the third desperate woman sat sulking over her breakfast.

Pretty little Mary Miles Minter, eighteen, was dreading another day at the studio. Despite the servants who curled her hair and laid out her

clothes, Mary felt overworked and unloved. To her imperious mother, whose lyrical, Louisiana-laced voice sent tremors of fear through everyone in the house, Mary was little more than a cash cow. At Famous Players, she was being groomed as the new Mary Pickford, but all this Mary wanted was to run away.

Convinced she wasn't strong enough to escape her mother on her own, Mary longed for a knight in shining armor to ride in and rescue her, as the gallant heroes did in her films. For a young girl who'd never known her father, every older man became a potential savior, and Mary lost her heart to a number of them. In fact, she had lost more than that to one particularly conniving old lech. That was why Mrs. Shelby, Mary's mother, watched over her daughter like a guard at the gates of Buckingham Palace.

Yet of all the older men Mary had fallen in love with, none had mattered more to her than the courtly William Desmond Taylor, who'd been her director. Mr. Taylor, Mary declared, was the love of her life. If not for Mrs. Shelby, Mary was convinced, they would have been married a year ago.

Impetuous and spoiled, romantic and impressionable, Mary was most of all just very young. She'd been on the stage since she was a toddler, and she'd been forced to play the adult on the screen since her early teens. She'd never had a childhood, and so she lived in her daydreams. Unlike Gibby, Mary didn't care about fame or being a star. What she wanted instead was to be the pampered, protected wife of some strong man who could take her away from her mother. Unlike Mabel, Mary's only addiction was love.

That exasperated Mrs. Shelby. At home, the young actress "made no secret" of her feelings for Mr. Taylor. Remembering what had happened with that other older man, Mrs. Shelby shadowed Mary around the lot, frequently giving Taylor hell if he came too close to her daughter. "They fought all the time," Mrs. Shelby's secretary observed. "Always on the set when he was directing."

So it was with great relief that Mrs. Shelby learned, about six months ago, that the studio was separating Mary and Taylor. The director was being promoted to the main headquarters on Sunset Boulevard, while Mary would remain making pictures at Famous Players' subsidiary, Realart. Mrs. Shelby was overjoyed. But Mary was devastated.

Finishing her breakfast and trooping out to the car with her mother to begin another day of playacting in front of the cameras, Mary was focused on one goal: to find a way to insinuate herself back into Mr. Taylor's life.

Mabel, Margaret, and Mary were three very different women, with different dreams and different dilemmas. But it was the same man, William Desmond Taylor, who would unspool the common thread among them.

# THE ORATOR

On the afternoon of Sunday, September 26, 1920, the sun filtered through the fronds of the eucalyptus trees along Melrose Avenue, etching a lacy pattern of shadows across the partly dirt road. Steering an open cabriolet automobile around the potholes was a young man by the name of Harry Fellows—blond hair, brown eyes, medium build, professional demeanor. Behind him, perusing some notes, sat his employer, William Desmond Taylor.

Fellows pulled into a parking lot beside a long concrete building. Taylor stepped out of the car, the afternoon sun casting shadows across the chiseled architecture of his face. Forty-eight years old, clean-shaven, with iron-gray hair, the Irish-born movie director possessed the "bony look of a stone bishop on a medieval tomb," as one writer would describe him. Striding through the parking lot of the Brunton Studios, Taylor carried himself with the studied grace of an experienced stage actor. As always, he was dressed in monochrome grays and tans. There was never "even a bit of jewelry or a striking cravat to relieve the dullness of his costuming," one studio artist observed.

Although well regarded in the film colony, Taylor was a bit of a cipher. His prominent participation in the Motion Picture Directors Association notwithstanding, he kept mostly to himself. No one knew much about his past, or what he'd done before he came to Hollywood, besides acting some years on the stage. A confirmed bachelor, Taylor would offer condolences when acquaintances got married. Yet he wasn't like Tinseltown's other bachelors, cutting up the rug at the Alexandria Hotel with starlets

on weekends. In fact, his neighbors in genteel Alvarado Court observed that Taylor was home from the studio most nights by seven, and usually spent his evenings alone, reading at his desk until late at night.

The only clew to his past that Taylor ever offered was to say that he had known "great sadness" in his life. That, perhaps, explained why his face seemed perpetually somber and grave. Rarely did a smile curl Taylor's thin lips, and when it did, it was anger, perversely, that summoned it, not pleasure. In those instances, Taylor's cool blue eyes hinted at things he preferred to keep hidden from the prying gazes and wagging tongues of the young, impetuous movie colony. A colleague described him as "quiet, like a camouflaged man."

Yet while Taylor's reserved demeanor served as a kind of armor, it also commanded respect. His boss, Mr. Zukor, regarded Taylor highly because he did not let emotion rule his actions—a rare attribute in a town of temperamental artists. For that reason, Taylor had been asked to preside over this afternoon's gathering of film folk at the Brunton Studios. The movie chiefs hoped the event might serve as an antidote to the recent run of damaging headlines and generate a cycle of more sympathetic press coverage for Hollywood.

In the last few months, Taylor had become the movies' most ardent defender against the increasing calls for censorship. In his deep, commanding voice, he argued in interviews and public speeches that audiences wanted pictures that reflected life as it was, not life as the moralists wanted it to be. "Give the public real human pictures with hearts in them, and life and love and passion," Taylor told one reporter, "and the public will rise up and call you blessed."

He'd been especially busy these last few weeks as criticisms of the film industry mounted following Olive Thomas's drug-related death in Paris. Few were as articulate as Taylor as spokesman for an industry in dire need of some major public-relations varnishing.

That, ultimately, was what this assemblage at the Brunton Studios was about, though it was also what it was billed as: a tribute, a place for people to come together and grieve. The film colony was a small town. If it weren't for the palm trees that stood in for maples and oaks, Hollywood could almost have been mistaken for a New England factory town, with movies replacing brass pipes or rubber tires as the local manufacture. Everyone knew each other, no matter what studio they worked

for. They belonged to the same clubs; they ate at the same restaurants; they shopped at the same stores and attended the same dinner dances. Very few lived more than half an hour's drive from anyone else—and how easy it was to zip around in this auto-centered city! Downtown sometimes got congested at rush hour, with Pierce-Arrow runabouts and Oldsmobile touring cars puffing exhaust. But the movie people had settled, for the most part, at the ends of the long streets that radiated outward from the city center, past the citrus groves and date farms and oil wells. Driving to the studios in the morning in their open-air automobiles, the film folk waved to each other as they passed on the street, and again as they headed home in the evening.

So when someone died, it was a loss for the entire community. And when many died at once—and in violent and tragic circumstances, as had happened these last few months—it was an issue for everyone, not just the particular studio where the deceased had been employed.

They came together this afternoon to memorialize their dead. Ormer Locklear and Milton Elliott, aviators who'd been killed in a movie stunt gone wrong. Pretty starlet Clarine Seymour, whose mysterious death had stunned everyone. Bobby Harron, he of the "accidental" revolver discharge. And of course Olive Thomas, whose tragedy was still being played out in the daily headlines. RUMORS OF DRUG AND WINE PARTIES. GAY REVELS IN UNDERWORLD OF PARIS. Even staid papers like the *Los Angeles Times* reported the "sinister rumors of cocaine orgies" that had swirled around pretty little Ollie.

All around the country, editorials were lambasting the morals of the movie people. It was Taylor's task, as industry point man, to mollify such critics. In his eulogy at the Brunton Studios, his goal was to put forward a respectable, decent face of the film colony.

On the Longacre stage, the largest of the studio's film sets, eight hundred mourners—"stars and stagehands, producers and supers"—were filing solemnly into the pews that had been hastily arranged by Brunton property men.

With all eyes on him, Taylor stepped up to the podium to speak.

Sitting in the audience that day were some of the most important people in the film colony. Adolph Zukor's partner, Jesse Lasky. Zu-

kor's rival Thomas Ince. Zukor's chief director, Cecil B. DeMille. Such top stars as Betty Compson, Harold Lloyd, Mae Marsh, Richard Dix, Thomas Meighan, Lila Lee, Charles Ray, Will Rogers, Bebe Daniels. And the biggest names of all, sitting front row and center, Mary Pickford and Douglas Fairbanks, whose marriage, after Mary's quickie Nevada divorce from Owen Moore, had caused its own scandal headlines.

The whole world was watching them. Everyone in that audience was well aware of that fact. They were all depending on Taylor to say what needed to be said.

He'd won their confidence over the past few months. In his most recent film, *The Soul of Youth*, Taylor had very wisely given a small part to Judge Ben Lindsey, a nationally recognized child advocate. It proved a masterstroke of publicity. After the experience of being in a movie, Lindsey became an enthusiastic supporter of Hollywood, offering a powerful counter to those who called movies too permissive and too dismissive of traditional values and religion. "The motion picture is doing great work," he declared. The effect of movies on children, Lindsey insisted, was "overwhelmingly good." Taylor's sagacity in co-opting Lindsey to the movies' cause had won him fans among the industry chieftains.

What they faced was the old eternal battle between traditionalists and modernists, brought into stark relief by the end of the war. A new generation of moviegoers, finding, in Fitzgerald's famous phrase, "all gods dead [and] all faiths in man shaken," were flocking to pictures that reveled in a new sexual freedom, such as DeMille's *Old Wives for New* and *Male and Female*. "Film subject matter was changing to fit the times," Adolph Zukor acknowledged, and he believed their job as filmmakers was to "stay abreast" of the times.

For every *Rebecca of Sunnybrook Farm*, there were many other films that celebrated a new kind of woman—free, unapologetically sexual—and new kinds of relationships that men and women could enjoy. Other films exposed the seamier side of modern life, with prostitutes, pimps, alcoholics, and gangsters all striding across the celluloid for everyone, including children, to see. Even if good (usually) triumphed in the end, the very depiction of such things was enough to give the church ladies palpitations.

And so out had come the censor's shears. In Pennsylvania, state-appointed moral guardians had even snipped out scenes of "a woman making baby clothes, on the ground that children believe that babies are brought by the stork." What was next? asked the *New York Times*. "Will it be a crime to show a picture of a man giving his wife a Christmas present on the ground that it tends to destroy faith in Santa Claus?"

Zukor and the other film chiefs loudly bemoaned this loss of artistic freedom. But the real pain they felt, of course, came from decreased profits. That was why Taylor had been dispatched to the Brunton Studios memorial to say some kind words about the industry and try to slow the march toward censorship in other states.

In his deep, resonant voice, Taylor intoned the names of the dead: "Sweet little Clarine Seymour, radiant with youth." He paused for effect. "Gallant, fearless Ormer Locklear." Another pause. "True-hearted Bobby Harron." And finally, with a tremble of emotion, "Generous, great-hearted Ollie Thomas."

The melancholy strains of Chopin's famous Funeral March filled the Longacre stage. The Reverend Neal Dodd, pastor of St. Mary of the Angels Episcopal Church, known as the motion picture people's church, gave a reading from scripture. The Metropolitan Quartet followed with the popular piece "The Rosary," by Ethelbert Nevin. No matter that most of the studio chiefs were Jewish, or that, except for Harron, none of those being memorialized had been especially religious. This little show at the Brunton Studios had a wider audience than just those present. The good Christian ladies in Newark, and Birmingham, and Des Moines—the ones who could either mobilize for censorship or stop such a campaign in its tracks—were the ones the movie bosses really wanted to impress.

At last it was time for Taylor's eulogy. Standing tall and erect like the military commander he had been—during the war he'd attained the rank of captain in the British Army—Taylor orated in a rich, resounding voice that rang through the studio. He spoke in glowing terms of those who had been lost. No scandal was mentioned. Instead, Taylor spoke of honor, and devotion to duty, and friendship, and family. Many in attendance were moved to tears.

"William Taylor's beautiful tribute to the memories of the recently departed stars tried even the stoutest hearts," the reporter from the *Los*

*Angeles Examiner* observed, "and will never be forgotten by the motion picture folk who made the unique pilgrimage of sorrow to the studio."

"His sympathy," declared another attendee, "was a thing of beauty. In it, with the utmost delicacy, he touched the tragic notes in the violent passings of youths who had all life and accomplishments before them, while from his stock of supreme tenderness he pointed his moral, revealing with the philosophy of a thoughtful and clear-visioned soul, the light in all things."

Standing there before the high and the mighty of Hollywood, Taylor was their man, their voice. They saluted his oration with rousing applause. Pickford, Fairbanks, Ince—all of them commended Taylor for his advocacy. He seemed an impeccable propagandist to defend their industry, their livelihoods, their world. Difficult days still lay ahead; no one believed they'd put an end to the censorship movement overnight. But William Desmond Taylor had the strength, the authority, and the character to meet the challenges head-on.

But looking out at his audience, Taylor knew something they did not.

For all his noble bearing and dignity, he harbored some dark secrets of his own.

Of course, everyone had secrets in Tinseltown. Mabel, Gibby, and Mary had trunkloads of them. Even the mighty Adolph Zukor had Brownie Kennedy in his past. The film colony was a bubbling cauldron of hidden lives.

But the secrets of the man charged with its championship, William Desmond Taylor, would make the rest seem tame indeed.

# A RACE TO THE TOP

In his eighth-floor office on Fifth Avenue in New York, Adolph Zukor cursed.

Another movie mogul was going to beat him into the sky in Times Square. A skyscraper was going up on the northeast corner of Broadway and Forty-Fifth Street that would include offices and a state-of-the-art theater. Construction was projected to cost nearly $2.5 million, and the building would top out at sixteen stories.

Exactly double the height at which Zukor sat at the moment.

Worst of all, the mogul who would beat him was Marcus Loew.

Zukor and Loew had been friends and rivals for a very long time. In the beginning, they'd been partners, too. They had run a business called Automatic Vaudeville, a penny arcade on Fourteenth Street, in the heart of the city's tenderloin, surrounded by saloons and dance halls and immigrants looking for a cheap way to pass the time. For a penny, these uneducated laborers could peer into the peep shows and watch sexy girls swivel in serpentine dances. Their first year in business, Zukor and Loew raked in more than $100,000, a pirates' booty of pennies and nickels. Soon they had a chain of arcades.

But then they had split. Neither man was the type to share power easily. Both wanted to be the boss, so Zukor and Loew went their separate ways to run their own shows. Still, they remained intertwined in each other's lives. In those early days, the two men lived across the street from each other on 111th Street and Seventh Avenue. Their wives went shopping together, and their sons played on the same baseball teams.

Loew found success with a chain of theaters that showed only moving pictures, without any vaudeville—a radical move at the time. And of course, as the most powerful producer of moving pictures in the world, Zukor became one of Loew's biggest suppliers.

If only they could have maintained such a symbiotic relationship.

But Zukor wanted more. When he started accumulating his own theaters, placing himself in direct competition with Loew, his former partner retaliated by taking over Metro Pictures, a struggling movie studio in Hollywood. That put him in direct competition with Zukor in film production, and Creepy was not pleased. Why was Loew always trying to show him up?

And now he would beat Zukor into the sky, too.

The two men couldn't have been more different. Zukor dressed conservatively, trying not to look like the parvenu he was. Loew was "a dandy in a high hat and fur coat," Zukor said, and Loew didn't disagree. "I wear 'em to impress 'em," he said. Where Zukor was private and deliberate, Loew was loud and impulsive, "a jolly mixer type, knowing everybody." Zukor rarely socialized anymore. His days of raucous laughter and high spirits were over. Now he could be found in some dark corner at Delmonico's restaurant, presiding over late-night, smoke-hung, business-heavy dinners. At another table across the way, Loew continued to party, with friends and acquaintances constantly pulling up chairs. But no one stopped by Zukor's table unless summoned.

About the only quality the two men shared was ambition. As Loew admitted, "You must want a big success and then beat it into submission. You must be as ravenous to reach it as the wolf who licks his teeth behind a fleeing rabbit." Zukor would never have been as upfront or loquacious about it, but he would have entirely agreed with the sentiment.

They played out their rivalry on the tennis court. Loew, bigger and stronger, nearly always won. When he suggested they don boxing gloves for a little sparring in the ring, Zukor declined. He was not lacking in courage, and he was certainly not averse to risk. But Zukor's risks were always calculated. He understood the wisdom of a strategic retreat.

What Loew lacked was Zukor's foresight. As savvy a businessman as he was, Loew had failed to see the potential of feature-length films. The "flickers," he argued, would always remain ten to fifteen minutes

long. No one would sit still much longer than that. So when Zukor imported the nearly hour-long French film *Queen Elizabeth*, starring Sarah Bernhardt, Loew had placed a sympathetic arm around Lottie Zukor's shoulders. Her husband, Loew told her, "had lost his head." His money was sure to follow.

*Queen Elizabeth* turned out to be a huge hit, launching the era of feature-length films. Zukor made sure Loew received a report of the box-office receipts in the mail. Anonymously, of course.

Yet what finally separated the two old acquaintances was something more personal. Loew was loved, while Zukor was feared. Reporters told stories about Loew's friendship with his elevator boy, whose troubles the film mogul would listen to every day as they rose from floor to floor. Zukor's elevator boy knew to keep mum when taking the boss up. Loew's employees feted their employer on every birthday, but Zukor's staff shrank from the man they called Creepy. Loew was modest and gave credit to others: "I have had the help all the way along of a great many very capable men." Zukor only ever spoke of his own efforts. Loew said he'd been lucky in his career. Zukor insisted luck had had nothing to do with his success.

But only bad luck could explain why his beloved daughter Mildred, whom he called Mickey, had fallen in love with Loew's son Arthur.

Zukor believed Loew had encouraged Arthur's courtship of Mickey, knowing full well that the romance would get under his skin. But both fathers had been surprised when Mickey had accepted Arthur's marriage proposal. Grumbling all the way, Zukor had paid for a lavish wedding with 350 guests in the Crystal Room at the Ritz-Carlton—as much to impress Mickey's father-in-law as herself. Moving-picture cameras, of course, had recorded the momentous event.

If anyone was hoping that a family alliance might tamp down the rivalry between the two men, they would have been disappointed. The marriage of their children only exacerbated the competition between the fathers-in-law. "Then you did not let blood ties interfere with business?" an attorney would ask Zukor, years later. "No!" Zukor replied, as if it were the most foolish question ever posed.

Sitting at his desk, Zukor uncurled a map of New York. Circled in red were the theaters that belonged to him. In blue were those that be-

longed to Loew. That fall, Zukor's rival had bought six more theaters, bringing his total to forty-one. And word was that he was getting ready to acquire more.

Zukor scanned the rest of the map with his sharp eyes. Dozens of other theaters remained uncircled, just waiting to be snagged by one of them.

Controlling the exhibition of movies was key to all of Zukor's future success. The numbers told the story. The combined annual income of all American producers was $90 million—but the combined revenues of all American movie theaters was $800 million. Zukor wanted a piece of that. The most substantial piece, in fact.

A year earlier he'd taken personal affront when some of the biggest first-run theaters in the country had formed First National Pictures. The exhibitors had organized in response to Zukor's increasing control of the market, but the Famous Players chief saw the move as offensive, not defensive. Ever paranoid, Zukor felt "raided." His first reaction was to try to buy out First National. When that failed, he decided to hobble it. He'd acquire as many theaters as possible before First National could get to them.

Now Zukor owned close to three hundred theaters throughout the United States, most of them showing only his Paramount pictures. His plan was vertical integration of the industry: he would make the pictures, distribute them, and exhibit them. Zukor wanted what all capitalists ultimately want: to eliminate the competition and create a monopoly for himself.

But acquiring all those theaters hadn't been easy. In many cases, Zukor had had to coerce or bully the local exhibitors into coming on board with him. In this, he had found a determined opponent in Sydney S. Cohen, the head of the Motion Picture Theater Owners of America (MPTOA). With Cohen around, Zukor was finding it increasingly difficult to get his way. "Cohen must be destroyed," the Famous Players chief wrote in a memo to his staff, "and his organization broken down." The note found its way into the hands of the exhibitors, and open war broke out between Zukor and the MPTOA.

Of course, Marcus Loew had moved right in to take advantage of the situation—or at least, that's how Zukor perceived it. At the MPTOA's most recent gathering, Zukor's daughter's father-in-law had riled up his

fellow exhibitors even further by thundering from the podium that no producer should want to "drive the exhibitor out of the game"—a clear indictment of Zukor. That, he said, was "killing the goose that lays the golden egg." When Loew finished speaking, those uncouth theater owners—most of them illiterate immigrants, Zukor sniffed—cheered and stamped their feet. A beaming Loew basked in their applause.

No one ever cheered for Zukor.

It didn't matter. He was richer and more powerful than any of them. He'd accomplished what no one had ever thought possible: he'd turned the flickers into big business. He'd marched into the offices of Kuhn, Loeb & Co., the biggest investment firm on Wall Street, and made his case for a $10 million loan. Zukor's colleagues, Loew chief among them, had thought he was crazy. But he'd convinced the firm's chief, Otto Kahn, that "the screen was becoming the entertainment medium of the great body of the public" and that Famous Players was "the spearhead of this vast new industry." Kahn had responded with a $10 million stock issue. Famous Players went public, and the movies came of age.

As did Zukor. No longer did he move among showmen and vaudevillians, as Loew still did. Zukor's associates were the city's richest men. Kahn. Jacob Schiff, director of the National Bank of New York. Lord Beaverbrook, the powerful Canadian-British newspaper tycoon. So what if Zukor didn't get the cheers and the backslaps Marcus Loew got?

The little orphan boy from Hungary had done pretty well for himself these past seventeen years. His father—or so he'd been told; Zukor didn't remember him—had built his dry-goods store in the little village of Ricse with his bare hands. Zukor had done the same with his own business, metaphorically. He'd started with nothing, but film by film, screen by screen, dollar by dollar, he'd created a business like none before, entirely of his own design.

That fall of 1920, 35 percent of all motion picture revenues in America were generated by Paramount films. Famous Players operated twenty-eight branches throughout the country and six in Canada, as well as offices in more than ten countries worldwide. Zukor was more than a king. He was an emperor. And soon, he told himself, the entire industry—production, distribution, exhibition—would be brought under his centralized command. Famous Players would swell to include every aspect and every territory of the movie business, becoming bigger

than anything anyone had ever imagined. Too big for any of his competitors to withstand the onslaught. Too big to be contained.

Too big, Zukor believed, to fail.

Providing, of course, these silly scandals didn't keep stirring up the wrath of the church ladies.

Zukor's daily newspapers were black and smudgy with scandal. For two solid weeks the press had bannered Olive Thomas's grisly death in Paris. Investigations were followed by autopsies and funerals. And then had come the censure.

"We are told the wages of sin is death," one newspaper editorialized, "and judging from the trials of our much advertised movie folks, misery goes hand in hand with those who scoff [at traditional values]." The *Philadelphia Evening Public Ledger* thought the movies "show altogether too much of the side of American life erroneously called gay. A child educated in the movie theatres might well suppose that he lived in a profligate world." Another paper declared, "It may be time, at long last, for the government to investigate the goings-on in Movie Land and perchance take over the running of the various businesses from its libertine leaders."

This was why Zukor feared the reformers. They could bring the government down on him, and only the government had the power to turn back Zukor's advance. So far he'd been fortunate. President Wilson's zeal for trade reforms, like everything else, had dimmed since his stroke. But his vile creation, the Federal Trade Commission, still breathed like an ugly, pulsing leviathan, waiting to strike at everything Zukor had built. Further antitrust regulation could prevent his consolidation of the industry, and federal censorship could snatch control of production right out of his hands. His beloved Uncle Sam, who had given him so much since he'd come to these shores, could willfully roll back all the gains Zukor had made.

Zukor took some comfort in the fact that pro-business Republicans had taken over Congress in the last election, ousting the unionists and the socialists who were determined to destroy everything great about America. A poor orphan could come here and make as much money as he wanted, by working hard and learning how to play the game. Zukor

hoped that, come November, Republicans would expand their majorities and take back the White House as well, and maybe then he could breathe a little easier.

But frequent scandals, he knew, increased the odds of a government investigation. And in an industry teeming with secrets, further scandals were perpetually looming, including his own.

That fall, brooding in his office high—but not high enough—above Fifth Avenue, Zukor grew paranoid. He questioned the motives of everyone who came through his door. He distrusted every letter, every phone call. People were out to get him: Marcus Loew, Sydney Cohen, the exhibitors, the reformers, the government. He had worked very hard to get where he was, and not a single dollar would he give up without a fight.

Like all megalomaniacs, Adolph Zukor lived with the fear of losing it all.

# MABEL

On the morning of September 28, 1920, Mabel moved carefully down the steps of St. Thomas Episcopal Church at Fifth Avenue and Fifty-Third Street. If she had tried to hurry, she might have tripped, and the mob surging ahead of her might easily have trampled her underfoot. Hordes of hysterical, wailing people in the street were pushing against a barricade of trembling policemen. No one had ever seen anything quite like this.

At the curb, Olive Thomas's casket rested on a bier, covered in thousands of purple orchids—Ollie's favorite flowers, final gifts from her husband, Jack Pickford.

For Mabel, the funeral was excruciating. Ollie was her second good friend to die in a six-month period. Young Clarine Seymour, who'd passed away in April, had hero-worshipped Mabel, smoking cigarettes and knocking back shots of gin just like her idol. The producer Hal Roach often scolded Mabel for using off-color language around Clarine, but Mabel would "talk even dirtier" just to get his goat. How that had made Clarine laugh. Mabel thought the teenage actress was the sweetest, dearest little thing.

Then, suddenly, Clarine died. Her family claimed she'd contracted some mysterious intestinal illness. But people whispered it was drugs.

Mabel knew that was possible. She was well aware how much both Clarine and Ollie had partied, having partied with them both herself.

The crowds surged forward. So many fans jammed the street that Ollie's funeral cortege couldn't begin its procession to Woodlawn Cem-

etery in the Bronx. Police were estimating that fifteen thousand people had turned out. Fifteen thousand! For an actress, not a president or a statesman. It was unfathomable. People stood sobbing in the street. Their heartfelt, often gut-wrenching cries echoed off the Gothic limestone exterior of the church.

Such was the power of their profession, the movie folk on the church steps seemed to realize, perhaps fully for the first time.

Mabel was just one of the movie stars there that day, being shoved by the crowds and pursued by *Daily News* photographers. Box-office champ Thomas Meighan served as a pallbearer. So did Owen Moore, a Selznick star like Ollie and the former husband of Mary Pickford, which meant, briefly, he'd been Ollie's brother-in-law. Mary herself didn't show—the queen had paid her respects in Hollywood, at the Brunton Studios memorial—but her sister Lottie, a major serial star, was there, with their mother. Standing prominently on the steps was Mae Murray, the exotic blond Famous Players star, who'd started out with Ollie in the Ziegfeld Follies. The photographers were particularly eager to get a shot of Murray, who was always camera-ready with her bee-stung lips. She didn't disappoint this day.

Mabel, however, lowered her face into the crowd to avoid the popping flashbulbs. She wasn't there for publicity. She had come because Ollie was her friend, and now her friend was gone.

Mabel's nose, almost certainly, was starting to itch.

The cocaine kept her going, armoring her against the agonies of Tinseltown. In the beginning Mabel had used the drug mostly because it made her laugh and feel happy, and Mabel liked to laugh. Young and carefree, she'd thought nothing could slow her down. "Mabel wanted to be smart," said the director Allan Dwan, "and being smart meant doing what wasn't done"—like drinking liquor, and snorting coke, and telling dirty jokes.

"What was the slipperiest day in Jerusalem?" Mabel asked her fellow merrymakers at one party. "When Saul went through on his ass!" They all laughed hysterically, tossing down a shot or snorting another line.

"When she spoke," her friend Blanche Sweet said, "toads came out of her mouth, but nobody minded." Everybody loved Mabel.

But now they pitied her too. In the film industry, Mabel's addiction had become common knowledge. Not long before, the social butterfly

Hedda Hopper had paid her a visit. She'd found Mabel in bed, "a shadow of her former self," the room reeking of rotting flowers. Dozens of bouquets had been sent to congratulate Mabel on her latest picture, but she'd taken none of them out of their boxes. Hopper hunted around for "the white powder" she knew was there. When she found it, she flushed it down the toilet.

But for Mabel, getting more was just too easy.

Police finally pushed back the crowds and allowed the orchid-covered casket to be loaded into the hearse. Mabel, numb, made her way back to the Ritz-Carlton.

She was distraught. She didn't like the dependency that had taken over her life. The deaths of Clarine Seymour and Ollie Thomas had served as wake-up calls.

But her cravings were never far away. Liquor was as easy to get in New York as it was in Los Angeles, and all Mabel needed to do to score some cocaine was place a telephone call and speak a few coded words. Sometimes her dealers were even waiting for her at the Ritz when she arrived.

At the hotel, Mabel did what she always did when she needed support. She took out pen and paper and wrote to Billy Taylor. Mabel addressed him as "Desperate Desmond," after the popular comic strip, and signed her letters "Blessed Baby," Taylor's pet name for her. They understood each other. After all, Mabel knew that Billy lived with "a great sadness," too, although he'd never revealed the nature of it. Their friendship was based on "comradeship and understanding," Mabel said. They "loved so many of the same things—books, music, pictures."

Mabel trusted Billy like she'd never trusted any other man. Soon after meeting him, she had confessed her addiction and asked for his help. Billy had vowed to support her any way he could.

This was a new experience for Mabel. Men manipulated her, exploited her, hurt her. They didn't support her. In fact, all the problems of Mabel's life could be attributed to men, stretching all the way back to her father.

"From her French father," Mabel's biographer would write, "Mabel inherited a love of music, art, romance, and strong drink, along with

recklessness and melancholy." Two decades past their little boat rides off the coast of Staten Island, Claude Normand's wanderlust had become Mabel's own. "See the world," her father had told her, pointing over at Manhattan. If she stayed where she was, he warned, she'd always be ordinary. But in the big world that was waiting for her, Mabel could shine like the very special star her father wanted her to be.

Book learning, Claude told his daughter, wasn't as important as getting out into the world and finding her place. So by the time she was a young teenager, Mabel had dispensed with much of her schooling and made her way to the mainland using the only asset she had: her looks.

With jet-black hair and inch-long eyelashes, Mabel was pretty in a quirky sort of way, with poached-egg eyes and "a complexion that makes you think of gardenias," according to her friend, the writer Frances Marion. But it was Mabel's sexy figure that landed her on a stool in the Manhattan studio of the famous illustrator Charles Dana Gibson, modeling for postcards. Mabel graced the covers of several magazines and posed for advertisements that were plastered all over New York. In one, she held a strangely shaped glass bottle of a fizzy new drink called Coca-Cola.

Not long afterward, she was making movies.

She got her start at the old Biograph Company on East Fourteenth Street, near Union Square, working for D. W. Griffith. One of her first friends there was a big, bluff Irishman named Mack Sennett. Mabel was sixteen. Mack was twenty-nine.

With his intense hazel eyes, Sennett watched the tiny, impish teenager bounce around the room. Mabel seemed to have springs affixed to her shoes. "Skittery as a waterbug," Sennett thought, and always laughing. "She would tell stories, wisecrack, and play practical jokes by the hour. She turned any place she was into an uproar and if she couldn't think up better things to do, she would pull chairs out from under fat men." Sennett was enchanted.

The following winter, when the Biograph Company departed to make movies in Los Angeles, Mabel was left behind. Sennett couldn't stop thinking about her. He sat in the bathtub at the Hotel Alexandria and wrote her a gushy poem, plagiarizing the words from a popular song. Right from the start there was pretense and fraud in his relationship with Mabel, but the smitten teenager pretended she didn't know.

"She wrote me very sweetly," Sennett would remember, "and said the poem was beautiful." She signed her letter, "Your girl."

And for the next six years, Mabel was.

When Sennett started producing his own Keystone comedies, he brought Mabel out to Hollywood to be his leading lady. They made some terrific pictures together: *Mabel at the Wheel. Mabel's Married Life. Tillie's Punctured Romance.* Under Mack's guiding hand, Mabel became a top star. But he pushed her hard. Even through the haze of coke and booze, which many at the studio used, Mabel came to realize that what Sennett really cared about was the money she could make for him.

Still, she was in love with the big lug. She expected she'd marry Mack and have his children. But Sennett had a roving eye. The studio was overrun with pretty young girls, and Mack was a randy fellow. One day Mabel found him with her best friend, the actress Mae Busch. Fists flew. Bottles—and not the prop bottles used on the set—smashed over heads. Not long after, Mabel turned up at the studio in bandages. Some said she had tried to kill herself.

Sennett did everything he could to make things up to her. But Mabel had seen the light. She had been so foolish: after turning her back on an ordinary life by leaving Staten Island, she'd succumbed to the bourgeois dream of love and marriage. How much more ordinary could she get? Never again, Mabel vowed.

Pushing Mack out of her mind, "she refused to have anything to do" with her former fiancé, according to Sennett's lawyer, and remained "absolutely unmanageable and unalterable" on the point. Eventually Mabel left Mack's studio and his bed, replacing him with Sam Goldwyn on both counts.

This time, Mabel thought she could handle work and romance. She didn't love Goldwyn the way she had loved Sennett, so there were no messy heartstrings to get in the way. But she was wrong. Things only got worse with Goldwyn—far, far worse—but now, two years past the devastation, Mabel never talked about any of that.

Except, possibly, to Billy Taylor.

———

After Sennett and Goldwyn, William Desmond Taylor was a godsend.

Billy's interest in Mabel was purely intellectual, and she found his friendship refreshing and liberating. Billy tended to be diffident around women, "never in the least forward," as one colleague said. But women adored him because "he was ever ready to talk to them of their interests, their achievements, their hopes and ambitions." When she was with Billy, Mabel was in heaven.

In his small, cozy apartment in Alvarado Court, Taylor shared his books with Mabel, teaching her about Virgil and Shakespeare and Freud and Nietzsche, catching her up on the education she'd missed. Surrounded by leather-bound books in the soft amber glow of his living room, draped in shades of mulberry and mauve, Taylor helped Mabel cram entire college courses into a single night. Mabel longed for knowledge the way she'd once longed to see the world.

Maybe it wasn't too late to change course. As the pinched face and puffy eyes in her mirror reminded her, the world hadn't turned out quite the way she and her father had imagined.

One friend thought Mabel had "exhausted the incandescence that had set her apart from the ordinary." She had wanted to be special; now all she wanted was to sit with Billy Taylor and fill her mind with literature and ideas. With Billy, Mabel was happier than she'd ever been.

If only her nose didn't itch so much.

# GIBBY

Margaret "Gibby" Gibson paused under the dusty chandeliers in the lobby of the Melrose Hotel and listened. Over by the old oak bar, word among the fellows was that the cops were looking for Joe Pepa. Something about a stolen car.

In the past, Gibby might have run upstairs and called Joe to warn him. But not anymore.

Gibby was getting smarter. In the last few months, she'd made some decisions about fame and success, and they were very different from the ones Mabel had made. Unlike Mabel, Gibby hadn't abandoned her quest for fame and success. In fact, Gibby thought no price was too high to pay for them. She knew she'd need some help in securing the nice things she still dreamed about, but she'd come to understand that con men like Joe could no longer help her get them.

Patricia Palmer was going high-class.

Now that her résumés and head shots were distributed all over town, Gibby climbed the uneven stairs back to her room and waited for her contacts to call. And why wouldn't they? Patricia Palmer had everything producers wanted. She was pretty and willing to do whatever a director required—and she was only nineteen. Patricia was bound to be snatched up by a big, important producer. High-class. Gibby had to think high-class.

For too long, she'd been depending on two-bit crooks like Joe Pepa. Gibby had to think higher if she was ever going to fulfill the vow she'd made to her mother years ago. On a mountain road between Colorado

Springs and Ottawa, Kansas, Gibby had thrown aside the rusty spoons they were using and promised someday they'd have silver. "Father left us with nothing," the young Margaret had said. "But I will get us everything."

From town to town they had traveled, Gibby singing and dancing on the stages of run-down theaters, hoping some famous company would take her on. "Her life has been one long succession of hotels and theaters," one early press report said about Gibby. "Her one desire to have a home of her own prompted her to enter pictures."

Her early, fleeting success had brought her enough cash to buy a couple of small properties on North Beachwood Drive, but these were hardly movie-star residences. So Gibby used the income from the little houses to pay her rent at the Melrose. After a couple of years, she figured, she could sell the Beachwood properties and move into a glamorous mansion.

But things hadn't quite worked out that way.

No wonder she had turned to Joe Pepa. Joe had shown her there were other ways to get what she wanted. And for a while, he'd been right. But the cost had been too high: it was because of Joe that Gibby had been arrested for prostitution at "a house of ill fame" in Little Tokyo on that terrible afternoon of August 25, 1917. Her dreams had nearly died right then and there.

The whole sordid tale began in a downtown taproom popular among picture players—in the days before Prohibition, of course—where Gibby first met Joe Pepa.

At that moment, Joe was enjoying a dash of notoriety. His right arm was draped in a sling, broken in twenty-two places by police bullets, and he was suing the department for $15,863 to cover his medical costs. When Gibby came across him, he was holding forth at his table, gesturing dramatically with a glass of whisky in his left hand. Everyone there had read his story in the papers: Suspecting him of smuggling opium over the Mexican border, the cops had followed him to his little stucco house on Rodgers Street and demanded to search his car. Standing outside the front door, Joe had told the cops to beat it. At that point, according to the official police report, Joe reached for his gun,

although Joe insisted he was only raising his hands as ordered. In any event, one of the officers fired. An explosion of gunfire rattled the quiet street. When the smoke cleared, Joe was lying on the ground with a shattered arm.

A search of Joe's car found no opium. Of course not: Joe was too clever for that.

So instead the cops arrested him for bigamy. It was this little detail that had turned Joe, a low-rent drug smuggler, into a citywide celebrity. While in Mexico, Joe had married an actress, Betty Benson, who was a bit notorious herself, having just served as a key witness in a scandalous alienation-of-affection case between two Chicago businessmen. The fact that Pepa was already married was irrelevant. Betty Benson was a knock-out, and he'd wanted her, so he'd married her in Tijuana. The cops ended up arresting Betty, too, after finding an opium pipe in her room.

But that was just the beginning of Joe's fame. When Betty died after her stint in the city jail, newspaper sob sisters turned her death into a cause célèbre, claiming that unsanitary conditions in the lockup had killed her. What really did poor Betty in, according to her death certificate, was "acute yellow atrophy" of her liver—alcohol poisoning. Still, Betty's grieving, two-timing "widower" suddenly became the guy everybody wanted to meet.

Despite a record stretching back a full decade, Joe boasted that "he would never be convicted of any charge because of his cleverness." In all his dozens of arrests, he'd gone to jail only a couple of times, and then for very short stays. In most cases he'd weaseled out of the charges by paying off corrupt cops or by dazzling judges with his wit and his intense black eyes. Joe was an incredibly magnetic man, the son of Italian immigrants, strikingly handsome, with wavy black hair and a solid, stocky frame. When Gibby met him that night in the early spring of 1917, he was just twenty-four years old. She was twenty-two, and instantly enamored.

Joe drove a fancy car and wore expensive fur coats—things he didn't buy with the money he made at his regular job as a driver for a wholesale liquor company. He told Gibby that she too could earn a little extra income to buy herself some pretty things. She may have been shocked at the idea he had in mind—at least at first. But she went along with the plan.

In Little Tokyo, Joe introduced Gibby to his friends Ralph and Lola

Rodriguez. The couple advertised "furnished rooms" at 432½ Commercial Street. The neighborhood was rough. Robberies were frequent; drug deals flourished in back alleys; a man had just been killed at a dance hall run by Rodriguez's brother. Such danger only electrified Joe Pepa. He and his brother-in-law, the shrewd defense attorney Sammy Hahn, were frequent visitors to the Rodriguezes' house. They knew the police were keeping tabs on the place, but they didn't care. Hahn told Lola Rodriguez he'd gladly defend her in court if she were ever accused of killing a cop.

Across the street, their elbows sticking to the greasy tabletops of a restaurant, Officers Lester E. Trebilcock and James C. Douglas watched the front door of the house. They'd been keeping their eyes on the place for days, taking note of those who came and went. On this day they counted no less than seventy-one men, all of them Japanese. And every day the same young woman with golden brown hair.

Inside Gibby slipped into a silk kimono, apron-style, with ties in the back. "The top was quite low," an observer recalled, "and the bottom dropped scarcely below her knees." Gibby kept her shoes and socks on, however, and took her seat with the other girls. "Japanese men entered the hall," one of Gibby's fellow geishas, Ruth Slauson, testified in court. "They would either tap us on the shoulder or motion to us, and we would accompany them to a room."

All at once there was commotion at the front of the house. Two policemen were pushing their way inside, flashing badges, barking that they were all under arrest. Four johns were marched out to the paddy wagon, pulling up their pants. For the cops, the real treat was nabbing Joe Pepa: they charged him with lewdness, and the Rodriguezes with running a disorderly house.

Through it all, Gibby was cool as an April breeze. Sauntering up to one of the officers, she asked sweetly if she might put on her street clothes. He allowed her to do so. Once properly dressed, Gibby laughingly told another officer that she was an actress, visiting the house to soak up some "local color" for a vaudeville sketch, and she ought to be "turned loose." She'd never been at the Rodriguezes' before that day, she insisted. When that line didn't work, she tried flirting with Officer Trebilcock, but that didn't work either, "Don't try to love me up," the cop snapped.

One of his colleagues wasn't so righteous, however. As Gibby stood waiting to be ushered out to the paddy wagon, another officer pushed her against the wall and kissed her hard. Looming over her, he said she was an "unusually pretty girl to be found in such a place." Gibby was frightened. She wasn't laughing anymore.

Her mother posted the $250 bail to save her from spending the night in jail. The other girls, not so fortunate, pleaded guilty and got ninety days. Gibby knew the only way to salvage her dreams was to fight the charges and demand a jury trial.

She'd need a lawyer, and a good one. Not Sammy Hahn; Gibby knew she couldn't be linked to Joe anymore. So she turned, no doubt with tears and contrition, to the movie industry. Only someone with clout could have hooked up a two-reel comedy player like Gibby with Frank Dominguez, "one of the most entertaining political orators in the state," whose law partner Earl Rogers had defended Clarence Darrow. It might have been Al Christie who made the connection, or possibly Rogers's daughter, *Los Angeles Herald* reporter Adela Rogers St. Johns, who knew lots of movie people. Or maybe it was Gibby's old pal Billy Taylor.

Whoever got him, Dominguez was the perfect choice to defend Gibby. He strode into the courtroom bellowing out his client's innocence, his white hair and eyebrows in striking contrast with his olive skin. His adversary was deputy city prosecutor Margaret Gardner. With seven women on the jury, it was thought wise to have a woman prosecuting the case; female defendants were much more likely to be acquitted than their male counterparts. But Gardner came off like a starchy scold, frequently being told to sit down by police judge Ray L. Chesebro. Meanwhile Dominguez strutted around the courtroom, gesturing over at his client and calling her "this little girl." When Ruth Slauson took the stand, giving her halting account of a kimono-clad Gibby escorting men to the back rooms, Dominguez "severely arraigned her in an effort to impeach her testimony." By the time he was through, Slauson was weeping "so copiously that she was excused."

Then it was Gibby's turn to testify.

How small she seemed on the stand, how delicate. Reporters were surprised when Gibby gave her age; they thought she looked like a schoolgirl. The actress was dressed in a dark green suit, her golden-

brown hair "forming a halo beneath a black hat." Gibby repeated her claim that she'd been in Little Tokyo merely to gain atmosphere. "When she saw the character of the place," one reporter wrote, "she declared it interested her, and she went three more times to study it, hoping it would help her in her film work." With "flashing eyes," Gibby denied that she had ever worn a kimono. Looking over at the women on the jury, she described how one lecherous cop had stolen a kiss from her. The ladies were horrified.

When Dominguez asked Gibby about her childhood, her eyes welled with tears. "Since I was twelve years old, I have been engaged in the show business," she said. "My father left my mother at that time and I have been her only support ever since." The jury saw her look over at her mother, seated in the courtroom, tears slipping down her cheeks.

The trial lasted four days. At five o'clock on September 19, the defense rested its case. The jury took only fifteen minutes to deliberate. The foreman read a verdict of not guilty.

Gibby had gambled. And she had won.

Joe Pepa wasn't so lucky. At his trial, prosecutors brought up every blot on his record, enraging Joe so much that several times he "started to leave the witness stand as though he were going to whip the attorney." Finally Joe was found guilty of "being a lewd and dissolute person and of resorting in a house of ill fame" and was sentenced to six months in city jail. They'd finally gotten him. The cops and the court took no small satisfaction in that.

Gibby had learned a valuable lesson. She couldn't be waiting for Joe when he got out. "Underworld gunmen" were threatening those witnesses who'd testified against him. Gibby could have nothing more to do with that sort of world. Patricia Palmer needed to be sweet and innocent. Patricia Palmer had never known Joe Pepa, and had never set foot anywhere near Little Tokyo in her entire life.

Despite her determination to start over, however, Gibby made little headway with her "high-class" contacts. Every day she checked, but no one from the big studios ever left messages for her at the Melrose Hotel.

She was running out of ideas. She knew there were whispers that Margaret Gibson and Patricia Palmer were one and the same, and the

whispers may have been loud enough to keep her contacts from help-
ing her. Billy Taylor, for instance. If he had helped her in the past, he
seemed to have washed his hands of her now. When they'd worked at
Vitagraph, both of them just starting out, Gibby had shared her dreams
for the future with Billy. But now that he'd made it big, he offered no
help whatsoever. And it wasn't as if Gibby hadn't asked.

From the Christie plant, she could look over at the sprawling backlot
of Famous Players. No doubt Gibby had watched, many times, as the
company's biggest stars—Gloria Swanson, Billie Burke, Alice Brady,
Mary Miles Minter—were driven up to the front gates by uniformed
chauffeurs in their shiny town cars. Now that was class.

If Billy had wanted to help Gibby, he had the power to do so.

He might have been high and mighty now, but Billy hadn't always
been so irreproachable. What most everyone in the industry seemed to
have forgotten was that, long before he was so well known, Taylor had
been rather ingloriously fired by Vitagraph. No reason for his dismissal
had ever been made public, but Gibby was there when it happened and
likely knew why. Indeed, she likely knew a number of the secrets Taylor
kept so deeply hidden from Hollywood.

And if Joe Pepa had taught Gibby anything, it was that you used any
means at your disposal to get the nice things you wanted.

# MARY

She knew her mother was likely to blow her top like a geyser in Yosemite National Park, but Mary had stopped giving a damn one way or another.

Mary Miles Minter steered her eight-cylinder Cadillac roadster down Wilshire Boulevard. The car had been built just for her, with a driver's seat specially designed to fit her diminutive frame: Mary stood just five-two and weighed barely a hundred pounds. She'd ordered the car in her favorite color, robin's-egg blue, and loved seeing how fast she could get it to go. Forty, fifty, sometimes sixty miles an hour. Next, she told the studio, she wanted to take flying lessons. The life insurance companies warned her that if she ever took to the air, they'd declare her policies just "scraps of paper."

Mary laughed. She'd only been joking. Well, half joking, anyway.

She was out past her curfew. Whether she cared about her mother's rules or not, it was always better to avoid a scene than to cause one. "Mrs. Shelby," Mary called her; sometimes, out of earshot, she dropped the "Mrs." It was a made-up name, anyway, an attempt to claim descent from Isaac Shelby, the first governor of Kentucky. Their real name was Reilly. There were lots of ruses like that in their lives, and Mary was expected to keep them all straight.

How tired Mary had become of her mother's rules. Lately she'd been testing Mrs. Shelby's patience more and more. Mary was getting braver, or maybe just more foolhardy. But after all, she was now eighteen years of age. That gave her certain rights.

At least, Mary liked to think so. Shelby thought otherwise.

They'd just returned from a vacation in Yosemite. They'd stayed at Lake Tahoe—she and Mrs. Shelby and Mary's older sister Margaret, as well as Mary's grandmother, the only one in the family Mary felt any affection for. It was her grandmother whom she called "Mama," even as Mrs. Shelby treated her own sixty-seven-year-old mother "as a glorified servant girl at her beck and call." But that was how they'd all lived these past fifteen years: in service to Mrs. Shelby.

Driving through the elegant columned gateway of Fremont Place, Mary couldn't deny that her mother, for all her tyranny, had accomplished a great deal for her family, shepherding them from a rather dreary "there" to a very fashionable "here." When they moved to Los Angeles, Mrs. Shelby had insisted that they "find a suitable millionaire's home to rent." Their home was an ornate two-story neoclassical mansion on spacious grounds, with a garage, a tennis court, swimming pools, and stables. The house had been Mary Pickford's for a couple of years—undoubtedly the reason Mrs. Shelby had thought it perfect for her Mary, whom everyone was calling Pickford's heir.

That was Mrs. Shelby's goal: to see her daughter become one of the biggest stars in moving pictures. Mary heard that refrain every day, and she was getting tired of it. Mabel had achieved that status, and now wanted something else; Gibby yearned for it, and would have killed for a stage mother as determined as Shelby; but Mary simply didn't care. True, she enjoyed the life her stardom gave her. Her fancy little roadster and the fabulous parties would be hard to give up. But if it meant escaping from Mrs. Shelby, Mary would have chucked it all in an instant.

How she ached to be free to live her own life. She despised being told "when to go to bed, when to get up, whom to meet and whom not to meet." There had to be a way out of her mother's clutches.

Mary turned the knob of the front door and stepped inside.

Charlotte Shelby was only a couple of inches taller than her daughter, but somehow even the biggest, most brutish studio guards always stepped aside to let her through. Her kewpie-doll face was invariably pinched, her clenched smile signaling either pleasure or anger. Shelby

was feared and loathed by nearly everyone who knew her, including her own family.

But even her detractors couldn't contest her brilliance or her ability. To succeed in a world run by men without resorting to sex or trickery was virtually impossible for a woman in Tinseltown. But Mrs. Shelby had managed to do just that. Fifteen years ago she'd left the stink of her husband's linotype shop and found a new world for her daughters and herself, propelled only by her dreams and her belief in herself.

Charlotte Shelby had been born Lilla Pearl Miles, the bloom of a faded aristocracy, her speech still edged with the flowery Louisiana lilt of her youth. Mary later described the "gentility" of her mother's family, part of an old South "where Negroes knelt to pull on the gloves of the plantation owners." Lilla Pearl grew up determined to reclaim her birthright. When she married her struggling husband, some predicted she wouldn't last long as a newspaper printer's wife. They were right. As soon as her two daughters were school age, Lilla Pearl packed them up and took them to New York, without telling her husband when they'd be back.

"When I was a baby, just four years old," Mary lamented, "[Shelby] took me away from my home and my daddy." To Mary's mother's way of thinking, there was no life for them in the bayous. Their names were changed so her husband couldn't find them.

In Manhattan, the newly christened Mrs. Shelby advertised herself as an acting coach, despite never having acted a day in her life—unless playing the part of a working-class Shreveport wife and mother counted. She taught her pupils the Delsarte method of applied aesthetics, while her widowed mother, Julia Miles, served as babysitter and cook.

Within a short time Shelby had pushed both her daughters out onto the stage. But it was little Juliet—Mary's birth name—who became the star. Before she was ten, Juliet was signed by theater impresario Charles Frohman and packed his houses with her sexy nymphet act. When child labor laws caught up with them, Mrs. Shelby sent back to Louisiana for the birth certificate of a deceased cousin, Mary Minter, and slammed it down on producers' desks, claiming it revealed Juliet's

real age and name. From that point on, the little girl became Mary Miles Minter.

She also became sixteen when she was only ten. Slathered with lipstick and mascara, she was dressed in high heels and long skirts. "These things have an effect upon a child that all the training and coaching in the world cannot eliminate," Mary would say. Shelby wanted her daughter all grown up fast. One day she snatched Mary's favorite doll from her hands and burned it in the oven in front of her. The bereft child cried for weeks. "They never would let me be a girl," Mary said, "to have a girl's pleasures, to do the things that other girls would do."

Only one thing mattered in life, Mrs. Shelby taught her daughter. "From morning till night," Mary said, "I had money, money, money talked and preached to me."

Money, of course, was something Mrs. Shelby was very good at getting. Although Mary made movies for producers in New York and Santa Barbara, California, Mrs. Shelby always had her eye on a bigger prize. She was determined to get her daughter the most lucrative contract in the film business, even if that meant going toe-to-toe with the biggest man in the industry, Adolph Zukor.

When she finally got an offer from Zukor, Shelby had the nerve to play it against one from Lewis J. Selznick of Select Pictures, watching smugly as the two moguls fought for Mary's services. Zukor won— Zukor never lost—to the tune of $1.3 million, making Mary "the little girl with the biggest motion-picture contract in the world." Zukor used the teenager as the linchpin in his newly formed Realart Picture Corporation, which had its own studio out on Occidental Boulevard near Wilshire.

Mary was an instant hit with audiences, her innocent smile and curvy little body especially popular with men. She had, in her own words, "matured very quickly in this glorious sunshine and gorgeous setting of California." The men who flocked around her made her feel very grown up, but they made Mrs. Shelby very uneasy. Mary believed her mother was simply afraid some man would steal away her golden goose. But Shelby had other reasons to worry, even if Mary didn't like to remember them.

She'd been barely fifteen, a budding rose of adolescent charm and sexuality. James Kirkwood had been her charismatic forty-two-year-old director.

Predictably, Mary had fallen in love.

Standing with Kirkwood in a field of wildflowers overlooking the Santa Barbara coast, Mary took her director's hands in her own. He'd wanted her for so long, Kirkwood told her. But since Mary was still a virgin, he would never think of debasing her honor. So here, under the brilliant blue sky, Kirkwood proclaimed he would marry her, before God.

With strong hands, the director lifted Mary and placed her on a rock. She stood above him like a goddess, her ringlets blowing in the wind. Kirkwood dropped to one knee. With the sun and the sky their only witnesses, they pledged themselves to each other. Mary was enraptured.

Then Kirkwood took her down from the rock, yanked off her dress, and had sex with her in the grass.

Soon afterward, Mary was pregnant. She was deliriously happy, certain that Kirkwood would take her away from her unhappy home; together they'd raise their baby and have many more. But soon Kirkwood was gone, off to New York. Mary wrote him passionate letters, begging him to come back. One of the letters was intercepted by Mrs. Shelby.

Shaking with rage, Shelby dragged the terrified girl to a doctor who provided clandestine services for women who could afford it. Mary was strapped to a table, her legs pulled apart and secured. Given only the mildest anesthesia, she shuddered as a long, cold, sharp tool was inserted inside of her. The doctor dilated Mary's cervix and carefully, painfully, scraped out her uterus with a curette.

After the procedure, it was common to try to reassemble the pieces of the fetus to make sure nothing was left inside the woman's womb.

Mary had many reasons to hate her mother. But surely this topped the list.

The Kirkwood affair had been devastating, but it hadn't ended Mary's interest in men, nor theirs in her. Before long, she had fallen in love

again. But her latest love was very different from James Kirkwood. True, William Desmond Taylor was another older man, another authority figure. But the new director assigned to Mary was polite, deferential, distant, and reserved, with none of Kirkwood's prurience, which only made Taylor more appealing.

On their first day working together, on an adaptation of the novel *Anne of Green Gables*, Taylor addressed his leading lady as "Miss Minter." That won her over. Usually her directors called her "Mary," as they might talk to a child. But Taylor was different: he saw her, Mary believed, as a woman. "Heart hungry as I was," she would remember, "I loved him the first time I saw him." She looked into his face and thought, "This is God."

Taylor was tall, distinguished, and austerely handsome. He was also even older than James Kirkwood, forty-seven to Mary's seventeen. Mary watched his every move with puppy-dog eyes.

Mr. Taylor decided to shoot *Anne of Green Gables* outside Boston, where it would be easier to evoke the story's Prince Edward Island location than in Southern California. Cast and crew packed their bags. Mrs. Shelby and Mary's grandmother went along as chaperones.

In the little town of Dedham, Massachusetts, Mary lay awake in their guesthouse, listening for Mr. Taylor's footsteps. "I recognized them as they went up the stairway and into his room," she said. More and more, Mr. Taylor filled her every waking thought.

On a trip into Boston, the director took a seat in the chauffeur-driven automobile between Mary and her grandmother. "The road was rough and bumpy," Mary recalled, "and his arms were spread across the rear of the backseat. One bump threw grandmother against him and he said, 'I guess I will have to hold you.' But his arm did not embrace me." Desperate, Mary thought, "Dare I? Dare I?" She did indeed. She "reached up and tugged at his coat sleeve" until Taylor dropped his arm about her waist. "The thrill of that innocent act thrilled me for days and days," Mary said.

Despite what had happened with Kirkwood, she remained an innocent. One day she and Mr. Taylor were walking when it started to rain. Wrapping his coat around her, Taylor hurried Mary back to the guesthouse, only to run into Mrs. Shelby, who was "fairly raging." As Mary would remember, "She accused Mr. Taylor before the entire company

of taking me out, humiliating him most shamefully." Later, when Mary apologized to him for her mother's outburst, Taylor replied, "Your mother is right, Mary. You must always obey her."

Mary didn't. Back in Hollywood, she went riding with her beloved and wrote poetry to him. He was always "Mr. Taylor" to her. Unlike Mabel or Gibby, she never called him Billy. "The man was too wonderful for that," she said.

Finally Mary confessed her feelings to him. Mr. Taylor was gallant and tender, and probably flattered. But he thought of her only as "a nice little girl," his chauffeur Harry Fellows understood. Taylor told her, as gently as he could, that she was May and he was December, and it was best they not see each other socially anymore. "I can't give you what a boy your age could give you," he told her kindly.

And he thought that would be that.

But Taylor's very remoteness only made him more attractive to his admirer. To her mind, Mr. Taylor wasn't rebuffing her. "He reciprocated my love," Mary fervently believed. He was only trying to protect her honor. "He never by look, by word, or by deed gave me any reason to doubt any of my ideals that were placed in him absolutely," she said. He just wanted to wait until she was old enough to be free of her mother before they could be together. The only obstacle to their happiness, Mary believed, was Mrs. Shelby.

When Mr. Taylor was promoted to the main Famous Players studio on Sunset Boulevard, his absence only made Mary's heart grow fonder. On one occasion, when her true love visited the set where she was working, Mary maneuvered a seat very close to him. At that moment her mother walked in. Charging up to Taylor, Mrs. Shelby thundered, "If I ever catch you hanging around Mary again, I will blow your goddamned brains out!"

Shelby's secretary, Charlotte Whitney, witnessed the episode. "She was livid with rage," Whitney said, "and shook her fist in his face and swore dozens of times."

This was the woman Mary now faced from across the room.

"Have you been out with Taylor?" Mrs. Shelby demanded.

Mary resented the question. How dare her mother even ask such a

thing? After all, it was Shelby herself who'd driven Mr. Taylor away from her.

The two women stood glaring at each other. There was a time when Mary had wanted her mother's love. When she was younger, she had tried cuddling up to her, "to kiss and fondle her," but she'd been pushed away and told not to be silly. Now there was no love left.

Shelby accused Mary of being intimate with Taylor.

"Do you really mean that?" Mary asked, full of indignation.

"I certainly do," Shelby told her.

Mary screamed in rage. To cool her down, Shelby tossed a glass of water in her face.

The young woman's eyes popped. Her wet hair dripping down in front of her eyes, Mary cried, "I'm going to end it all!" and ran up the stairs.

Mrs. Shelby, her mother, and her secretary followed, only to hear Mary lock herself in Mrs. Shelby's room. They pounded on the door but got no reply.

Suddenly there was a shot from inside the room. Then another one.

Shelby screamed down the stairs to Frank Brown, her security guard, and Chauncey Eaton, her chauffeur. The two men came running. Shelby told them to break into the room.

Eaton and Brown rammed their shoulders against the door. It fell inward.

"And there," Shelby would tell investigators later, "lay Mary on my bedroom floor." Her mother's gun was beside her.

With extreme tenderness, Eaton picked the young woman up in his arms.

"Why, Mrs. Shelby," the chauffeur said, "there's no blood on her."

It was Mary's grandmother who had the presence of mind to inspect the limp figure in Eaton's arms. "Why, no," Mrs. Miles concluded, "she is not shot." The old woman took a step back. "Stand her up, Chauncey."

Eaton put Mary down on her feet. The pretty little movie actress opened her eyes and looked around defiantly at everyone staring at her.

"I thought I would give you all a jolt," she said.

As Mary stalked off to her room to sulk, Mrs. Shelby told Eaton

to search the room for the spent bullets. He found one lodged in the closet, the other in the ceiling.

Later, when she told the story to police, Shelby would insist she was "afraid of pistols." But when her statement was repeated to Charlotte Whitney, the secretary laughed. "Mrs. Shelby," she insisted, "is not afraid of anything."

# RIVALS AND THREATS

A steady rain beat down across Manhattan on the night of November 2, but that didn't deter thousands from gathering outside City Hall to watch the presidential election returns. In the age of motion pictures, waiting for the next day's papers to learn who'd won was very nineteenth century. Tonight the results were being projected onto giant screens set up outside the offices of the *New York Tribune*. In between returns, newsreels of the candidates were shown. When images of the Republican candidate, Warren G. Harding, flashed on the screen, the crowd of ten thousand, cold and drenched, "with only their high spirits to protect them," erupted with cheers. Pictures of the Democratic candidate, James Cox, elicited mostly boos.

Uptown at the Ritz, cigar and brandy in hand, Adolph Zukor was cheering Harding too. During the campaign Zukor had met several times with Harding's manager, a tenacious little bird of a man named Will H. Hays. Hays assured the mogul that Harding would do nothing to hinder any attempts to consolidate business holdings. Under a pro-business Harding administration, Zukor would have nothing to fear.

In return for such promises, Zukor—indeed, all of Hollywood— had gone all out to put Harding in the White House. Newsreels suddenly became ubiquitous—except that audiences saw virtually none of Cox. Instead they soaked up images of Harding on his front porch in Marion, Ohio, receiving distinguished visitors, many of them from the film colony. Pickford and Fairbanks were the ones moviegoers were

most excited to see. Poll watchers believed the newsreels had had an effect. Who could vote against a guy endorsed by Mary and Doug?

But Zukor was keeping his eye on another race that wasn't quite as comforting. That was the contest in New York's twelfth senatorial district, where the Democrat, the flamboyant young James J. Walker, was cruising to an easy reelection. A former Tin Pan Alley songwriter, Walker spent more time in the city's speakeasies than he did the state house in Albany. But working stiffs loved the guy. The ambitious Walker made sport of hounding fat-cat capitalists, and he was counting on riding a populist wave to ever-higher office.

What made Zukor despise Walker most, though, was his role providing legal counsel for the Motion Picture Theater Owners of America. Walker, Sydney Cohen, and Marcus Loew were bosom buddies. Zukor would see them at Shanley's or Delmonico's, laughing and carrying on, everyone stopping by their table to say hello.

There had been a time, many years ago, when Zukor had laughed like that in public. Those were the days when he and Loew, flush with the stunning profits from Automatic Vaudeville, had knocked back their share of whiskies and pulled more than a few chorus girls onto their laps. Zukor had been young then, high-spirited. He hadn't yet become cautious, or cagey, or circumspect. He hadn't yet become paranoid.

These days, when he spotted Loew across the room, raising a glass of ale spiked with rum at a table with Walker or Cohen, he marveled at how easy it was for his old friend to laugh. People from all walks of life were drawn to Marcus. What was it? What made everyone like Marcus Loew? What must it feel like to be everybody's friend?

Zukor had no idea.

"There is no question," the vile Jimmy Walker had told a rally of exhibitors during the campaign, "that what Famous Players is doing with its acquisition of movie theaters should be investigated by the trade commission under federal anti-trust laws."

Lately it seemed everyone was challenging Zukor's power. Filmmaker Thomas Ince, who'd previously released his films through Paramount, had suddenly broken ranks, launching his own distribution company, Associated Producers, with partners including Mack Sennett. There was also a challenge from W. W. Hodkinson and Hiram Abrams, two for-

mer associates with personal vendettas against Zukor. Hodkinson, the founder of Paramount, had been ousted after Zukor cajoled stockholders into replacing him with Abrams—an underhanded move, perhaps, but a necessary step in his quest to merge production and distribution. A few years later Abrams himself had been unceremoniously dumped, the fall guy for the Mishawum Manor affair. Now both Hodkinson and Abrams were back to bedevil Zukor, Hodkinson distributing the sort of independent productions Zukor felt were drains on the industry and Abrams working for United Artists in their quest to merge with some or all of the Associated Producers.

Zukor intended to squash them all underfoot like insects.

He'd rather be feared and loathed, and come out on top, than be loved and admired and come in second—which was the fate Zukor believed awaited Loew.

From his comfortable chair at the Ritz, Zukor lifted his eyes to check the latest returns. No way could Cox catch up with Harding now. Zukor was pleased.

Soon after arriving in America, the ambitious immigrant had become a Republican, "because all the people I knew were Republicans." He hadn't gotten where he was by playing the outsider. Shrugging off the old country like a peasant's shawl, Zukor had enthusiastically embraced everything about America. He took up baseball. He boxed with Italians and Irish, forever proud of his cauliflower ear. He ate lobster with gusto and decorated an enormous fir tree every Christmas. Zukor's Americanism came first, his Jewishness second. Back in Hungary, his uncle, a devout Talmudist, had urged him to become a rabbi, but there was "never a danger" of that, Zukor would say. The only part of his religious education that had ever interested the future moviemaker was the Bible itself, because it was a primer in how to tell good stories.

Now Zukor lived in an elegant town house on Manhattan's Upper West Side, stuffed full of antique Oriental rugs and Chippendale sofas and original artworks by some of the great masters. He owned another house in rural Hudson River Valley and drove an expensive Pierce-Arrow automobile—"a self-indulgence," he'd say, "since I enjoy good things." Zukor believed a man should surround himself with good things, for in doing so "he sets a standard in his own eyes as well as those of others."

As a young man, sweeping the floors of a dry-goods store in Hungary, the young Adolph had seen "nothing but darkness" in his future if he didn't somehow get to America. His parents had died when he was very young; Zukor had never known the nurturance of a mother or a father. Wearing the rags issued by the government to orphans, he'd felt as if he'd been "dipped in a sewer." As one biographer wrote, Zukor's life was "the story of a man who had been emptied out in childhood, who had lost or been deprived of love and who then set about to fill himself back up again, even if that meant appropriating everything around him."

When he stepped off the boat at New York's Castle Garden, Zukor had only a tenth-grade education and spoke no English. His pockets were filled with nothing but ambition. His fellow movie chiefs all came from similar humble beginnings: William Fox toiled in New York's garment industry until he invested in a penny arcade in 1903; Universal's Carl Laemmle was a bookkeeper who opened a Chicago movie theater on a whim in 1906; and Thomas Ince was a struggling vaudevillian before taking a job as a movie actor for $5 a day in 1908. Now they ran three of the most profitable film factories in the world.

But Zukor had moved faster and further than any of them. Even before the turn of the century, the impoverished immigrant had already transformed his start-up furrier business into a profitable enterprise. At nineteen, he was "swimming in money." Zukor believed he was different from his competitors because he made his first fortune before he went into the movies. That made him more "level-headed" than the others, more comfortable with money—and that confidence enabled him to expand his business empire with the swiftness of a prairie fire.

Now the orphan from Hungary had the ear of the man who would be the president of the United States. Where else could that be possible but in this great land? The only time Zukor would ever show emotion in public was when he expressed "his gratitude to his adopted country."

As the rising sun sent its long pink fingers between the skyscrapers of Manhattan, the final presidential returns rolled in. Zukor was tired, but he was smiling. Noisemakers blew, and the room at the Ritz exploded in confetti. Harding won the election with more than 60 percent of the vote, the largest share of the popular vote in a hundred years.

Now Zukor could forge ahead with a free hand, without fear of government intrusion. He was so close to his dream that he could taste victory on his tongue.

Only the church ladies still had the power to keep him awake at night.

Adolph Zukor might have been the most powerful man in the film industry, but in some ways the women who sat on national boards and ran civic clubs and wrote letters to newspapers had more influence than even he did. No matter who was in the White House, the church ladies still had the ability to organize boycotts, pressure lawmakers, and drive public opinion. They could vote now, too. The 1920 election was the first in which women had the right to cast ballots. To underestimate the power of these women would have been foolish. And Adolph Zukor hadn't gotten where he was by underestimating his foes.

These reform-minded women seemed to be everywhere. The National Board of Review, the organization charged by the industry to ensure that all films released were suitable for the screen, depended on the service of 150 volunteer reviewers, and a good number of them were conservative Christian women. On the various affiliated Committees for Better Films scattered throughout the country, such women as Mrs. Thomas H. Eggert of Houston, Texas; Mrs. Neil Wallace of Birmingham, Alabama; and Mrs. Eugene Reilley of Charlotte, North Carolina, exerted tremendous authority. One word from one of these matrons could be enough for a local municipality to forbid the showing of a particular film, which often led to the film being banned in surrounding communities.

And then there was Mrs. Ellen O'Grady in Manhattan.

Mrs. O'Grady had made history as one of the first policewomen in the New York Police Department. Irish-born, a widowed mother of three daughters, Mrs. O'Grady had been charged with the protection of young girls and investigation into prostitution rings. She was known for her bravery, her compassion, her efficiency, and her strict adherence to the rules.

She was also a devout Roman Catholic. In a speech before the Na-

tional Conference of Catholic Charities in September, Mrs. O'Grady said that "the elimination of sin" guided her work. To the Women's City Club, she insisted, "Girls should not paint or powder. There should be no improper dress. I know how hard it is when tight skirts are in fashion."

This was the woman the NYPD placed in charge of the city's public welfare laws as they related to motion picture theaters. Not surprisingly, Mrs. O'Grady had some pretty strong opinions about the movies. If a picture wasn't "clean," she argued, the police "must have the power to stop the showing." She added, "Our foreign-born citizens get their ideas of our institutions from the moving pictures. Some kind of censorship is needed."

On the afternoon of Sunday, November 14, 1920, a tragedy occurred that brought many of the reformers' simmering resentments against the movies to the surface. An audience of nearly three hundred people, most of them children, had crowded into the New Catherine Theatre on the city's Lower East Side for the latest installment of the Vitagraph serial *The Veiled Mystery*, starring Antonio Moreno. When smoke from a faulty furnace began billowing up through the floorboards, someone shouted "Fire!" and panic ensued. In the mad rush for the exits, six children were trampled to death. In the chaos outside, mothers screamed for their babies in half a dozen different languages. Initial reports said one door was locked, which led to the theater owners being charged with manslaughter. But charges were dropped once an investigation determined that the doors were actually open, and the owners had followed all safety regulations.

That, however, did not satisfy Mrs. O'Grady. She used the tragedy of the New Catherine fire to further her goal of getting children out of movies entirely. Rounding up eighty-seven fellow officers in the Police Welfare Bureau, she announced a crackdown on New York's movie houses. "Some theatre proprietors are unscrupulous and money mad," she declared. "It is up to you to show no leniency where violations are detected." Any manager who admitted children without a parent or guardian would be arrested. Officers would patrol the aisles and pluck out any child not accompanied by an adult. And of course, the children's tickets would be refunded.

That, of course, would have spelled financial disaster for the film industry. The theaters depended on children for a large percentage of their receipts. But now, with the city's women's clubs and many religious groups backing Mrs. O'Grady in her campaign, exhibitors had little recourse. People were angry. The present system wasn't working, the reformers charged, and they were tired of broken promises from the film industry. Censorship was the only solution.

Even President Harding might not be able to stop this groundswell.

But in New York City, the reformers lost the battle. Zukor had little love for Sydney Cohen of the Motion Picture Theater Owners of America, but in this case the two found common cause. In early December the organization, whose members forked over a great deal of taxes to the city, sent Cohen to call on the chief of police. Shortly thereafter, Mrs. O'Grady was stripped of her oversight of the movie houses. The chief called her work there "too strenuous." Outraged, Mrs. O'Grady removed her badge and handed it to the chief. "I'm through with the police department," she said, and walked out.

Zukor could only have been pleased by this takedown of one of the movies' most vocal opponents. But the film industry hadn't heard the last from the church ladies.

Least of all Mrs. Ellen O'Grady.

# GOOD-TIME GIRL

The weeks after Olive Thomas's funeral were among the worst in Mabel's life. She dropped out of sight. Few friends knew where she was or how to get in touch with her.

In such situations, confronted by tragedies that could have been their own, some addicts are scared straight. Others, overcome, feeling trapped and helpless, spiral into self-destruction, gorging on drugs and booze. What Mabel's reaction was, no one knew.

But whatever hell she went through in those terrible weeks after Ollie's funeral, at the end of it, she had finally reached a turning point.

With trembling fingers, she placed a transcontinental phone call to Billy Taylor.

From Los Angeles, Taylor encouraged her to take the next step. It would be difficult, but it would also be the most courageous decision of Mabel's life.

In the late fall of 1920 she checked into the Glen Springs Sanatorium above Seneca Lake in the little town of Watkins Glen in central New York. Mabel immersed herself in the black, briny healing waters of the natural springs. She meandered across the rolling green hills, playing golf and picking autumn vegetables for the supper table. She "went to bed when the moon came up and arose at the crack of dawn," she'd recall later.

No doubt the cravings still gnawed at her, threatening at times to overwhelm her. But out in rural Schuyler County there were no dealers to call, and eventually the need ebbed.

From three thousand miles away, Billy Taylor called to cheer her on. Some in the film colony believed that Taylor himself was footing the bill for her stay at Glen Springs. Mabel had been spending her earnings on drugs—up to $2,000 a month, some whispered—and even if that was exaggerated, it was easy to see where her money had gone, and why she likely needed Taylor's financial help.

It was a long and painful process. But Mabel wasn't just purging herself of her addictions at Glen Springs. She had other, even more profound healing to accomplish as well.

For all the heartbreak Mabel had endured with Sennett, it couldn't compare to the hell she'd gone through with Sam Goldwyn.

How persistent he'd been in his advances. Eventually Mabel had given in. After all, Sam was her boss. As much as Mabel loathed it, sleeping with Sam Goldwyn was job security.

Goldwyn was nearsighted, squat, bald, and selfish. Cocaine was the only thing that helped Mabel tolerate sex with him. Once, on a train, she'd excused herself from his sweaty clutches and hurried into her compartment to snort a couple of lines. When she returned she was glassy-eyed and frenzied, the better to deal with Goldwyn's pawing hands and sloppy kisses.

But what was even worse was his Napoleonic presumption of power. Goldwyn wanted to change Mabel, to refine her. That was perhaps the worst thing of all. With each new etiquette lesson he arranged for her, Mabel's resentment toward him grew.

Sitting in the shadows of a movie set with Frances Marion, she nursed her discontent like a gin and tonic. "Look at him," Mabel seethed under her breath, pointing her finger at Goldwyn as he waddled through the studio, hunched over and beady-eyed. "That stuck-up bastard! That—" And she proceeded to "let fly a string of cuss words that no longshoreman could improve on," Marion recalled. At last, out of breath, Mabel said, "Excuse me, Frances, for pointing."

When it came to Sam Goldwyn, Mabel's anger ran deep. But it wasn't just because of the unwanted sexual passes and hectoring about etiquette.

Julia Brew, her companion-nurse, knew just how deeply Mabel de-

spised Goldwyn. Julia had come to work for Mabel fresh from the nursing school at St. Vincent's Hospital. Assigned her first case—"a movie star at Seventh and Vermont"—Julia was told the job was top-secret. So the bespectacled young woman took the trolley five miles to Mabel's apartment without telling a soul.

On Mabel's door hung a brass knocker shaped like the Mask of Thalia, the smiling muse of comedy. Julia took hold and rapped hard. A maid let her inside. The apartment was deathly still. Julia was told her patient was upstairs.

In the second-floor hallway the nurse spotted "a young balding man with wire-rimmed glasses" looking "pale and quite nervous."

It was Sam Goldwyn.

Opening the door to Mabel's room, Julia found the actress in pigtails and a flannel nightgown, rocking on the bed in terrible pain. She was in labor, Julia realized, and losing a great deal of blood.

Immediately Julia went to work delivering the baby. Mabel's "large eyes closed with pain and then opened again." The five-month-old male fetus was born dead.

When Mabel had learned she was pregnant, she hadn't demanded Goldwyn marry her, as many other young women in her position might have done. She didn't love Goldwyn, so she wasn't going to marry him. Neither had she undergone an abortion. A network of doctors and midwives stood ready to provide the illegal procedure; Mary Miles Minter knew that firsthand. But not Mabel. What she'd been planning to do when the baby came, she told no one. She might have dropped out of sight for several months and then given the child up for adoption—or adopted the boy herself, from a sympathetic orphanage, some months later.

But in the end she was spared any of those decisions.

Mabel looked down at her dead baby. "Miss Normand was in a terrible state," Julia would remember.

Goldwyn came into the room and kissed Mabel on the forehead. "I'm so terribly sorry," he said. Mabel didn't answer. She didn't want to see him. This was what happened when she gave in, when she let a man run her life.

From now on, she was on her own.

———

Mabel spent about a month at Glen Springs. Then, suddenly, she resurfaced.

"Mabel Normand has a pair of callused hands to prove she has been rusticating in Staten Island," columnist Louella Parsons reported. A few nights earlier, Parsons had spied Mabel at the Times Square Theater at a performance of *The Mirage*. Mabel regaled the columnist with stories of "her efforts to conquer that fascinating game called golf," and revealed that she was putting on weight, adding "a pound a week."

All true—except it wasn't Staten Island where Mabel had been rusticating.

She had fallen far, but Mabel was determined to prove to her doubters that she was made of tougher stuff than they gave her credit for. She was not Olive Thomas. She had survived not only drugs but betrayal and exploitation, and the loss of a beautiful baby boy.

Mabel returned to Manhattan with a new gleam in her eye.

There would be no orchid-covered casket for her.

# LOCUSTS

"They loitered on the corners or stood with their backs to the shop windows and stared at everyone who passed," Nathanael West would write in *The Day of the Locust*, describing those who lived in the margins, who'd been denied their share of fortune in the land of sunshine and dreams. "When their stare was returned," West continued, "their eyes filled with hatred." Little could be discovered about them, West wrote, "except that they had come to California to die."

Gibby had yet to turn as sour as all that. For now, her dreams still held. But a dull, dead look moldered in the eyes of the lost souls who congregated on the stairs of the Wallace Apartments, a building full of hookers and dealers on Georgia Street downtown. Leaning against cracked stucco walls, they chain-smoked cigarettes and watched as Gibby climbed past.

She'd come here at the invitation of a new friend, Don Osborn, who shared her determination to make it to the top. Osborn, just a month younger than Gibby, had big plans. Like so many of the postwar generation, Osborn thought everyone could be millionaires if they just put their minds to it. Not for long would he be stuck living at the Wallace. Palatial homes awaited him. Fancy automobiles. Big-budget pictures. Just as they awaited Gibby.

They'd gotten to know each other on the set of *The Tempest*, a two-reel film based loosely on the Shakespeare play, starring the veteran actor Tom Santschi. But *The Tempest* was hardly a prestige picture. Made by independent producer Cyrus J. Williams and released by

Pathé, the film flickered across only those few screens still uncontrolled by Adolph Zukor or the other big chains. Although Williams renewed his contract with Pathé for another series of pictures with Santschi, he had not rehired Gibby. Had her past caught up with her yet again?

By now, she'd run out of people to turn to. She had, in her own words, asked "every one" of her contacts for help by now. And none of them had come through.

Enter Don Osborn.

Sitting with her new friend in the courtyard of the Wallace Apartments, the yellow paint peeling off the walls, Gibby listened eagerly as Osborn told her how he planned to rewrite the rules. Osborn might not be high-class—yet—but he had high-class ideas. The big studios might be closed off to people like them, Osborn told her, but the trick was to team with an independent like Williams and make a picture that generated so much publicity that audiences would beg theaters to book it. Even Adolph Zukor would be powerless to stop exhibitors from showing a film if the public demanded it strongly enough. All they needed, Osborn insisted, was a little hype. He had friends who wanted to invest money in pictures. So he was going to direct a fantastic picture and beat Hollywood at its own game.

Gibby was entranced. Don Osborn was Joe Pepa without the criminal record. Shrewd, smart, spontaneous, Osborn had the same fatal charm with women as Pepa. He was six feet three, lean and muscled at a hundred and sixty-eight pounds. His dark hair was offset by striking blue eyes, and he sported the pencil-thin mustache that was all the rage on the motion-picture screen. Most important, he was ambitious. He'd help Gibby get what she wanted, and he'd do it more cleverly than Pepa had with his inelegant schemes. Don Osborn was just the man Gibby was looking for. Soon they were "intimately associated and involved," as she put it.

But their passion wasn't so much for each other as it was for what they might accomplish. It was greed, not sex, that aroused them. Their Cupid was cupidity. Osborn was married; Gibby knew and didn't care. Pepa had been married, too. What mattered was what they could do for each other. Nathanael West wrote of the relationship between two of his fictional locusts: "She wasn't sentimental and had no use for ten-

derness, even if he were capable of it." He might have been describing Margaret Gibson and Don Osborn.

If Gibby believed Don Osborn's schemes were aboveboard, she'd soon find out how mistaken she was.

When he was nineteen, Osborn had masterminded a profitable forgery business out of his downtown apartment at 312 South Flower Street. Knowing the cops were squeamish about arresting women, Osborn had used his new bride, the former Florence Vennum, to sign the checks. Their "worthless paper," according to newspaper reports, was "scattered throughout Southern California." When police finally closed in, Osborn blamed it all on Florence; the police took pity on her and let her go. Just as her husband had counted on.

Not surprisingly, Florence left Osborn soon after this, taking their infant son, Earl, with her and suing for child support, though Osborn rarely gave her a cent. Moving back in with his mother, Osborn found day jobs at the movie studios. In the last five years, he'd walked though the backgrounds of dozens, maybe hundreds, of pictures from a variety of studios. When he registered for the draft during World War I, he was working for the Triangle Motion Picture Company in Culver City. But Osborn's name would not be found on the Triangle payroll: he probably never held a job on the lot for more than a few days at a time.

Osborn firmly believed that the rules were stacked against people like him. If he was going to succeed, he'd need to go around the rules. He'd also need money. That was the basis for his friendship with George Weh, a middle-aged bachelor and the moderately successful owner of a sheet-metal company. One night, as they luxuriated in the saltwater plunge at the Sultan Baths on South Hill Street, across from Pershing Square, Osborn struck up a conversation with Weh. Osborn told Weh about his dream—to make an independent picture that could crash through the gates erected by the big producers and distributors. All he needed was financing. Weh was intrigued by the younger man. Soon he was frequenting Osborn's "drinking parties" with their bootleg booze and attractive girls, most of them would-be movie actresses, the kind casting agents used as dress extras and called "soft goods."

Among the loveliest was Osborn's second wife, the teenage Rae Potter,

who'd won a Chicago newspaper contest naming her "the prettiest working girl in the city." Armed with such clippings, Rae had set out for Hollywood. But the only person in Tinseltown who showed much interest was Don Osborn. They married on her eighteenth birthday.

So much in love was Rae that she didn't mind supporting her husband, dancing in two shows a night at Pelton's Theatre in Burbank so the couple could pay their bills. Rae would later describe Don as not "the kind of man who liked to work." Not that she was judging: Rae sympathized with Osborn's plight. Don Osborn could be a great film director, Rae believed, if only someone would hire him. But the men in power were jealous of Osborn's artistry. "You haven't a friend in the world," Rae would say, commiserating when her husband came home, depressed after making the studio rounds.

Yet for some reason her tenderness enraged Osborn. Rae was "too good" to be married to him, he snapped, and he began staying away from home. Rae sank into deep despair. One afternoon the nineteen-year-old swallowed some bichloride of mercury tablets, the same poison Olive Thomas would consume a year later. In a suicide note she said she "longed for the love of her husband."

But the dosage she took wasn't as high as Olive's, and Rae made a full recovery. She also made the papers. STAGE BEAUTY WILL LIVE, the headlines cried. Like a moth to the spotlight, Osborn came fluttering back to Rae's side, making a great show of contrition.

But within a few months they had separated again—leaving the door open for Gibby.

Margaret Gibson was like no girl Don Osborn had ever encountered before. She wasn't a docile accomplice like Florence, or a besotted acolyte like Rae. Gibby had her own dreams, her own ambitions. And they were at least equal to Osborn's own.

What they both wanted was to get inside the gates. They were tired of being on the outside, watching the lives of their betters with their noses pressed up against the glass.

On the night of December 1, both Gibby and Osborn could have glanced outside their windows to see the searchlights crosshatching the dark sky, heralding the opening of the Mission Theatre. All they

would have had to do was walk a few blocks from their respective hotels to witness the fuss and glamour of Hollywood's A list. The Mission's first show was the premiere of Douglas Fairbanks's *The Mark of Zorro*, and the elites had turned out in force. Gibby and Osborn might well have stood among the crowd of screaming fans watching as Doug and Mary arrived in their Rolls-Royce, turning to the crowd to wave before heading up the velvet carpet to the theater. Following close behind was the mayor of Los Angeles, and Cecil B. DeMille, and Gloria Swanson, and Tom Ince, and William Desmond Taylor, and Mary Miles Minter. The women dripped with diamonds, the men dazzled in top hats and tuxedos. Cameras flashed; searchlights swung across the theater; fans shouted their favorites' names.

This was the world Gibby and Osborn aspired to join. This was the world they believed was walled shut against them. And this was the world they intended to conquer.

# THE MADDEST WOMAN

It hadn't been easy seeing Mr. Taylor at the Mission Theatre premiere. Mary was doing her best to forget him, but every time she got a little distance, there he was again, looking so handsome, so debonair, his square shoulders and noble bearing giving him the appearance of a cavalier at some European court. All that was missing was a sword at his side and a plumed hat. In those moments, Mary's feelings came rushing back at her like a runaway train.

Their mansion on Fremont Place had been sold, and Shelby hadn't yet found them another rich man's house to call home, so Mary and her mother were packing to spend Christmas back East. Mary's heart ached for the love she was leaving behind. She studied the photograph Mr. Taylor had given her. He had signed it, "Yours now and forever."

Now and forever.

Shelby was no doubt pleased at the chance to get her daughter away from Hollywood and Taylor for a while. They had a great deal to accomplish while they were in New York. They would need to see Mr. Zukor, their imperious employer, while they were in town, so Shelby ordered Mary to write to him. Mary got out pen and paper and did as she was told.

"I am very, very happy in my work," Mary wrote to Zukor in her girlish script. "I know that behind it all is you." She closed her letter with a paean that must have pleased both her mother and her boss very much: "Don't forget that there's a little girl three thousand miles away whose main ambition is to make you proud of her."

That was malarkey, and even Mary, as oblivious as she could sometimes be, must have known it. Her main ambition wasn't to please Adolph Zukor. It was to make Mr. Taylor notice her again.

Nothing Mary had done to forget him had worked. As a distraction, she had even tried getting close to Monte Blue, one of her costars. Monte was a little younger than Mary's usual crushes—thirty-three—but he was part Cherokee, handsome in a dark, exotic kind of way, and Mary was powerfully attracted to him.

Shelby, of course, had put a stop to that.

So all Mary was left with were the memories of Mr. Taylor, for whom she was determined to wait like Dickens's Miss Havisham—"until the end of my life," she insisted.

Mary decided another letter was in order.

"I want to go away with you," she wrote to Mr. Taylor on a sheaf of her perfume-scented, butterfly-engraved stationery, using an easily decipherable children's code. "Wouldn't it be glorious to sit in a big comfy couch by a cozy warm fire with the wind whistling outside, trying to harmonize with the faint sweet strains of music coming from our Victrola? I'd . . . tie fresh ribbons on the snowy white curtains and feed the birds and fix the flowers and, oh yes, set the table and then in my spare time, I'd darn your socks. I'd put on something soft and flowing [and] lie on the couch and wait for you. I might fall asleep for a fire always makes me drowsy—then I'd wake to find two strong arms pressed around and two dear lips pressed on mine in a long sweet kiss."

There was more. Several pages more of gushing, romantic, sexualized innuendo.

Mary slipped the letter into an envelope and sent it off to Mr. Taylor.

Heartbroken, miserable, bullied by her mother, Mary drifted into a world of delusion. Her innocent outings with Mr. Taylor the year before had taken on great consequence in her memory. The life she imagined for them in her letter could be theirs, Mary believed, if only Shelby didn't force her to keep making movies, to keep genuflecting at Mr. Zukor's altar. If Mary were free of her mother, Mr. Taylor could admit that he loved her as much as she loved him. Then they could live a life every bit as wonderful as she dreamed, with cozy fires and fresh ribbons and two lips pressed against hers.

If only Mary could find some way to escape her mother.

As they packed up the house, Charlotte Shelby kept a sharp eye on her daughter.

She recognized Mary's moods. She knew when her daydreams took over. It was precisely at times like these that Mary needed to be watched like a hawk. After the episode with the gun, Shelby would have been derelict in her duty if she hadn't watched her closely.

She knew the world was full of men—like James Kirkwood—who would take advantage of her daughter. But Shelby was stronger than any of those filthy, despicable men. Never in her entire life had she depended on a man. She'd made a successful life for her family all on her own. If only Mary could learn that men could not be trusted. But the girl was a romantic fool.

Not long before, Shelby had found Mary with "that halfbreed Indian" Monte Blue. "I was about the maddest woman that could ever be," Shelby admitted later. As Blue tried to flee the scene, Shelby had grabbed the terrified actor by the shirttail and ordered him to stay away from Mary. He obeyed.

And Mary fumed.

Shelby didn't care. If Mary had forgotten that day at the abortionist's, Shelby hadn't.

But then, one night shortly before they were to leave for New York, she glanced around the house and realized Mary had managed to slip past her eagle eye. The girl had taken off into the fog in that "big, fast roadster" of hers.

Pulling on a long overcoat, Shelby ordered her chauffeur, Chauncey Eaton, to drive her across town. Secretary Charlotte Whitney went along for the ride. Barking directions from the backseat, Shelby directed them through the foggy streets. "Turn right here," she commanded. "Turn left here." Only she knew where they were heading.

At last Shelby told Eaton to park at the corner of Fourth Street. Her destination was still a few blocks south, but the determined woman didn't want to give herself away. She told Eaton and Whitney to wait for her, then headed off toward Alvarado Street on foot.

Within a few minutes she was banging on William Desmond Taylor's door.

The house was dark. Taylor didn't respond. Shelby continued to knock.

"Who is there?" the director finally called out, raising his upstairs window and peering down into the foggy courtyard.

"This is Mrs. Shelby."

Taylor knew the voice from the set, where she had harangued him relentlessly. He told her he'd be right down.

When he opened the door, he was wrapped in his robe. He asked Shelby inside.

Once in the house, Shelby scanned the small living room and adjoining dining area for her daughter. The only sign of Mary was the photograph Taylor kept on the room's wainscoting, along with portraits of his other leading ladies, including Mary Pickford and Winifred Kingston.

Shelby looked directly into Taylor's eyes. She told him Mary hadn't come home that evening. Now it was midnight, and the fog was getting worse. Did he know where Mary was?

Taylor replied that he did not.

Shelby said she'd telephoned everyone she could think of, and no one had seen her errant daughter. That left Taylor.

But Taylor insisted Mary wasn't there.

Shelby held his gaze. She didn't seem to believe him.

In his most courtly, respectful voice, the director offered to make a few calls for her. Stepping into the little telephone nook under the stairs, Taylor rang one of the assistant directors at the studio, then several other people. But none of them knew where Mary was.

Finally Shelby gave up. She bid Taylor a terse good night.

"Be sure to call me and let me know if anything has happened," Taylor said as Shelby made her way back out into the fog.

Returning to the waiting car, Shelby reported that Mary was not at Taylor's. It was at that moment that Charlotte Whitney noticed that her employer was holding her blue steel .38 revolver—the same gun Mary had fired in her mock suicide attempt. The revolver had been given to Shelby by a private detective on the advice of district attorney Thomas Lee Woolwine, after Shelby had expressed fears of intruders and Mary's overzealous fans. Whitney realized the entire time Shelby had been talking with Taylor, she'd been holding that gun in her sleeve.

And if Shelby had found her daughter at Taylor's house, Whitney believed, she would not have hesitated to pull the trigger.

# IMPUDENT THINGS

All along Broadway the electric signs of Los Angeles's movie theaters—the largest concentration of picture palaces in the country—flashed on and off, lighting up the night in intermittent glows of pink, gold, and green. Straight-backed and efficient, Harry Fellows drove his employer, William Desmond Taylor, past Sid Grauman's elaborate Million Dollar Theatre, the pink-stucco Rialto, the French Renaissance–inspired Palace, and the New Theatre of Alexander Pantages—all but the Palace under the sway of Mr. Taylor's boss, Adolph Zukor.

The car Fellows drove was a brand-new McFarlan, the luxury auto of the season, specially ordered by and custom-built for Taylor. The chrome still shone; the leather of the seats was still fragrant. The screen's most popular leading man, Wallace Reid, also drove a McFarlan, racing them in a number of his pictures. Strikingly beautiful in design, McFarlan interiors included pillows, hassocks, and armrests, with optional bar sets and golf-bag compartments. According to the *Los Angeles Express*, Taylor had ordered his car "with all the trimmin's."

Pulling up in front of Clune's Broadway Theatre, Fellows waited as his employer stepped out onto the sidewalk. The marquee above announced WILLIAM D. TAYLOR'S PRODUCTION OF *THE SOUL OF YOUTH*. The picture had continued to serve as the industry's best answer to its critics. While racy on the surface, with scenes set in a whorehouse, *The Soul of Youth* was redeemed by its message, and this was what Taylor had come to preach at the theater this night.

Meeting with reporters before the screening, Taylor insisted the pic-

ture was about uplift. "*The Soul of Youth* is the story of a street gamin," he explained. "It shows what kindness, sympathy and education will accomplish in developing character in the boy of the streets." In other words, the end justified all that preceded it. How could redemption be shown, Taylor argued, without dramatizing the temptations that came before? It was a brilliant argument, allowing the producers to appear to agree with their critics while still making money off the public's desire to witness sensation and vice.

With spokesmen like Taylor, the industry was learning how to fight back against the church ladies. When the American Humane Society called for a national censorship board, Taylor stepped forth as first responder. "The heads of the motion picture industry," he argued forcefully, "have been to every effort to make films which entertain and yet instruct and are of moral value." Pointing again to *The Soul of Youth*, he averred that the film offered "sufficient refutation of the charge that the public is being led from the sweet, simple human drama to plays which exploit individuals of doubtful reputations."

And certainly no one in the film colony, Taylor implied, had a doubtful reputation.

The Hollywood press knew better.

A few days after the screening at Clune's Broadway, Taylor was stopped by a reporter on the Famous Players lot. Notebook in hand, the inquiring scribe asked Taylor to spill "the biggest secret" in Tinseltown.

Lightheartedly, Taylor suggested that the biggest secret was "how a star owes more to her cameraman than to her modiste and hairdresser . . . how double chins are removed with a spotlight . . . how skillful backlighting is more precious than a gallon of peroxide." He expected the reporter to laugh, then step aside.

But the newspaperman was digging for dirt. "Anybody been murdered in the movies lately?" he asked. "Got killed?"

Taylor fixed him with an icy stare. With all the bodies stacked up in Hollywood's morgue this past year, some things weren't joking matters. He scolded the reporter for encouraging the public's interest in "morbid, silly, prying, impudent things."

William Desmond Taylor understood the importance of maintaining secrets. His goal was keeping Tinseltown safe.

After all, he owed a great deal to the movies. The industry was his

anchorage. He had now lived longer in Los Angeles than he'd lived anywhere else since leaving his childhood home in County Carlow, Ireland, at the age of eighteen. Where he'd been and what he'd done in the interim, no one knew, except for the few years he admitted to spending on the stage. But the truth was he'd lived many different lives and been known by many different names in his half century of existence. And those were just some of William Desmond Taylor's secrets.

At his home in Alvarado Court, there were others.

Greeting him was his valet, a chubby young man named Edward F. Sands. Or at least, that was the name he'd provided when Taylor hired him a year earlier. The director hadn't pried too closely into Sands's background; after all, everyone was entitled to keep his history to himself. All Taylor cared about was Sands's experience as a cook at the Famous Players commissary. Given his frequent heartburn, the director needed a houseman who could whip up meals that were tasty but bland. At this, Sands proved extremely capable.

The valet quickly gained his employer's confidence. Occupying the upstairs bedroom at the back of the house, he soon became a familiar sight around Alvarado Court. When Mary first met the portly, apple-cheeked young man, she'd thought him "very round," that if "you knocked him over, he'd bounce back up again." Sands spoke with a pronounced Cockney accent that Mary called "very, very Limey." Some questioned whether the accent was real.

But Taylor never appeared to doubt him for an instant.

That was unfortunate, because whenever he had the chance, Sands snooped through Taylor's closets and drawers to satisfy a voyeuristic compulsion.

With small eyes shifting under heavy eyebrows that nearly met over his nose, the crafty valet paid close attention to the select few who visited Taylor at his home. Usually the director spent his evenings alone, but on occasion the living room rang with the hearty laughter and four-letter oaths of Mabel Normand or the congenial conversation of Neva Gerber, leading lady of westerns and serials. But of late, the most frequent guest to 404B Alvarado Court had been George James Hopkins, a soft-spoken, easily startled, bespectacled young man of twenty-four.

Hopkins's visits weren't just social. As Taylor's production manager, he helped devise extraordinary visual effects for the director's films. Both men were quite pleased with their latest achievement, *The Furnace*, which had opened in theaters the third week of November. The film contained lots of audience-pleasing special effects: for one scene, Taylor had dynamited a hill near Griffith Park. The picture had gone way over budget, topping out at $700,000, but Taylor figured it would be worth it. Audiences liked spectacle. And in one fantasy sequence, there was even a glimpse into the depths of hell.

*The Furnace* wasn't the first time Taylor and Hopkins had pushed the envelope. For *The Soul of Youth*, they'd made nightly forays into the red-light districts of Los Angeles, along Commercial Street and deep into Little Tokyo, searching out materials, props, and extras. Such outings were in search of "color," one friend reported. "[Taylor] was always seeking the bizarre, the unbelievable, the unusual." In one establishment, opium and morphine were "wheeled in on tea carts." Despite the attitude he displayed toward Mabel's drug use, Taylor was apparently not averse to the occasional opium party, if it were held in one of his favorite clubs. As one journalist would describe the scene, "The men would lie in silk kimonos, smoke the essence of the poppy flower, and so commence their ritual, old as Sodom."

The inference was clear: the club Taylor belonged to was a homosexual society—or "cult," as the journalist called it—"held together by a bond, unthinkable, unnameable, unbelievable," in which each man swore "an oath of undying affection for the others." One friend would later admit to Taylor's "visiting the queer places in Los Angeles."

Here, then, was one of the secrets Taylor was keeping from Hollywood. Since coming to the movie colony, he'd formed relationships with both women and men. Until a little more than a year previous, he'd been engaged to marry Neva Gerber. Now he was involved in another relationship, one that bridged the professional and the personal. George James Hopkins was not only his collaborator but also his lover.

Hopkins would later describe how his heart had raced the day he'd first laid eyes on Taylor, striding aristocratically onto the set. Just eighteen at the time, Hopkins had developed a powerful crush on the handsome, confident director, much as Mary Miles Minter would do a little later, and at about the same age. But Hopkins's mother, one of the

studio's designers, was far more open-minded than Charlotte Shelby, encouraging the match between her son and the prominent director. An "affair of the heart, discreet but passionate," as Hopkins called it, blossomed under the nose of Taylor's unsuspecting fiancée, who eventually broke their engagement. One of Gerber's chief complaints had been the director's melancholic moods. Now, with Hopkins at his side, Taylor's outlook brightened.

Yet while the relationship with Hopkins was kept circumspect, it was far from Taylor's direst secret. Throughout the film colony, other gay couplings flourished. Leading man J. Warren Kerrigan lived with his "secretary," James Vincent. The actor Gareth Hughes and the producer Ryszard Ordynski moved in relatively undisguised gay social circles that occasionally overlapped with those of Taylor and Hopkins. The press showed no strong desire to unmask such people, unless their behavior provided an excuse for titillating blind items—exactly the same criteria applied to their heterosexual counterparts. As long as Taylor continued to lead his discreet, even reclusive private life—underworld visits notwithstanding—he needn't worry about exposure.

Indeed, the secrets Taylor shielded from the world—and from his employers, who counted on him for so much—went far deeper than his relationship with Hopkins. His young lover was as much in the dark about them as anyone else.

Only his prying valet, snooping through his drawers and in the dark corners of his closet, would discover what they were.

# DOPE FIENDS

Thirty pounds was a lot of weight. To lose thirty pounds meant the hollowing of cheeks, the shriveling of arms and legs. To gain thirty pounds meant the opposite. Cheeks filled out, breasts swelled and rose. Thirty pounds brought color back to the complexion and restored a bounce to the step. Thirty pounds, either way, could mean the difference between life and death.

It certainly did for Mabel.

Stepping off the California Limited in San Bernardino, Mabel hoped to avoid the press and slip discreetly back into town. But she was just too plump, too healthy, for people not to notice. A group of photographers chased after her as she hurried, laughing, to a waiting car.

"Looking like the Mabel of five years ago," the *Los Angeles Times* reported on Christmas Eve, "Miss Normand has just returned to town from the East." Once again, the report noted, she was rosy-cheeked and curvy. To those in the know, word spread that the cure had worked.

"How did you do it?" Adela Rogers St. John asked Mabel when she visited.

"I don't know," she said with a shrug.

How could she tell St. John about all she'd been through at Glen Springs? The times when she'd tried to give up? The times the craving had felt like an animal trapped inside her, clawing and biting its way out?

But she had come back, whole, to Tinseltown. By living and not dying, Mabel had surprised them all.

And no one was more thrilled or proud of her than Billy Taylor.

Usually Mabel visited Billy at his place, but this night he came to see her at her apartment on West Seventh Street. The upscale building contained three other duplex residences, one occupied by Charlie Chaplin's brother Sydney.

Taylor found Mabel fired up, excited about getting her career back on track. "I refuse to make another picture until I can get the story I want," she declared. Knowing the struggle with Goldwyn that would involve, she was now pursuing the once-unimaginable idea of breaking her contract with him. Remembering that terrible kiss he'd given her after the stillbirth of their son, the pathetic apology he'd offered, Mabel never wanted to see the man again.

There had to be more to life than pain and suffering. There had to be a way back to the fun and the laughter. More than a decade earlier, Mabel had left Staten Island because she'd wanted to experience the world. As disillusioned as she might have become with her career, she still knew there was more out there for her to see and do—especially now that she was "off the hop," as the saying went.

These were the things Mabel talked about with Billy Taylor. He'd stuck by her through thick and thin. Now he encouraged her to go after her dreams.

But their conversation was interrupted by a knock at the back door.

Mabel stood, telling Taylor it must be a salesman calling. That was odd, given the late hour. But she promised to get rid of him and be right back.

It was a salesman, all right. Mabel's drug dealer was there to welcome her back to Hollywood with some goodies, just like old times. She was looking for fun and laughter. Here it was.

Taylor waited for Mabel to return. When the minutes ticked by, he grew suspicious. Making his way to the back door, he found Mabel speaking to someone. Whether the visitor had been invited or not, Taylor didn't know. But he recognized the bundle the man was holding in his hands.

Taylor exploded.

As he'd tell an investigator later, he "not only forcibly ejected the peddler from the house but threatened to do him bodily harm" if he ever came around to harass Mabel again.

Skulking off into the night, the dealer shouted back at Taylor, "I'll get you sometime! You can't butt into my trade!"

Mabel was horrified. Had she weakened? Had she attempted to buy a gram or two of cocaine? Taylor wasn't sure. But for the moment, all that mattered was that he had chased the man from her door. Mabel felt he had saved her life, yet again.

A short time after the incident at Mabel's, Taylor sat waiting in his office at the Famous Players studio at the corner of Sunset and Vine. He was expecting a visitor, someone he hoped would end Mabel's troubles once and for all.

The studio occupied two city blocks, the first block crammed with offices, stockrooms, warehouses, labs, wardrobe buildings, various small stages, and the large Stage 4, with its retractable glass roof. The second block was the studio's "back ranch," a wonderland of exterior facades. One path led to a European village, another to a Lower East Side Manhattan neighborhood, another to a western outpost. Along Sunset, the small wooden buildings adorned with green awnings gave no indication of the fantasy inside. To an observer, the world's biggest, most influential movie company would have looked like a block from any small-town Main Street.

Taylor's visitor was US Attorney Tom Green, who'd been invited onto the lot by general manager Charles Eyton. Green was the federal attorney in charge of alcohol and narcotics control for the Los Angeles district. That Eyton had asked Green, a law enforcement official, to nose around inside their operation was an extraordinary move. Clearly the dope situation had gotten out of hand.

In the more innocent days before the war, dope had been a source of humor on the screen. Douglas Fairbanks had played a jolly opium-smoking detective in *The Mystery of the Leaping Fish*. Everyone partook. Adela Rogers St. Johns recalled Cecil B. DeMille handing out a psychedelic combination of hyoscine and morphine at parties. But the war had institutionalized the drug traffic, and the prohibition of alcohol had only made illicit drugs more popular—a recipe for widespread addiction.

By going to Green, Eyton was clearly trying to take care of the problem before the press got wind of it. At Famous Players, dope had become a serious problem. Wally Reid, he of the McFarlans and dashing

public profile, was what the press commonly called a "dope fiend." The studio knew all about Reid's addiction and was paying for treatments from a string of doctors and therapists to get its big moneymaker off the stuff. Originally Reid's supply of morphine had been delivered by his chauffeur, who'd gotten it from a ring so deeply infiltrated into the studio that Charles Eyton was forced to call in Tom Green for help.

And when Green showed up, one of the people Eyton suggested he speak to was William Desmond Taylor.

The director offered to tell the investigator everything he knew. "It was then Green learned the extent to which the drug traffic had injected itself into the motion picture industry," a newspaperman would report. Right away Green could see that for Taylor, this fight was personal. The problem went well beyond Famous Players, Taylor explained. "One woman in particular," working at another studio, "was being pressed in every way" to keep up her expensive habit. This woman was "a film star of the first magnitude," Taylor told Green; it was clear that he cared a great deal for her. Taylor's determination, Green surmised, was "not so much to wipe out the ring generally but to save the actress from the clutches of these parasites."

The US attorney agreed to assign two men to investigate the matter. Taylor promised to give them all the help he could—names, places, identifications. For several weeks, federal agents fanned out across the Famous Players lot.

Ultimately, however, Green's investigation went nowhere. The attorney blamed the failure on the "wealthy and powerful" drug users themselves, movie stars like Wallace Reid who—unlike the locusts who congregated at places like the Wallace Apartments—had the means to thwart the investigators at every turn.

No arrests were made. But Green learned just how dangerous the enterprise had become in Tinseltown. One of his agents had asked specifically about Mabel. A source replied, "Before she's through, somebody's going to get killed on her behalf."

For all of Taylor's worries, though, Mabel did not relapse. Her weight stayed on. Her cheeks remained rosy. And she moved ahead with her plan to break away from Goldwyn.

Goldwyn did little to dissuade her. Her pictures hadn't been bombs, but neither had they made the kind of money Mabel used to pull in for Sennett. Goldwyn was also weary of her—the drugs, surely, but no doubt the accusation and the blame he saw in Mabel's eyes troubled him as well. So when someone came along and offered to take Mabel off his hands, Goldwyn didn't hesitate to let her out of her contract.

To everyone's great surprise—Mabel's especially—that someone was Mack Sennett.

He was still in love with Mabel. "If I had been a farmer, a mechanic, or an ironworker," Sennett mused, "and if she had been an average girl in an average town, we would have been married long ago." But Mabel never wanted to be an average girl.

Mack had written a script just for her, "a big romantic comedy" he was calling *Molly O'*. He professed high hopes for the picture—and for the two of them. He wanted the team of Sennett and Normand reunited, personally as well as professionally.

Mabel had other ideas. She was stronger now, no longer the compliant little girl Sennett had once exploited and cheated on. She decided to accept his offer, but insisted they keep everything strictly business. "She looked on me coldly," Sennett recalled, "and refused to talk to me on the old basis." Mabel "made it plain" that their relationship was now simply actress and producer.

She liked this new sense of control.

Just how much stronger Mabel had become was demonstrated by the "weeks of negotiations" that followed before she was satisfied with the terms of the deal with Sennett. No way was Mabel about to enslave herself again. Her deal was for *Molly O'*, and *Molly O'* only. Maybe she'd do a picture after that, or maybe not. Mabel wasn't committing herself.

She got everything she asked for. The exact amount of money Sennett was paying her was kept a secret, but word around Hollywood suggested it was close to $1 million.

Mabel might be back with Sennett, but this time she was calling the shots. If this was what her new life would be like, she would do just fine.

As long as she never answered those late-night knocks on her door.

# GREATER THAN LOVE

One day in the early winter of 1921, Gibby stepped off the Big Red trolley at the Ince studios on Washington Boulevard in Culver City. At long last, one of her contacts had come through for her. Louise Glaum, a popular actress known for playing vamps, had gotten her cast in a big, expensive first-class picture. No more cheap comedies for Gibby.

Six years earlier she'd made another picture with Glaum, a low-budget western called *The Golden Trail*. Back then, however, Gibby had been the leading lady, and Glaum just a supporting player. Now their roles were reversed. Glaum was the glittering star, Gibby the sidekick. Still, it was a start. And as always, Gibby had a plan.

The director of Gibby's film was Fred Niblo, who'd just helmed *The Mark of Zorro* for Douglas Fairbanks. Quite a change for a young woman used to working with C-listers. The film's producer, J. Parker Read, was in the process of building his own company, and Gibby had a proposal for him. A proposal that would take her and Don Osborn out of their seedy hotels and turn them into power players in Tinseltown.

The thirty-five-year-old Read had recently joined Associated Producers—Tom Ince's "Big Six," established to counter Adolph Zukor's growing control of the industry. Alongside heavyweights like Ince and Sennett, Read was eager to prove himself. His biggest success so far had been *Sex*, also starring Louise Glaum, which had raked in the cash while sending the moralists over the edge. Read hoped to make a name for himself with sex pictures.

Gibby, of course, knew a few things about selling sex. She and Read seemed like a perfect fit.

At her meeting with the producer, she shared the idea that she and Don Osborn were cooking up. It was to be a "very modern and daring" picture. Gibby would star and Osborn would direct. Read seemed interested—but he wouldn't give her a definite answer until their current project wrapped. Gibby left the meeting encouraged. Perhaps she was finally about to make good on that promise to her mother all those years ago.

Out on the sprawling Ince lot, Gibby got down to work on the current film, which was called *Greater Than Love*. She was playing a prostitute. Her past hadn't hurt her this time; it might have even helped. Louise Glaum certainly knew the truth behind the Patricia Palmer alias, so maybe Read did too, and maybe that was the real reason he'd cast Gibby as Elsie Brown, the little hooker with a heart of gold.

Certainly Gibby had leaped at the chance to play her. Although Elsie dies early in the picture, it's her death around which the whole movie turns. When Elsie's bereaved mother arrives at the brothel, the other girls, led by Glaum, pretend it's just an innocent boardinghouse to protect the memory of Elsie, a conceit that unravels dramatically at the picture's conclusion. Gibby might have been billed third, but hers was the part that audiences would remember.

Every day at the Ince studio, she poured her emotions, her history, and her ambitions into her portrayal of Elsie Brown. How right she'd been to put the likes of Joe Pepa behind her; for once, Gibby was going after her dreams honestly and aboveboard. How refreshing that she didn't need to lie or cheat or sell herself to get what she wanted. At night, she'd hurry back downtown on the trolley to encourage Osborn to finish the script that would take them to the top. The payoff, Gibby believed, was finally at hand.

But Osborn was feeling discouraged. Bank after bank had turned him down when he'd tried to get financing for his independent production. The bankers would pull out maps showing all the theaters controlled by Adolph Zukor and the other big chains nationwide. The number of independent theaters was dwindling. Even if Osborn could raise the money needed to make a picture, the bankers told him, his

options for where to show it would be extremely limited. Why should they invest in a nobody like him?

Osborn was ready to give up, but Gibby tried to rouse him. This was their moment, their chance, she argued. She tried to get Osborn to approach J. Parker Read. But it was difficult to get Osborn to do anything now that his niece Rose had come to town.

Don Osborn's intense blue eyes were trained on the young woman across the room. His wife was not pleased.

Osborn's wife, Rae, had come back to him yet again, still desperately in love and willing to forgive him everything. They were living with Don's mother in Highland Park. Also in the house was Don's niece Rose Putnam, recently arrived from Vermont, licking her wounds after a difficult divorce. At the moment Rose was working as a salesclerk at Hamburger's department store on Broadway in downtown Los Angeles.

Rose was a very pretty woman, dark and petite, and seven years older than her twenty-five-year-old uncle. The anomaly was explained by the wide difference in age between Don and his eldest sister, Rose's mother. But even at thirty-two, Rose was still a looker, pretty enough to stir up feelings of envy and unease in Don's wife Rae, who had just turned twenty-one.

Rae didn't understand her husband's fascination with his niece, nor could she have articulated the reasons it bothered her. Since coming to Los Angeles, Rose and Don had become "thick as thieves," Rae observed. She would walk into a room and find her husband and Rose whispering together, only to fall silent when they caught sight of her. What on earth was going on?

Gibby wondered the same thing. Osborn no longer had time to see her. He brushed her aside when she came to visit. Gibby was likely only momentarily bothered by the loss of their personal relationship; it was the disruption of their professional plans that truly unsettled her. When she demanded to see the script Osborn had written, he made excuses, claiming it wasn't ready. Gibby realized he'd produced nothing of substance since Rose had arrived.

She was furious. Here she was, working for Associated Producers, one of the few organizations that could go up against the Zukor machine, and Osborn had failed to put together a proposal she could take to Read. Osborn argued they didn't need Associated Producers. He'd start his own production-distribution company with George Weh's money. Why be beholden to J. Parker Read and Tom Ince? Gibby was flabbergasted.

Osborn might be willing to let the opportunity pass, but Gibby wouldn't be that foolish. As soon as *Greater Than Love* wrapped, she strode into the Ince studio armed with scenarios and broadsheets. She "made inquiries about setting up a production company of her own, possibly to produce Westerns," as she'd tell one reporter—modern, daring, sexy westerns, no doubt.

To Read, she projected confidence and professionalism. But the producer barely looked at her proposals. He thanked her but declined. He didn't even offer her a contract for a second picture with Glaum.

The industry, it seemed, really was stacked against people like her.

All of Gibby's noble ideas about doing things honestly—of insisting on high-class—shattered at her feet.

Don Osborn's little house at 1533 South Bronson Avenue was becoming a gathering place for the down-on-their-luck. In April he and Rae moved into their own home, a cheap stucco cube with a postage-stamp backyard. There were always people hanging around the place, smoking cigarettes on the front steps or crashing in the second bedroom. George Weh came around, still hoping Osborn could help him make good. Fred Moore and other struggling actors drank and bitched and moaned. And Gibby was there, too, once she got over her pique at Osborn for botching their chance with J. Parker Read.

Those who packed Osborn's place, swilling rotgut booze and snorting cut-rate hop, had never enjoyed much success in an industry that had made a rarefied few rich and famous. They burned with envy and resentment against people like Mabel Normand and Mary Miles Minter and William Desmond Taylor—and Adolph Zukor himself—who had made much of themselves while starting with

less. Was it merely a matter of luck and connections, as those griping at Osborn's house insisted? Or was it greater determination, discipline, and talent?

In some ways, the reasons didn't matter. For the scowling mob congregating at Osborn's house, it was simply unfair. Their resentment was left to bake inside those cramped, stuffy rooms, pulsing off the stucco walls like heat from an oven on a sultry afternoon.

# THE SEX THRILL

On Adolph Zukor's sprawling country estate in the wooded hills of Nyack, New York, his caretaker, Patrick Murphy, loaded a trap gun full of buckshot and hung it opposite the front door. Tying a string to the trigger and threading it through a pulley on the ceiling, Murphy secured the other end to the knob on the door. If anyone broke into the house when the Zukors weren't there, the gun would discharge, pumping the intruder full of buckshot.

Adolph Zukor trusted no one.

There were people out there, he believed, waiting to snatch everything he'd achieved. At his five-hundred-acre estate on the banks of the Hudson River—Zukor called the place "his farm"—the studio chief kept many valuable antiques and paintings. Even more precious was the large stock of bonded (legal) liquor stored in his basement. To patrol the place, Zukor had hired an armed watchman, but the trap gun would give him added peace of mind.

If only it were so easy to protect the rest of his empire.

The latest marauders at the gate were a particularly militant band of zealots called the Lord's Day Alliance. They were led by seventy-one-year-old Brother Wilbur F. Crafts, a self-proclaimed "Christian lobbyist" and a speaker of such fire and brimstone that Jonathan Edwards would have been impressed. Crafts was a tall, thin scarecrow with a short beard of gray straw. Beneath heavily drooping lids, his eyes burned with all the passion of the true believer. Crafts's International Reform Bureau had been instrumental in bringing about Prohibition.

Now the skeletal spiritual soldier turned his eyes toward other causes, like cigarettes, close dancing, "joy rides" in automobiles, and—most especially—the movies.

As its name implied, the Lord's Day Alliance had initially focused on banning all amusements on Sundays. But that wouldn't be enough to cleanse the nation of the sins Hollywood had perpetrated. The film industry, Crafts charged, was in the hands of "the devil and 500 non-Christian Jews" (as if there were any other kind). Federal censorship, he declared, was the only way to halt the corruption of American youth by the movies. "I do not ask autocratic exclusion of films," Crafts said, trying to seem less fanatical in the press, "but only such supervision as the Government gives to all other great financial interests."

In his eighth-floor office, Zukor brooded.

*Only such supervision as the government gives to all other great financial interests.*

President Harding had pledged to protect the studios from regulation. But for how long?

If industries like railroads and banking were regulated, the reformers were arguing, movies should be too. Conservative lawmakers, who controlled both houses of Congress, tended to dislike regulation, but many were also sympathetic (and accountable) to the country's strong religious constituencies, who were the ones calling for federal censorship.

Only a few months after Harding's election, Zukor was starting to worry again.

In Washington, DC, Brother Crafts was marching his flock, mostly somber-faced women in long gray dresses, to the steps of City Hall, his long black coattails flapping in the breeze. Turning to the gathered newspapermen, he dramatically lifted a file of papers over his head, like Moses wielding a stone tablet. The "flickering filums," he announced to the newsmen, were endangering the public's morals. He had just spent two months hunkered down in the dark, watching every film shown in the theaters of the nation's capital, and he could say without a doubt that "the sex thrill was the great objective" of the vast majority of motion pictures. Crafts had taken pains to compile every kiss, every flash of a woman's leg, in the study he now held in his hands. "The sex thrill," Crafts charged, was taking the place of "the alcoholic thrill" of the saloon. His flock responded with a cacophony of *amens*, and with

that Crafts turned and entered City Hall, ready to make his case to the district commissioners.

Editorial cartoons across the country satirized and ridiculed Brother Crafts, but Zukor viewed him with deadly seriousness. Crafts was part of a movement that, despite all the industry's best efforts, seemed unstoppable. Another censorship bill awaited the California legislature. Pro-censorship governors had been elected in Massachusetts and New York, two of the biggest markets for moving pictures. Still struggling to climb out of its pool of red ink, the industry remained extremely vulnerable to this kind of assault. Zukor knew that until the ever-looming threat of censorship was vanquished once and for all, he could not fully push forward with his dream of industry domination.

With all that on his mind, he picked up his phone and placed several key calls. It was time to put his distrust aside and meet with his rivals, including Marcus Loew. It was time to make common cause.

The building that housed Delmonico's restaurant, on the corner of Fifth Avenue and Forty-Fourth Street, was a six-story confection crowned with spires. The venerable New York eatery was known for creating lobster Newburg, Baked Alaska, French-fried potatoes, and the Delmonico steak. On a cold night in February 1921, in a private dining room above the main hall, a gathering of some of the most important men in the movie business was taking place.

Zukor, of course, presided from the head of the table. His partner, Jesse Lasky, sat as usual on his right. The rest of the gathering included William Fox, Sam Goldwyn, D. W. Griffith, Carl Laemmle, Lewis Selznick, Joseph Schenck, and William A. Brady, president of the national association. Loew arrived late, glad-handing around the table, laughing and joking with the others, until Zukor's steely eyes stopped him cold. It was time to get serious.

Something had to be done, Zukor declared. If they didn't act to protect themselves, they would be controlled by state, and possibly federal, regulations. He'd gathered everyone together because he had a plan. With that, he turned the discussion over to Lasky.

Zukor's partner was the good cop to his bad, as easygoing as Zukor was hardline. A former vaudevillian, Lasky had never fit comfortably

around a corporate table. He was far from a prude, but he'd come to the conclusion that the reformers had outmaneuvered them, and that the film industry was fighting a losing battle. It was either federal censorship imposed on them from the outside, Lasky told the film execs, or self-regulation managed from within.

He snapped open his briefcase, withdrew a stack of carbons—a "code of rules," he said—and passed them around the table. All Famous Players directors would be directed to follow these guidelines, Lasky announced, and he urged his fellow producers to do the same with theirs. Fourteen specific recommendations were outlined. The first was perhaps the broadest: "No picture showing sex attraction in a suggestive or improper manner will be presented." Movies should only depict "wholesome love and avoid sensuality."

Eyebrows shot up all around the table.

They had no other choice, Lasky argued.

He reviewed the rest of his points with the stunned movie men. No depictions of "white slavery." In other words, no prostitutes. No illicit love affairs unless accompanied by a moral lesson. No nudity or "inciting dances." ("All close-ups of stomach dancing must be cut absolutely," Lasky had written.) No "unnecessarily prolonged passionate love scenes." No stories predominately focused on vice and crime. No films that "might instruct the morally feeble in the methods of committing crime." No insults to any religious belief or disrespect to religious symbols. ("Scenes showing a crucifix kicked about or pages torn from the Bible should be eliminated," Lasky advised.) No suggestive comedy. No unnecessary bloodshed. No "salacious" titles, stills, or advertising.

The executives were dumbstruck. Lasky's fourteen points would have wiped out most of the successful pictures of the past year.

Again Lasky insisted it was the only way. He claimed that all their directors—"even including Cecil B. DeMille," one of the most frequent transgressors of those fourteen points—were "in sympathy."

Reluctantly, the group agreed that Lasky was right. They pledged to sign an agreement among themselves adopting the fourteen points. Their intention, clearly, was to beat the censors at their own game. If pictures had to be neutered, they'd rather do the castration themselves.

To Lasky's mind, the meeting at Delmonico's was "epoch-making." Galvanized, he wanted to go public with their new code of rules. "We

cannot fight this censorship situation behind closed doors and with secret meetings," he argued to Zukor. Public opinion would "swing over to our side immediately" if they announced the actions they were taking.

But Zukor had other plans. That night at Delmonico's, he let Lasky run the show. His silence implied that he agreed with his partner's code of rules. But he was adamant that there should be no public announcement for now. He had his reasons.

The other film execs agreed with Zukor, but Lasky wasn't pleased. After nearly a decade of partnership, Lasky was tired of always ceding final authority to Zukor, of having to seek his approval on spending and hiring decisions. And as the partner more involved in the actual day-to-day production of motion pictures, Lasky was eager for a nuts-and-bolts solution to the looming threat of censorship. Going public with his fourteen points, he believed, would be a public relations bonanza for the company.

On his way back to Hollywood, as the farms of the Midwest passed outside his train window, Lasky decided that for once he wouldn't abide by Creepy's wishes.

On the morning of February 25, Zukor arrived at his New York office. As always, he slipped in without speaking to anyone and rode the elevator in silence up to the eighth floor. As usual, his newspapers were waiting for him on his desk. That week's *Variety* was among them.

Opening the trade paper to the "Pictures" section, Zukor was stopped short by a headline.

### FAMOUS PLAYERS-LASKY BAN SEX FILMS BY FOURTEEN "DON'TS" TO STUDIO OFFICE

"For the first time in history," the article read, "a 'production code' has been issued, which all executives associated in the making of Famous Players pictures will have to follow."

Zukor felt the blood rise in his neck. He was not one for showy displays of anger. He did not boil over. Instead, as many employees attested, his pique would manifest itself in subtle ways: a sudden tightening of his lips, a reddening of his neck and cheeks.

He called his secretary in to take a letter. When she asked who it would be addressed to, Zukor responded coldly: Jesse Lasky.

In no uncertain terms, he accused Lasky of "a breach of faith." He was terribly embarrassed, he said, as they'd all agreed not to go public with the fourteen points. Now Lasky's impertinence had made Famous Players look bad in front of their competitors.

But that was hardly Zukor's chief complaint.

True to form, Zukor had played devious at the meeting at Delmonico's. While he'd agreed that self-policing was better than government intrusion, he'd also known that eliminating sensuality, suggestive comedy, and stories about crime and vice would also eliminate profits. It was one thing to agree to such sanitization in theory. It was quite another to spell it out so precisely, publishing the details of how they were going to achieve it. One false move—one leer too many from Fatty Arbuckle toward a pretty girl—and they'd have the church ladies wagging their fingers at them, accusing them of breaking their own code.

The majority of Lasky's fourteen points were impractical, Zukor believed, and he had no intention of ever enforcing them. But if his competitors had adopted them—now, *there* was a benefit to Lasky's ridiculous code. Let Fox and Laemmle and Marcus Loew churn out films devoid of inciting dances, passionate love scenes, and crime. Zukor would have enjoyed watching their profits plummet.

But now those damn fourteen points were public. Now Famous Players–Lasky was actually expected to follow them. The National Board of Review declared it would use the fourteen points as guidelines to award seals of approval.

Zukor grumbled.

But as always, he would do his best to salvage the situation.

He knew his top directors had never intended to follow the memo Lasky was busy tacking up on all their sets. Cecil B. DeMille, supposedly "in sympathy" with the code of rules, was at that very moment making *The Affairs of Anatol*, in which Wallace Reid cheats on his wife, Gloria Swanson, and Swanson retaliates with her own sexy fun. Into this one picture DeMille was packing just about every sin that gave the church ladies palpitations. Swanson shows off her legs and strips in front of men. Marriage vows are made, broken, and made again—with other people. Reid visits the mirrored den of a prostitute named, of all

things, Satan Synne. It was no surprise that the National Board of Review, when it saw a rough cut of the film later that year, recommended major revisions to the picture or risk critics calling the film "an attack upon the sanctity of the home."

Zukor had no intention of making cuts to *The Affairs of Anatol* or any film. But those fourteen points were now on everybody's lips.

He had an idea. A meeting was scheduled with Brother Wilbur Crafts in a few weeks. Maybe Lasky's fourteen points could work to their advantage after all.

On the cold gray morning of March 14, Brother Crafts stepped off the train from Washington and made his way across town to the offices of the National Association of the Motion Picture Industry. The wind whipped the sparse white hair on the old man's head, and he and his followers had to turn their faces against the rain. But they walked decisively on, ready to announce a major national campaign for federal censorship when they arrived for the meeting.

At the Times Square office, the wet, chilled crusaders were greeted by a select group of movie men. Zukor was noticeably absent. Given Crafts's anti-Semitism, the film industry was represented by NAMPI's president, William Brady, an Irishman with the gift of gab. Brady was backed up by other gentiles like Charles L. Pettijohn of the Selznick studio and lawyer J. W. Glennister. Crafts had his own heavyweights with him. Flocking to his side as he took his seat were Mrs. Ella Boole, state president of the Woman's Christian Temperance Union, and Mrs. Clarence Waterman, head of the Committee on Moving Pictures of the City Federation of Women's Clubs. There were handshakes all around, but the mood in the room was tense. The meeting's organizers were so afraid it might founder that they'd arranged for former justice Peter A. Hendrick of the state supreme court to mediate.

But the talks proceeded surprisingly smoothly. Upon arrival Crafts was given a copy of Lasky's fourteen points, and he read and approved them. His object was "to cleanse the 'substance' of the modern movie," Crafts declared; how it happened was "a matter of minor consideration." Since the industry had pledged to follow Lasky's code, Crafts agreed to call off all agitation for a federal censorship law.

A few blocks away and eight stories up, Adolph Zukor was smiling.

It didn't matter that, a short time later, Crafts was back to his old

ways, calling for a federal commission to compel producers to abide by the fourteen points. All that mattered was that the reformers' momentum had been slowed. Now the film industry appeared to be the reasonable, rational side: they had come up with a code of rules, and if they failed to live up to that, public opinion, not government censors, would be the final arbiter.

A few months later, *The Affairs of Anatol* was released. Nothing had been cut. Not the extramarital affairs. Not Satan Synne. Not Gloria Swanson's legs. The closing title read: "All of which goes to prove that there is so much good in the worst of us and so much bad in the best of us that it ill behooves any of us to talk about the rest of us." It was a final raspberry to the reformers, courtesy of Cecil B. DeMille and Adolph Zukor.

And of course it was a gigantic hit. Just as Zukor knew it would be.

W. D. McGuire, head of the National Board of Review, was furious. "If [a producer] cannot apply the fourteen points to his own product," he wrote to Zukor, "then he is incapable of enforcing them on his competitor's product."

Precisely.

Self-censorship was a ruse, a marketing ploy. Lasky might have intended to apply his fourteen points, but Zukor had merely used them to disarm Crafts, to force the agitators to disperse. It was a temporary solution—the moralists were already regrouping—and Zukor knew it. But he believed they were fighting a losing battle.

What Zukor was counting on was the fundamental American belief in free speech. The previous year, D. W. Griffith had argued against a censorship bill in Virginia, calling it "un-American, dangerous, misguided, senseless, unjust, artless, unlawful, needless, intolerant." Virginia legislators had promptly voted the bill down. That, Zukor believed, was the American way. The America he loved, the land of the free that had called to him when he was a poor clerk in Hungary, was not a place that stifled free expression or inhibited free enterprise. That was what made America great, and that was what Zukor was counting on now.

Let the bluenoses make noise about government regulation, Zukor thought. They'd win a few battles. But not the war.

It was a gamble. But Zukor had been gambling his entire life.

———

On the night of May 1, a twenty-nine-year-old bootlegger and ex-con named Edward Coates snuck through the woods with a companion toward Adolph Zukor's country house. They'd heard about the treasures inside—especially the alcohol in the basement. Coates was wearing an army pistol and a belt sagging with extra cartridges. Prying open the lock on the front door, he stepped inside—and Zukor's trap gun fired on cue, hitting him in the stomach.

The two thieves ran. Alerted by the sound of gunfire, Patrick Murphy, the caretaker, took off in pursuit. Coates was losing a lot of blood. His companion got away, but Coates dropped facedown into the dirt. Murphy found him dead a short time later.

Zukor wasn't home. In fact, he had left some weeks earlier on board the SS *Aquitania*, bound for England. He and Lottie traveled first class, mingling with such luminaries as *New York Times* publisher Adolph Ochs, Mr. and Mrs. Jacques Cartier of the jewelry family, and General Cornelius Vanderbilt. It was a long way from steerage.

Convinced his American empire was safe for the moment, Zukor was sailing to conquer new worlds: England, France, Belgium, Germany.

But in Boston, a different sort of foe had emerged, an unexpected adversary who had discovered Zukor's darkest secret. And no chicanery or trap guns could stop this aggressor in his tracks.

# PRYING EYES

"Let's go up," said Edward Sands, "and see who slept with the old man last night."

William Desmond Taylor's plump, red-cheeked valet was speaking to Manley Tiffany, the director's new chauffeur, whom everyone called "Earl." The two of them made an odd-looking pair. Sands was short, stout, and fair. Tiffany was tall, slender, and dark. But they shared a penchant for mischief. Tiffany's predecessor, Harry Fellows, had been straight-up and trustworthy—so much so that Mr. Taylor had hired him to be his assistant at the studio. Sands wasn't unhappy that Fellows was gone and Earl Tiffany had taken his place. He told the new chauffeur to call him "Jazz." All his friends did.

Up the short flight of stairs Jazz and Earl crept toward Taylor's bedroom. Sands was distinctly bowlegged, so his walk was a little comical.

For months, whenever the director wasn't home, Sands had been snooping around the Alvarado Court apartment. Now he showed Tiffany the interesting things he'd uncovered:

A douche bag.

Some suppositories.

And a pink silk nightshirt of some kind.

It was a big, boxy thing, not very feminine in appearance, but Sands assumed it must have belonged to a woman. It was pink, after all. Others would call the garment "flesh-colored," but to Sands it was pink. And what man would wear a pink nightshirt? It had to be a woman, the valet believed.

To find out which woman, Sands had an idea. By folding the garment "in a trick manner," he told Tiffany they'd be able to discern if it had been worn the next time they looked.

Not long afterward, Sands and Tiffany snuck up to Taylor's room again. And eureka! The trick had worked. The garment was folded differently from how they had left it. "The old man" was clearly having sex with some woman! Or at least some woman was spending the night, snuck in after Sands had gone to bed.

But who? Sands "paid particular attention to the visitors to the Taylor home . . . and drew his own conclusion," according to a later report. The valet told Tiffany he suspected one of three women: Neva Gerber, Mabel Normand, or Mary Miles Minter.

Next time one of them came around, Sands would have to keep an eye on that pink nightshirt and see if it had been used.

Of the three ladies Sands suspected, only Mabel had been spending any time with Taylor of late. But Mabel's evenings with Billy always ended with a brotherly kiss—exactly why she found spending time with him so wonderful and refreshing. Liberated from the kind of sexual tension that had poisoned her relationships with Sennett and Goldwyn, Mabel could relax when she was out with Taylor and have a good time.

In the last few weeks, they'd frequently been spotted twirling around the dance floor in the grill room at the Ambassador Hotel. Columnist Hazel Shelly called the Ambassador the new "Mecca" for the filmfolk; the grill room would soon be christened "the Cocoanut Grove." Green monkeys with lighted eyes, perched in towering potted palms, watched as Ruth Roland "tripped the light fantastic" in a pink chiffon dress, and Gloria Swanson dazzled in a flame-colored sequined gown. Back at their tables, deposited there by attendants and carefully cloaked by the tablecloths, were suitcases filled with "the precious cargo of expensive booze."

How easy it would have been for Mabel to indulge if she wanted. But not with Taylor. He made sure his "Blessed Baby" stayed clean. An occasional cocktail was fine, but nothing more. They sat discreetly, never drawing much attention to themselves. One night their dinner

companions were the distinguished actor Mahlon Hamilton and his wife. Hamilton had just finished shooting *Greater Than Love* at the Ince studios. Perhaps he shared stories of working with Patricia Palmer, whom Taylor knew better as Margaret "Gibby" Gibson.

For all their discretion, Mabel and Taylor were still watched by the columnists. Grace Kingsley had fun with a blind item: "Mabel Normand has caught a distinguished looking one with gray hair this time!" But the pair never gave the press anything to gossip about. Taylor, as always, was tight-lipped and mysterious. And Mabel, for the first time, seemed calm and content.

That didn't stop people from drawing their own conclusions.

People like Edward Sands.

Sands had a way of finding out things, but he knew how to get away with things too. Like his employer, he had lived many different lives. His name wasn't Sands, but rather Snyder, and despite his accent, he wasn't English at all, having been born in Ohio twenty-seven years earlier. As a teenager, he had fled his strict father's belt by enlisting in the US Navy. Told he was too young, he'd lied about his age. It was the first lie of many.

While on board the USS *Paducah*, Snyder was arrested for fraud and embezzlement after overcharging for supplies in the mess room and pocketing the difference. Court-martialed, he was found guilty and sentenced to twelve months of hard labor. The experience turned Snyder bitter. A year in the brig seemed excessive punishment for making a few extra pennies on Lifebuoy soap, Colgate toothpaste, and peanut butter. For the rest of his life Snyder would try to stay one step ahead of everyone, even his benefactors, whom he felt he could never really trust. After serving his time, he was dishonorably discharged from the navy.

He found his way back, however, enlisting in the coast guard and later the US Navy Reserve, neither time disclosing his court-martial. During the war he was promoted to commissary steward. At last things were going well for Snyder, but he was simply too self-destructive to thrive for very long. One night he stole a car and

smashed it into a telegraph pole. Ordered to pay for the damages, he deserted instead.

But military life was all Snyder knew. Once again he enlisted, this time under the name Edward Strathmore, this time in the army, where one of his duties was drawing up government checks. On October 4, 1919, temptation proved impossible to resist. He made out a check payable to himself for $481.53, forged the signature of the finance officer, and deserted.

Now he had several branches of the US military looking for him.

Snyder ended up in Los Angeles, that place of last resort for so many fugitives. He found the perfect cover working for Taylor as Edward Sands.

His years in the military had taught him how to keep a shipshape house. Every morning, Sands made Taylor's bed crisply and prepared his food precisely to order. Taylor was pleased with his valet's work, and Sands seemed happy as well, at one point telling his employer he'd be glad to be his "servant for life." Julia Crawford-Ivers, Taylor's most frequent screenwriter, thought "there never was a more devoted man serving another." George Hopkins liked Sands as well, though he felt a little sorry for him. To Hopkins, Sands seemed to carry around the sadness and humility of a "defrocked priest."

There were reasons a priest was defrocked. Perversions. Wickedness.

A villainous smile pushed against Jazz's pudgy cheeks.

Telling Earl Tiffany he had other things to show him, Sands led the chauffeur into Taylor's living room. "In every way possible," Tiffany came to realize, Sands had been prying into Taylor's life. And the most sensational discovery he'd made wasn't in the bedroom, but in the rolltop desk in the living room. Flinging it open, Sands exposed bundles of letters and stacks of checks. He'd been through them all. And he told Tiffany what he'd discovered:

Their esteemed employer's name wasn't William Desmond Taylor.

It was William Deane-Tanner.

And once a month he wrote a check to a woman named Ada Deane-Tanner, who lived with two young daughters in Monrovia, a little more than twenty miles from Los Angeles.

Sands felt such knowledge gave him the upper hand with Taylor. "If

the old man ever gets hard with me," he told Tiffany, "I will let him know where I get off at, and where he gets off."

Why Sands felt he needed an upper hand, Tiffany wasn't sure. Taylor had always been fair and generous to his valet. But never in Sands's restless life had he let much time go by before succumbing to his fetish for self-destruction.

For Tiffany, what made the valet's attitude all the more troubling was the .45-caliber Colt revolver he carried around. Sands's time in the military had taught him a lot about guns. One time, when Taylor was trying to fit the shoulder piece onto the German Luger he owned, Sands quickly stepped in to help. "Without a word, Sands took up the two, and by one motion fitted them together," an observer would recall. Taylor was astonished. "Is there anything Sands does not know?" he asked.

But Earl Tiffany found the valet's proficiency with guns unnerving.

Stepping out of Taylor's car one day, Tiffany saw Sands waiting for him. In his chubby hand he held the Colt revolver, and he stuck it alongside the McFarlan's door. When Tiffany asked what the idea was, Sands just laughed and walked away.

For all their shared love of mischief, Sands made Tiffany uneasy. When he was asked to describe the valet, the chauffeur used one word.

Ungodly.

# SO THIS IS WHAT IS GOING ON

Mary was writing letters again.

Dipping her pen into the inkwell, she composed her thoughts. In front of her lay a page of her blue butterfly stationery. Filled with emotion, Mary began to write, her pen making a frantic scratching sound as it crossed the paper.

Mr. Taylor might have been trying to keep his distance from her, but Mary would not be ignored.

"I wrote letters," she'd admit. "Passionate, impulsive letters. I did everything I could to make him break his resolve and marry at once. I loved him, oh, so sincerely—and he loved me." That much she'd never doubt. Mr. Taylor had told her so, Mary insisted, "many, many times."

She folded the letter, squirted it with perfume, and slipped it inside an envelope. Then, in her flowery little girl's script, she addressed it to the man she wished to serve as she "would have served the Lord."

Jazz Sands sniffed the letter, laughed, and passed it to Earl Tiffany.

> *Dearest—*
> *I love you—I love you—I love you—*

This was followed by nine small x's and one enormous X that took up most of the page. The letter was signed, "Yours always—Mary."

Taylor's two servants got a good kick out of that.

———

Living with her mother was hell. Terrible memories sometimes over-whelmed her. The sickening odor as her beloved doll burned in the oven. The cold metal and the rough fingers as the abortionist violated her body.

As soon as Mrs. Shelby wasn't looking, Mary bolted.

Hopping into her little blue runabout, she sped over to the Famous Players studio on Sunset Boulevard. Through the front gates she ran, her blond curls bouncing on her shoulders. As a top star, Mary could go where she liked. No guard was going to bar her from a set. She made a beeline for the company shooting Taylor's new picture, *The Lifted Veil*.

From across the set, Taylor's screenwriter, Julia Crawford-Ivers, a sharp, sturdy lady of fifty-two, caught sight of Mary's approach. It wasn't the first time the petite actress had barged onto one of Taylor's sets, and Ivers wasn't happy to see her. "Oh, there is little Mary again," the older woman said in exasperation. "What can she be wanting this time?"

When Mary reached her, Ivers tweaked her chin as if she were a child.

Mary resented Ivers's condescension. Behind the screenwriter's back, she called her a "very fat, large woman." Ivers had the power to rile Mary like few others. She was always hanging around, refusing to budge from Mr. Taylor's side. Would Mary never get the chance to see her great love alone again?

Not if Ivers could help it. The screenwriter knew how harassed the director felt, and she felt duty-bound to protect him. So she made sure to position her considerable bulk in front of Taylor whenever Mary came around making a pest of herself. Furious, Mary finally turned on her heel and stomped out.

But she had no intention of giving up.

In the little nook under the director's stairs, the telephone was ringing.

Earl Tiffany, passing by, answered. It was Mary Miles Minter, ask-ing to speak to Mr. Taylor. As both he and Sands had been instructed, Tiffany replied that the director was out.

Mary didn't believe him. Hopping back into her little blue car, she zipped across town to Alvarado Court. When she came trudging

through the courtyard and saw that Mr. Taylor *was* at home, she looked to Tiffany "as if she were about to cry her eyes out." Faced with the delicate task of calming the distraught young woman, Taylor sent his chauffeur home, telling him he wouldn't be needed anymore that day. The cynical Tiffany assumed that meant Taylor was getting ready to take the diminutive teenage star to bed.

Not quite. As kindly as he could, Taylor told Mary that she shouldn't contact him again, that if he wanted to see her, he would telephone. Eventually Mary agreed to return to her car and drive back to her mother's new rented mansion on Seventh and South New Hampshire Avenues.

It was only another strategic retreat.

George Hopkins sat at his desk at the studio, catercorner to Taylor's, dreaming the impossible. He knew that his relationship with the director would always need to be discreet, that he could never hope for more than what they already had—an association that, while intimate, was also irregular and indefinite. But that didn't stop Hopkins from wishing for more, imagining what it might be like to be with Taylor "all of the time, to live with him, and for the whole world to know" of their love.

It was a fanciful pipe dream.

Then his phone rang. On the other end was the actress Vivian Martin, whom Hopkins planned to escort to the opening of Verdi's *Otello* at the Philharmonic Auditorium the next night. But Martin was calling to say she had the flu. Hopkins said he hoped she'd feel better soon, then hung up the phone thoughtfully. A crazy thought was taking shape in his head.

Leaning across Taylor's desk, Hopkins impulsively asked the director to be his date instead.

Taylor looked over at the young man with those bracing blue eyes of his. To Hopkins's great surprise, he accepted his invitation.

It was a daring move. Two men never accompanied each other to the theater alone, without female escorts, let alone to such a prestigious event. The arrival of the famed soprano Mary Garden's Chicago opera company had been anticipated all season. "Everyone has been telling

everyone else for months that it would be the gala climax of the year," *Los Angeles Times* cultural critic Edwin Schallert reported.

Perhaps Taylor was feeling brave. Perhaps he wanted to reward Hopkins for all his support, personal and professional, these past several months. Whatever the reason, he tossed his usual caution aside and made the young designer very happy.

On the night of April 4, 1921, Hopkins drove his plain black Ford from his mother's house in Pasadena to a parking lot on Olive Street in downtown Los Angeles. Perfectly turned out in white tie and tails, he pulled his little car alongside Taylor's shiny McFarlan. Earl Tiffany sat at the wheel, smoking a cigarette. "The boss has gone inside to wait for you," the chauffeur told him.

Hopkins might have wished he and Taylor had walked into the event together, facing the snapping photographers shoulder to shoulder. But he was content to meet Taylor in the lobby. Even that was more than he'd ever expected.

The young man's eyes grew wide at the glamorous crowd milling all around him, "one of the most distinguished gatherings ever seen," according to a newspaper reporter. The movie folk were there—the DeMilles, the Laskys, the writer Rupert Hughes—but it was the minks and diamonds of "Southland society" that really elevated the evening beyond the ordinary. Mr. and Mrs. Richard Jewett Schweppes, Mr. and Mrs. J. Benton Van Nuys, Mr. and Mrs. Mattison Boyd Jones, and hundreds of others.

Through their mother-of-pearl opera glasses, these Los Angeles socialites watched Taylor and Hopkins make their way to the front orchestra.

As the two men took their seats, the two women seated directly in front of them turned to stare. To his horror, Hopkins realized who they were: Charlotte Shelby, in emerald green, and Mary Miles Minter, in orchid chiffon. Mary had an ermine wrap draped across her slim white shoulders and a silver bandeau wrapped around her blond curls. When she saw the two men, Mary's eyes almost popped from their sockets.

There was no time for greetings. *Otello* has no overture. The curtain

rose abruptly, almost violently. There on the stage, as Schallert would describe, was a scene "breathtaking in its action and pictorial realism." Otello was returning on his ship to Cyprus after a long voyage. Many in the audience gasped at "the flare and flash of real stage lightning," while Charles Marshall, playing the title character, overwhelmed everyone with "the fullness of his voice."

At that moment—in the midst of one of the great scenes of the opera stage, as the stink of magnesium wafted over the crowd from the theatrical lightning—Mary turned again to glare at Taylor and Hopkins. Her blue eyes flashed in the dark.

"So this is what is going on!" she hissed.

She spun back around, curls swinging.

Hopkins felt Taylor tense. For the rest of the act, the young man wasn't able to concentrate. He suspected his companion suffered similarly.

At intermission, even before the lights were fully up, Taylor bolted from his seat. He told Hopkins he had a migraine and fled from the auditorium. Hopkins followed. At the car, Taylor shook his sleeping chauffeur awake and climbed into the backseat of the McFarlan. Without even a good-bye, he left Hopkins standing there alone, trembling.

After a few moments, the young designer returned to his seat, burning with rage. The "little ninny" in front of him had ruined his special night with the man he loved. For the rest of the opera, Hopkins was deaf and blind to the sound and spectacle thundering from the stage. "All that went through my mind," he would remember, "was an overwhelming urge to smash my fists down on top of Mary's golden head."

# FIVE THOUSAND FEET OF IMMORALITY

Adolph Zukor slowly exhaled the smoke from his cigar, filling his office with the fragrance of spicy cedarwood. No, he said, his voice soft yet firm. He would not sell the Putnam Building.

In front of him, the accountants from the firm of Dominick & Dominick shifted uncomfortably in their seats as their most important client snubbed their advice. Zukor told them he didn't care if a sale of the Putnam property would pay off Famous Players' debt. Didn't they understand? This was going to be his skyscraper. His monument. No way was he giving it up.

Marcus Loew had a skyscraper. Zukor wanted one too.

The accountants again tried to make their case, but Zukor was still resistant. Just back from Europe, he was getting bombarded from all sides. On his desk lay a financial statement that was not at all encouraging. Every week, cash on hand was plummeting. Famous Players had gone from about $2.3 million at the start of April to about $2.1 million at the end of the month, and that figure was expected to keep dropping. To offset this decline, borrowing from banks had risen from about $3.1 million to about $3.3 million in the same period of time, while revenues remained stubbornly static and sluggish, totaling only about half a million dollars a week. If something didn't change soon, the accountants feared prosperity would never return.

Zukor accepted part of the blame. As the recession had subsided, he and Lasky had optimistically increased production. But now the studio

was bulging at the seams with unreleased films. "Motion pictures is the only industry in the world where fortunes can be tied up for months in a few tin cans," the ever-loyal William Desmond Taylor had told the press, explaining his bosses' predicament. "The producer pays cash for story, production costs, salaries—everything. He must wait three months, six months, even a year for his returns."

From Zukor's point of view, the problem was that too many theaters remained outside his control. If he owned all the theaters in the country—in the world!—he could show whatever films he chose, whenever he liked. Under such conditions, there would be no pileup of cans of unreleased celluloid. There would be no waiting for returns on his investment.

Since that wouldn't happen soon enough to offset the current crisis, however, Zukor had agreed to make some major production cost cuts. But he adamantly refused to sell the Putnam Building. When his accountants made one last plea for him to change his mind, he cut them off with an icy stare. How myopic could these halfwits be? Didn't they understand the value of possessing the biggest flagship theater in New York? Especially now, as Marcus Loew's imperial headquarters was rising into the sky just down the street? Zukor had seen Loew out there at the site, wearing his ridiculous fur coats, blathering loudly and rashly, rubbing shoulders with that execrable Senator Jimmy Walker. How he longed to show them both up.

Zukor hadn't worked so hard for eighteen years just to turn back now. These accountants had no idea what it meant to work, to plot, to scheme, to take risks. They came from families where the money was as old as the dirt under their Connecticut mansions, their paths worn smooth for them by their fathers and grandfathers. They didn't understand what it felt like to stand empty and alone, without a family, without a country, on the pier at Castle Garden. They had no clew where Zukor came from or where he was going.

Zukor would have his skyscraper, and it would make Loew's seem puny by comparison.

He was grateful that Otto Kahn, at least, agreed with him that selling the Putnam Building would be a shortsighted remedy. Divestiture had never been Zukor's policy. Growth and consolidation was the only way he knew.

It was a riskier strategy, perhaps. But Zukor didn't fear risks, not when the rewards were so great.

Even if the invaders were already climbing over the walls.

Mrs. Ellen O'Grady, late of the New York Police Department, was weaving a path through the crowded assembly chamber of the state capitol as all around her the buzz of hundreds of conversations echoed into the vaulted ceiling. Mrs. O'Grady was in Albany on a mission. She was preparing to testify before a legislative committee about the evils of the movies.

Censorship was about to come to the state of New York.

Not long ago, with his shrewd deception of Wilbur Crafts, Zukor had brushed off the possibility. But now censorship seemed like a fait accompli, with Governor Nathan Miller's advocacy and a surprising number of pro-censorship votes in both the senate and the assembly. But still William Brady was there, huffing and puffing, once again promising "a clean sweep from coast to coast" of all objectionable pictures. "We ask you to hold this measure over until next year," Brady pleaded with legislators, "in order to give the industry an opportunity to demonstrate that it can handle this situation."

But Mrs. O'Grady and her cohorts had heard it all before. Lasky's fourteen points were unenforceable, with objectionable films still showing up every week in theaters all across the state. Mrs. Clarence Waterman, who had stood at Wilbur Crafts's side at that meeting with those duplicitous movie men not a month before, had taken it upon herself to sit through as many of the devil's entertainments as she could tolerate, cataloging every sin. She'd brought her list of shame to the state capitol, where she sat stiffly beside Mrs. O'Grady, waiting to testify. The church ladies could see through the spin being promulgated by industry agents like William Desmond Taylor, calling "sex plays moral lessons." Mrs. Waterman held in her hands proof that for every "fifty feet of moral film" there were "five thousand feet of immorality." Let the film chiefs try to wriggle out of these cold hard facts!

The committee chairman banged his gavel and called Mrs. O'Grady to the stand.

"I am fond of motion pictures," the former policewoman told the packed chamber. "But the industry has passed into the hands of unscrupulous men whose God is Mammon. I could cite you case after case of boys and girls gone wrong because of films. It makes my blood boil. I have been to those places where evil pictures are shown and I have often wished that I were a thousand men so I might tear the films into shreds. These men are not fighting for their art as they tell you. They are fighting because the market is flooded with filth and they would lose money if they could not show it on the screens."

Suddenly overcome with emotion, Mrs. O'Grady concluded her testimony with the story of an immigrant girl who'd expressed her wish to become an American lady. "Her idea of such a lady," Mrs. O'Grady sniffed, "was one who went to cabarets and enjoyed a constant lively time." Where had she gotten such a perverse idea of womanhood? "From the moving picture shows," Mrs. O'Grady said with indignation.

There was grumbling from the gallery. Many were fed up with the sanctimony. As Mrs. O'Grady made her way back to her seat, she was harangued with boos. The author Rex Beach, whose novel *The Spoilers* had been made into a major movie hit some years earlier, stomped past her up to the podium to seize the moment and denounce censorship advocates as "narrow-minded bigots." That brought more hissing from the gallery, this time from the other side.

But it was all theater. The end result was no longer in doubt. Dr. William Sheafe Chase, canon of Christ Church in Brooklyn, had personally collected thousands of pro-censorship signatures. Now he dropped them dramatically, like a lead weight, on the table in front of the assembly. A few days later the state senate passed a bill setting up a board of censors. Shortly thereafter the assembly did the same, crushing the free-speechers 102 to 38. On May 14, 1921, Governor Miller signed censorship into law for the state of New York.

The film industry had just lost huge revenues from its most important domestic market, and Senator Jimmy Walker lost no time in pointing the finger. It was the movie producers who were to blame, he said. Walker and the exhibitors had proposed a compromise that would have watered down the bill. If the "matter had been handled

properly," Walker insisted, they wouldn't have found themselves in this pickle. But since "certain producers" had controlled the negotiations, New York was now stuck with one of the strictest censorship laws in the nation. Everyone knew who Walker was accusing. The National Association of the Moving Picture Industry took its marching orders from Famous Players and its crafty chief.

Zukor loathed Walker more than ever.

But Walker was the devil he knew. There were others he still didn't know about.

The passage of censorship in New York was a dark day for Zukor. But things were about to get much worse.

In his office in Boston, J. Weston Allen, the brilliant, ambitious attorney general for the Commonwealth of Massachusetts, put the finishing touches on his case against District Attorney Nathan Tufts. The charges against Tufts grew out of that memorable party at Mishawum Manor, presided over by the notorious madam Brownie Kennedy. Allen knew that when the details of the report were made public, he would face "one of the greatest legal battles ever fought in the Commonwealth" as he endeavored to remove Tufts from office.

After three fraught years, the secret Zukor had been hiding was about to explode.

Among other crimes, Allen had incontrovertible evidence that Tufts had engineered the extortion of $100,000 from Adolph Zukor and other Famous Players executives. The attorney general understood that those executives had friends in high places—like the Oval Office—who preferred that no names be brought out in court. But Allen had only so much power over that.

The news broke on May 27, in a flurry of enormous headlines. Tufts, Allen charged, had conspired with certain persons "to defraud certain men upon a fictitious charge, upon which he threatened to indict them in order to aid [his co-conspirators] with obtaining large sums of money." For now, the public did not know who these "certain men" were. No clew appeared in any newspaper that the movies were involved at all. But surely, soon after his arrival back into New York,

Zukor had received word about what was afoot, likely from his contacts within the Harding administration. At some point he was also formally notified by Allen.

Ruminating in his New York office, smoking eight to ten "very black cigars" a day, the most powerful man in the film industry feared personal ruin. This wasn't merely the loss of revenues from the state of New York. This could mean losing everything. Zukor had long believed his enemies were out to get him. Now the assault had finally arrived. They were aiming for his heart. It was one thing to be called out by Jimmy Walker for failing to stop censorship—quite another to see his own name join those of Robert Harron, Olive Thomas, and Margaret "Gibby" Gibson in the scandal headlines.

But the worst part was the embarrassment he'd bring to Lottie. His faithful, devoted wife.

How beautiful Lottie had been when they'd first met. Back then, Lottie had been the catch, the prize, not Zukor. Lottie was the pretty niece of the wealthy backer of Zukor's furrier business; he'd been just another guy trying to make good, a slightly awkward, taciturn fellow, whose Hungarian accent had not yet been sandpapered down. How much Zukor had wanted Lottie to notice him, to gift him with a smile. Instead she'd been distant, too good for him. He decided to win her over. Another gamble—but Zukor never lost.

One day he invited Lottie to come watch him play baseball. Barely out of his teens, the young Adolph looked ludicrous in his ill-fitting, oversize uniform. But he took his ball playing very seriously. Those long eyes of his fixed on the pitch. He swung and—crack!—he hit the ball. His little legs frantically carried him around the bases before sliding home.

In her lacy dress and parasol, Lottie watched. Something about the short, spunky slugger won her over. Not long afterward, Lottie agreed to marry him, and Zukor was the happiest man in the world.

Through all the lean years, Lottie had been at his side. Whenever they'd endured hard times, Lottie had taken charge. "Well, so we move again," she'd say. "I'll find a place. How much can we afford?" Zukor believed he "could never have survived" his early, difficult years without his wife. He'd never have become a success without her by his side.

He trudged home to break the news to Lottie about the impending scandal.

Of all the deals he'd brokered, all the decisions he'd made, and all the actions he'd taken, this was probably the hardest thing Zukor had ever done.

# BUNCO BABE

From beneath heavily mascaraed lashes, Gibby watched the man check in at the Melrose Hotel. He was a middle-aged traveling salesman stopping for a few nights in Los Angeles. For the next couple of days, Gibby kept her eyes on the man. She memorized his movements. In the late afternoon she watched as he sat by himself in the lobby, reading a newspaper or smoking a cigar. Slinking over to the hotel desk, Gibby made a phone call.

Not long afterward Don Osborn showed up, accompanied by his niece, Rose Putnam.

From a discreet vantage point at the far end the lobby, Gibby and Osborn watched as Rose went to work.

Strolling nonchalantly over to the man, she took a seat and struck up a conversation. Flirting came naturally to Rose, as it did to Gibby. Within a very short time Osborn's niece had the traveling salesman laughing. She leaned in as he lit her cigarette. She crossed her legs, showing off her shapely calves, dangling her shoe from her toes.

Eventually Rose and the man stood and made their way upstairs.

It was all going according to plan.

Glancing at his watch, Osborn gave his niece ten minutes.

At the exact scheduled time, Rose burst back into the lobby, her face a mask of horror and outrage. The man followed, his hands pleading. This was where Osborn came in. Hurrying over to Rose, he asked her what was wrong. Amid a torrent of tears, she pointed at the salesman.

He'd tried to accost her! She'd had to fight him off! She covered her face and sobbed.

Now it was Osborn's turn to show off his own acting abilities. Never in his long career as a movie extra had he ever landed such a meaty part. With anger flashing like neon signs in his icy blue eyes, he drew close to the salesman's face. At six-three, Osborn could be very intimidating. Through clenched teeth, he identified himself as Rose's husband and snarled that he had no choice but to call the police. The man begged him not to do so. Wasn't there something he could do to keep the police out of this?

Osborn turned, locking his eyes onto the trembling man. His wife's honor was worth a great deal, Osborn declared.

The salesman agreed.

In that case, Osborn said, maybe they could work out a deal.

After a bit of haggling over just how much Rose's honor was worth, the traveling salesman wrote Osborn a check. Then he packed his bags and hightailed it out of the hotel as quickly as he could, scrambling back to wherever it was that he had come from—Iowa, perhaps, or Michigan or Wisconsin or North Carolina.

And Osborn and Rose took the check to the bank.

Gibby, of course, got her cut for setting the jig into motion.

The hapless traveling salesman was their first chump. He was certainly not their last.

People did what they had to do in Tinseltown. No one was getting any work. With the studios struggling to unload their backlog of unreleased pictures, *Variety* reported, actors without long-term contracts—people like Gibby and Osborn—weren't being hired.

Meanwhile, Gibby's rent was due. She had to do something.

She'd tried playing by the rules. She'd tried going high-class. But no offers had been forthcoming after *Greater Than Love*. So she'd had to drag herself back, tail between her legs, to Al Christie and his Gayety shorts. The area around Sunset Boulevard and Gower Street, where Christie and other low-budget comedy producers had their studios, was called the "Corner of Last Hope" wthin the industry. For Gibby, a re-

turn to Christie meant more slapstick. More silly, inconsequential roles for which she was paid pennies. To make matters worse, Christie sent out a humiliating press release marking her return. "Patricia Palmer is back in comedy, following her desertion, for she found that work in the dramatic field was not all that it was declared to be." Talk about rubbing salt in her wounds.

It wasn't fair. Gibby had worked so hard. She'd come up with scenarios, budgets, and production schedules for her proposed picture, but no one was willing to take a chance on her. Nearly a decade she'd spent in front of the camera. She knew as much about making movies as anybody. Why couldn't she catch a break? Why did everyone else get to have nice things except for her? Mary Miles Minter in her luxurious rented mansions—Minter didn't even *want* to make movies! Gibby would've killed for one of Mary's rejects. And Mabel Normand! She'd just gotten a million-dollar contract, even though her pictures hadn't been making real money for years. A million dollars! When Gibby couldn't even pay her rent!

Why was the world so out of balance?

At Osborn's house on South Bronson Avenue, the locusts thronged. Rae would come home late at night after performing at a downtown burlesque theater to find her husband and George Weh, or Fred Moore, or out-of-work director Jack Nelson, completely intoxicated. And there was a new character, too, brought into the group by Weh, who sat drinking his whiskey off to one side, coiled like a snake, seemingly ready to strike at any point.

His name was Blackie Madsen. A long history of barroom brawls and back-alley fights was etched into his coarse features. His face was like a living mug shot, with small, devious black eyes over a prominent nose. Heavyset, in his fifties, Madsen walked slowly and was bowlegged. On his left wrist was tattooed a blue star.

At the moment Madsen was on the lam from the San Diego police for fleecing a tourist out of $16,000 through a fake stock exchange. Clearly this Blackie character knew how to make money. That was why Weh had brought him to Osborn's.

But Madsen had no interest in motion pictures. He had other ideas about how they might earn a living.

Madsen told Osborn that the pigeons at the Melrose Hotel were rinky-dink. If he ever hoped to make more than pocket change, he'd need to start casting for bigger fish.

And so they started compiling a list.

The movie colony was a limitless source of easy marks. Ambitious young writers could be swindled with the promise of a producer reading their scripts. Out-of-work actors would pay anything for a chance at landing a part. Thousands of gullible stooges, moping around soda fountains and loitering in pool halls, could be swayed by get-rich-quick stories.

According to a report that would come later, Osborn and Madsen started "looking around for victims for their bunco schemes." Rose and "other women" often served as bait.

But Blackie Madsen pointed out that they didn't need to go to all the trouble of setting someone up. In Tinseltown, after all, most everyone had secrets. How much easier it was to just rattle a few skeletons in various closets than concoct some elaborate racket. A simple blackmail job could bring in a lot of cash, with far less overhead.

Among their first victims during the spring and summer of 1921 were "a film exchange man who was cheating on his wife" and a man who "owed a great deal of money to the government." By July, Osborn and Madsen were counting out their payola with glee, throwing the bills onto the bed so Rose could roll around on top of them in ecstasy. Their minds raced. Who else could they shake down? Who else had secrets? How easy this blackmail game was!

Over the next few months Osborn and Madsen would put together "a long list of names" of potential victims. And they almost certainly had help in compiling it. Gibby had assisted Osborn before; she could easily have come up with a few ideas again. After all, Gibby knew lots of people who had secrets.

Chief among them William Desmond Taylor.

That spring of 1921, Gibby was feeling no love for her old friend Billy. When she'd made the rounds of studios the previous summer, traipsing across Hollywood on a sweltering day, practically begging for a job, she'd visited every contact she'd ever had, which surely included

Taylor. And here she was, more than half a year later, still unemployed, forced to resort to bunco schemes to make a few dollars.

Thanks for nothing, Billy Taylor.

What different directions they had traveled since starting out together. Eight years earlier, *Illustrated Films Monthly* had carried a serialization of their picture *The Night Riders of Petersham*, along with a photograph of Taylor standing beside his horse, staring lovingly down at Gibby, holding her hand. In *The Kiss*, Gibby had played a discontented shopgirl who sets her eyes on a wealthy man, played by Taylor, believing he can get her the pretty things she wants. An ironic bit of foreshadowing, perhaps.

But in fact Gibby had known Taylor—or known of him—even longer than that.

When he directed Judge Ben Lindsey in *The Soul of Youth*, Taylor had told the magistrate an interesting story, one of the few occasions he ever discussed his past. As he related to Lindsey, around 1910 he'd been mining for gold in the mountain town of Ouray, Colorado. During this period, he would make "frequent visits" to Denver. On one such trip, Taylor told the judge, he'd been arrested. Despite insisting that he was a victim of mistaken identity, Taylor was beaten by the arresting officer and tossed in jail overnight. In the morning, when his identity was proven, Taylor was released with extravagant apologies. He made no complaint and returned to Ouray. At least, that was the version he told Judge Lindsey.

During that same period, Gibby was also in Denver. She was fourteen at the time, singing and dancing in the city's Pantages Theatre, trying to earn a living for herself and her mother. Gibby might well have been aware of Taylor's "frequent visits" to the city. In May of that year, Taylor was on the Denver stage himself, advertised in newspapers as appearing at the Tabor Grand Opera House in *As the Sun Went Down*. So at the very same time Gibby danced and sang at the Pantages, Taylor was appearing at a theater just a block away. Did they meet? Did Gibby know something about Taylor's night in jail? Did she hear talk that the incident involved more than just a case of mistaken identity?

Maybe Taylor's arrest was just as he told it to Judge Lindsey. Nonetheless, Gibby had been nearby when it happened—just as she was

present for other key moments in Taylor's life, when she had the chance to witness things he might have preferred to keep private.

When Taylor was fired by Vitagraph, Gibby was there. Taylor would insist that he had quit, but a notice in the *Moving Picture World* proved otherwise. Just why the company would sack the star of their important upcoming picture *Captain Alvarez* was perplexing. Clearly there'd been some bad blood. When *Captain Alvarez* turned out to be a giant hit, Taylor's name was sometimes omitted from the credits. Had someone discovered that his name wasn't actually Taylor? Or was he fired for other reasons? Some kind of transgression, perhaps?

And how much had Gibby observed or overheard?

Even now she still had connections to Taylor. One of her acquaintances was a twenty-one-year-old Tennessee-born actor and dancer named Starke Patteson, with whom she and Osborn had appeared in *The Tempest*. Patteson, also a friend of George Hopkins, was preparing to play a small role in Taylor's forthcoming picture *Morals*, scheduled to begin shooting that summer. And a year earlier, Patteson had acted in *Sweet Lavender* with Mary Miles Minter, not long after the young actress's obsession with Taylor began.

So not only was it possible that Gibby knew, through her connection with Patteson, all about Taylor's relationship with Hopkins, but she might also have heard a few juicy stories of the director's troubles with his fanatical admirer.

If Gibby did decide to add Taylor's name to a list of patsies for Osborn and Madsen, she would have had plenty of goods on him.

Everybody in Tinseltown had secrets. But few had more than William Desmond Taylor.

# AMONG THE LIONS

The ballroom of the West Hotel in downtown Minneapolis stank of smoke, sweat, and testosterone. On the excruciatingly hot afternoon of June 28, 1921, three thousand theater men gathered for their annual convention. Shedding their coats and removing their collars, they argued among themselves about everything from tariffs to censorship. But then, all at once, their squabbling ceased. Silence fell over the great sweltering hall. The only sound was the squeak of the ceiling fans overhead. All eyes turned as a little man in a fedora hat filed into the room.

Adolph Zukor.

For the last few days Zukor's photograph had dominated the newspapers. He was the central figure in an exploding scandal out of Boston, involving prostitutes and a corrupt district attorney. The exhibitors, many of them union men and fervently anticapitalist, had gotten some good chuckles observing Zukor's predicament.

### BIG MOVIE MEN SAID TO HAVE PAID
### THOUSANDS TO ESCAPE PROSECUTION

Zukor and Hiram Abrams had been revealed as two of the men involved in the $100,000 shakedown in Boston. For the past two days in Minneapolis, salacious details of the Mishawum Manor dinner had been passed around the convention hall like bottles of beer in a saloon. The imperious Adolph Zukor, caught with his pants down!

Zukor paid no attention to the smirking faces as he proceeded

through the muggy ballroom, his hooded eyes staring straight ahead. He took his seat with several of his Famous Players lieutenants.

He could have stayed away from this gathering of his enemies. But there he was, sitting among three thousand men who wanted his head. Zukor had promised to be there, and so he was. He'd come to Minneapolis to answer the charges the exhibitors had against him. To back out after the scandal broke would have been seen as cowardly. So he braced himself and made the trip.

Besides, as difficult as it was, heading to Minneapolis might have been preferable to staying home and witnessing the hurt on Lottie's face.

She had seen the headlines about her husband, and yet she had not turned her back on him. What "great strength and understanding" Lottie had, Zukor would say. She endured this trial as she had others: selflessly. When Lottie worried about things, her husband would say, "her concern was never added to mine." Yet Lottie's magnanimity likely made Zukor's guilt only more difficult to bear.

So he sat among the barbarians, a wounded man. His enemies may have smelled blood, but they were also impressed that he hadn't backed down. No one could call Zukor chicken.

Across the aisle, Marcus Loew held court like a king, standing out from the crowd in his snazzy suit and brightly colored tie. Loew seemed to be anticipating quite the show now that his rival had arrived. When word got out that Zukor would attend the Minneapolis convention, Loew was asked if he planned to be there, too. "Try and keep me away," he'd answered to a chorus of laughter. Fireworks were inevitable, and Loew wanted to see them.

He didn't have to wait long. As speaker after speaker took the podium, Zukor was excoriated as a greedy oligarch out to destroy them all. His worst sin, the exhibitors declared, was the practice of "block-booking," wherein theater owners were forced to take second-rate pictures if they wanted top-of-the-line product as well. To keep Fatty Arbuckle or Wallace Reid on their screens, they had to buy dreary low-budget romances or cheap westerns as well—which meant half-empty houses much of the time. The injustice was blamed squarely on Zukor.

The film chief made no response. He just sat there stoically, his tie still knotted at his throat, his collar tight despite the sweltering heat.

But surely his blood was boiling as the next speaker strutted up the podium to a chorus of cheers and whistles.

Senator Jimmy Walker.

Locking eyes with Zukor, Walker called a spade a spade. Famous Players' acquisition of theaters, he said, amounted to a "trustification" of the industry. Walker spoke of "powerful Wall Street interests" that were "exerting pressure on banks not to advance any loans to independent producers." Struggling young filmmakers, he charged, fired with the same dreams that had once propelled Zukor forward, were now being denied the same opportunities the Famous Players chief once enjoyed. And even if some young filmmaker could find the financing to make a movie, Walker asked, "Where will this man show his picture—up the alley?"

Don Osborn would have applauded.

Zukor's corporate greed was hurting real people, Walker declared. Poor Mrs. Pauline Dodge, the mother of a three-year-old son, had watched as her little theater in Morrisville, Vermont, was stolen right out from under her by Famous Players agents. Behind on her mortgage payments, Mrs. Dodge was elbowed aside by one of Zukor's "henchmen" who cajoled the bank into reverting the theater to its previous owner—who, of course, had a deal to turn it over to Famous Players.

"Don't forget, Mr. Zukor," Senator Walker said, speaking directly to the mogul, "that while you had your early struggles, Mrs. Dodge is having hers now."

The men roared in defense of the little lady from Vermont.

Zukor burned in his seat, but he gave no indication of his ire. These exhibitors were certainly a coarse lot. They'd been waiting a long time for this moment, to confront him face-to-face. Ill-bred boors. And Democrats, which to Zukor was often the same thing. Uneducated, illiterate Irish, Italians, Poles, and Greeks. Worst of all, to Zukor, were the lower-class Jews, the kind to whom he felt no kinship. Some Jews, Zukor believed, "were not very well liked because their behavior wasn't such that people could admire." As the raspberries and catcalls flew all around him, Zukor saw multiple examples of such loathsome behavior.

Still, he'd given his word to be there. He had appeared at the exhibitors' New York gathering a few weeks earlier to tell them he resented

being called "a liar and a crook." He'd spent the best years of his life in this business, he said, and "I have my reputation at stake." So he had agreed to come here to Minneapolis and submit himself to their abuse. No one could ever say Adolph Zukor ducked a fight.

It was about much more than that, however.

The old proverb "It never rains but it pours" was especially true that summer of 1921. Exhibitor agitation, the lingering effects of the recession, and the scandal of Nathan Tufts and Mishawum Manor were all bad enough. But potentially worse than any of that was Zukor's greatest worry, which seemed at last to be at hand.

The Federal Trade Commission was considering action against Famous Players. The repeated use of the word *trust* by Jimmy Walker and Sydney Cohen had finally reached the ears of Washington.

Zukor, of course, resisted any idea that he was in violation of the Sherman Antitrust Act, that Wilson-era law prohibiting restraint of trade. Famous Players wasn't restraining anybody's trade, its chief insisted haughtily. The company was simply a superior competitor. Yet the FTC apparently disagreed, as rumors spread that an investigation was imminent.

Zukor quickly placed a call to Washington.

A short time later George B. Christian, President Harding's private secretary, summoned the head of the trade commission, Houston Thompson, to a meeting at the White House. "I understand you have issued a complaint against the Famous Players Corporation," Christian said. "What do you mean by issuing a complaint without giving these people a hearing?"

Thompson replied that the commission had not yet issued a complaint, but acknowledged that one was under consideration. Without asking him directly to halt the investigation, Christian made sure Thompson understood that the president was not pleased with this situation. "This case will never go through," Thompson believed Christian was telling him.

Zukor could only hope that pressure from the White House would deter the Federal Trade Commission from pressing on with its complaint. But there were ways he could maybe help bring about that out-

come himself. Some very public overtures to the exhibitors would be extremely prudent at this juncture. That, more than anything else, was why Zukor had come to Minneapolis.

And so the little movie chief stood when his name was called and made his way to the podium past all the staring eyes and hardened faces.

He opened with a grand gesture. He would write a check, right there at the convention, to pay poor Mrs. Dodge a fair rate for her theater as well as to cover all her legal expenses. Henceforth, Zukor promised, he would "protect the exhibitor from the sort of treatment" Mrs. Dodge had endured at the hands of those ruffians.

A smattering of surprised, suspicious applause followed his words.

But then Zukor narrowed his canny eyes and lowered his voice. The exhibitors should not, he cautioned, pit themselves against him. The only way to proceed, Zukor asserted, was through cooperation. He pledged to do his part. Would they do the same?

The room was mostly silent as Creepy returned to his seat.

What did he mean by that? How would Zukor cooperate with them? He hadn't promised to do away with block-booking. There were so many other issues, from tariffs to unfair acquisitions, that he hadn't addressed. The exhibitors started to grumble. Zukor wasn't looking for cooperation, they murmured among themselves. He was hoping for capitulation.

Some of the speakers who took the podium after Zukor said his word wasn't good with them. There was talk of forming an exhibitors-producers alliance led by Lewis Selznick to oppose Famous Players. Listening to this, the film chief seethed. Why had these oafs insisted he come to their damn convention if they had no intention of working with him? If all they intended to do was continue to oppose him?

Zukor had had enough. Early on the morning of June 29, he walked out. Since he had not been "accorded convention courtesies," he instructed a spokesman "to tell President Sydney S. Cohen what he thought about it." He took the train back to New York.

Marcus Loew sat in his seat on the convention floor, his chin in his hand.

He wasn't smiling anymore. The laughter and backslapping had ceased, and Loew was stewing over the way Zukor had been treated. Watching his former partner hold his own against that hostile crowd, standing up to those jeering exhibitors, his head barely clearing the podium, Loew had felt a wave of sympathy for Zukor. They'd been through so much together. Zukor might be cutthroat, driven largely by self-interest. But he'd also done more to create this industry than anyone else, and he deserved respect for that at least. Loew, who saw the good in people before he saw anything bad, wasn't thinking about how Zukor's appearance in Minneapolis might benefit him in the eyes of the Federal Trade Commission. Instead, he simply saw the fact that the Famous Players chief had had the courage and the decency to meet the exhibitors on their own turf, that he had walked into the lion's den with his chin held high.

Risking the backlash of the exhibitors whose support he needed to retain, Loew strode up to the podium himself and asked for a chance to speak.

"It took a damned big man to apologize as Zukor has done," he told the crowd. If Zukor came here asking for cooperation, then they should take him at his word, Loew insisted. They could work with Zukor if they talked to him "in the proper vein." To provoke him further, Loew cautioned his fellow theater owners, would only make him fight back harder.

Much of the crowd muttered and groaned as Loew tried to defend the man they all loved to hate. A few, however, were won over by his appeal. Jimmy Walker, of all people, admitted he'd felt some grudging admiration watching "that little man" move through a roomful of irate exhibitors, who shouted "cruelly unkind things" at him as if they were tossing rotten fruit.

When Zukor learned of Loew's defense of him, he was surprised. In a similar circumstance, it was hard to imagine Zukor rising to plead for Loew. But that was the sort of man Marcus Loew was. He might do his best to beat Zukor in the height of his skyscraper or in the number of theaters he owned. He might buy a house right next door to Zukor's country estate, just to stay in competition with him. But then he'd turn around and do something like this.

"Business has nothing on me once I go home at night," Loew told

Zukor at one point, lugging over a basket of cucumbers he'd grown himself to Zukor's country house, sitting with his old rival on the front porch and sharing a cigar.

Zukor looked over at him with a bewildered expression. What did he mean about not bringing business home with you? To Zukor, Loew seemed to be speaking a foreign language he didn't understand.

Yet Loew was right about one thing. He understood Zukor better than anybody, and he knew just how hard his competitior would fight. Backed into a corner by the triple threats of Nathan Tufts, the FTC, and the exhibitors' campaign against him, Zukor would come back at them swinging. He had come too far, gained too much, to shy away from the battle now.

But his fight wasn't just about the money, or even the control, and this Loew understood as well. Yes, Zukor liked being rich, and yes, he intended to get a lot richer. It was true that Zukor was a megalomaniac and had no interest in sharing power with anyone. But the reason he fought went much deeper than that.

Nearly two decades earlier, Zukor had glimpsed the promise of the movies before anyone else. "There was nothing to the whole industry but terrible products in little doses [and] cheap methods," William Brady wrote. "No actor of any standing would have anything to do with celluloid. Zukor was about the only living human being who could guess what was going to happen."

Seeing beyond the five-minute quickie comedies that played on vaudeville bills in those days, Zukor envisioned longer, more complex narratives for films. He took the movies out of their makeshift store-front theaters and enshrined them in grand palaces of entertainment. More magnificent possibilities, he believed, were still to come.

Adolph Zukor loved the movies. They were part of his soul. They were the core of his past, and certainly of his future. Right now movies were silent and black and white, with piano accompaniment and oc-casional hand-tinted frames. What if someday they could be synchro-nized with music scores? What if they could be shot in color? What if movies could talk?

Right now, nearly every city and town in America had a movie

house, but Zukor dreamed of the day when every city and town around the world would have one too. What if movie theaters became more than just places to screen the latest releases? What if they got bigger and more elaborate? What if, someday, movies were taken as seriously as the legitimate stage, as an art form in their own right? What if movies could be, as some now imagined, brought into the homes, shown on screens or on devices not yet invented? What was the future of moving images? What forms might they take? How prevalent might they become in everyday life?

Zukor was eager to find out. He didn't think just about today, or even tomorrow. He imagined what things might be like ten, twenty, fifty, a hundred years in the future.

That was what set him apart from the others.

To some, Zukor's long eyes were ferocious and threatening. But the theatrical impresario Robert Grau thought the president of Famous Players had "the face and eyes of a dreamer." Both observations were correct.

That was why, in the end, Marcus Loew expected that Zukor would prevail.

# DEPRAVITY

Pretty little Rae Osborn had no idea where her husband Don was getting all his money. He hadn't worked in months. But suddenly Don was wearing new suits and drinking high-grade contraband booze. And his niece Rose Putnam flaunted some very fancy new dresses when she came around, which was practically every day.

Still naive after three years in Hollywood, Rae was terribly confused. Every morning when she left for her job as a stenographer, her husband would still be sound asleep. Rae would type letters all day, then dance all night at the burlesque theater. When she finally staggered home well after midnight, she'd find Don stinking drunk with Rose, or Gibby Gibson, or Blackie Madsen. Often Madsen brought along his much younger common-law wife, the dope fiend May Ryan. Retreating to her bedroom, Rae would cry herself to sleep. If she ventured out to the kitchen, she'd have to hold her breath not to inhale all the opium being passed around by crazy-eyed May.

Rae thought she couldn't get any unhappier. She was wrong.

Late one sultry evening in the early summer of 1921, she stepped off the trolley and trudged back to the little house on South Bronson Avenue. Even before she reached the door she could smell the cigarette smoke wafting from the windows and hear the honky-tonk music playing on the old Victrola. Rae braced herself and stepped inside. As usual, Don was sitting with some friends, soused. Perched close to Don's side was Rose—too close, Rae thought.

"I went on to bed," Rae would later reveal, "and let them go on with their party."

Around three o'clock she woke up with a start.

Rae looked around. The house was very quiet. Her husband was not beside her. Rae tiptoed out of bed and peered from her bedroom door. She had a clear view across the hall into the second bedroom.

What she saw sickened her.

Osborn and his niece Rose were naked in bed together, in each other's arms.

Rae screamed. Her husband bolted out of bed and ran toward her, "making all sorts of excuses." Somehow he was able to mollify Rae, and returned to bed with her. But in the morning Rae still felt sick to her stomach. Although she managed to drag herself off to work at nine o'clock, two hours later she became violently ill and returned home.

She found Don and Rose back in bed together.

Ever since she first arrived in Hollywood, when she was just eighteen, Rae had been devoted to Don. Without Don, Rae feared she'd be nothing. Where would she go in this terrible town? She had tried walking out on Don before—she had even tried taking her own life—but each time she failed. Each attempt to leave him left her feeling worse without him than she had with him. Rae was trapped.

Even in the face of her husband's depravity, Rae couldn't walk away.

A few nights after finding Don and Rose together, Rae came home from the burlesque theater, desperate to find a way to make the marriage work. But Osborn had other ideas.

He met her at the door with a gun. Swinging the weapon around in the air, he ordered his terrified wife out of the house.

Rae ran to the police, but they escorted her right back to Osborn. A wife shouldn't walk out on her husband, the police counseled. Had she disobeyed him in some way?

Rae was horrified. Was every man in Los Angeles insane?

In utter terror she passed the night. Although the police had promised to keep watch on the house, Rae was convinced that Don would

burst into the room at any moment and shoot her dead for what she had witnessed between him and Rose.

But as terrifying as the night was, it proved an epiphany.

In the morning, Rae packed her things and finally bid Osborn good-bye.

Osborn raged.

Rae had walked out on him. No woman walked out on Don Osborn.

Worse, Rae had something on him. That Osborn couldn't abide. In a divorce suit, she could destroy him with what she knew. So the only answer was to get something on Rae as well.

Osborn found the hotel where his wife was staying. With Blackie Madsen posing as his father, he took the room across from Rae's.

If his foolish little wife thought she'd escaped him, she was mistaken.

No one got away from Don Osborn.

# QUESTIONS OF LOYALTY

Just back from a trip to London, refreshed and relaxed, William Desmond Taylor opened the door to the garage at Alvarado Court and stared in horror at his cherished car.

The McFarlan was a wreck. Its front end was smashed in, its windows shattered.

Taylor grinned, that strange way he had of expressing anger. Then he went looking for Earl Tiffany, demanding answers. The chauffeur told him that Edward Sands had run amok while Taylor was abroad. He had smashed the car and then taken off.

Taylor decided to check the house for other damages. In his room, he discovered that seven of his custom suits were missing. Downstairs at his desk, he opened the bank statement that had arrived in the mail and found inside a canceled check for $4,500—a check he hadn't written. Turning the check over, Taylor saw that Sands had forged his name. More evidence of the valet's perfidy lay on the desk: twenty checks on which Sands had practiced signing his employer's name, each attempt a little better than the last.

Taylor stepped into the telephone nook under the stairs and rang the police.

A short time later, Detectives E. R. Cato and William Cahill arrived in their big black police car. After looking around, they issued a felony warrant for the arrest of Edward Sands.

But Taylor doubted the rogue would ever be found.

A fortnight later, he fired Earl Tiffany. The chauffeur had done nothing to stop Sands's spree, and besides, he was threatening now to keep a diary of where he went and what he did for the director. A man with as many secrets as Taylor was not keen on his chauffeur keeping a diary.

Now Taylor had two posts to fill.

A new chauffeur proved easy to obtain. Harry Fellows had been dependable and discreet, so Taylor tapped his younger brother Howard to take over the job. A trustworthy valet, however, was going to take a while longer to find, since this time Taylor would make sure to check references.

In the meantime, he had other matters to attend to.

In a name, Mary.

The heartbroken nineteen-year-old weighed heavily on Taylor's conscience. For so long, he'd kept Mary at arm's length—for her own good, the director believed. But her entreaties had finally worn him down. When Mary arrived back in Los Angeles after her own trip abroad, she'd reached out yet again, asking to see him. This time Taylor agreed.

He was trying to be magnanimous. But he was playing with fire.

Mary's spirits leaped. This was what she'd been waiting for. She fixed her hair and wore her prettiest dress. How fortunate that Shelby had been delayed in Chicago. If her horrible mother were home, Mary would never have been able to enjoy this reunion with her one true love. When Mr. Taylor arrived, he had flowers for her. And, Mary believed, "a lovelight in his eyes that told me his affection for me had not diminished during my absence."

Taylor's attempt at kindness accomplished the exact opposite of his intention. Instead of healing Mary's broken heart, he only welded it more securely to his own. After that meeting, the lovesick little actress came by Taylor's house several more times. He tried to be patient with her. But he knew he'd soon have to set limits again, even as he dreaded the scene it would cause.

He was saved from such an ordeal by the return of Charlotte Shelby,

who once again laid down the law and forbade her daughter ever to see the director again.

And if that old lech Taylor ever came near her delicate little cash cow again, Shelby told Mary, she'd kill him.

That summer, without a valet, Taylor was a very solitary man.

His neighbors noticed him returning from the studio at night, walking through the courtyard so elegantly, so ramrod straight, so carefully buttoned up in his tweeds and gabardines. A single light would go on when he entered his house, his silhouette flickering through the blinds as he sat down at his desk. There he would stay for hours at a time. Rarely did anyone stop by. Occasionally his scenic director from the studio, George Hopkins, visited. But his only other regular guest, Mabel Normand, was in New York that summer.

Such a private man, that William Desmond Taylor.

Late one August night, his neighbor across the courtyard, Neil J. Harrington, spotted movement around the director's bungalow. Watching carefully, Harrington discerned a figure peering into one of Taylor's windows. Whether Taylor was at home, Harrington wasn't sure, but he did think the behavior of the person lurking outside was odd.

Finally, Taylor found his new valet.

Henry Peavey wore bright-colored golf stockings and knickers that made Mabel laugh when she met him later that fall. "A funny colored boy with lots of mannerisms," she said of Taylor's new man. Yet despite being illiterate, Peavey possessed "the assurance of one accustomed to associate only with the 'best people,'" in the opinion of one observer. The valet had come highly recommended by Vivien Cabanne, the former wife of movie director Christy Cabanne. The two had known each other since they were both youngsters in Berkeley, California, where Vivien's mother, a seamstress, had made Peavey's first pair of long pants. After the Cabannes divorced, Vivien had brought her old friend Henry down to Los Angeles to work for her, a far better gig than Peavey's last job, traipsing around San Francisco as a messenger for the Corona

Typewriter Company. Perpetually smiling, Peavey seemed very grateful for this chance at a new life.

He was efficient, too, even if he lacked the military precision of Sands. But Taylor's new valet was honest. After everything Taylor had just been through, that made all the difference.

Still, he chose not to have Peavey live with him. With so many secrets stashed away in his closets and his drawers, Taylor figured it was better if his man arrived before breakfast and left after dinner. To compensate for the lack of room and board, Taylor paid his valet an additional $5 a week for rent on top of his $25 salary. Taking a room on East Third Street, Peavey rode the trolley every morning to report for work by seven thirty sharp.

It seemed like an arrangement that would last.

# A CLUSTER OF CALAMITIES

Marcus Loew, wearing a large boutonnière of roses and baby's breath, greeted guests as they entered the Ritz-Carlton ballroom as if he were the king of the movies. With his new skyscraper towering over Times Square, Loew seemed more puffed up than ever to Adolph Zukor. Kissing Lillian Gish and Norma Talmadge on the cheeks, Loew strutted through the ballroom with a huge smile on his face. Zukor fumed.

He'd come out tonight, September 7, 1921, for a private preview of Loew's production of Dumas's *Camille*, a modern, stylized adaptation starring Madame Alla Nazimova. The eccentric Russian diva, in extravagant furs and feathers, had flown out from the Coast to be there herself. At her side was her slinky-eyed, pomaded costar, the year's hottest new sensation, Rudolph Valentino, whose previous film, *The Four Horsemen of the Apocalypse*, was still raking in cash for Loew's Metro Pictures. The nascent producer stood there beaming, confident he had another smash hit on his hands with *Camille*.

Zukor fretted that once again, Loew was trying to do him one better.

Loew's business interests had become nearly as integrated as Zukor's. Buying up theaters left and right, Loew owned more than a hundred by now. "Unless Marcus Loew slows up in this business of acquiring theaters," wrote the *New York Times*, "some city, somewhere, some time, is going to achieve fame unique . . . as the only place without a Loew house." Now he was looking across the Atlantic as well, sending his son Arthur to England, France, Belgium, Sweden, Portugal, and Spain in a

couple of weeks, "in the interests of Metro Pictures." Naturally Zukor's daughter Mickey would accompany and assist him.

That summer, Loew seemed to be taking everything near and dear to Zukor.

At least the sneak preview of *Camille* was held at the Ritz, not Loew's new State Theatre, the opulent movie house at the base of his skyscraper. Like its proprietor, the State was gauche and flamboyant, with imported Sienna marble wainscoting and walls finished in walnut and gold leaf. Hundreds of goldfish swam in a giant reflecting pool in the lobby. Over it all, Loew ruled from his perch on the sixteenth floor.

That Zukor attended the *Camille* preview was a testament to his pride and resilience. As he had demonstrated in Minneapolis, he would not retreat into seclusion when things got tough—and these past several weeks had been the toughest of Zukor's movie career. In July the Tufts trial had gotten under way with an overflow crowd listening raptly as all the lurid details were exposed. "An orgy of drink and lust" was how one prosecutor described the night at Mishawum Manor. Dragging on through the summer, the trial had Christian reformers declaring that Zukor had been poisoned by "the greed of Gehazi and the sins of Sodom."

And if the film chief had hoped for a quick resolution once final arguments were made on August 11, he was disappointed when the five justices of the Supreme Judicial Court announced they would take their sweet time with the evidence. Now, with nearly a month gone by, there was still no verdict. Zukor dreaded the return of the headlines—and the snickering behind his back—once the decision was finally announced.

Yet as embarrassing as the trial in Boston had been, the end of the month brought an even worse calamity for Zukor. The Federal Trade Commission finally launched its attack.

As he took his seat to watch *Camille*, Zukor knew that everyone around him, despite their warm greetings in the lobby, was rooting for him to fail. Even those who held no personal animus against him were hoping this latest challenge to Zukor's supremacy would succeed—because if it did, they'd all have a much easier time of things.

Late in the day on Tuesday, August 30, Famous Players was officially cited by the FTC for violating antitrust laws. "As a result of conspiracies and combinations and through acquisition and affilia-

tion," the conscientious Houston Thompson declared, "the Famous Players–Lasky Corporation is now the largest concern in the motion picture industry." Much of the company's unchecked growth had been accomplished by "coercion and intimidation," Thompson charged. In short: Famous Players was a trust. And the job of the Federal Trade Commission was to break up trusts.

Thirty days. That was how long Zukor and his subsidiary companies were given to answer the complaint before hearings would be held and a trial date set. In public Zukor acted unworried, making light of stories that had him "gobbling up" the industry. "For dinner it seemed I started off with a theater or two," he said, "followed by a producing company, and ended with a few stars lured from other companies, served up with cream and sugar."

But back at the office, his lawyers were working day and night to come up with a defense that would keep their multimillion-dollar conglomeration together. If they failed, Zukor's dreams would have to be cut back, reconsidered. And cheapening his vision was something Zukor could never abide.

Yet for all that, as he filed out of the screening of Loew's *Camille*, Zukor was likely smiling.

One thing he'd learned in his nearly two decades in the film industry was just what made a good movie. He knew a hit the moment the rushes flashed on a screen. He could stand outside in the lobby, listening to an audience's reaction, and gauge how much money a picture would make. He could also sniff out a flop. Surely he knew that Madame Nazimova's pretentious film was doomed to be a financial disaster. As he offered his polite congratulations to Loew, a smug little smile must have played over Zukor's face, leaving his rival to worry.

The next day, that smile was still there. Reports from Wall Street were very good. The FTC announcement had come just as the markets were closing for Labor Day, and for the next three days Zukor had wondered how it would affect the company's stock. Much to his relief, when business resumed, prices remained unchanged. Zukor relished the *Variety* headline on his desk:

## FAMOUS PLAYERS UNSHAKEN BY GOV'T INVESTIGATION

"The general view was that the company would emerge victorious from any investigation by the Federal Trade Commission," the story reported.

Zukor's enemies could stick the corks back in their bottles of champagne.

But very different headlines were just a day away.

On the afternoon of September 10—exactly one year after the story of Olive Thomas's poisoning broke—another of Zukor's fears came true: one of his own stars was caught in a scandal.

## FATTY ARBUCKLE EXPLAINS DEATH OF MOVIE BEAUTY
### VIRGINIA RAPPE MYSTERIOUSLY STRICKEN
### AT PARTY GIVEN BY COMEDIAN

The next day's news was even worse. Arbuckle had been taken into custody by the police, wanted in connection with the young woman's death.

It seemed at every turn, whenever Zukor found some measured reason for optimism, he was forced to negotiate some new calamity. Over the past year, he and the industry had weathered suicides, drug use, prostitution, and graft. This time, however, it might be murder.

For the first time, Adolph Zukor had no idea what to do.

# A PRODUCT OF THE GUTTERS

As soon as she heard the news about Roscoe Arbuckle, Mabel Normand rang her old friend Mintrattie. That was the nickname she'd given Arbuckle's wife, Minta Durfee, back when they were all just kids, jumping out of cars and slipping on banana peels for Sennett's Keystone pictures. In those days, Mabel had nicknames for everybody. Arbuckle was Big Otto, after the elephant at the Selig Zoo in Lincoln Park. Roscoe hated being called Fatty, but he was fine with Mabel calling him Big Otto. He knew she said it with love.

By now, Big Otto and Mintrattie had separated, but they remained good friends. When Mabel got her on the phone, Durfee was preparing to head to San Francisco, where Roscoe was being held at the city jail as lawyers fought over his bail. Mabel told Mintrattie she knew Big Otto was innocent. Surely everyone would see that eventually.

But the world had changed since those carefree, prewar Keystone days, before Tinseltown had become a corporate behemoth. Certainly Mabel had changed. She was on her annual sojourn back East, once again staying at the Ritz. Nearly a year had passed since her rehab at Glen Springs. But the vulgar details of Roscoe's troubles, printed in all the newspapers, no doubt revived painful reminders of her old life. Booze, drugs, sex. A party that got out of control. Mabel knew the scene all too well.

But she also knew the charges against Arbuckle couldn't be true. The district attorney was claiming that Roscoe had raped and murdered

a starlet named Virginia Rappé—that his three-hundred-pound bulk had crushed the young woman when he forced himself upon her.

That was a lie, Mabel knew. Roscoe was far too gentle, too considerate, ever to hurt someone deliberately. Some believed that the case against Roscoe grew out of an attempt to extort some money from him or from Famous Players–Lasky. There were also rumors that Rappé had undergone an abortion shortly before the party, and that it was this procedure, not Arbuckle's weight, that had ruptured her bladder and led to the peritonitis that killed her.

Roscoe had thought they'd all just had too much to drink. He'd gone back home to Los Angeles after the party without a clew as to Rappé's true condition. Not until police showed up at his door did he even know that she had died. When he was told he was wanted on suspicion of murder, Arbuckle was bewildered. "And who do you suppose I killed?" he asked.

Watching her old pal torn apart in the press, Mabel was shattered. She and Roscoe had been babes in the business together. In those simpler times, costarring in a series of popular "Fatty and Mabel" comedy shorts, they'd thrown custard pies at each other, tumbled down flights of stairs, and gotten washed away by floods. Off camera, they would joyride through the Palm Springs desert and swim with the dolphins off Venice Beach. Now Roscoe was behind bars. His lawyers—led by the flashy Frank Dominguez, the same who'd gotten Margaret "Gibby" Gibson acquitted of prostitution four years earlier—were fighting to get him released on bail. But San Francisco district attorney Matthew Brady, who had his eye on the governorship, was fighting just as hard to keep Arbuckle incarcerated until his trial.

What was most unreal to Mabel—to all who knew Arbuckle—was how quickly the public turned on their former idol. Once as beloved as Santa Claus, the roly-poly comedian was now booed whenever he appeared on the screen. Petitions demanded that Adolph Zukor fire the rogue. In the public mind, Arbuckle had already been found guilty.

In Washington, DC, a black-robed figure looking like death itself approached a group of waiting reporters, a prepared statement fluttering in his skeletal hands. "A product of the gutters!" Brother Wilbur Crafts hissed. "A man who never rose above the gutters despite wealth and

success. Roscoe 'Fatty' Arbuckle should be hanged within ten days after his conviction!"

Sensing the opportunity, reformers wrung every drop of outrage they could from Rappé's death, hoping to use the scandal to spur the sort of regulations they'd nearly given up on achieving. "Picture the scene for yourself," Crafts raged. "Arbuckle, clad only in his night clothes, is kidding Miss Rappé. She doesn't seem to mind his attentions. The party gets wilder. More liquor is consumed. Jazz music fills the room. It's all just part of the immorality . . . typical of life in Hollywood."

Overnight, Arbuckle vanished from the screen. At the Manhattan Opera House, a rerelease of one of his shorts with Mabel, *Fatty and Mabel Adrift*, was scrapped at the last minute. When a title card announced that "in view of public feeling due to the San Francisco affair, it was deemed advisable to substitute another subject," the audience erupted in applause.

That broke Mabel's heart.

It also terrified her.

Because if they were gunning for Fatty today, she might be in their crosshairs tomorrow.

In the media firestorm surrounding Arbuckle's arrest, the big guns were out, trained on everyone in Hollywood. All their secrets were fair game.

Something had fundamentally shifted. The movies, once the nation's happy diversion, had become a scapegoat for those who were frightened by the changes rocking American society since the end of the war. Women were claiming social and sexual freedom. Divorce was on the rise, church attendance on the decline. The races were mingling, and the laboring classes were demanding better conditions and pay. Alarmed by a free-floating sense of moral decay, angry citizens swarmed town-hall meetings, gathered at statehouses, and picketed theaters. *The movies were to blame!*

Leading the charge, Brother Crafts called the Arbuckle affair "a fire bell to awaken the public to the need for reforms at which many have sneered."

The triumph in his voice was clear. Let Adolph Zukor try to stop censorship now, with all of Tinseltown's secrets being exposed.

With growing alarm, Mabel read the current issue of *Variety*. "There is a dope ring on the Coast beyond shadow of a question," the paper reported, having uncovered details of Tom Green's investigation some months earlier. "It is known that the wife of one of the most popular of the younger male stars has time and again had the peddlers of dope supplying her husband arrested, but she has been unable to get her husband to break his habit." The article practically spelled out Wallace Reid's name.

But Reid wasn't the only one *Variety* had targeted. "One young girl star," the article continued, "who spent several months in the east . . . took a cure and signed a contract to star again, only to fall back on the use of the 'stuff' and slip among the addicts."

Reading that, Mabel must have wept.

Because they were wrong. She was not an addict, not anymore. She had worked hard to stay clean. She had sweated and cursed and struggled and turned the relentless dealers away from her door. Billy was proud of her. But no one believed she was clean. The problem was that she was ill so often. The bloom of good health she'd enjoyed the previous winter had faded once she'd started work on *Molly O'*. Sennett thought "she photographed without her old-time sparkle and bounce." Mabel was off the hop, but her former lover knew that "all those years of neglecting herself, of fun for fun's sake and ice cream for breakfast . . . had left a mark."

Indeed, earlier that summer, Mabel's doctor had diagnosed her with pleurisy. For nine days she'd been sick in bed, sending forlorn telegrams to Billy in London. Four months later, she still wasn't entirely recovered. She was tired all the time. Hacking, coughing. Now that she was sober, why did she have to be sick? Besides diminishing her sparkle, her ill health convinced people that she was still using.

It was brutally unfair, but Mabel no longer expected fairness. She had witnessed just how impersonal moviemaking had become, the way the lust for profits and control had crowded out everything else. Was this what happened to those with too much ambition, to those who set out to prove themselves in the big, wide world? Would the public always turn on its heroes once they got too big, too successful, too proud, too careless?

If so, Mabel might have been better off staying on Staten Island after all.

On the night of September 15, Mabel headed uptown to the Apollo Theater in Harlem for the New York premiere of Mary Pickford's *Little Lord Fauntleroy*. A gala crowd turned out: Norma and Constance Talmadge, Joe Schenck, Dorothy Gish, Marshall Neilan, Mae Murray, and Jack Pickford, among others. Douglas Fairbanks was also on hand to support his wife. But outside the theater, so many reporters shouted questions about Arbuckle that Mary was left rattled when she tried to give her welcoming speech. Bursting into tears over the continued assault on her beloved industry, she had to leave the theater by a rear exit.

If Mabel shed any tears that night, they were for Roscoe and for her friends and for herself. For the industry, she had shed her last tears long ago.

# RIDING FOR A FALL

Adolph Zukor had always prided himself on having it all figured out. He was never caught off guard. He had responded quickly and effectively to the exhibitors and their shenanigans. His lawyers had been prepared for Nathan Tufts. He'd even been one up on the FTC, having his own moles in the Harding administration.

But this new battlefront was something altogether different.

Gigantic black headlines stared up at him.

### Scandal Hits Industry
### Worldwide Condemnation of Pictures

Oh, how Zukor despised Roscoe Arbuckle.

He'd resented Fatty ever since he'd hired him for Famous Players a few years back. Arbuckle had demanded an obscene salary: $3,500 per week, plus 25 percent of the profits from his pictures, which he split with his producer-manager, Joseph Schenck. To make matters worse, Arbuckle spurned the kind of personal publicity Zukor felt was necessary to sell pictures properly. The movie chief had wanted his star to visit theaters showing his film *Gasoline Gus* over Labor Day weekend, but Arbuckle had refused. He'd had other plans.

A certain party in San Francisco.

Zukor could have throttled him.

Scandal was always arriving at the least opportune moment. Although business had started to improve in the last few months, finan-

cial conditions remained fragile, and something like the Arbuckle brou-
haha could easily destroy all the gains they'd made. "At this time, when
business in the theaters is not too good," *Variety* opined, "the attacks
against the picture industry delivered by the various churches may hurt
the box offices everywhere, with the exception of possibly the big cen-
ters."

*May hurt the box offices everywhere.*

In the foulest of moods, Zukor rode the elevator to the ground floor
and stormed out onto Fifth Avenue.

Immediately reporters pounced. Flashcubes popped. "No com-
ment," Zukor snapped when asked about Arbuckle. So far he'd said
nothing about the scandal, and he intended to keep it that way. But
the newsmen kept shouting after him. There was a report out of Los
Angeles that Sid Grauman had yanked *Gasoline Gus* from his Million
Dollar Theatre and canceled all outstanding contracts for Arbuckle
films. Was it true?

Hurrying into the backseat of his waiting car, Zukor said nothing.
But the report was true. Despite the fact that Famous Players controlled
Grauman's theaters, the exhibitor had bowed to public sentiment and
banned all Arbuckle pictures from his screen. Grauman had no other
choice, and Zukor knew it. "To have shown them," the film chief said,
"might have resulted in riots. At best the outcry would be so great as to
damage the whole industry."

From across the country, he was hearing the same thing. Theater
owners told horror stories of church ladies and civic reformers, many
brandishing crucifixes as if to ward off vampires, barging into their
offices and demanding they never again show Arbuckle's films. Other-
wise, they promised, they'd be back—with placards and bullhorns and
photographers. One by one, theater owners in cities from coast to coast
backed out of their agreements to show Arbuckle's films. Portland,
Maine. Providence, Rhode Island. Buffalo. Detroit. Chicago. And so
Zukor kept the unreleased Arbuckle pictures in the vault, "at a loss of
roughly a million dollars."

Oh, how he cursed Fatty Arbuckle.

If not for these cans of unreleased Arbuckle films in the studio ware-
house, Zukor would have let the fat slob rot in jail.

But instead he hired Frank Dominguez, who'd handled a number of

cases for the film industry, to represent the troublesome star. Dominguez was costing Zukor big bucks, and every dollar spent was a stab to his heart. Even under the best conditions, Zukor hated spending money on actors. This was absolutely sickening. If by some miracle Arbuckle managed to get through this thing in one piece, Zukor vowed, he would have to repay every dime.

Such an outcome was still possible, Zukor knew, if unlikely. So far no charges had been filed against the comedian. District Attorney Brady wanted Arbuckle charged with murder, but Dominguez thought the evidence was so lacking that he'd ask the judge to dismiss the case altogether. Dominguez believed—everyone in the industry believed—that Arbuckle was innocent in the death of Virginia Rappé. But Zukor wasn't paying Dominguez to defend an innocent man. He was paying him to make the entire debacle go away.

Because on some deep level, Arbuckle's plight wasn't just about business for Zukor.

Very likely, it also tapped something very personal for the millionaire mogul, reminding him of a time when he, like Arbuckle, had been powerless, when he too had been innocent of a thing and unable to prove it.

At the age of fifteen, Adolph Zukor, dry-goods apprentice, pushed a broom across a dirty wooden floor. All he could think about was escape. If he stayed in Hungary, sweeping floors would be his lot for life. America was his only hope.

But how could he get there? He hadn't a single forint to his name.

Zukor's only hope was the Orphans Bureau. They might sponsor his emigration. After combing his hair and borrowing a pair of shoes, he walked the several miles to the bureau's office. There, seated on a stool in front of a superintendent, so small that his feet didn't reach the floor, looking far younger than his years, the young Adolph "poured his heart out," pleading for financial assistance.

But his passion only made the superintendent suspicious. Why was the boy so anxious to leave the country? He must have committed some crime, the superintendent concluded. He must be trying to avoid punishment by escaping to America.

Zukor was astounded when he heard the charge. It wasn't so! He did his best to persuade the doubting bureaucrat that he'd done nothing wrong. But the man was not convinced. If the superintendent denied his request to emigrate, Zukor's life would be ruined. He'd be left to rot in Hungary, forever consigned to menial tasks. That man held his life in his hands!

Back at the dry-goods store, Zukor explained what had happened to his employer, who came to his defense, contacting the bureau and assuring them that young Adolph's record was spotless. But until Zukor knew for sure what the bureau's answer would be, he worried. His dreams might have been extinguished right then and there.

They weren't, of course. The Orphans Bureau gave him the money. But if one man hadn't been willing to stand up for him, Adolph Zukor might never have made it to America.

Languishing in a jail cell in San Francisco, Roscoe Arbuckle was just as innocent as Zukor had been all those years ago, and surely Zukor knew it. But where Zukor's employer had saved the day for him, Arbuckle's was not so willing.

Because even if Arbuckle wasn't guilty of killing that girl, he wasn't exactly innocent. He had allowed himself to get caught with booze and women in compromising circumstances. How stupid could he be, especially after all the bad press following Olive Thomas's death?

Zukor seethed. Arbuckle had put his dreams in jeopardy. He had complicated the fight against censorship and compromised Famous Players' defense against the FTC. For such recklessness alone, he deserved to be punished.

But not on Felony Row. Even Zukor had to concede that. For all his misconduct, Arbuckle didn't deserve to hang.

And so he instructed Dominguez to do whatever he could to get the case dismissed.

In an aggressive public-relations campaign, the sharp attorney brilliantly co-opted the language of the reformers in the comedian's defense. "The Christian sentiment of this God-fearing nation," Dominguez wrote in a widely syndicated press release, "will not adjudge any

person guilty of an alleged crime until the same has been proven in the spirit of our Master, who said, 'Judge not lest ye be judged.'"

But the reformers weren't buying it. This was just more propaganda from the film industry, which had broken its word too many times to be trusted now.

On September 14, 1921, Arbuckle was charged with manslaughter. Brady had wanted murder, but he had to settle for this. Dominguez pressed on, fighting to have all charges dismissed. It was up to Judge Sylvain Lazarus to decide. On the day of the hearing, more than a hundred church ladies, outnumbering the men almost two to one, filed into the courtroom. When Arbuckle was brought in, the women hissed and jeered so much that Judge Lazarus ordered the defendant returned to his cell and kept there for his own safety.

The newspapers loved it.

## FATTY THREATENED BY MOB OF ANGRY WOMEN

On September 28, Judge Lazarus announced that he had made his decision. Reporters scrambled to the courthouse. In New York, Zukor sat waiting for Western Union to deliver a telegram with the news.

Lazarus took his seat. He looked out into the courtroom, at the faces of the defendant, his lawyers, the district attorney, and the church ladies. Finally he announced that enough evidence existed—"I may say barely enough"—to continue the case against Arbuckle.

A murmur rippled through the courtroom. The church ladies restrained themselves from applauding.

The judge had more to say. He saw the case in front of him broadly and emblematically. "We are not trying Roscoe Arbuckle alone," Judge Lazarus declared. "In a large sense, we are trying ourselves. We are trying present-day morals, our present-day social conditions, our present-day looseness of thought and lack of social balance."

Judge Lazarus was right.

This wasn't just one man on trial.

This was a conflict for the soul of the nation.

And the reformers were itching for the fight.

———

On October 1, in Boston, Nathan Tufts was finally found guilty of extortion and expelled from office by the state supreme court. The national press, caught up in other scandals, barely noticed. Zukor could take comfort that one nightmare, at least, was finally over. The only one crowing over Tufts was, not surprisingly, Brother Crafts, who conflated "that famous party in Boston" with Arbuckle's troubles. "No one was killed in that party," Crafts preached to his followers, "but there was adultery and the sale of liquor. What is the difference morally? None!"

Zukor and Arbuckle, equally culpable? Crafts was obviously playing to the balcony, but the suggestion cut a little too close to home for Zukor, who was increasingly cloistered in his Fifth Avenue office.

Soon after Arbuckle's release on bail, Joe Schenck gave Zukor a letter he'd received from the troubled comedian. Zukor read the words scrawled in Arbuckle's slightly jumbled handwriting. "When something happens in half an hour that will change a man's whole life," Arbuckle wrote, "it's pretty tough especially when a person is absolutely innocent in deed, word or thought of any wrong."

Zukor had been there once. He knew.

"Tell Mr. Zukor," Arbuckle added, "before passing judgement, to remember the Boston party. He knows what a shakedown is." Of course, there was one difference: Zukor actually *was* guilty in the Boston scandal. "When it is over," Arbuckle concluded, "I have got the guts to come back and I will come back and make good." He vowed that Zukor would see his investment repaid.

But Zukor had already given up on that investment. He didn't want Arbuckle to come back. He wasn't paying the lawyers for an acquittal. Once they'd failed to get the case dismissed, Zukor's best hope was that the comedian would be found guilty. With church and civic organizations crying for his blood, riots would surely follow if Arbuckle were exonerated. Better the comedian should pay for his reckless behavior and save them all from ruin. Better one man sacrificed than the entire industry.

At least, under a manslaughter conviction, Arbuckle wouldn't hang.

Zukor felt no regret over the episode. As always, he was able to side-step introspection and self-reflection. "A man is kept busy wrestling

current matters and plotting the future without reliving the past," he was known to say.

Still, there must have been nights, in the darkness and the solitude, with only Lottie beside him, when Zukor remembered a young boy back in Hungary, whose dreams—whose entire life—had hinged on an accusation of a crime he did not commit.

# BAD CHECKS

Going home is never easy, and for Gibby Gibson it must have been especially difficult. But as she stepped off the train onto the wind-swept Colorado plateau, her hopes were high. Looking around at the landscape of her childhood, she saw those cold purple peaks enclosing the valley. Once upon a time those mountains had seemed like a barrier—an impervious wall that kept Gibby from her dreams. But she had broken through, and now she had returned to make good with a new plan for success.

Gibby always had a new plan.

This one came courtesy of independent producer Charles Seeling, who had hired her for a western; Gibby's equestrian skills continued to serve her well. They were both determined that the picture they'd come to Colorado to make, *Across the Border*, would break through the domination of the big chains and bring theater owners running to them. Seeling was optimistic that a government-mandated breakup of Famous Players–Lasky was imminent. When that blessed event occurred, he and other independent producers would have hundreds of previously off-limits screens available for showing their pictures. Then, he and Gibby were convinced, the cash would come pouring in.

She had to believe it would happen. Otherwise, how could she go on?

And so, as always, Gibby threw herself into making the film, playing the feisty heroine opposite Guinn "Big Boy" Williams. Wouldn't it be wonderfully ironic to grab success on the same roads where she had first promised her mother those nice things?

Shooting lasted about a week. Then the company trekked back to Los Angeles . . . where the film they'd all worked so hard on sat tightly spooled in its tin can, waiting for Seeling's state's rights distributor to find a theater, any theater, to show it.

Weeks passed. Then months. As 1921 drew to a close, *Across the Border* had not been screened anywhere. Seeling was advertising the picture in the trades, but the number of independent theaters was dwindling, and there were no takers for his film.

Another plan gone bust.

Gibby despaired. It was a low period for her and her friends. One week they'd be flush with cash from their bunco schemes, the next they'd be broke. Sometimes the dry spells went on for months. Don Osborn had given up trying to mount an independent feature, having failed at the same quixotic mission as Seeling. Now he laughed at Gibby's determination, her naiveté in thinking she could still make it on the level. Didn't she understand that the only reliable cash came from the unsuspecting patsies who fell for their con jobs and blackmail schemes?

Gibby wasn't averse to taking cash where she could get it. But she refused to give up on her dreams, despite all her setbacks, even if Osborn had.

She sat in the backseat of Osborn's car, no doubt still gloomy over her failed attempt with *Across the Border*. But Gibby wasn't so depressed that she would turn down an invitation to a party. Sometime late in 1921, a carful of locusts headed out to the desert town of Blythe. Of course Osborn's niece Rose came along; she was never far from Don's side. Also on board were George Weh and a new acquaintance, a handsome Scottish-born actor named James Bryson.

Gibby probably had no designs on Bryson—he was a struggling actor without a bank account or any connections—but even if she did, she would have quickly noticed the way the Scotsman kept looking over at Rose. Osborn noticed the flirtation as well. He wasn't pleased.

Exactly what kind of hold his niece had over Osborn wasn't yet clear to Gibby, but it was plain as day that when Bryson started flirting with Rose, Osborn seethed.

After returning from their trip to Blythe, Osborn brooded. He'd seen the way Bryson and Rose had made eyes at each other all weekend, and he'd hated watching as Bryson drove her back out to Pasadena, where they were both staying at Osborn's mother's place. But he'd become even more steamed when he heard from his mother that the two had never showed up. Where had those double-crossers gone?

From George Weh he learned that Bryson and Rose had spent the night together at the Cadillac Hotel in Venice Beach. Osborn raged.

What a fool he'd been to let Bryson into his group of friends. The Scotsman had seemed like a good fellow, an actor hoping for a break but running out of ideas. They were all in the same boat. Bryson had even picked up one of Osborn's tricks: writing bad checks. Osborn had seen Bryson cash a check for $10 at the Yule Café, without any funds to back it up.

Speeding across town toward the Cadillac Hotel, he remembered this little bit of information. Osborn knew an awful lot about Bryson. About Rose, too.

Didn't they know what he was capable of? Surely they remembered how thoroughly he had destroyed his wife, Rae, during their divorce proceedings. Before Rae had had a chance to expose his affair with his niece, Osborn had staked out her hotel room and claimed he'd witnessed several men going in and out. Rae was devastated by the "dirty filthy evidence," but Osborn's charges shut her up.

Bryson and Rose must have known he'd do even worse to them if they resisted him.

Bounding up the stairs of the hotel, Osborn forced his way inside Bryson's room. When he saw Rose there, he threw a fit. But he was too late, Bryson told him. They were leaving for San Diego to get married.

Osborn exploded. He was through helping the both of them, he declared; they'd better get their belongings out of his mother's house immediately, or he'd destroy everything.

Rose and Bryson made haste for Pasadena.

Osborn, suddenly calm, headed in the other direction.

His car pulled in at the central police station downtown. With detailed precision, he told the cops where they could find a certain man who'd defrauded the Yule Café with a bad check.

A short time later in Pasadena, Mrs. Osborn peered out of her win-

dow. Police cars were surrounding her house. Officers came banging on the door, and Jim Bryson was arrested.

His San Diego wedding would have to wait.

Not long afterward, a contrite Rose Putnam showed up at Osborn's door. She had finally realized she could never live without him. Could he ever forgive her?

Still obsessed with the dark, beautiful woman standing before him, Osborn wrapped his arms around her and took her back.

Rose was beautiful, no question. But the sheer wickedness of their relationship was probably what really entranced Osborn. He was a man who thrived on breaking rules. He was aroused by deviance. Rose's dark eyes—eyes passed down from his sister—electrified him.

From now on, Osborn vowed, he'd make no secret of his love for his niece, however taboo the rest of the world might think it was. They would live together as man and wife.

And he knew just the person who could provide the roof over their heads.

Osborn paid a call on Gibby. He inquired about the properties she owned on Beachwood Drive, explaining that he and Rose needed a place to live. He also admitted the truth of their relationship. Would Gibby be able to countenance them as tenants?

It wasn't even a question. Gibby was broke again. For a steady $30 a month, she could countenance anything.

# THE HIGHEST POSSIBLE STANDARDS

In the nation's capital, Will H. Hays was dictating a letter to Adolph Zukor regarding a matter of "magnitude and importance." His hands moved as he spoke, fluttering like scrawny birds. He told his secretary to type "Confidential" across the top of the letter and then underline it.

It was Monday, December 12, 1921. Late the previous week, Postmaster General Hays had received a joint letter from the various film chiefs, asking him to head up a reorganization of the National Association of the Motion Picture Industry. And Hays, much to their delight, was interested.

The letter from the ten film executives—Adolph Zukor first on the list, of course—had been written on December 2, the day Roscoe Arbuckle's case had gone to the jury. Forty-eight hours later, the jury had returned deadlocked, ten to two for acquittal. Two stubborn holdouts had kept the nightmare alive. Arbuckle would have to endure a second trial.

So would the film industry. More than ever, its chiefs needed help. And so they had turned to Will Hays.

"We realize that in order to insure that we will have proper contact with the general public and to retain its confidence," the studio bosses had written, "it will be necessary to obtain the service of one who has already, by his outstanding achievements, won the confidence of the people of this country." That person, they said, was Hays.

Though Lewis Selznick had hand-delivered the letter, Hays knew where the real power in the industry rested, and he addressed his re-

sponse directly to Zukor. The two men had been in touch frequently over the past year, and Hays recalled "the pleasant talks" they'd had "on the whole subject matter of the industry." Whether he accepted the job depended, in large part, on whether Hays felt he could work with Zukor.

Both were small men who had achieved big things. At barely one hundred pounds, Hays was even smaller than Zukor—a slender reed of a man who might be knocked over by the slightest breeze. "You could put him in the pocket of Bill Brady's greatcoat," the *Film Daily* quipped, referencing the man they hoped he would replace—William Brady, the bombastic impresario who headed up the NAMPI.

In visual terms, Hays was a rather comic figure. Sitting behind his desk, the postmaster general looked a bit like a hand puppet, with slightly uneven jug ears and a mouthful of crooked teeth. And yet he was always smiling. Unlike Zukor, there was nothing creepy about Will Hays. He was forthright and plainspoken, a rarity in Washington.

Much of what he had accomplished in his year as postmaster general, Hays would admit, "added up to public relations." He'd spent his time in office crisscrossing the country, appearing at trade conventions, professional gatherings, and women's club meetings, shaking hands and giving speeches. He was a politician, after all, and he'd just run one of the most effective political campaigns in American history, getting Warren Harding elected to the White House. Hays's success at the post office was due in large part to how forcefully he had sold that success to those around him. He'd brought people in, made them feel a part of the process, and convinced them that they had a say in his decisions—even if it wasn't always true.

That was precisely why the movie men wanted him.

And they were proposing to pay him $100,000 a year.

The idea appealed to Hays—"as it must appeal to any man who realizes the ever increasingly important place which the screen will occupy in our advancing civilization," he wrote to Zukor. Or at least to any man who realized how comfortably he could live on a hundred grand a year. Hays promised Zukor that he would give the matter his full consideration and "let you know as soon as possible."

In a postscript, he added that he knew "how thorough" Zukor's cooperation would be if he took the job. But Hays was savvy enough to

know that what the mogul was offering him was less likely to be cooperation than a struggle for control.

Zukor read Hays's letter with great interest.

"I want carefully to consider how much good I can do, how much service I can be to you and to the others," Hays wrote. *And to the others.* No doubt that phrase made Zukor wary.

The postmaster general was not his man. That sneaky independent Lewis Selznick had proposed inviting him. But the Arbuckle situation demanded an immediate solution, so Zukor had little choice but to go along with the letter to Hays. He had nothing personally against him; they'd worked together in the past. But Zukor might have preferred a candidate of his own choosing. Herbert Hoover, for instance, who as secretary of commerce had been an enthusiastic booster of Zukor's interests overseas. Yet Zukor's Wall Street angels had nixed the secretary as too independent. They preferred Senator Hiram Johnson of California, but the public wasn't likely to trust someone whose constituents were the dissolute citizens of Hollywood.

So Hays it would have to be. If he said yes, that was that.

Zukor agreed that they needed to replace the NAMPI with a new organization. The association had lost much of its clout when it had failed to stop censorship from passing in New York. Besides, the trade association was irrevocably linked to Brady, its longtime president and an avid Democrat. With the new administration in Washington, what they needed was an influential Republican. In that sense, Hays was ideal.

And setting up its own supervisory body might be the only way the industry could forestall outside jurisdiction. The time had passed when smoke and mirrors could stave off regulation. No longer could Zukor get away with the kind of stunt he'd pulled on Wilbur Crafts with Lasky's fourteen points. As the Arbuckle crisis worsened, the obvious parallel was with major-league baseball, which had responded to the Chicago Black Sox gambling scandal in 1919 by hiring the esteemed judge Kenesaw Mountain Landis as the sport's first commissioner. Likewise, the movie industry needed someone equally unimpeachable as a figurehead—someone the church ladies would trust.

Once again, Will Hays fit the bill. Not only was he a respected cabinet member and adviser to the president but also an esteemed elder in the Presbyterian church. His family stretched back generations in this country, all the way back to the ships that had brought them over from England and Scotland in the eighteenth century.

In other words, Hays wasn't Jewish.

That mattered to the increasingly emboldened reformers. "Word comes from Los Angeles of the almost complete submergence of moviedom into the hands of Jews," read the diatribe of automaker (and notorious anti-Semite) Henry Ford in his widely circulated newspaper, the *Dearborn Independent*. Ford placed the Arbuckle scandal firmly at the feet of the Jews. Joseph Schenck and Marcus Loew, he said, were "two Jewish gentlemen who naively assert that the comedian must be innocent because he means a lot of money to them." But the worst Jews in Ford's opinion were those "in charge of the destinies of the Famous Players–Lasky Corporation, which is accused of being a motion picture trust." Zukor and Lasky had promised reform, Ford wrote, but they hadn't delivered; now, "lacking the courage to write off their losses and publicly proclaim that they have no further use for men of Arbuckle's caliber," they were trying to hedge their bets, leaving themselves the option of rehiring their former star if he was acquitted in a second trial.

Zukor knew that bringing on Hays wouldn't completely silence bigots like Ford, but it would deprive them of one of their most potent, and loathsome, rallying cries. The leader of the movies would no longer be a Jewish infidel, but a Christian elder.

At least, Zukor would let them think as much.

He was confident that the postmaster general shared his view on the issue of censorship. Hays had spoken about the subject in the past. "I have always believed that the principle of self-regulation, in contrast with regulation from without, will take firm root if given a chance," Hays declared. "Self-regulation educates and strengthens those who practice it." What surely gave Zukor some comfort was the knowledge that Hays was as much of a believer in the market as he was. "Box office receipts," Hays argued, "are the surest way of interpreting the mind of the public."

Just where Hays stood on other sorts of regulation, however, was not entirely clear. What was his opinion of the Federal Trade Commission? After

all, Hays had gotten his start with the trust-busting Teddy Roosevelt and considered himself a progressive Republican, not shy about his support for organized labor. While Zukor, too, had once been gung-ho on Roosevelt, a decade had passed since then, and now he was casting his lot with Harding's more hard-line Republicans—the "standpats," as they were called. What would Hays consider "unfair trade"? Would he side with Zukor, or with his smaller competitors?

That one phrase in Hays's letter—*and to the others*—surely left Zukor wondering.

Looking out his train window across the snow-covered farmland of New Jersey, Will Hays was happy to be getting away from Washington. He was heading to a friend's home in Yonkers, New York, to retreat from the world and think over his prospects.

Certainly the salary the movie chiefs had offered him was astounding—four or five times greater than what he was getting from Uncle Sam. How could he turn that down? He had no personal family fortune. But he did have a five-year-old son and a wife who was in and out of hospitals. At the moment, Helen Hays was in the St. Luke's sanitarium in Chicago. The doctors didn't know what was wrong with her. No doctors ever did.

Still, Hays was humble enough to care about what people might say. "I knew that if I accepted the offer I would be criticized for yielding to a mercenary object and renouncing, as it were, dignity for gain," he wrote, "as if being Postmaster General were something priestly, consecrated by vows which a man might not forsake with self-respect."

Even if he took the job, would the pressures he'd face as movie czar be worth the money?

He'd already gotten a glimpse of what his life might be like. When news of the film industry's offer leaked, a savvy reporter from the *New York World* got Zukor to admit that a plan was afoot to reorganize the national association. Although the film chief would neither confirm nor deny Hays's involvement—"We have decided nothing definite as yet"—his words were still enough to fire up presses all across the country.

Hays was overwhelmed by the attention. When he got to his friend's

house, he went directly to bed. For the next several days, he remained holed up in a darkened room, not even looking at the newspapers.

On December 18, he got out of bed and issued a statement. To quiet all the speculation, he said he still had not made up his mind. He worried that what he didn't know about motion pictures "would fill the *Encyclopedia Britannica.*"

But what worried him even more were the church ladies.

Hays was a deeply religious man. A faithful attendee at the little Presbyterian church in his hometown of Sullivan, Indiana, he often led the congregation in prayers and hymns. But he was not a reformer. "And precisely because I was not a reformer," he would recall, "I dreaded the blunders the reformers would make in dealing with this new and vital force" of the movies. Hays was thinking of Prohibition, "which had by no means produced the era of national sobriety its proponents had contemplated." He knew if he took the position that he'd been offered, he'd find himself head-to-head with the reformers—God-fearing Protestants like himself—who would surely call him a traitor to Christ.

Was he prepared for that? He wasn't at all sure.

Because, like everyone else, Will Hays had secrets.

The man who was being called to uphold the morals of Hollywood— the savior who would instill "the highest possible standards" in the industry—spent as little time with his sickly wife as possible. Not in many years had they lived together as a married couple. Indeed, Hays was sometimes spotted with other ladies in the nation's capital, some of them divorcées. Although it was highly unlikely that anything improper went on between Hays and these lady friends, the moralists would not be pleased by such goings-on. They would expect Mr. Hays and his wife to be together, side by side.

Washington had been a fiercely cutthroat working environment. But the private lives and peccadillos of politicians were generally ignored by the press. Not so in Tinseltown.

Before he decided to step into that morass, Will Hays would have to think long and hard.

CHAPTER 29

# ON EDGE

Sashaying through Mr. Taylor's house, Henry Peavey dusted end tables and straightened his employer's desk. The valet was enjoying his new job very much. He found Mr. Taylor to be an exceedingly fine man.

As the holidays approached, though, one thing concerned Peavey: Mr. Taylor's mood had considerably darkened. He was no longer quite as courtly or gracious when Peavey arrived in the morning. He seemed constantly anxious, jumping at the slightest noise.

Strangest of all, the house telephone kept ringing—and when Peavey answered, there was no response at the other end of the line. Mr. Taylor was extremely bothered by these calls.

Peavey wasn't the only one who noticed the director's sudden agitation. At the studio, screenwriter Julia Ivers also noticed the furrows in Taylor's brow. When Ivers asked what was troubling him, Taylor confided in her about the phone calls, which sometimes came in the middle of the night. He had "not the slightest idea" who was calling him "or what the purpose was," he said. To Ivers, Taylor seemed "annoyed and mystified."

At least part of his unease could be easily explained. On the night of December 4, Taylor had come home to find his house burglarized yet again. This time, the thief had taken some jewelry and his entire stock of expensive, imported, gold-tipped cigarettes. Everyone suspected Sands, since he'd robbed the place before. But no one could be absolutely sure.

One morning, as Peavey bent down to retrieve the newspaper and

the bottle of milk from the front steps, he noticed something else: a butt from one of those gold-tipped cigarettes. It hadn't been there the night before.

When Peavey showed his employer what he had found, Taylor confirmed that the cigarette was one of his. But he hadn't replenished his stock since the burglary.

The realization was chilling: whoever had burglarized his apartment two weeks earlier had returned—and stood right there, smoking a cigarette on the front steps, as Taylor slept upstairs.

There was more trouble afoot.

On Friday, December 23, Mary Miles Minter drove her little blue runabout downtown to do some Christmas shopping. At Hamburger's department store, she bought several gifts, including one for Mr. Taylor. He'd been on her mind even more than usual lately. She'd seen him at the Screen Writers Guild ball a few weeks earlier. Not to speak to, of course. He'd forbidden that. But Mary had watched him carefully all night, her pretty blue eyes riveted on him as he laughed and joked with Mabel Normand, who sat beside him at his table.

Mary sulked. Why did Mabel get to spend so much time with Mr. Taylor when she couldn't? What did Mabel have that Mary didn't?

Other men wanted her. Why didn't Mr. Taylor?

Thomas Dixon, reported to be the heir to the Dixon Ticonderoga lead pencil fortune, had asked her to marry him. "In a freak of despondency," Mary had agreed, though she didn't really consider them to be engaged and had more or less stopped seeing him soon afterward. And Marshall Neilan, one of the biggest directors in Hollywood, had popped the question, too, though he was certainly jesting. At least Mary thought he was.

But the point was: other men saw her as a woman. They weren't afraid to smile at her, flirt with her. If only Mary could get Mr. Taylor to put aside his concerns about age. And while he was at it, put aside George Hopkins and Mabel Normand as well.

That day in Hamburger's, however, she came to the realization that "it was over" between her and Mr. Taylor. Her dreams would never come true. It was a cruel fact, but Mary decided to do her

best to accept it. She was nineteen now. She had to move on with her life.

And then, just as the thought was crossing her mind, she looked up and saw him, standing across the aisle from her in the store.

Taylor had come downtown to buy a flask at Feagan's jewelry store. Given how keyed up he'd been the last few weeks, running into Mary in Hamburger's was probably the last thing he wanted. But he was gracious when she spotted him. "He smiled so sweetly," Mary said, "bowed, and was gone."

At the same time, a clerk came up to her. It might easily have been Rose Putnam. But Mary, dazed by the sight of Mr. Taylor, could barely respond as the clerk displayed various samples. "I told her to wrap it up," Mary said, hardly even aware of what she was buying, and hurried out of the store.

For the rest of the day, Mary had only one thing on her mind. If things were really ending between her and Mr. Taylor, the end would come on her terms, not his.

She had to see him one last time.

That night, after everyone else had gone to bed, Mary tiptoed into her grandmother's room. She told the old woman she was going to see Mr. Taylor. If Mrs. Shelby had been home, Mary might not have risked leaving the house so late. But she thought her grandmother would be more understanding. At first Mrs. Miles tried to dissuade her, but when she saw how determined Mary was, she offered to come along.

Mary shook her head. "This is something I must do alone."

In her dramatic style, she walked through the house, gathering up everything Mr. Taylor had ever given her. His photographs. A little mesh bag. Then she sat down at her desk to write him one last note. "Dear William Desmond Taylor," she inscribed in her flowery script. "This is good-bye. I want you to know that I will always love you."

She sealed the note in an envelope, then motored across town to Alvarado Court.

A light was shining from the first-floor windows. Despite the hour—about five minutes to midnight—Mr. Taylor was apparently still awake. Mary rang the bell.

When he opened the door, he seemed distracted, and certainly not happy to see her. "It is rather late, isn't it, Mary?" Mr. Taylor asked.

It was, she admitted. But she pushed past him into the room.

Given the events of the past few weeks, the move must have rattled Taylor. He wasn't in the best frame of mind to deal with a hysterical teenage girl in the middle of the night. Perspiration beaded on his brow; he clenched his fists so tightly that his nails drew blood as they dug into his skin. Mary took his distress to mean that his heart was just as broken as hers.

But she took no pity on him. They could have been together—if he had only taken her away from her mother! All her long-suppressed rage boiled over, and Mary let Taylor have it. Perhaps he'd believed that stringing her along would only hurt her more—"but it wouldn't have hurt one-millionth as much," Mary cried, tears flying, "if you had just explained to me and not left me in the dark!"

Taylor was at a loss. "I can't explain to you," he said simply.

Of course he couldn't. He had tried, many times. But Mary heard only what she wanted to hear.

She tried embracing him, but he held her at arm's length. So she thrust her farewell note at him. Taylor read it, then escorted her out to her car. Slipping behind the wheel, Mary reached up and plucked his handkerchief from his jacket pocket, replacing it with her own.

One last romantic gesture from a very sentimental young woman.

Then she sped off, overcome with emotion.

Taylor shut the door against the night and all its dangers.

Mary's midnight visit deeply disturbed him. The way she had tried to embrace him had made him very uncomfortable, as friends would later report. It appeared to frighten him.

But then again, for the past three weeks, Taylor had been frightened of many things.

Four days later, on December 27, there was more.

Taylor glanced down at the mail Peavey had brought in for him. He recognized the handwriting on one large envelope, postmarked Stockton. Tearing open the package, he shook out two pawn tickets for the jewelry that had been stolen from his house. The items had fetched $30, far less than their value.

The envelope also contained a note. "So sorry to inconvenience you

even temporarily," it read. "Also observe the lesson of the forced sale of assets. A Merry Xmas and a happy and prosperous New Year." The note was signed "Alias Jimmy V"—a reference to the popular play and film *Alias Jimmy Valentine*, about a safecracker who was always eluding the police.

The handwriting in the note confirmed to Taylor who lurked behind the alias.

It was Edward Sands.

But far more blood-curdling was the name Sands had signed on the pawn tickets.

William Deane-Tanner.

It was Sands's way of telling his former employer that he hadn't forgotten his secrets.

# A WORK SO IMPORTANT

On Christmas Day, Will Hays was home with his family in Sullivan, Indiana—a rare moment when he and Helen were in the same room at the same time. Turkey was roasting in the oven; a fire popped in the parlor. Aunts and cousins buzzed through the house, as well as Hays's brother Hinkle, his wife, and their two little boys. When the turkey was ready, Hays, as always, intoned the prayer before the meal.

After dinner, he took his place in his easy chair in front of the fire. The children were running through the house, and the adults had gathered around the Christmas tree, but Hays sat off by himself, deep in thought. He had an important decision to make, and he was still unsure what to do. Should he take the job the movie chiefs were offering him? Even with the pressures that came with it? Even with the power struggle he'd face with Adolph Zukor?

The sounds of his young son and nephews playing distracted him.

"I want to be William S. Hart!" his son Billy cried.

"No, I'm going to be him!" shouted one of his cousins.

"No, I am!" insisted the other. "You can be Doug, and Billy can be the bad guy."

Hays was struck. The boys were imagining themselves to be William S. Hart and Douglas Fairbanks. Not the heroes of history or folklore that Hays had once pretended to be—not Daniel Boone or Paul Bunyan or Buffalo Bill, the idols of little boys for generations, but not anymore.

In that moment, Hays's decision became clear.

"To these little boys and to thousands of others throughout our

land," Hays realized, "William S. Hart and Mary and Doug were real and important personages and, at least in their screen characters, models of character and behavior. I realized on that Christmas day that motion pictures had become as strong an influence on our children and on countless adults, too, as the daily press."

Hays would forever credit those three little boys with making up his mind for him, of convincing him that he should take on "a work so important" as this.

"Come on, let's go!" he said, his favorite phrase, feeling suddenly galvanized as he headed back to Washington. Soon after the New Year, he informed the president that he would be leaving the administration. On the same day, he wired New York that he was accepting the offer.

The film chiefs were jubilant. "We know we have secured the right man and the best man in Mr. Hays," they declared in a statement. "The President, in releasing Mr. Hays that he might undertake his new, nationwide task, has expressed his appreciation of that task's importance. We, the undersigned, are also mindful of the responsibility that weighs upon us, and we welcome, gratefully, in our work, the cooperation, advice and association of Mr. Hays."

Almost immediately the movie men insured Hays's life for $2 million. A considerable sum—until it was remembered that Zukor had insured his own life for $5 million.

William Desmond Taylor. "A camouflaged man," one colleague called him.

An actor before he was a director, Taylor was fired for unknown reasons soon after completing the lead role in *Captain Alvarez* (1914).

In the weeks after Taylor's murder, the newspapers were filled with accounts of his many aliases. COURTESY BRUCE LONG

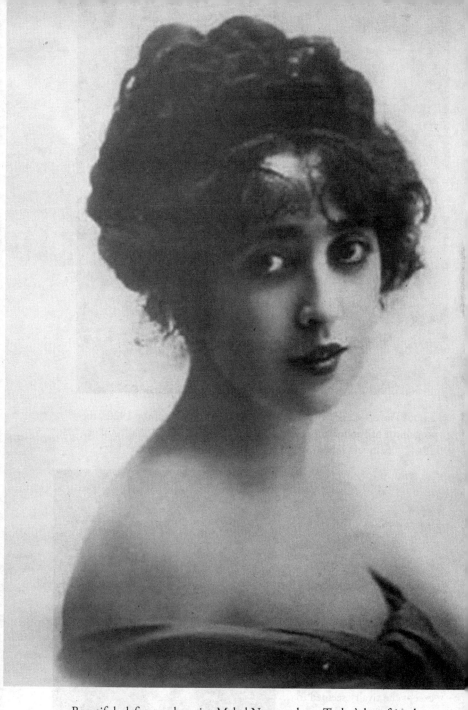

Beautiful, defiant, subversive Mabel Normand was Taylor's best friend.

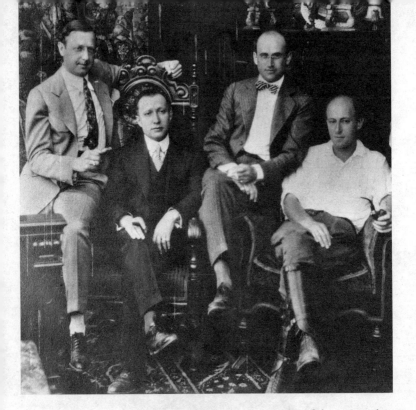

Famous Players–Lasky, the most powerful movie studio of the 1920s, the progenitor of Paramount, with its founders: Jesse Lasky, Adolph Zukor, Samuel Goldwyn, and Cecil B. DeMille. PHOTOFEST

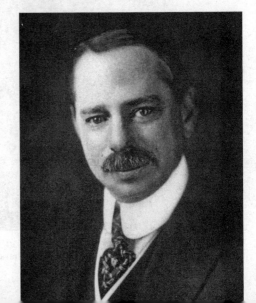

Marcus Loew was Adolph Zukor's greatest rival—except the rivalry seemed to go only one way.

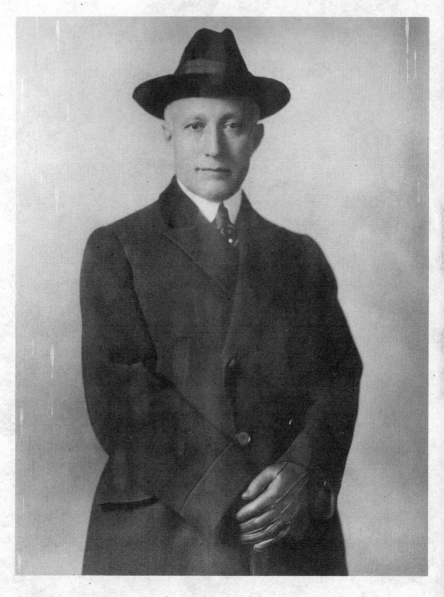

Almost single-handedly, Zukor created the system by which American movies are made, sold, and shown. PHOTOFEST

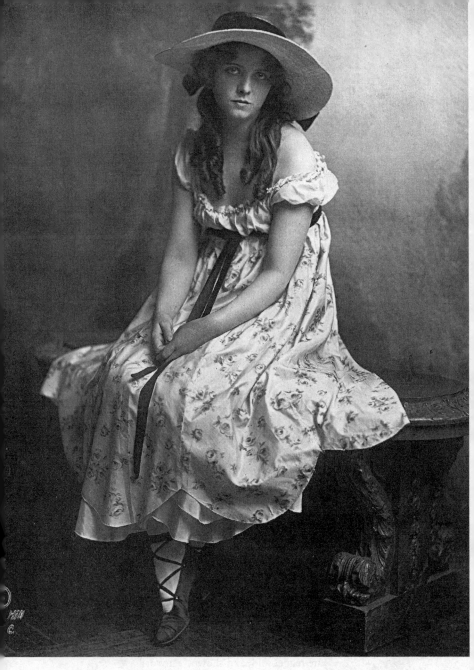

Olive Thomas's accidental drug-related death in 1920 launched half a decade of scandals that forever changed the way Hollywood did business.

Among the other scandals were the drug addiction and death of popular actor Wallace Reid . . .

. . . and the rape-and-manslaughter trials of Roscoe "Fatty" Arbuckle. Zukor did his best to manage the fallout from the Arbuckle case, just as he did with the Taylor murder.

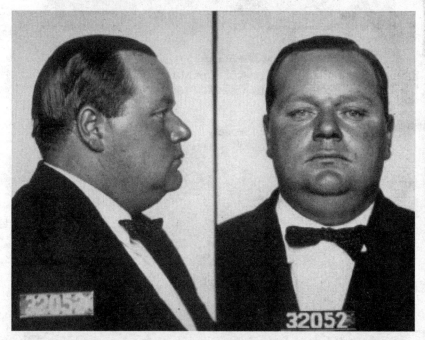

Mabel was devastated by Arbuckle's troubles, remembering
happier days when they made comedies for Mack Sennett, such as the famous
*Fatty and Mabel Adrift* (1916). PHOTOFEST

When the irreverent Mabel spoke, "toads came out of her mouth," said Blanche Sweet—nobody minded. Everybody loved Mabel.

Margaret Gibson was poised to become a huge star in 1916. Then she was caught in a kimono during the raid of a brothel in Little Tokyo.
COURTESY RAY LONG

558

A little thing like being arrested didn't derail Gibby's ambition. She'd promised her mother to find a way out of the dire poverty they lived in, just as she often did on the screen. COURTESY RAY LONG

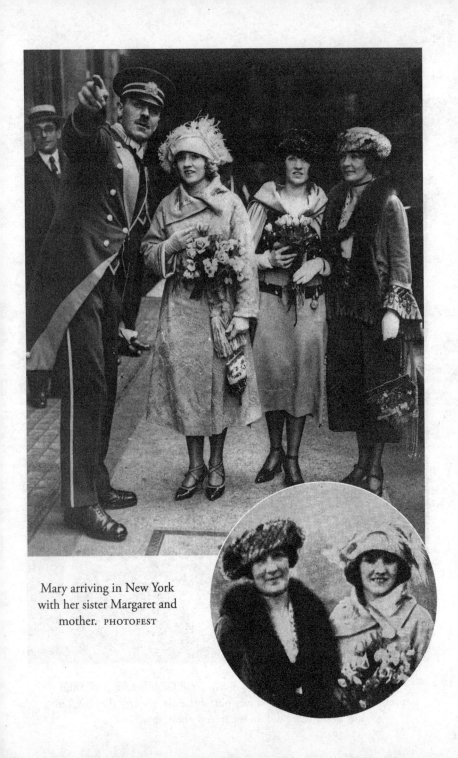

Mary arriving in New York
with her sister Margaret and
mother. PHOTOFEST

Eighteen-year-old Mary Miles Minter lived in a world of fantasy and illusion, one in which she was free of her controlling mother, Charlotte Shelby, and united in love with her "soul mate," William Desmond Taylor.

Mary *(left)* with her mother and her beloved grandmother, Julia Miles. During the summer of 1922, the aged Mrs. Miles traveled back to her home state of Louisiana and threw a gun into a bayou.

*Right:* Gibby starred with Taylor in *The Riders of Petersham* (1914). *Below:* Mary and Gibby attended a 1916 exhibitors' convention together in Indianapolis.

## Motion Picture Stars Hold Interest at Convention of Exhibitors Here

LEFT TO RIGHT—RUTH STONEHOUSE, LEAH BAIRD, MARY MILES MINTER, MARGARET GIBSON AND ELAINE IVANS.

Group of Film Actresses Find Exciting Experience in Having Photograph Taken—But It Was on Windy Roof.

### G. O. P. LEADERS URGE BIG VOTE

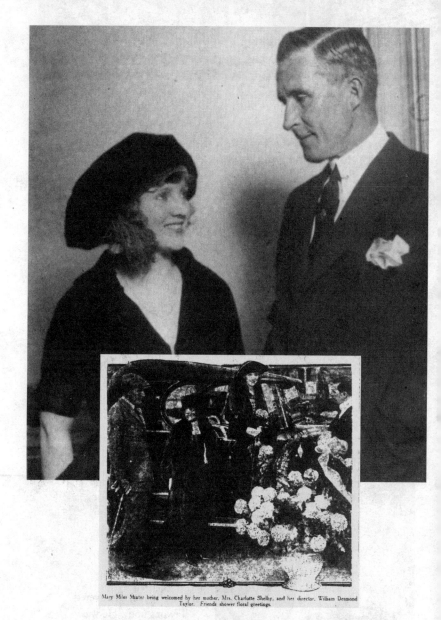

Mary Miles Minter being welcomed by her mother, Mrs. Charlotte Shelby, and her director, William Desmond Taylor. Friends shower floral greetings.

*Top:* Mary and Taylor pose for the publicity cameras after completing a picture together. *Below:* A rare shot of Taylor, Charlotte Shelby, and Mary together. The look Shelby seems to be giving Taylor pretty well sums up her feelings for the director. From the *Los Angeles Express,* October 14, 1919. COURTESY OF BRUCE LONG

George James Hopkins was Taylor's set designer and his lover. He'd go on to win Oscars for *A Streetcar Named Desire, My Fair Lady, Who's Afraid of Virginia Woolf?*, and *Hello Dolly!*.
ACADEMY OF MOTION PICTURE ARTS AND SCIENCES

Henry Peavey discovered Taylor's body. He was later kidnapped by journalists trying to scare a confession out of him, an act resulting in charges by the NAACP. CORBIS

# A GHASTLY STRAIN

In the early-morning hours of January 1, 1922, Mabel Normand sat pouting in the backseat of Taylor's newly refurbished McFarlan. She hadn't wanted to leave the New Year's Eve party that was still going strong at the Cocoanut Grove. She'd been having a smashing time, partying with her pals Renée Adorée and Tom Moore—and Wesley Ruggles and Pat Murphy and God only knew who else. But Billy had insisted they leave. "Somebody got awfully drunk," Mabel would later admit. That somebody was probably her.

Now she sat angrily in the backseat beside Billy, giving him the silent treatment. He could be such a bore sometimes. Mabel loved Billy—she'd always be grateful to him—but sometimes he was just too protective. At the party he'd resented her flitting around the place, talking to everyone, leaving him standing by himself. Was it Mabel's fault that she was outgoing and he was so reserved? She'd given up cocaine and the other drugs; if she wanted to let loose on New Year's Eve with a little more champagne than usual, what was so wrong with that? She'd had enough with Billy's nagging, and she told him so.

"For God's sake," Mabel had snarled. "Why do you stand around with that trick dignity of yours? You make me sick!"

Taylor said he wasn't trying to be dignified, but that after all he'd done for her, he wished Mabel wouldn't be so dismissive of him.

"Good God, don't be melodramatic," Mabel replied.

Later she'd regret her tone. "I got a little nasty," she'd admit.

But the truth was Billy *had* been irritable lately. Everything seemed to set him off. Mabel had no idea what was eating him up, and at that particular moment, sitting in the backseat of his car, she felt no sympathy for him. Her fury at Billy for ruining her night muted any compassion she might have felt for him. When Billy tried to speak to her, Mabel told him to be quiet.

Up front, the eighteen-year-old chauffeur, Howard Fellows, found it all very unusual. Usually Mr. Taylor and Miss Normand were "very affectionate" with each other, but tonight they were both "very much excited"—and not in a good way. When they arrived at Mabel's home on West Seventh Street, she stormed out of the car, slamming the door behind her.

The argument left Taylor visibly upset. When they got home, he "broke down and wept" in front of his chauffeur—highly uncharacteristic for the private, self-controlled director.

Something wasn't right.

Two days later, the director had Fellows drive him to Feagan's jewelry store, where he laid out $1,250 for a jade ornament. Then he asked to be driven over to Mabel's, where he presented the forlorn actress with the gift.

The two friends quickly patched things up. But whatever devils were tormenting Taylor did not disappear. Mabel and Fellows weren't the only ones to notice strange things happening in Billy Taylor's life that month.

During the second week of January, the cast and crew of Taylor's current production, *The Green Temptation*, piled into cars and headed out along Colorado Boulevard through Glendale to Pasadena. They were slated to spend three days in the "city of millionaires," shooting location footage for the new film, a tale of the criminal underworld.

Among the actors was the forty-year-old Russian-born Theodore Kosloff, a former dancer with Diaghilev's Ballets Russes. One day, while Kosloff was with Taylor, he witnessed something he couldn't explain.

As the two men were walking through a field, a man suddenly emerged "almost with a spring" from behind a thicket of brush. Yet even "quicker than this surprising stranger," Kosloff observed, was Taylor, who lunged to confront the man. The two "stood eye to eye for a

moment," neither uttering a word. To Kosloff, the two men seemed locked in a battle of wills, each trying to stare the other down.

At last the stranger turned and walked away.

Taylor offered no explanation for the incident. He simply resumed the conversation he'd been having with his actor. Whether the director knew the stranger, Kosloff didn't ask, and Taylor didn't say.

On Thursday, January 26, having wrapped *The Green Temptation*, Taylor and his friend Antonio Moreno took in a performance of the famed dancing duo Maurice and Hughes at the Cocoanut Grove. Since going out on the town with another man was obviously problematic, Moreno asked the actresses Claire Windsor and Betty Francisco to accompany them. Windsor was Taylor's date.

At the Grove, Windsor found the director "extremely reserved and diffident." At one point she asked him about the burglary at his house.

Taylor's eyes darkened. "If I ever lay my hands on Sands," he said, "I will kill him."

At another point the pair wandered over to the studio of the silhouette artist Gene Ross, located in the lobby of the Ambassador Hotel. Ross had known Taylor since her days sketching art titles for Famous Players. To her, the director had always seemed distant and emotionless. But on this night her sharp artist's eye discerned a very different man.

As Windsor wandered around the studio, examining Ross's work, Taylor bit his lips and paced the floor. He seemed "nervous, absent-minded, haggard," Ross thought. When other people came through the studio, he jumped. He seemed to be "under a ghastly strain of some sort," Ross observed. Even his voice sounded different. "Usually he spoke in a calm, colorless, beautifully modulated voice," Ross would recall, "but that night his remarks came in jerks."

It was as if a veil had been stripped from his face. Was this, Ross wondered, the real William Desmond Taylor?

Finally, a few nights later, on Monday, January 30, Taylor's neighbor Neil Harrington noticed more unusual activity in front of the director's bungalow in Alvarado Court.

This time he spotted two unfamiliar men at Taylor's door, one "much smaller than the other." The men had apparently rung Taylor's doorbell, but when no one answered, they tried the door with a key, which did not appear to work. For some time thereafter they lingered on the front porch, talking.

Perhaps they were friends of Taylor's, Harrington thought. Or studio employees.

Or perhaps they were something more sinister.

# A HOUSE IN THE HILLS

Gibby Gibson stepped off the trolley at the busy intersection of Sunset and Vine and made her way down the tree-lined street toward the Christie studios, returning to the Corner of Last Hope.

Al Christie wasn't surprised to see her. Yes, he told her. He'd give her a job.

The forty-year-old Canadian producer had been one of the first to make pictures in California, back in the days when most of the traffic racing along Sunset Boulevard was still horses and wagons. Even Gibby could remember a time when this strip had been mostly farmland and citrus trees. Both she and Christie had been in Hollywood a long time.

Maybe that was why Al took pity on her, and why he could always be counted on to help her when she needed it. Gibby needed it now. She'd made two more features for Charles Seeling, but none of the films had made it to theaters. Seeling was still hoping for success the moment the government ruled against Adolph Zukor and Famous Players, but in the meantime Gibby was idle, doing nothing but growing older. So Christie came through for her, yet again.

Glancing down at the script she'd been given, Gibby probably felt her heart drop. But beggars couldn't be choosers. Her part in the two-reel comedy, a satire of hoary Northwest Mounted Police melodramas, was minuscule. The star would be the fresh-faced, nineteen-year-old Viora Daniel; Gibby would play an older woman with a baby. Her role required her to pretend to lose her baby to a pack of wolves and to carry

on farcically. For that, Gibby would be paid maybe fifty bucks. Not much, but it would help pay the rent.

She drowned her sorrows with bootleg champagne with Don Osborn and Rose Putnam up at 2575 Beachwood Drive. Gibby was an indulgent landlady: when the locusts partied, she never asked them to turn down the music or put away the hooch. She was right there with them, raising her glass—and her skirts—as she shimmied to songs like "Ain't We Got Fun" and "The Sheik of Araby" on the scratchy Victrola.

The Beachwood house was a "small, shanty-like arrangement," with two small rooms and an enclosed porch. Osborn and Rose slept in the back room, but a sleeping couch in front and an army cot on the porch accommodated frequent guests. Blackie Madsen and May Ryan were often there. So were George Weh and Fred Moore and his wife, Jackie. A shady real estate agent named Jay R. Overstreet would recall plenty of "cheap liquor" flowing at 2575 Beachwood—all paid for by Osborn, who, like Gibby, would be periodically flush with cash, then suddenly broke again, depending on the success or failure of their latest con job. Osborn's parties sometimes spilled out into the street, where at least two neighbors, the small-time western actors Leonard Clapham and Leo Maloney, joined in the fun.

What none of them knew, as they partied and carried on, was that a small figure lurked outside in the darkness, watching them through the window.

Osborn's former wife, Rae.

When she saw Osborn lean down and kiss Rose on the lips, Rae recoiled in disgust. Her ex-husband had "a weak, diseased, decayed mind," Rae concluded. But she remained as obsessed with him as ever. For three nights she prowled outside the house, watching the locusts and wallowing in her revulsion.

Rae kept tabs on everything Osborn did. She knew all about his bunco jobs. She'd heard how he'd squealed on Jim Bryson. How a man could "do a thing like that to his own friend," Rae did not know. She prayed that one of the many men Don had fleeced ("God only knows how many there are") could find the courage to fight back against him.

But that would never happen, Rae feared. Osborn and Madsen al-

ways chose patsies who were too compromised to fight back. Married men. Prominent men. Men with secrets.

Almost certainly, Gibby was still sending suckers their way and still getting a cut. How else could she buy the occasional nice dress? Certainly the movies weren't making her rich.

In the early weeks of January 1922 Gibby spent much of her time drinking with her new tenants. She was lonely and depressed. She hadn't had a man in her life since her dalliance with Osborn a year earlier, but Gibby wasn't looking for romance. She was looking for someone who shared her dream to make it to the top. She'd thought she'd found him in Osborn, but she was starting to learn that real ambition is a solitary enterprise.

If only she could get a job at one of the major studios instead of Al Christie. If only she could get hired by the crème de la crème, Famous Players–Lasky.

Was there even still time left for Patricia Palmer to become a major Hollywood player? Gibby wasn't sure anymore. In just two years, she'd be thirty.

So any money she could collect from Osborn—rent or otherwise— would have been very much appreciated. The sporadic kickbacks she got from Osborn must have felt like manna from heaven, a chance to splurge on shoes and earrings and presents for her mother. Osborn may have been a flop at making movies, but he'd perfected his bunco operation. He ran "a gang of eleven [that] did nothing but look for schemes," one source would later reveal. Most of the locusts were now in on the business: George Weh, Fred Moore, and probably newcomers like Leonard Clapham, too. The payola wasn't enough to buy them cars or houses, but it kept the whisky flowing and the records playing. Until she made it as a big star, Gibby would have to be happy with that.

And, unlike Rae, she had to hope that the men Osborn and Madsen were swindling never found the guts to stand up and fight back.

CHAPTER 33

# LAST DAY

While her chauffeur, William Davis, drove her around town on a series of errands, Mabel Normand sat in the backseat of her car, eating peanuts and dropping the shells all over the floor.

It was almost six in the evening. The sun was setting, staining the sky red and orange like a still-wet watercolor and sending purple shadows of palm trees across the roads. Mabel didn't want to be out late. She needed to be up early the next morning, in costume and fully made up when the studio car came to collect her for location shooting for her new picture, *Suzanna*. But Billy had phoned earlier to say he'd bought a couple of books for her. So Mabel had told Davis to swing by Billy's place before taking her home. Mabel always had time for presents from Billy.

The date was February 1, 1922.

The night grew dark. There was no moon. As Mabel's car made its way through downtown, about a mile and a half away a man was stepping out from the shadows at the intersection of Alvarado and West Sixth Streets. Walking into the pale golden light, he headed up the asphalt to the Hartley and Son gas station. It was just before six o'clock.

Floyd Hartley, the station's owner, looked up. The stranger appeared to be in his middle twenties. He had dark hair and wore a dark suit with a light cap.

Hartley's employee, Lawrence Grant, also stopped work to observe

the stranger, who asked them if they might know the address of William Desmond Taylor, the movie director.

Of course they did. Taylor's flashy McFarlan often stopped by the station to fill up. Hartley gave the man directions to Alvarado Court, only about a four-minute walk up the street.

The stranger headed back into the shadows.

A couple of minutes after seven o'clock, William Davis brought Mabel's car to a stop alongside the courtyard on Alvarado Street. Brushing peanut shells off her lap, Mabel stepped out onto the sidewalk, asking Davis if he'd mind sweeping the rest of the shells out of the car. The chauffeur agreed. Mabel told him she wouldn't be long.

She hurried up the sidewalk. She'd brought a bag of peanuts for Billy as well.

It was a chilly night, especially for Los Angeles. Temperatures were sinking into the low forties and were expected to keep dropping. Billy's front door was open, with only the screen door as a barrier from the cold night. But Billy liked fresh air, Mabel knew.

She rang the bell.

"Good evening, Henry," Mabel chirped when she spotted Peavey through the screen. "Is Mr. Taylor here?"

"Yes, ma'am," the valet replied. "He's on the telephone."

Mabel decied to wait for him on the step. A few minutes later, Taylor bounded out to greet her, laughing when Mabel gave him the peanuts. He took both her hands and led her inside, insisting she had to stay long enough for a drink. He didn't have to twist Mabel's arm.

Asking Peavey to bring in the serving tray, Taylor took a seat in front of his cluttered mahogany rolltop desk, while Mabel sat on the stool in front of the small upright piano. Billy seemed in a good mood, with no signs of the tension he'd been exhibiting lately. He asked Mabel to guess what books he'd bought for her.

Mabel grinned and guessed correctly: a translation of Nietzsche and *Rosa Mundi* by Ethel M. Dell, the popular English romance novelist. No doubt she'd been hinting to Billy she wanted them, and she was delighted. Billy had introduced her to so many great writers. Her current favorite was Stephen Leacock, the Canadian humorist who reminded

some of Mark Twain. She also "surprisingly, tenderly understood" the deeply psychological novels of Knut Hamsun, who'd just won the Nobel Prize in Literature.

How transformative Billy had been for her. As she leafed through his latest gifts, Mabel was happy and grateful. What would she ever do without him?

Outside on Alvarado Street, the night was getting darker.

Mrs. Marie Stone, age fifty, was walking up the block from South Carondelet Street to babysit for her nine-year-old granddaughter, who lived with her parents, Mr. and Mrs. Arthur Wachter, at 412A Alvarado Court, on the other side of the complex from Taylor. As Mrs. Stone paused at the corner of Sixth, she noticed a man apparently waiting for the streetcar. But the streetcar came and went, and the man did not board. Instead, he walked "aimlessly" up Alvarado, Mrs. Stone observed.

For some reason, the man made Mrs. Stone nervous. She kept a safe distance behind him. Under the glow of the streetlamps, she could discern only a few details about the man. He wore an ill-fitting dark suit that bulged at the collar, tan oxford shoes, and a cap that was either plaid or checked. Mrs. Stone couldn't tell the man's age, but she could see that he was of medium height, with a ruddy complexion, and that his neck and earlobes were thick.

For a moment she thought the man might have been Edward Sands, Mr. Taylor's former valet, whom Mrs. Stone had seen many times in Alvarado Court while visiting her daughter. Sands was bowlegged, so his walk was recognizable. But she couldn't be sure.

At some point the man abruptly stopped walking. As Mrs. Stone watched, he "transferred something from his left hip pocket to the right-hand pocket of his coat." Then he turned right on Maryland Street and disappeared from view. Mrs. Stone, heading up the steps to her daughter's home in Alvarado Court, thought no more about the stranger.

Maryland Street ran directly behind Taylor's apartment.

As Mabel and Billy talked, Peavey wheeled in a silver-and-cut-glass tray bearing a martini shaker and a couple of large stemmed glasses.

"How do you do, Miss Normand?" the valet asked, bowing. "I trust all is well with you."

Mabel couldn't help but laugh. She found Peavey comical. He dressed so colorfully and spoke so effeminately. "All's well, Henry, thanks," she managed to say. She didn't notice how the smile shriveled on Peavey's face. She had no clew that Peavey resented the way she laughed at him.

The valet informed Taylor that he had washed the supper dishes, turned back the covers of his bed, and placed some ice water on the bedside table. Would there be anything else? Taylor told him that was all and bid him a good night. "And don't worry," he called after Peavey. "I think I can fix up everything downtown tomorrow."

After the valet had left, Mabel asked Taylor what he'd meant.

He proceeded to fill her in about Henry's troubles "at some length," Mabel recalled, detailing the valet's arrest and his visit to see the judge about the charge. Taylor told Mabel he'd put up a bond of $200 to secure Peavey's release.

Then he suggested they move over to the William and Mary dining table, where they clinked glasses and sipped Henry's orange-infused martinis. Mabel lit up a cigarette. They talked about whether Sands would ever be caught, and about Mabel's work on *Suzanna*, and about the upcoming cameramen's ball, which they both planned to attend. The gin slid down easily, and soon they were both just a little bit happier than they had been moments before.

For Taylor, after weeks of anxiety, a few moments of respite with Mabel must have felt like heaven.

Catercorner from his apartment, Taylor's neighbors in 406B were sitting down to dinner. Douglas MacLean was an actor who'd worked for the director in a couple of pictures, though at the moment he was under contract to Thomas Ince. His wife, Faith, was an East Coast debutante, the daughter of a former speaker of the New York Assembly. Their Danish-born maid, Christina Jewett, was carrying the various courses in and out of the dining room.

On one of her passes through the kitchen, Jewett paused. From outside the window, she could hear footsteps "come from the corner and go down in the alley" that ran behind the house. At that moment, Mrs.

MacLean rang the bell, so Jewett had to hustle the next course out to her employers. But when she came back into the kitchen, she could still hear the footsteps. Jewett thought the man was now walking out toward the garage.

The garage sat between the MacLeans' apartment and Taylor's.

Mabel was playing the piano for Taylor, making him laugh by hitting a lot of deliberately bad chords. Finally, around 7:35, she announced that she was tired, and Billy admitted that he had a lot of checks to write, as it was getting near tax time. But he might call her later to see if she'd had the chance to dive into Nietzsche. Mabel told him not to call until nine o'clock.

Taylor helped her into her coat and walked her out to her car.

As usual, he left his front door open.

At the end of the sidewalk, Mabel's chauffeur, Davis, stood amid a litter of peanut shells. Glancing inside the car, Taylor laughed out loud. There lay a copy of Freud, which Mabel was in the midst of reading, as well as the latest issue of the *Police Gazette*, the celebrated tabloid of true crime, sports, and burlesque.

"Good Lord, Mabel," Taylor said. "You certainly are going for heavy reading this winter." But that was what he loved about her. He kissed her good-bye. She pulled his earlobe. "Toodle-oo, Billy," Mabel said, slipping into her car. He told her he'd call around nine o'clock to see how she liked her new books.

"As my car turned around," Mabel would remember, "I waved at him. He was partly up a little stairs there. I looked back and we wafted kisses on our hands to each other for as long as I could see him standing there."

It was approximately 7:45.

Taylor stood on the curb waving to Mabel until her car passed out of sight.

Then he turned and headed back up through the courtyard to his apartment.

# A SHOT

After dinner, Faith MacLean was feeling chilly. Temperatures outside had slipped precariously close to freezing. Sending Douglas upstairs to fetch a small electric heater, she settled onto the davenport to do some knitting.

Faith was a pretty woman. Thirty years old, she had been married to Douglas for eight years. They had no children, and despite her husband's increasing popularity in the movies, Faith wasn't exactly enamored of Hollywood.

The events of this evening would do nothing to change her mind.

At about 7:50, Faith heard "a shattering report," as she called it. It was a muffled sound, but still it seemed to penetrate every corner of the room.

"Wasn't that a shot?" Christina Jewett asked, leaning in from the kitchen.

Faith couldn't be sure. Living so close to Alvarado Street, they often heard the backfire of automobiles. Standing, she walked across the room and opened the front door. "There were several lights in the living room, back of me," Faith would recall. "They reflected from the screen door." So she pressed forward against the screen to see better, peering out into the dark.

She spotted a man.

"He stood on a corner of Mr. Taylor's porch," Faith would later reveal. The man's back was to her, and Taylor's door was open. Amber light spilled out into the darkness.

As Faith watched, the man turned to look at her. "He did not seem surprised or startled," she said, "surely not alarmed."

Although the darkness made it impossible to see much, Faith felt certain of one thing. As the man looked at her, he suddenly smiled.

"I could see the corners of his mouth curl in the shadow of his cap," she said.

He looked stocky, Faith thought, of medium height. He might have had a prominent nose, though that could have been merely the shadows playing tricks. The man seemed to be wearing a muffler around his neck; it was certainly cold enough for that. And his cap, Faith thought, might have been plaid.

Then, as though Mr. Taylor had called from the inside the house, "the man turned away," Faith would report, "walked to the door and almost disappeared inside. It seemed he was bidding his host good-bye. It was all done in a moment."

Then he closed the door. He didn't slam it or shut it with any particular heed. He just closed the door as anyone might—anyone without a care in the world.

As Faith watched, the man walked down the porch steps and turned back toward her. He crossed in front of Taylor's house and headed "into the walk between the houses." In seconds he had disappeared into the dark.

Faith thought "absolutely nothing" of what she had seen.

She closed the front door.

Douglas came down with the electric heater. They set up a table and played dominoes for a while. Then they went to bed and slept soundly, until Henry Peavey's screams woke them the next morning.

PART TWO

# HUNTING, HUSTLING, AND HIDING

# THE DEAD MAN ON THE FLOOR

The MacLeans weren't the only ones who heard Peavey crying that Taylor was dead.

In 408A, Verne Dumas was shaving at his bathroom sink when the valet's voice suddenly shattered the peaceful morning. Pulling on a bathrobe, Dumas hustled out into the courtyard, along with his roommate, Neil Harrington. Two doors down, at 406A, Emile Jesserun, the proprietor of Alvarado Court, also hurried down his front steps into the chilly air.

But upstairs in 402A, Edna Purviance, Chaplin's beautiful leading lady, wasn't going anywhere. Awakened by all the commotion, she peered down into the courtyard, watching Peavey run around in circles and several men in bathrobes scurry across the grass. The angle of Purviance's apartment prevented her from seeing Taylor's residence, but the night before, when she'd returned home around midnight, she'd noticed that all of the director's lights had still been blazing. Now Edna was terrified. Pulling herself away from the chaotic scene outside, she picked up the telephone. If Taylor was indeed dead, she knew someone for whom that news would be very important.

Jesserun, the landlord, reached Taylor's apartment first, with Harrington and Dumas close on his heels. Peavey followed, fluttering in terror. Jesserun had been sick in bed these last few days; traipsing in to look at a corpse was hardly how he wanted to be spending his morning. But the Jamaican-born Jesserun wasn't just the proprietor of Alvarado Court; he'd also designed and built these apartments. This was his ter-

ritory. He might have been ailing, but he knew it was his responsibility to see what had happened in 404B.

The four men crowded into Taylor's small living room.

The corpse lay at their feet, head toward the west, arms at its sides. Dumas reached down and touched the dead man. He found Taylor's arm "absolutely stiff." They could all clearly see the puddle of congealed blood behind his head, staining the expensive purple Axminster carpet.

A few minutes later Douglas MacLean appeared at the door. His boyish movie-star good looks lit up with alarm. "Mr. Taylor is dead," Jesserun told him.

How had this happened? MacLean asked. No one was sure. Except for the blood under his head, the dead man looked immaculate. His clothes were smooth and undisturbed. He lay flat on his back, not twisted in any way, as if he had calmly and carefully laid himself down to die. Taylor's coat was arranged "perfectly along his body," MacLean observed, not "thrown back or anything." Looking down at the corpse, the actor was struck by the uncanny look of the body. "He looked just like a dummy in a department store," MacLean said.

Peavey finally collected himself enough to take a look around the place. Nothing seemed out of order. The place was exactly as he'd left it the night before. The serving tray still held the cocktail shaker Taylor had used to pour drinks for himself and Miss Normand. Two stemmed glasses stood in mute testimony to the evening's conviviality. The water of the melted ice cubes was flecked with orange pulp. Nearby an ashtray held the stub of a cigarette.

A quick check of the rest of the house also revealed nothing amiss. On top of the piano, several delicate ivory figures stood undisturbed. On a nearby table, a hand-painted ribbon dangled from a book, *Moon-Calf* by Floyd Dell, marking the place where Taylor had left off reading. The director's rolltop desk was covered with neat stacks of canceled checks, along with a ledger. From the looks of it, Taylor had been preparing his tax returns when he died. His checkbook was open, his pen still filled with ink. Above the desk hung a photograph of Mabel Normand.

Peavey checked the back door. It was locked, just as he had left it.

The front door had also been locked when he arrived, but that locked automatically when it was closed.

The only elements in the entire place that seemed out of whack—other than the dead man on the floor, of course—were the rug, one corner of which, near Taylor's feet, "was a little bit kicked up," Peavey observed, and a chair, usually kept against the wall right inside the front door, which now stood athwart Taylor's left foot.

Yet it was the position of the body—so neat, so composed—that perplexed observers the most. At last Harrington expressed what everyone seemed to be thinking: "I don't believe the man fell in that position."

Suddenly Taylor's fellow director and friend Charles Maigne came rushing through the door. Maigne lived about a mile away; how he had known about Taylor's death so soon, no one knew at first. But he too was "stumped" to understand how a man could die so neatly. Maigne kept "wondering how on earth Bill could have fallen the way he did."

But maybe, Douglas MacLean suggested, he hadn't simply fallen.

They all turned to look at him.

MacLean volunteered that both he and his wife had heard something the night before. They both thought it might have been a gunshot. Jesserun admitted he'd heard the sound, too, though at the time he'd shrugged it off as the backfire of a car. But like the others, he'd taken note of the fact that the lights in Taylor's house had been burning all night long.

The suggestion of foul play weighed heavily in the frosty morning air. As Harrington and Dumas, still in their nightclothes, traipsed back across the courtyard to their apartment, a curious woman opened her window to ask MacLean what had happened. The actor replied with a single word: "Murder."

A little before eight o'clock, the apartment began to fill up with new arrivals. Howard Fellows, alerted by Peavey, arrived with his brother Harry. Not long afterward came three more of Taylor's colleagues: Julia Crawford-Ivers; her son, cameraman Jimmy Van Trees; and George Hopkins, his face ashen with grief and shock at the sight of his lover's corpse.

A few minutes later Detective Thompson Zeigler, who'd been telephoned by Jesserun, came ambling through the court. A heavyset man in his sixties, Zeigler was nearing the end of a thirty-year tenure with the Los Angeles Police Department. And from what the experienced detective could see, there was no murder here.

The doors had all been locked, he determined, and all the pins were still in the downstairs windows. No one had gone in or out. And on the body, Zeigler could see no signs of violence. Besides, Taylor wore a wristwatch, and a large gold band with a diamond on one finger. If he'd been killed by a burglar, Zeigler pointed out, surely those items would have been taken. The policeman did note that one hand of the corpse was outstretched, bent at the wrist, almost as if—in his final moments of life—Taylor had made an attempt to clutch at something.

Upon getting Jesserun's call, Zeigler had telephoned a doctor, who soon arrived, carrying his medicine bag. Walking around the corpse, the doctor made no attempt to move the body. After a few moments he confirmed Zeigler's instinct and announced that Taylor had died of natural causes. A stomach hemorrhage, he speculated, which would explain the blood behind the head, which had presumably drained from the mouth. It was not an official ruling, of course. The coroner was on his way, and it would be left to him to determine the precise cause of death down at the morgue. But that was this doctor's conclusion.

Douglas MacLean wasn't convinced. What about the shot he had heard, and the fact that Taylor lay there so neatly, as if someone had straightened him out after he fell? No one, MacLean insisted, could look like a department store dummy after collapsing from a stomach hemorrhage.

The doctor seemed uninterested in MacLean's arguments, but they did trouble the others gathered in the room, who now included another friend of the dead man, the actor Arthur Hoyt, who'd probably been alerted by Charles Maigne. By now Taylor's small living room was nearly overrun with people. Maigne noticed that the stack of canceled checks, so neatly ordered on Taylor's desk when he'd arrived, had been disturbed, brushed by someone's coattail as they'd maneu-

vered around the corpse. Several checks were drifting down to the
floor like autumn leaves, coming to rest beside the dead man who had
written them.

Into this roomful of buzzing suspicions and compromised evidence
now stepped a middle-aged man wearing a pair of pince-nez. His hair
was carefully combed, sitting high on his prominent forehead. Charles
Eyton, general manager of Famous Players–Lasky, had received a call
from Harry Fellows, telling him of Taylor's death. He'd zoomed down
from his home on Vine Street at the base of the Hollywood Hills to
Alvarado Court, and from the moment he arrived, it was clear that he
was in charge.

Well acquainted with the studio executive, Zeigler offered no pro-
test. Over the last decade the veteran police detective had learned to
give studio chiefs considerable leeway. He'd witnessed the spectacular
rise to power of the motion picture industry—and in particular, of Fa-
mous Players, the most powerful of all. Zeigler had come to accept that
when a studio official was present, he sometimes had to take a step back.

Known for his clipped New Zealand accent, the pugnacious Eyton, a
former prizefight referee, surveyed the scene as Fellows, MacLean, and
Maigne deferentially stepped aside. The manager walked around the
body. Taylor was still wearing the same tan gabardine suit he'd worn
the day before at the studio. Seeming satisfied that the director had died
of natural causes, Eyton did not press for any further investigation. The
doctor departed the bungalow as swiftly, and as anonymously, as he
had arrived.

MacLean, however, pressed his claim, repeating his story that he had
heard a shot. Eyton countered with a question: If Taylor had been shot,
then where was the bullet hole? The corpse seemed too pristine to have
been killed with a gun.

Perhaps Taylor had been shot in the back, MacLean suggested. But
no one wanted to touch the body until the coroner got there.

Eyton recognized that he had precious little time to act. People were
gathering in the courtyard. More cops had arrived. All of this was sure
to attract the press. And more press at that particular moment, with
Fatty Arbuckle sweating out his second trial in San Francisco, was pre-
cisely what Eyton's bosses, Mr. Lasky and Mr. Zukor, did not want. In

his days as a ref, Eyton had frequently scuffled with newspapermen—and with the law as well. He knew that a successful resolution to a crisis depended on taking control right from the start. Whether Taylor had been murdered or just dropped dead, Eyton knew the kind of headlines that might arise. So the unsmiling man with the Kiwi accent knew what he had to do.

Ivers, Van Trees, Hopkins, Fellows, Maigne, and Hoyt all worked for Famous Players. Eyton knew they'd obey orders. Pulling them aside, he instructed them to slip upstairs and search Taylor's bedroom. Anything written, no matter how seemingly innocuous, was to be collected and taken away before any reporters or more aggressive cops showed up.

Without Zeigler attempting to stop them—there was no evidence of a crime, after all, and these were all friends of the deceased—the studio employees got busy. They opened cabinets; ransacked drawers; dumped boxes of letters, production logs, and files into sacks. "We got all the literature and things like that that we could get and put them in a package," Fellows said. He handed off a package of papers to Van Trees, who hurried out of the house with them. Hopkins accepted another batch from Eyton himself, piled high in a wire wastebasket. The young designer was instructed to take the papers back to the studio and lock them in a safe.

As Hopkins went scrambling out through the courtyard, he passed Ivers, who was busy prying a letter from Taylor's locked mailbox with her hatpin.

Meanwhile, Douglas MacLean was growing frantic. "Charley," he pleaded, turning to Eyton. "Don't let them take his body away without turning it over."

The studio chief said nothing.

It was now past nine o'clock, an hour and a half since Henry Peavey had discovered the body. As Eyton had predicted, at least one reporter, Frank Bartholomew of the United Press, had already started nosing around, just as the deputy coroner, William MacDonald, finally arrived with his stethoscope and medical bag. Eyton insisted to MacDonald that the cause of death had been a stomach hemorrhage. But MacDon-

ald, trained as a nurse, knew a closer examination was needed before they could be sure.

He also knew that he could not ask the general manager of the most important film company in Los Angeles to step aside as he examined the body. So MacDonald permitted Eyton to bend down with him, shoulder to shoulder, as he reached his hand under Taylor's coat. When MacDonald withdrew his hand, his fingers were sticky with blood.

"I should say it was a stomach hemorrhage," the deputy coroner said sarcastically.

Now Eyton took over entirely. Reaching across the corpse, he started unbuttoning Taylor's vest. Pulling back the left side, he found that the dead man's shirt was stained a deep red. Looking back at MacDonald, Eyton declared that was "evidence enough" to turn the body over, and the deputy coroner offered no argument. Calling for a pillow to be brought to him, Eyton cushioned Taylor's head and took hold of one side of the body—"stone cold and very stiff and rigid," he'd describe it—while McDonald gripped the other. Together the two men flipped the corpse onto its right side. "We pulled his shirt and his vest up," Eyton said, "and we found the bullet wound."

Murder it was.

In that moment, everything changed.

Zeigler declared the apartment a crime scene. He and the other cops shooed everyone out, especially the reporters. Yet *murder* was a word not easily contained. It leaped like a gazelle through the courtyard, sending people running to their phones. Already onlookers were speculating about who could have done it. Edward Sands, whose arrest Taylor had sought? Or maybe a bootleg gangster? After all, a cabinet in the dead man's living room had revealed a large quantity of expensive bonded liquors—apparently legal, but who could be sure with that many bottles?

Late that morning, Taylor's body was carried out on a stretcher through the courtyard. By then Alvarado Court was overrun with newspaper people. They trampled the grass and crushed Emile Jesserun's calla lilies underfoot. Eleanor Barnes of the *Los Angeles Record*

managed to slip inside the bungalow, noting the martini glasses on Taylor's tray before police ordered her out. Undeterred, other reporters tried to sneak through the back door and snap photographs through windows. Others bolted off into the neighborhood, giving any residents who wanted their names in the papers the chance to tell what they had seen or heard, or what they'd imagined they'd seen or heard.

The madness had just begun.

# REACTIONS

Uniformed police officers trampled across Mabel Normand's expensive rugs in their dirty leather boots. Watching as they strode into her Seventh Avenue apartment, Mabel was hardly able to think, let alone form actual words. Standing in front of her, Officers Jesse Winn and Wiley Murphy confirmed what Edna Purviance had called early that morning to tell her. Mabel hadn't believed Edna. She'd asked her neighbor, Charles Maigne, to hurry over to Alvarado Court to investigate. Now, even before Maigne could report back to her, the presence of those grim policemen in Mabel's living room was evidence that the unthinkable had happened.

Billy was dead.

Murdered.

The cops were asking Mabel what she knew, where she had been, whom she had seen.

As best she could, Mabel recounted for Winn and Murphy the details of the night before. She had stopped by Billy's place for the books. They'd had a cocktail. She'd played the piano. They'd laughed and talked, and then Billy had walked her to her car. No, he hadn't phoned her at nine o'clock as he'd promised. No, she hadn't thought it was odd that he didn't. She'd fallen asleep before then, and her maid never woke her for phone calls.

Winn leveled his eyes on hers. Mabel's testimony was going to be important, he told her, because she was the last person to see Taylor alive.

But surely the last person to see Taylor alive had been his killer.

The officers glared at her, suspicion in their eyes.

Mabel was suddenly terrified.

By ten o'clock that morning, news of Taylor's death had spread throughout Tinseltown. Phones rang off their hooks. Telegram offices buzzed.

At the studios, directors called "Cut!" and light crews hopped down from the rafters as news of the murder passed from set to set. Actors and actresses, one paper reported, "their pallor showing through the greasepaint of their makeups, gathered in knots to discuss the tragedy and speculate on what prompted the crime."

At the Christie plant on Sunset Boulevard, directly across the street from Famous Players–Lasky, word arrived quicker than most. Many of those on the lot had frequently seen Taylor riding regally along Sunset in the back of his expensive car. Among the actors at the studio that morning may well have been Margaret "Gibby" Gibson. Was she distraught by the news? She and Taylor had been good friends once. Or did she say very little to those around her, choosing not to share her memories of her aristocratic costar, or the fact that Taylor had failed to help her when she'd asked?

Two miles to the east, on North Hobart Boulevard, Mary Miles Minter heard the news through the least desirable channel: her mother.

At eleven o'clock, Mary was just waking up. She rose from her bed, sleepy-eyed, still exhausted from the strenuous wrap of her last picture, *The Heart Specialist*, in which she'd been "thrown into a deep well, containing real, wet cold water." Days later, Mary was still recovering.

She dragged herself out of bed and over to her vanity, where she sat in her slip at her mirror, fixing her hair. All at once Mrs. Shelby started banging on her door.

"Let me in!" the older woman shouted.

Mary was surprised to hear her mother's voice. Mary, her sister, and her grandmother had all temporarily moved into a little house on North Hobart while their mansion on South New Hampshire was being renovated. Shelby, however, had remained behind to oversee the construction. Why was she here, banging on Mary's door?

"Mary, let me in!"

Mary told her she wasn't yet dressed. Her mother snarled that if she didn't open the door, she'd smash her way in.

Mary opened the door.

"Taylor has been murdered," Shelby announced. Her voice sounded almost triumphant.

How she knew, she didn't say. Nor did Mary ask. The stunned actress was unable to speak.

"Where were you last night?" Shelby asked.

Mary didn't answer. She might have asked her mother the same thing. Because, in fact, Mary had been right here with Margaret and her grandmother, reading out loud from the book *The Cruise of the Kawa*, a satire of South Seas travelogues by Walter Traprock, "laughing all the evening." But Mrs. Shelby had not come by to see them all night.

The two women just stood there for several moments, studying each other.

Finally, in a daze, Mary finished dressing and grabbed the keys to her car. She needed to get over to Alvarado Court. Pushing past her mother, she made her way to the stairs.

"Where are you going?" Shelby shouted.

"To him, of course," Mary replied.

"I shall not let you," Shelby declared, overtaking her daughter and positioning herself between her and the door downstairs. Mary glared at her.

Memories of the past likely flashed through Mary's mind: Shelby screaming at Taylor in front of the crew. The abortionist's bloody table. Her doll's face melting inside the oven. Something inside Mary cracked. She felt like an animal, she'd say later. All instinct. Fixating on her mother's neck, Mary was filled with the urge to tear out Shelby's jugular vein with her teeth.

"I am going to him," she seethed, "even if I have to throttle you to get past."

Stunned into silence, Shelby stepped aside.

Never before had Mary spoken to her mother in such a way.

Hopping into her speedy little car, she tore out of the driveway. Her seventy-year-old grandmother, worried about what might hap-

pen, ran after her, leaping up onto the running board to go along for the ride.

In San Francisco, Roscoe Arbuckle, waiting on tenterhooks for the jury's verdict, read the wire report passed to him by an enterprising reporter. "Mr. Taylor's death comes as a great shock to me," Arbuckle said, as newsmen gathered around to scribble down his words. "We were good friends and never a whisper of scandal arose about him. He was one of the finest fellows on the lot."

Back in Los Angeles, a testimonial from the likes of Fatty Arbuckle was the last thing Taylor's bosses at Famous Players–Lasky wanted.

The studio had been turned into a control room to manage the press. The banging of hundreds of typewriter keys echoed off the walls as publicists compiled glowing accounts of Taylor's career at Famous Players. The sordidness of his murder needed to be counteracted by the man's sterling reputation. If the studio could help it, Taylor would never be painted as a degenerate the way Arbuckle had been.

"Through a cowardly assassin's bullet," the statement from Charles Eyton read, "I have lost the best friend I ever had. I have known Billy Taylor for nine years, and we have worked side by side for the entire period without an argument or unfriendly word. In all the nine years, I have yet to find a man, woman or child who was not his friend."

Sometime after midday, newsboys started hawking the afternoon newspapers. "Murder shocks film colony!" they sang out in their prepubescent voices up and down city blocks. The giant black headlines, still wet with ink, showed what a daunting task the studio faced.

For the first time in weeks, another story had shoved Arbuckle out of the top spot. But even more shocks were waiting in a secure room at the Famous Players studio.

Eyton began going through Taylor's purloined papers. Page after page he lifted from the wire wastebasket, his eyes scanning each and every item gathered by his team of accomplices. Eyton's face grew serious. He summoned Jesse Lasky in to take a look.

Soon after that, Lasky placed a long-distance call to Adolph Zukor in New York.

Back at Alvarado Court, a car came screeching to a stop. It was just about noon.

Mary jumped out and ran across the courtyard. She was followed by her grandmother and a veritable army of newspapermen shouting questions at her.

Mary ignored them as she started up the steps of Taylor's front porch. But a policeman stood at the door, refusing to let her enter.

"It isn't true, is it?" the little actress asked dramatically.

The policeman confirmed that Taylor was dead.

With great flair, Mary flung her hand to her forehead and turned to the gathered newsmen. Growing up on the stage and in the movies, Mary always expressed emotion theatrically, with big, grand gestures. In front of the reporters she flailed her arms hysterically, uttering terrible cries. Mrs. Miles had to steady her to keep her from collapsing.

"Oh, my God, I can't believe it!" Mary wailed.

The newsmen pressed in around her. What could she tell them about Taylor?

"Why, he was a wonderful man," Mary said, "and everyone that knew him loved him." She didn't mention that her mother had been a notable exception to that rule.

The reporters had more questions for her, but Mary couldn't tarry any longer. She had to go to him. Pushing her way through the mob, Mary and her grandmother made it back to the car. As they sped off down the road, a caravan of newshounds followed, eager to see where the young star was headed.

Elsewhere in the courtyard, Henry Peavey was sobbing as he carried a bundle of bloody white cloths through the courtyard.

"His blood!" the valet cried to reporters. He'd been scrubbing the dark purple stain on the carpet, the last service he could perform for his

beloved employer. With a flourish, Peavey dumped the cloths into the court incinerator.

"I wish I could get the man that did it," the valet said, flashing his angry, bloodshot eyes. "I'd go to jail for the rest of my life if I could get him."

At the corner of Tenth and South Hill Streets, Mary slammed on her brakes and pulled her car up in front of the Ivy H. Overholtzer mortuary, a grand three-story Victorian house with a large portico and a tower. Leaving their cars at odd angles in the street, reporters scrambled to follow, magnesium cubes popping, as the distraught young actress made her way toward the funeral home. Mary leaned on the arm of her grandmother for support as she climbed the steep steps. To Mary, there seemed to be "a thousand of them."

Once they got to the top, the two women hurried inside and closed the door on the snapping newshounds behind them.

"I'm coming to give blood," Mary shouted deliriously as Ivy Overholtzer, a dignified man of forty-five, approached her. "Is he here? Is it true he was shot? He must be losing blood."

Overholtzer tried to reason with her, to explain that Taylor was dead, but Mary was having none of it. Either she was really delirious, or she was giving one of her finest performances. "I can lie down on the table," she insisted, "and you can pump the blood out of me into him."

"I can't do that," Overholtzer told her.

"You don't understand! This is my mate! I have the right! I claim this man!"

Overholtzer repeated that Taylor was dead.

Mary was becoming hysterical. "Many times you think people are dead, but if you just take the right action, they'll come back. Just stop arguing, Mr. Overholtzer! Take me to him!"

But the undertaker could not let anyone see the remains of the victim. At that moment, in a private room of the mortuary, the coroner, Frank Nance, was preparing for the postmortem examination. Overholtzer promised that if Mary came back the next day, he'd give her some time alone with the body. After much cajoling, she finally agreed to leave.

Pushing through the crush of reporters back to her car, Mary couldn't go home. Not yet. There was one more place she needed to go.

At her apartment on Seventh Street, Mabel was worn down by the policemen's incessant questions. For the third or fourth or maybe fifth time, Mabel recounted her movements of the night before. She'd been out running errands. She'd bought some peanuts. She'd swung by Billy's to pick up the books.

At first she'd been unsure of the exact time—who paid attention to clocks?—but eventually she'd narrowed it down. She'd left Billy's around 7:45, she told the police. He'd been standing there, in the courtyard, blowing kisses to her as she drove away.

It was the last image she would have of him.

Mabel sobbed.

How could she get through all this without Billy to support her?

Suddenly there was a commotion outside. A crowd had been growing all morning around Mabel's apartment, and now police were trying to prevent someone from reaching her front door.

"I want to see Miss Normand," a girlish voice was crying above the din.

Mabel made her way to the top of the steps. "Who is it?" she called down to the police.

"It's Mary Miles Minter," shouted the little figure, nearly obscured by a phalanx of blue-uniformed officers.

Mabel told her to come upstairs.

The police stepped back, letting Mary march determinedly past them to the second floor.

Mabel beckoned Mary to follow her into the bathroom.

"We'll run the water," Mabel said, shutting the door behind them. "If they've got anything going, they can't hear our conversation."

Mabel knew the long, tortured history that festered between Mary and Billy. She wasn't about to let anyone hear what Mary might say about their so-called romance.

The two women weren't exactly friends. There was nearly a ten-year age difference between them, they'd never worked at the same studio, and their temperaments were as different as chalk and cheese. But Ma-

bel had made efforts to be kind to Mary, perhaps because she felt sorry for her, living with such heartbreak over Billy. The previous summer, she had sent the younger woman flowers before her trip to Europe. And while Mary might have been envious of Mabel's closer relationship with Taylor, she couldn't deny that the comedienne had been one of the few people in Hollywood who had been genuinely decent to her. So she had felt safe, at this terrible time, coming to Mabel.

She also seemed determined to find out just what Mabel knew. As the water splashed into the sink, Mary asked if she and Taylor had been lovers.

"We were good friends," Mabel told her. "But we were never lovers."

Mary breathed a sigh of relief. But what had Mr. Taylor ever said about her?

Mabel was shrewd, and once again kind. She told the young woman exactly what she wanted to hear. "Mary," Mabel said, "Billy worshiped the ground you walked on. But you were so young that he feared you would love him all the days of his life. He didn't want to hurt you."

Such carefully chosen words reassured Mary that her deeply held beliefs were real. Mr. Taylor had loved her. He had truly, truly loved her.

The two women turned off the water and emerged from the bathroom. The officers did not attempt to question Mary as she descended the steps of Mabel's apartment. But they did take note of the young actress's distress. Every last detail would be reported back to their superiors.

The police wondered why was Miss Minter so upset. Why she was so desperate to speak to Mabel Normand. Just what sort of relationship did Mary Miles Minter have with Taylor?

And what might she know about the events of the night before?

As night fell, Charlotte Shelby withdrew to her mansion on South New Hampshire Avenue, where in the coming days she would keep a low profile. Unlike her daughter, the very private Mrs. Shelby did not draw attention to herself with frantic rides all over town. Instead, she continued overseeing the renovations of her house, stepping carefully through the sawdust and the plaster, doing her best to carry on even as the furor outside intensified. By minding her own business, Mrs. Shelby ensured that no policemen came knocking at her door.

# KING OF THE COPS

Very early on February 3, 1922, barely twenty-four hours after Henry Peavey found the cold body of William Desmond Taylor sprawled out on his living room floor, Edgar C. King, forty-six, an eighteen-year veteran of the police force, made his way through the congested streets of downtown Los Angeles. Another frosty day was dawning over Southern California. Many of the ficus trees had browned overnight, and the palms seemed to tremble in the arctic air.

Detective Sergeant King's destination this morning was the white-marble Hall of Records on West Temple Street. The twelve-story structure, with its several peaked attics, soared over all the other buildings in the surrounding neighborhood. Even the majestic clock tower of the adjacent red-stone courthouse didn't reach as high into the sky as the imposing Hall of Records.

Sergeant King rode the elevator almost to the top.

There, on the eleventh floor, higher than nearly everything else in the City of Angels, were the offices of the famous flamboyant "fightin' prosecutor," Thomas Lee Woolwine, who had summoned King into his presence.

District Attorney Woolwine's sobriquet came not only from the fierce battles he waged in courtrooms. A year earlier, he'd also hauled off and punched a defense lawyer, leading to a fine for contempt of court and the disruption of several trials. A few months later a county grand jury investigated Woolwine's office, calling it a "carnival of extravagance, waste and corruption," but most agreed the move was politically mo-

tivated (Woolwine was the rare Democrat in Republican Los Angeles) and the investigation went nowhere.

Even with his penchant for grabbing the headlines, Woolwine retained a homespun air. His modest home in Echo Park was the best evidence against his enemies' charges that he was accepting kickbacks. Although he was undeniably ambitious—he'd had his eye on the governor's mansion for some time now and hoped to launch his campaign in the spring—his personal aspirations were tempered by an authentic commitment to justice. Catching Taylor's killer would certainly boost his campaign for the state's top job, but that didn't make Woolwine's passion for catching crooks any less genuine.

Flush with excitement, King took a seat in front of the colorful DA. "The 'bumping off' of a famous person like William Desmond Taylor," King would later write, "is the sort of oyster that any detective delights to open." So he was elated when Woolwine, in his rich, melodious Tennessee accent, asked him to represent the district attorney's office in the murder investigation. Woolwine wanted an ironclad case when the killer was brought to trial.

What drove Eddie King wasn't the prospect of glory, but the thrill of the hunt. Around the department, King was heralded as having "solved more major crime mysteries than any other police officer in Southern California." Most famously, he'd helped catch the kidnappers of wealthy young Mrs. Gladys Wetherell a year earlier, by using new technology at the central telephone station to trace the kidnappers' ransom calls. He'd also played a key role in the arrest of Louise Peete, a notorious murderess currently serving a life sentence.

King brought Woolwine up to date on the Taylor case. The autopsy performed at the Overholtzer mortuary had located the .38-caliber hollow-point bullet. The little blue slug had entered the victim's left side, six and half inches below his armpit, before traveling upward through the seventh interspace of his ribs, penetrating his left lung, passing out of his chest and finally lodging in his neck. Such an unusual trajectory made a queer sort of sense: the holes on Taylor's jacket and vest did not line up. The dead man's arms had apparently been raised in the air when he was shot.

Given the position of the body on the floor, police were speculating that Taylor had been seated at his desk at the time of the attack. The

killer had likely snuck up behind him, either startling him enough that he threw his arms in the air, or ordering him to "stick 'em up."

That was all interesting. But what really got the detectives' attention was what they'd found in Taylor's papers. Not that there were many of them; King told Woolwine that several Famous Players employees had made off with armfuls of documents before Officer Zeigler had declared the apartment a crime scene. But the few scraps left behind by the studio people were provocative enough.

The murdered director, it turned out, had led a whole other life before coming to Hollywood. His real name was William Deane-Tanner, and some years earlier he had walked out on his wife and daughter in New York. This past summer, however, according to letters found in the apartment, Taylor had met with his daughter, Ethel Daisy, on his way back from Europe. It was the first time she had seen her father in more than a decade.

Was this girl the "secret sadness" Taylor had told friends about? Attempts were being made to reach the wife and daughter, who, according to the letters, were living in Mamaroneck, New York. Evidently in his last months Taylor had been trying to reconcile some of the secrets of his past. But, as King explained, the abandoned family was only one of many mysteries in Taylor's life.

Considerable trouble had existed between the dead man and his former valet, Edward Sands. King gave Woolwine a full report of the stolen jewelry, the pawn tickets, and the warrant for Sands's arrest. Friends and associates also told police about a series of harassing phone calls Taylor had received over the last few months. A conversation with Neil Harrington, one of the Alvarado Court neighbors who'd found the body, also revealed the fact that two men had tried to gain access to Taylor's bungalow just a few days before the murder, and another person had been prowling around the place months earlier. For many detectives, this all pointed to Sands. Solving the Taylor murder, they believed, could be simply a matter of finding his former valet.

But King wasn't so sure, and he made his doubts clear to Woolwine. For one thing, Neil Harrington was absolutely certain that neither of the men he'd seen was Sands. Even more critically, King saw no logic in the theory that Sands would harass Taylor. What purpose would it serve? And why would a man wanted for a felony risk returning to Los

Angeles? Why, for that matter, would Sands kill Taylor? Greed was Sands's motivation. If Sands had been the one to pull the trigger, he would never have left behind the $78 in cash detectives found in Taylor's jacket pocket, or the two-karat diamond ring or platinum watch he was wearing.

To King, this case had "crime of passion" written all over it. Just what sort of passion, he wasn't yet sure. But he knew it was impulsive. Reactive. Maybe it was motivated by revenge. Or jealousy. Maybe it had happened in the midst of an argument.

Besides, their only eyewitness, Faith MacLean, was also emphatic that the man she'd seen leaving Taylor's home was not Sands. And she knew the former valet. Even in the darkness, she would have recognized him. He was not as heavy as Sands, she said.

Beyond that, MacLean hadn't been able to give the detectives much to work with. All she'd been able to recall was that the man she'd seen had been clean-shaven and wearing a plaid or checkered cap. He was stocky, she thought—"not fat but stocky"—and possibly had a prominent nose. He gave off a "rough" sort of appearance, she said. Pressed for more, MacLean said, "He was dressed like my idea of a motion-picture burglar." As for his age or his height, the young woman couldn't say. Only later, after much pressure, did she guess that he might have been about thirty-five and that he stood, possibly, about five foot nine.

Still, MacLean, along with Mabel Normand, had allowed detectives to establish a timeline of the killing. King told Woolwine there was general consensus that the killer had slipped into the bungalow during the few minutes when Taylor had been walking Normand to her car. He'd apparently been lurking in the shadows, waiting for an opportunity. The cement-paved alley behind the courtyard—the exact place where the MacLeans' maid had heard someone walking—had been littered with six cigarette butts, some only half smoked, leading detectives to conclude that the man waiting there had been anxious. One cigarette—likely the last one the killer lit before he spotted Taylor walking off with Normand and quickly sneaked into the house—was barely touched.

King estimated that probably no more than five minutes had passed between the time Taylor returned to his apartment and the time MacLean and others heard the shot. Whatever transpired between Taylor and his killer was brief. Either the man with the gun

came and did what he intended to do quickly, or something unexpected happened that caused him to shoot.

Taylor's own gun had been found in a drawer upstairs. It had not been discharged.

The director's chauffeur, Howard Fellows, had rung Taylor's doorbell at 8:15. There was no answer, Fellows told police, although the lights were on in the apartment; assuming the director was either asleep or out, Fellows had put the car in the garage and gone home. The chauffeur's statement fit the detectives' working timeline: by 8:15, Taylor had already been dead between twenty and twenty-five minutes.

Eager for a scoop, reporters had been scrambling through the neighborhood since yesterday morning, digging up more witnesses. Only now, King said, were police getting around to interviewing these people themselves. Two guys at a nearby gas station were among the most important witnesses. They told of a stranger asking for Taylor's address just a couple of hours before the murder. In addition, two streetcar operators reported a man boarding the Big Red at either 7:54 or 8:25—they couldn't remember precisely which. Given how few passengers ever boarded at the Maryland Avenue stop, though, they took note of the man. All four witnesses described a similar suspect: aged about twenty-six or twenty-seven, with dark hair. Like the man MacLean saw, this man also wore a cap. But he was also described as being well dressed—hardly MacLean's image of a motion-picture burglar.

The newspapers, however, disregarded the discrepancies and jumped to the conclusion that the witnesses were describing the same man.

King was absolutely convinced that the culprit was not Edward Sands. When Floyd Hartley, the gas station owner, was shown a photo of Taylor's former valet, he was "inclined to think they were different individuals." Besides, as King pointed out to Woolwine, why would Sands need to ask directions to Taylor's apartment?

King told Woolwine that while many on the force were convinced that Sands was the killer, there were other possibilities. Taylor might have been paying off a blackmailer. Police were learning that the director was considered "the easiest 'touch' in Hollywood . . . an extremely liberal man to borrow money from." Taylor's books, in full view on his

rolltop desk, were full of stubs marked "cash." These were presumed to be loans to individuals, but King wondered if some of them had been blackmail payments. Certainly a man with an abandoned family was susceptible to blackmail. The checks ranged from $200 to $1,500. Moreover, investigators were befuddled by a yawning disparity of some $13,000 between the figures Taylor had been preparing to report on his tax form and a preliminary accounting of his income and expenses.

Finally, King reported, some were speculating that Taylor might have been killed in a dispute over a woman. This was the theory the newspapers, especially the ones controlled by William Randolph Hearst, were favoring in their headlines:

JEALOUS MAN HUNTED AS SLAYER OF TAYLOR. POLICE CONVINCED EITHER WOMAN KILLED DIRECTOR OR FURNISHED MOTIVE.

In fact, police were hardly convinced of such a fact. Most were still betting on Sands. But jealousy as a motive did fit King's hunch that the murder was impulsive, a crime of passion.

But why had a woman even entered the speculation, given that all of the witnesses insisted they had seen a man?

King explained that detectives kept hearing about two particular females in Taylor's life. Both ladies had given them reasons to be suspicious. Mabel Normand was a known addict, with drug dealers and bootleggers as contacts. And Mary Miles Minter had made quite the spectacle of herself when Taylor's body was found. Exactly what was her relationship to the dead man?

Woolwine had his own suspicions. Finally he offered King a lead of his own, handing the detective a letter across his desk.

To his trained eye, the letter struck King as the work of a woman, evidently "a lady of refinement." The letter informed the police that a search of the basement of Mabel Normand's apartment at Seventh and Vermont would reveal a .38-caliber pearl-handled revolver. Taylor had been killed with a .38-caliber bullet.

All sorts of tips like this had been flowing into the district attorney's office, by phone, letter, and telegram. But this one, Woolwine thought, warranted an investigation as soon as possible. Taking the assignment,

King headed out of the Hall of Records to pay a visit to Mabel Normand.

Back on Alvarado Court, other agents from Woolwine's office were mapping out Taylor's bungalow and searching the surrounding neighborhood. Fingerprints were taken, but too many people had elbowed their way into the apartment on the morning the body was found, moving chairs, sitting at tables, and opening drawers, for the police to expect anything very useful to be found.

The district men, as they were called, wore more expensive suits than the gumshoes on the police force. With solemn, serious faces, they kept largely to themselves. The city cops viewed the district men as inefficient interlopers. But even worse, from their perspective, was a third investigation team, this time from the county sheriff's office, who the cops viewed as too lenient. Rivalries and tensions were percolating everywhere.

Stopping off at Alvarado Court on his way to Mabel's, Eddie King suddenly found himself in the middle. He would have to be a mediator as much as a detective in this mess. But King was up to the task. A native of Indiana like Will Hays, King possessed the same sort of midwestern sangfroid. He was plainspoken, a devoted family man, married for twenty-five years. He and his wife had raised their two children in a modest home on West Forty-Fifth Street in working-class South Los Angeles, a world away from the upscale Westlake district where Taylor had lived. Like Hays, too, King was a short man; "the smallest man in stature on the police force," one report called him. But that slight frame contained a substantial mind. Six years earlier King had been sent from police headquarters to the East Side substation, where he'd taken the younger plainclothesmen under his wing to train them as top-quality detectives. King's reputation endured, which was why Woolwine had made him his point man.

But the DA wanted him to work on his own, "independent of all officers of the police department." King knew that would cause only further resentment; besides, it wasn't his style. A lone-wolf approach hindered good detective work; King needed collaboration. So, in defi-

ance of Woolwine's orders, he approached Sergeant Jesse Winn, another longtime veteran of the force, and asked him to partner with him on the case. Winn agreed.

The two detectives complemented each other well. Winn was younger than King, just turned forty, and considerably taller than his partner. He was also more aggressive, the bad cop to King's good. Since Winn had already interviewed Mabel Normand the day before, it made sense that he accompany King now to the actress's fashionable abode on Seventh Street.

Could Normand really be hiding the gun that had killed Taylor? Had she pulled the trigger? Even if her story checked out that she'd left Taylor and gone home to bed, she still could have come back and plugged him. More than one detective had noted that if the gun had been fired while Taylor was embracing his killer, and if the killer had been short—about Mabel's size, in fact—then the unusual angle of the bullet through the body might have made sense. Had Mabel been in Taylor's arms when she shot him in the ribs?

Or maybe one of her drug contacts had offed him. Might Mabel have been in cahoots with her chauffeur, William Davis? The police were trying to determine if Davis "handled any hop." Wallace Reid, it was said, received his drug deliveries through his chauffeur. Maybe Mabel did as well.

King and Winn pulled up in front of the actress's apartment.

On edge, distraught, red-eyed from crying, Mabel did not try to stop the two detectives from searching the place. She stood back, morose and trembling, as King and Winn carefully scoured the place. "From cellar to attic we went," King said, "devoting a great length of time to turning over everything where it would be possible to hide a gun." Finally, in a dresser drawer in Mabel's bedroom, the two cops found something. Not just one gun. But two.

King inspected them closely. Both were .25-caliber revolvers, "neither of which could have had any connection to the murder," he realized.

King turned to Mabel and apologized for disturbing her. He and Winn left her alone without any further questioning.

This "beautiful, impulsive, unfortunate" woman, King firmly be-

lieved, had no involvement in Taylor's death. Mabel was a victim herself, of timing and circumstance. "I do not hesitate to say," King informed Woolwine, "that all suspicion cast upon her was unjust."

He wasn't so sure he could say the same about that other woman in Taylor's life, however.

And so King made plans to interview Mary Miles Minter.

# THE MORAL FAILURES OF ONE CONCERN

At about the same time that Eddie King was searching Mabel Normand's basement in Los Angeles, Adolph Zukor was being driven downtown to Pier 54 in New York. The studio chief traveled in the utmost secrecy. He didn't want any reporters on the pier to spot him.

He was hurrying to meet Cecil B. DeMille, arriving from Europe onboard the *Aquitania*. Night had fallen. A brackish mist rose from the Hudson River, allowing Creepy to move easily among the shadows. He knew the press dearly wanted a statement from him about the death of Taylor, and he just as dearly did not want to accommodate them.

Zukor had cabled DeMille to apprise him of the Taylor tragedy. The message had reached the director somewhere in the North Atlantic. No doubt at Zukor's urging, DeMille then sent his own ship-to-shore cable, explaining that he would not be able to take questions from the press when he disembarked. He explained he was suffering from an attack of inflammatory rheumatism, which, while not serious, was still "exceedingly painful," forcing him to be carried off the ship on a stretcher. Zukor hoped DeMille's little stunt would keep the hounds at bay.

But even as the mogul scurried down the pier, shrouded in fog, one of those infernal muckrakers had already made his way on board the ship and cornered DeMille in his stateroom, compelling him into making a statement.

"I have just heard of the terrible tragedy," DeMille said. "You may

look all the world over and you could not find a cleaner man than Taylor." When the reporter suggested that a woman might be behind the killing, DeMille instinctively guessed the studio's position and discouraged such talk. "Mr. Taylor was not that kind of a man," he insisted. Thankfully, the stretcher arrived at that point, and DeMille demurred from any further comment.

On the dock, Zukor facilitated the transfer of his top director from ship to ambulance. From there they zigzagged their way uptown to the Hotel Ambassador at Fifty-First Street and Park Avenue. Finally behind closed doors, Zukor filled DeMille in on all the horrific events of the past two days. The Taylor murder was only one part of it. Fatty Arbuckle's trial had just ended in a second hung jury. Not only were they faced with many months of the Taylor investigation, but they'd also have to endure the gruesome details of Fatty's pajama party for a third time.

The papers were absolutely giddy with scandal. Given the boost in sales they'd gotten from the Arbuckle calamities, editors were covering Taylor's murder with comparable headlines and sensation. "The murder of any screen director would have brought enough bad publicity," Zukor said. But "Taylor's strange career," he realized, "compounded the trouble."

As it turned out, Zukor's esteemed defender of the faith hadn't been quite as virtuous as he, and everyone else, had thought. Not only had Taylor abandoned a wife and daughter, for whom the press and police were still searching, but he'd also been supporting a sister-in-law, Mrs. Ada Deane-Tanner, and her two daughters in Monrovia, California, because his brother had also deserted his family. Had the two brothers run off together on some nefarious scheme? Some were speculating that Denis Deane-Tanner had actually been the man others knew as Edward Sands, and that he may have killed his brother to avoid exposure.

Zukor was appalled by all the lurid speculation. And yet what a coarse, meandering life the supposedly upstanding Taylor had led before settling down in Hollywood. Sometimes he'd been known as Tanner, sometimes as Cunningham Deane. He'd worked on the railroad down South and prospected for gold in the frozen Yukon. Day by day, reporters were locating more people who had known Taylor in his various other lives. Hollywood had known that the director was a man of mystery. But no one had suspected he'd taken $600 from the antique

store he'd managed in New York and then disappeared—making him as much a petty criminal as his valet Sands. Why had he been so desperate, gossips wondered, to run away from his wife?

The Hearst papers suggested an answer.

"Find the woman!" their headlines screamed. How dearly the Hearst editors wanted the murderer to be a woman. In the past year, two high-profile female killers, Louise Peete and Madalynne Obenchain, had kept their broadsheets selling like hotcakes. Fervently hoping for another glamorous murderess, Hearst's reporters were bending over backward to promote the theory. "It is police experience," the *Los Angeles Examiner* wrote, "that down below the surface of many such a crime may be found a woman."

Yet even as Famous Players tried to dismiss the "woman theory," calling it "Hearst hyperbole," the newspaper did have some basis for its stories. Detective Sergeant Eddie King, Woolwine's man on the case, had admitted to reporters that despite the fact that Mrs. MacLean, the chief eyewitness, was very clear that she had seen a man leaving Taylor's apartment, it was possible a woman had been the reason the killer had pulled the trigger.

Under this theory, Thomas Dixon, who'd been courting Mary Miles Minter, was being hunted for questioning. To Zukor's great distress, another Famous Players name, this time their innocent little blond star, was being dragged into the scandal.

For the studio, this was as bad as it got. But if Zukor thought it couldn't get any worse, all he had to do was wait a day.

The headline practically shouted up at him from the newspaper on his desk.

### DEAD DIRECTOR VISITED QUEER PLACES!

With a sinking heart, Zukor read on. Taylor's patronage of Los Angeles' red-light district was described in sensational detail—complete with the implication that the director had frequented all-male houses of pleasure. While some unnamed friends suggested Taylor had merely been seeking "color" for a picture, the damage was done. His "queer

habits" would henceforth be recurring themes in the syndicated dispatches of yellow journalists Edward Doherty and Wallace Smith. The reputation of Hollywood's noble champion lay in tatters.

By association, Zukor feared the same for Famous Players.

His foes were already pointing fingers. "It is a shame," Sydney Cohen said accusingly, "that some seem to permit such license. The entire motion-picture industry should not be blamed for the moral failures of one concern."

For the first three days of the story, the studio had failed utterly in the message wars. Trying to contain the "woman theory," Zukor's deputy, Charley Eyton, had only made things worse. "The police theory that a woman is at the bottom of the Taylor murder mystery was scouted at the Lasky studio today," the *Los Angeles Record* dutifully reported. "I know positively that Bill Taylor was not intimate with any woman," Eyton was quoted as saying. But the next day, when stories of Taylor visiting the "queer places" broke, he surely regretted his choice of words.

Lasky did what he could to contain the damage, telling the press that the studio was pledging "resources of time and money" to assist police in "the detection of the murderer." But that, of course, was a lie. Lasky had no intention of helping the police.

At least not until he and Zukor figured out how to deal with the information they'd discovered in Taylor's papers.

At home that night, Zukor told his valet to start packing his bags. It was time for the film chief to take a rare trip out to the land of palm trees and swimming pools.

The murder of Taylor—the man who'd once argued for the decency and integrity of Tinseltown—ratcheted the campaign of the reformers up to new levels. "Only a while ago," one editorial chided, "it was Miss Thomas going the primrose path to perdition in the hell-holes of Paris. Then [it was] the divorce scandal involving the Fairbankses, then the nasty mess in San Francisco. Now [it is] the murder of the director Taylor." The cumulative effect of these scandals and moral lapses, Hollywood's critics charged, would be to destroy the morals of those millions of children who attended the movies faithfully every week—children who would now, in the wake of Taylor's death, be subjected to stories

of drugs, love affairs, and abandoned families. "This fearsome scandal [would] have the effect of cleansing a profession which has recently shown alarming signs of moral decay," predicted another editorial.

No wonder Zukor was heading to the coast to take charge.

Even as the film chief bought his ticket, moralists were thundering that the Taylor murder had exposed the "mad pursuit of twentieth-century happiness"—which, in their definition, meant "loose morals, bachelor apartments, gay parties, drug sessions, new sensations and new experiences." Such depravity, they charged, was the fault of Hollywood's overpaid libertines. "The thing to get excited about, to our way of thinking, is not the fact that Hollywood stages some wild parties," wrote one paper in the nation's heartland. "They can be found on every Main Street. But the fact that a chit of a girl with a pretty face and an intellect that aspires no higher than *The Police Gazette* [an allusion to Mabel, obviously] can earn more in a year than we pay the President of the United States. Surely our standards of values are all wrong. Maybe we ought to pass a law about it, or have a congressional investigation, or something."

*Pass a law. Congressional investigation.* Such words struck cold terror into Zukor's heart. Inking his fingers with as many newspapers as he could read, the film chief recognized the stakes at hand. "The motion picture industry in this country," wrote the *McKean* (PA) *Democrat*, "as the result of another scandal, this time a murder, is on trial for its continued existence."

To Zukor, such reports were not hyperbole.

If he had been able to foresee Taylor's murder, the movie chief might have written February instead of March onto Will Hays's contract. How helpful it would have been if Hays had already been on the job, giving interviews, offering reassurances, defending the movies in the wake of the Taylor scandal—the way Taylor himself once had done.

But at the moment the postmaster general was on holiday at the Flamingo Hotel in Miami Beach. On the day Taylor's body was found, Hays was taking a joy ride on an eleven-passenger aerial cruiser across the Florida Straits to Havana. He told reporters he had "absolutely no plans to go to California." He was taking a rest, he insisted, "the first real one I've had in a long time," and nothing, not even a bullet in Wil-

liam Desmond Taylor's neck, would take him away from it. Hays knew the pressures he would be facing as soon as he stepped into the center ring. So, for the moment, he was having fun.

Zukor, not so much.

The spring of 1922 was supposed to have been the time when Famous Players rebounded from its troubles of the past twelve months. Zukor had decided to move all production to Hollywood, strengthening the studio's financial situation. He had proposed an ambitious schedule, "a production program that eclipses those of the past few years," *Variety* reported. The national economy was on an upswing. Unemployment was down, and weekly earnings were on the rise. Despite the ongoing Arbuckle calamities, his optimism had not been unfounded.

But that was before Taylor had been discovered on his living room floor.

On the day before Zukor was set to leave for Los Angeles, Famous Players' stocks were still down. Common stock had declined nearly 3 percent in the past year, preferred stock nearly 5, and there were no signs of a rebound. Even worse, the company's net income had plunged nearly $1 million during the same period.

Once again, at the moment Zukor glimpsed a light at the end of the tunnel, something happened to snuff it out.

How could he turn things around now, with the press peeling away Taylor's secrets—and Minter's, and Mabel Normand's—like some pungently ripe onion, layer by layer, until everyone was left slobbering all over themselves?

There was a way out, however, if Zukor chose to take it.

He could have cut his losses right then and there, and stopped the Taylor investigation in its tracks. All he needed to do was call Lasky and tell him to go to the police with what he knew.

At the Famous Players plant in Hollywood, Taylor's papers were still safely guarded under lock and key. The collection was substantial. Eyton, Fellows, Maigne, Hopkins, Ivers, and Van Trees had carried off quite a bit of material from the director's bungalow that morning. Many of the documents were undoubtably innocuous, the flotsam and jetsam of everyday life. But as later events would make apparent, amid all the electric bills and car repair estimates, Eyton had discovered

other, more pertinent information. Perhaps there was an accounting of Taylor's missing assets. Perhaps an explanation for why the director had been so distraught during his final months. Perhaps threatening notes, or diary entries, or blackmail demands.

Whatever was in there, Eyton and Lasky had read it, and they had communicated at least its significance, if not yet its details, to Zukor.

As would eventually become clear, somewhere in that mass of paper, secreted within those piles of onionskin and cardboard, production notes and calendars, red-striped air mail envelopes and Western Union telegrams, was evidence of Taylor's killer.

If he had chosen to, Zukor could have ended the investigation at any time by telling Lasky to go to the police, or by going himself.

But he didn't.

Which could only mean that revealing what he knew about William Desmond Taylor's killer would be worse—much worse—than the agonizing bloodletting his company was taking with each new edition of a newspaper.

# "DO YOU THINK THAT
# I KILLED MR. TAYLOR?"

Mary stepped gingerly into the funeral parlor like a newborn fawn still unsteady on its legs. In her arms she carried a bouquet of fragrant 'Black Prince' roses. As Mr. Overholtzer had promised, she was being given some time alone with Mr. Taylor's body.

By now the coroner had finished his grisly business, cutting open the victim's chest and sewing it back together. Mr. Overholtzer had dressed the corpse in clean clothes, combed its hair, and powdered its face. The body was now ready for viewing.

Mary stepped into the room alone. Mr. Taylor lay flat on his back on a table ahead of her, his hands folded over his chest. The room was bitterly cold.

Mary approached timidly.

She could barely reach the man she loved. The table was high, and she was so small. "I wanted to kiss him on the lips," Mary said. But she couldn't lean over far enough.

Mary despaired. She would have to be content just touching his hand.

But the moment she did so, she immediately shrank back.

"That deadly cold," Mary said, "convinced me as nothing else could have done. No life could return to this man."

Mary let out a howl. "God, take me, too," she cried, the sound echoing through the quiet mortuary.

Overholtzer hurried in. With tenderness he tried to guide Mary away

from the corpse, but she wouldn't let go of Taylor's rigid arm. Only with great effort was the undertaker able to pry the little actress away, hustling her into his office, where he gave her a glass of water.

But Mary was inconsolable.

"Who could have done this to him?" she cried. "They crucified Jesus! Now they've crucified my mate!"

A short time later, in her mother's presence, however, Mary's tears had dried.

Mrs. Shelby had temporarily emerged from her seclusion, having decreed that both she and Mary should meet the press. Something clearly needed to be done about all the insinuations in the newspapers. Mary's name could not continue to be dragged into this mess.

Because, Shelby knew, if they kept talking about Mary, eventually they'd get around to talking about her.

And so she invited a select group of reporters to North Hobart Boulevard. The newspapermen and women filed into the little house, notebooks in hand, cameras slung over their shoulders. No doubt Shelby had coached Mary on exactly what to say in order to squelch this trouble of theirs as soon as possible.

Mary daintily took a seat in front of her inquisitors. The first thing she was asked was whether Taylor had ever proposed marriage to her. No, she dutifully replied, he had not. Mr. Taylor was just a good friend to her, who looked on her "as a mere child."

How it must have killed her to say such things, but not in this setting, not with her mother looming behind her, could Mary refer to Mr. Taylor as her mate.

Her face darkened, however, when a reporter told her that Taylor had been married, with a daughter about her age.

"Married?" The little actress was horrified, flabbergasted. "I'm sure he wasn't," Mary managed to say, "or surely he would have told me." She paused. "We were such good friends."

That evening, unable to sleep, Mary took advantage of her mother's absence—Shelby was still spending her nights at the New Hamp-

shire house—to phone George Scarborough, who'd written the play on which her film *Moonlight and Honeysuckle* had been based. Would Scarborough like to go for a spin? Urbane, cultured, and a mature forty-two, the playwright was exactly the sort of man who could raise Mary's spirits a bit. Despite the hour, Scarborough was glad to meet the nubile young actress.

And so they careened around town in Mary's blue runabout, stopping at one night spot after another. But Mary was a fickle little fawn. At one of their stops she got word that her occasional beau, director Mickey Neilan, was looking for her, so she made a beeline for the Los Angeles–Salt Lake Railroad station, where Neilan was shooting some night location scenes. Scarborough hadn't expected to spend his evening with Mary watching Neilan and his cast work into the wee hours of the morning. But that was where Mary wanted to be.

After calling "Cut" for the last time, Neilan invited everyone back to his house for a little impromptu party. Despite the melodrama from earlier in the day, Mary was game. Gloria Swanson, with whom Neilan was having an affair, also stopped by. So did Jack Pickford. Mary tried frying some eggs for everyone, but she'd never done much cooking for herself, and she ruined them. That made everyone laugh. Mary's tears of the morning seemed forgotten.

But as the party was breaking up, Neilan turned serious.

"I've got something very important to say to you, Mary," he told her. He suggested they take a drive, just the two of them. Scarborough, suddenly superfluous, was taken home in Mary's car by Neilan's chauffeur. Mary climbed into the director's vehicle, and the pair zoomed off down Santa Monica Boulevard, nearly deserted that time of night.

They ended up at Neilan's studio. The lot was dark, with only the night watchman there to greet them. Another bitterly cold night held the city in an icy grip. Mary's teeth were chattering as they settled down in Neilan's office. The director switched on a light, aiming it at the young actress as if he were about to interrogate her.

In fact, he was.

The director lit a cigarette. He told Mary that she had no idea how terrible the Taylor investigation was going to become for her. The murder was shaping up to be the most sensational scandal Los Angeles had

ever seen. What they needed to do, Neilan insisted, was get her letters to Taylor before the police got hold of them.

Mary was surprised that Neilan even knew she'd sent Taylor letters. Of course he did. Charley Eyton had them, Neilan told her.

This surprised Mary. But she insisted there was "nothing in the letters that the world can't read." Part of her seemed willing, even eager, to get the letters out there. If published, her letters would set things straight about the love she and Mr. Taylor had shared and expose the lies she'd been forced to tell at her mother's hastily arranged press conference.

Neilan glared at her. "You loved Bill, didn't you?" he asked.

Mary admitted that she had.

Neilan was clearly concerned about this. He revealed that Taylor had told him about Mary's histrionic visit to him right before Christmas. The news stung: Mary felt it hadn't been very gentlemanly of Mr. Taylor to disclose the incident. But what worried Neilan was that if the police found out about Mary's visit, they might start to suspect her. "For God's sake," Neilan said, "if you know anything about the murder of Bill, tell me now!"

Mary was aghast. "Do you think that I killed Mr. Taylor?"

"I'm just trying to find something out about this," Neilan replied. "This is going to be an awful affair."

"I did not kill William Desmond Taylor," Mary said indignantly, "and don't know who did!"

Neilan lit another cigarette. He asked Mary to rack her brain and think of someone who had a motive to kill Taylor. Did she know anyone who had any conflict with Taylor? Had she ever heard anyone threaten him?

Mary paused. Neilan waited to hear who she might accuse.

But then she told him she couldn't think of anyone.

Neilan gave up. "You mustn't make any move without your attorneys," he advised, as he switched off the lights and prepared to bring her home. "This involves picture people, and you know how Hearst hates picture people." He reiterated the need to get Mary's letters.

The sun was coming up when he drove her home.

# POWDER BURNS

In the shooting gallery of the central police station downtown, Detective Sergeant King took aim at a piece of gabardine pinned to a dummy across the room and pulled the trigger of his gun. The .38-caliber revolver fired. Taking a few steps closer to the cloth, King fired again. He repeated the process several more times.

Finally he compared the powder burns on the cloth with those on the gabardine jacket Taylor had been wearing when he was shot. The evidence was clear. The killer had been standing not more than two inches from the victim when the fatal shot was fired.

It was Sunday morning, February 5. Outside the police station, church bells were ringing. The numerous bakeries of First Street and Broadway were fragrant with baked bread and pastries. Well-dressed citizens strolled the lane, carrying the bulky Sunday newspapers, smudgy with scandal, under their arms. At the bakeries, on the street corners, they gathered to share the latest in the Taylor mystery. Was the killer the crooked valet? Or some man who'd been in love with Mabel Normand or Mary Miles Minter? That Taylor sure had lots of secrets.

Overhead, the sun shone bright. Temperatures were finally warming up around Southern California. But so were the tempers of the police, the sheriff's department, and District Attorney Woolwine. Everyone had his own pet theory of who committed the crime and why. Police Captain David Adams still insisted Sands was their culprit, especially now that the former valet's criminal past had been uncovered. A navy veteran had recognized Sands in a newspaper photograph and come

forward to reveal the facts. Then Earl Tiffany, Taylor's dismissed chauffeur, had claimed that his wife had spotted Sands on the day before the murder while riding the streetcar at Sixteenth and Flower Streets. Sands had lost some weight, Mrs. Tiffany thought, which might have explained why Faith MacLean hadn't recognized him as the man coming out of Taylor's door. Adams thought this sighting of Sands meant they had an open-and-shut case.

But Eddie King wasn't buying it. Why would Sands risk coming back to Los Angeles? Why would he stop at a gas station to ask directions to Taylor's house?

King believed Adams was simply not a very good detective; he'd been wrong in other ways as well. The police captain was also arguing that Taylor had been shot from behind, from some distance away. That was why King had performed his little experiment with the gun and the powder burns. Taylor had been attacked up close, and he'd probably struggled with his attacker right before he was shot. Perhaps, in an effort to defend himself, the director had reached for the chair that had stood against the wall. Lifting the chair over his head might account for the peculiar path the bullet had taken through Taylor's body, especially if the killer had pulled back instinctively in self-defense.

Just how the chair ended up straddling the victim's left foot remained unanswered. Though the newspapers were reporting that the chair had been found overturned, King knew it had actually been standing upright. Someone had placed the chair over Taylor's leg after he was shot.

King wasn't the only one to disagree with Captain Adams. Some frustrated detectives, convinced Sands was not their man, asked for reassignments, "rather than continue investigating the murder with asserted misunderstandings existing." Some of the cops were pushing a theory that Taylor had been killed by a soldier with whom he'd served in the war, come back to exact retribution of some kind. But the notion gaining the most traction among investigators was the "woman theory," still being flogged endlessly in the Hearst papers. Sheriff William Traeger now believed that a "woman supplied the incentive and a man did the slaying."

Of course, none of the various theories were helped by the inconclu-

sive report given to police by the inquest jury the day before. What a day that had been.

Crowds had started gathering around the Overholtzer mortuary several hours before the inquest was set to begin. A blue line of police officers separated the crowd from those arriving to testify. "Hey, mac!" one fellow shouted over at an officer. "Is Mary Pickford droppin' by? How 'bout Doug?" The cop just shrugged.

By now the Taylor scandal had its own stars. Police cleared a path for the arrival of Henry Peavey, decked out in a well-tailored checked coat. Peavey smiled and waved at the crowd, seeming to enjoy the attention. An outsider all his life, anonymous and unsung, Peavey was finally basking in the camera's flash.

By contrast, when Faith and Douglas MacLean stepped out of a car, they shielded their faces, hurrying past the battery of photographers. The big question was when Mabel Normand would arrive. Everyone was looking for Mabel. But Mabel fooled them. Even as the crowd craned their necks to watch each person scurry up the mortuary steps, Mabel was slipping in through the back door.

What she found in the hushed rooms was a coroner's jury made up of six Los Angeles businessmen seated in a semicircle. Henry Peavey sat in front of them, no longer smiling, sobbing as he gave his account. Officer Zeigler described his arrival as the first policeman on the scene. Charles Eyton related how he had turned the body over and found the wound, though he neglected to mention his order to remove papers from the premises.

Then Mabel's name was read. A police officer led her through the room. Wearing a round hat and a fur-trimmed coat, "Miss Normand stepped briskly to the witness chair, the cynosure of all eyes," one report would detail. "She had steeled herself for the ordeal of questioning which, heretofore, had been only from the lips of detectives and comparatively easy. She had an air of forced composure, for the shadow of death lay heavy in the room, and beyond the wall lay the body of one of her best and dearest friends—'Billy' Taylor, she called him."

Nothing Mabel said—nothing anyone said—had thrown any new light on the mystery. The conclusion was that an unidentified person

had murdered Taylor. When he got the report of the jury, King grumbled he could have told them that and spared the county the expense.

After the inquest was over, Mabel had bolted out the back door, but this time the shutterbugs were lying in wait. Flanked by Sennett publicity men, Mabel made a mad dash for the gate behind the mortuary. "Click, click, click went camera shutters," one newspaper reported. "There was a race down the alley, with Mabel in the lead. Miss Normand managed to get inside the car. There she remained until the last of her guard piled in and down the alley sped the $7,000 automobile."

But Eddie King wasn't interested in chasing Mabel. He was much more curious about another young lady, equally lovely and nearly as famous, who hadn't been called to testify.

As King emerged from the station, the usual gang of reporters pounced, asking for any new developments in the case. King joked that he ought to be asking the same of them. The detective was impressed by the amount of legwork the boys in the press had done. Journalists from the *Times* and the *Examiner* had dug up plenty of witnesses. The love triangle idea, for example, had first emerged from reporters' inquiries, and King found this a far more compelling possibility than Sands. It was likely King who reporters were sourcing when they cited unnamed detectives "who adhered to the belief" that Taylor might have been slain for revenge in a love triangle. Sergeant King was not averse to occasionally bantering ideas around with reporters he liked. And his favorites were the intrepid Hearst hounds, even if their journalistic standards were the loosest in the business. Nevertheless, King admired their moxie and trusted their instincts. That was why he shared with them a bit of evidence he'd found particularly interesting.

The newshounds gathered to hear what King had to say.

Something very interesting had been found in Taylor's bedroom, the detective revealed. A filmy, pinkish silk garment that Detective Herman Cline thought "resembled a nightgown." Whose garment it was, no one was sure. There wasn't even a laundry mark on it.

The newspaper reporters pressed King about who owned this pink silk nightgown—which they didn't see, only heard described. King admitted that he believed it was a woman's garment, but as to just which

woman owned it, he was careful not to say. But after learning from Earl Tiffany how Edward Sands had monitored its use, the detective was absolutely convinced that this boxy piece of silk was an important clew to solving the mystery.

And anyone who'd been paying attention knew whose nightgown it was. Which young woman had been so smitten with Taylor that she had disappointed not one but two swains, Thomas Dixon and Marshall Neilan, in their pursuit of her? And could their disappointment have been enough for either of them to shoot Taylor down in cold blood?

King was extremely anxious to get Mary Miles Minter on the record.

His conviction that Minter was pivotal in solving the mystery was only strengthened after he interviewed Arthur Hoyt, a distinguished actor who'd appeared in several of Taylor's films, and who'd also been present at the bungalow on the day the body was found. Hoyt had told King a very interesting tale about Taylor's last days.

He hadn't told it willingly. Hoyt had wanted to respect what Taylor had shared with him in confidence. But Jesse Winn had grilled the actor hard. Finally Hoyt broke down and wept. "If it would help unravel the mystery surrounding the murder," he said he'd talk.

Hoyt then described an evening he'd spent with Taylor a short time before the tragedy. As many others had noted, the director had been anxious and depressed in those final weeks. When Hoyt asked what was bothering him, Taylor had said that "the dearest, sweetest little girl in the world" was in love with him, and described Mary's midnight visit. He had tried to send her home, Taylor told Hoyt, but Mary had threatened to cause a scene. "It was really becoming serious," Hoyt understood, and Taylor "didn't know what to do about it."

King had to wonder if Taylor's wretchedness in those last couple of months, described by so many people, had been the result of Mary's infatuation.

So far, however, he'd been unable to secure an interview with Minter herself. Her mother was rather powerful, he'd heard, and had managed to keep her away from the police. But the teenage actress couldn't remain untouchable for much longer, not with these stories of pink silk nightgowns and unrequited love.

Marshall Neilan's fears for Mary were about to come true.

———

Tipping his cap to his friends in the press, King hopped onto his motorcycle and revved the engine. Back in 1904, he'd been the city's first "speed cop," chasing down speed demons who roared down the vast uninhabited stretch of South Main Street. Small like a jockey, King handled his motorcycle as if it were a Thoroughbred. He tore off across town.

His mind was racing just as fast. The Taylor case obsessed him. So many clews. Which ones were important? Which were irrelevant? What about the luxurious touring car several witnesses reported being parked near Taylor's courtyard shortly before the murder? Ventura police reported that a woman had been spotted driving a similar car recklessly up the coastal highway early the next morning. Might there be a connection?

And what about Theodore Kosloff's story of a man jumping out at Taylor from some bushes in Pasadena? Was that the same person who'd been making the harassing phone calls? Or a blackmailer, which might explain those missing assets of Taylor's?

Or could Taylor's killer have been a drug dealer looking for revenge? Given Taylor's friendship with Mabel Normand, Detectives Theodore Mailheau and Lloyd Yarrow of the narcotics squad thought there was every reason to believe that the dead man "may have had knowledge of drug peddlers." That was definitely an angle to track down.

Finally, there was Taylor's murky past to consider. Hollywood was still in shock over the dual life their supposedly upstanding champion had hidden for so long. The newspapers, of course, loved the added sensation of an abandoned wife and daughter and missing brother. East Coast detectives had tracked down Taylor's former wife, Ethel May Robins, in the town of Mamaroneck on New York's Long Island Sound. In one of those crazy coincidences, she was now married to the proprietor of Delmonico's restaurant, where Adolph Zukor conducted so much of his business. With some reluctance, Ethel May told of the day Taylor—Deane-Tanner to her—had disappeared. She also described the day she had recognized the man on the movie screen as the father of her child.

Ethel May had been deeply hurt by Taylor's desertion. When she married her second husband, she'd torn up every photo she could find of her first. But when her daughter had expressed the desire to write to her father, Ethel May had given her consent, and had been pleased

when Taylor had agreed to meet the girl on his way back from Europe the previous summer.

But now the elegant Mrs. Robins, highly regarded in New York café society, took great offense at this intrusion from her past. Her long-ago marriage, she insisted, could throw no light on the murder. Her husband, Edward L. C. Robins, huffed, "I can't see why the newspapers are paying so much attention to Mamaroneck. It seems to me they ought to be trying to solve this mystery out in Los Angeles, where it happened."

Eddie King agreed. The killer walked among them, the detective believed. But making an arrest wouldn't be easy with so many false leads and dead ends. The phones at Central Station were ringing off their hooks. Lunatics wandered into headquarters and confessed to the crime. The cops were overrun with so-called witnesses.

Like Mrs. Ida Garrow.

She was a middle-aged dressmaker—she preferred the term *modiste*—who lived at the Rose of Sharon Apartments on South Coronado Street, on the other side of Westlake Park from Taylor. On the night of the murder, Mrs. Garrow was walking to a class, cutting across Ocean View Avenue. Near the corner of Grand View Street, she spotted a "short and heavyset" man ahead of her, whose "suspicious bearing and movements attracted her attention." As Mrs. Garrow watched, the man looked back at her, then hurried across the street and "disappeared into the shadows." The time was just after eight o'clock. Faith MacLean had seen the man leaving Taylor's home just before eight, so the two stories jibed. If the killer had cut up through the alley parallel to Alvarado Street—which was likely if he wanted to avoid detection—then eventually he would've emerged onto Ocean View, which in 1922 crossed Alvarado. Therefore, he would have passed Grand View at a time consistent with Mrs. Garrow's report of seeing a similar-looking man.

It was an intriguing clew, and King made a note of it.

But then again, there were hundreds of leads like that. King didn't have time to waste on all of them. Especially when he was convinced the answers he needed could be found in one, no-holds-barred interview with Mary Miles Minter.

# EVIDENCE FOUND

If Eddie King had known what was taking place at Alvarado Court, he would have turned his motorcycle around and burned rubber on his way there.

Unbeknownst to the DA's office, the police had decided to hold a little powwow with Charles Eyton and his chief lieutenant, Frank Garbutt. Apparently Captain Adams thought he could solve the mystery on his own and deny the department's rivals any credit.

The dead man's dining table, so recently the site of gin-and-orange cocktails with Mabel, was now "piled high with papers and letters." Detectives had gathered everything they could find in the apartment, and Eyton had agreed to bring back what he had taken. Accordingly, he'd dumped a stack of papers on the table for detectives to dig through.

Captain Adams believed Eyton when the studio executive insisted he'd brought back everything. Eddie King wouldn't have been so trusting.

Many times King, and other detectives, had wanted to dig through Taylor's personal papers, the ones that had been removed from the apartment. Among the "letters and personal belongings" that Eyton had made off with King was certain there was "much documentary evidence in this murder mystery."

Mabel Normand's personal letters to Taylor, for example, were missing. Mabel knew that Taylor had kept them, so where were they? The search for those missing letters had turned into its own separate investigation, though it was all a farce: everyone knew that Eyton had

them, even if he denied it to police. Taking studio-related material was one thing. Removing personal letters that might prove pertinent to the investigation was another. No doubt Eyton had received word from his bosses that Famous Players could not appear to be obstructing the investigation, and that was why he made a show of cooperating with Adams on this occasion.

But when he'd dumped Taylor's papers onto the dining room table, he'd held a few items back. As the cops dove hungrily into the pile, none of them seemed to notice when Eyton slipped quietly away.

He had business upstairs in the dead man's bedroom.

Eyton moved stealthily, hoping a creaky floorboard wouldn't give him away. If he was gone too long, someone downstairs would surely notice. Glancing around Taylor's bedroom, he tried to decide what to do with Mabel's letters. He couldn't just hand them over to the police; that would be admitting wrongdoing. It had to look as if he'd never had them. In a flash, Eyton had an idea. He stuffed the letters down into one of the director's boots.

When Eyton returned downstairs, he found the officers expressing disappointment that they'd found nothing in the pile of documents to illuminate their investigation. Of course they hadn't. Mabel's letters hadn't been the only papers Eyton had held back. All the important stuff was still back at the studio, safely locked away in Lasky's safe.

No way would the police ever see what they needed to see.

# DAMES EVEN MORE DESPERATE

Boys hung from lampposts. Grown men sat in trees. The windows of nearby buildings were filled with curious spectators. Mobs packed Olive Street between Fifth and Sixth and spilled over into Pershing Square, where vendors sold roasted chestnuts for a nickel a bag. More than ten thousand people had turned out for the funeral of William Desmond Taylor at St. Paul's Pro-Cathedral. They'd been gathering for the last three hours, hoping to catch a glimpse of the many celebrities whose names had been linked to the case. As the crowd swelled, police on horseback did their best to keep the situation under control. Some pickpocketing had already occurred, and a number of women had fainted.

There would be more of that before the day was done.

"Never before in the history of Los Angeles," one reporter would observe, "has there been such a crowd at the funeral of a private citizen."

Before his death, only a select group of industry insiders, censorship agitators, and diehard movie fans had known Taylor's name. Now it was a household word. An entire nation was riveted to the ongoing whodunit being played out every morning in their daily newspapers.

Dignitaries started arriving about a half hour before the two o'clock service, escorted through the throng by blue-uniformed police officers. Charles Eyton showed up with a delegation from Famous Players. Among them was George Hopkins, taking his seat beside Julia Crawford-Ivers and Jimmy Van Trees, remembering the man he had loved, unable to share what made his grief so personal.

Outside, it could have been a movie premiere. Constance Talmadge

arrived to squeals from the crowd. Arthur Hoyt. Antonio Moreno. Neva
Gerber, who the papers revealed had once been engaged to Taylor. But
the biggest cheers came when Mabel Normand was spotted stepping
out of her car, escorted on either side by female companions, "hatted
and furred so that her features were entirely obscured."

Mabel was shaking terribly. Led into the church, she spied the open
casket holding Billy's body and draped with the British flag. On top
of the casket rested the army cap he'd worn during the Great War. An
honor guard of British soldiers in full uniform stood at each corner of
the casket, their hands holding the butts of their rifles, the barrels rest-
ing on the marble floor.

Mabel did not approach the corpse as some of the others did. Instead
she took her seat in the second pew. Ahead of her, Henry Peavey keened
like a banshee.

The chancel was filled with flowers. Biggest of all, front and center,
was Mabel's wreath of roses. Billy had sent her flowers three times a
week. Now she was returning the favor.

A smaller arrangement near the bottom, a modest shower of lilies,
bore a card that read simply ETHEL DAISY.

Billy's daughter.

Like everyone else, Mabel had been stunned to learn of Billy's other
life. She'd thought she'd known her friend, her champion, her mentor,
so well. But in fact Billy had been a blank screen, onto which Mabel,
and so many others, had projected their own hopes and needs.

As the dean of the cathedral made his way up the center aisle, swing-
ing his thurible, the spicy fragrance of incense filled the air. Mabel
fought back tears. Her life had changed so much in just under a week.
Seven days ago, everything had seemed on track. *Molly O'* was a hit.
*Suzanna* was progressing well. Except for being sick a little too often,
Mabel was on the top of her game. She was working. She was solvent.
She was sober.

But the fears she'd harbored after Roscoe's arrest were coming true.

The press had her in their crosshairs. Every morning when she awoke,
Mabel found a new assault waiting for her in the papers. In virtually
every account of Taylor's death, her name appeared. Sennett's publicists
had sent out dispatches to exhibitors proclaiming Mabel's absolute in-
nocence and beseeching them to "correct any false impressions" that

appeared in their local papers. But the fact that Mabel's letters to Taylor had gone missing only added to the public's conviction that she was somehow involved.

The moralists were demanding blood—hers.

And it wasn't just Brother Crafts and Mrs. O'Grady who were targeting the movie industry anymore. Now self-appointed moral guardians in the press were doing the church ladies' work for them. The shrillest critics were Edward Doherty of the *New York Daily News* and Wallace Smith of the *Chicago American*, whose articles were syndicated to papers all across the country. Both Doherty and Smith were convinced that Mabel was implicated in some way in Taylor's death. They wouldn't let the idea go, grabbing onto it and swinging it around like a couple of dogs tearing apart a rag doll with their teeth. Mabel's days of cocaine and carousing were well known to Doherty and Smith, and the two yellow journalists refused to accept that those days were over.

In his most recent article, Doherty had written that Mabel was still attending "the 'hop' feasts." The writer used no names, but everyone knew whom he meant.

To *Examiner* reporter Estelle Lawton Lindsey, Mabel had made a direct appeal for fairness. "Get it straight, please," she'd begged. She hadn't been in love with Billy. They hadn't been planning on getting married. No one killed him out of jealousy over her. "And, please," Mabel added, "say that I never heard of that pink nightgown."

But what about the dope parties Taylor was suspected of hosting?

The question must have been like a dagger in Mabel's heart. Billy—who had worked so hard to get her off the stuff—accused of hosting drug parties! "Never, in God's world, never," Mabel averred. "Billy was one of the cleanest and most temperate men in all his habits. He loved clean, simple pleasures, and he was a kind and thoughtful friend."

How terribly Mabel missed him.

But as she sat there in the cathedral, Billy's cold, dead body laid out in front of the altar, she had to wonder if maybe, just maybe, Doherty and Smith were onto something.

Could Billy have been killed by one of her drug contacts? It wasn't so far-fetched an idea. Certainly Mabel remembered the pusher Billy had chased from her door.

The tears she shed at St. Paul's Pro-Cathedral that day weren't just wrung from grief. They had just as much to do with worry, fear, and guilt.

Suddenly, from the back of the church, came a terrible commotion. The guests all turned around in their pews.

The cops standing outside the front doors were shouting at the crowd to get back. Just as the service was getting under way, the mob had broken through the police barriers. People were sweeping up the front steps of the cathedral. Officers reacted quickly, "compelled to handle some of the foremost and most aggressive men and women with force to prevent them from taking the edifice by storm." In the crush, a number of women fainted. Screams and shouts penetrated the hushed nave of the cathedral.

For the remainder of the service, the doors were locked.

Back into the street the crowd was pushed. At the corner of Olive and Sixth, cars had to be redirected because of the sheer number of people blocking the way.

Among those standing in the unruly mob, observing the ruckus that had taken over the neighborhood, was, quite possibly, Margaret "Gibby" Gibson. The Melrose Hotel was just a couple of blocks down the street from St. Paul's Pro-Cathedral. Very possibly, when she learned what all the fuss was about, Gibby had joined her neighbors to get a glimpse of the mourners. Maybe she spent a few moments reflecting on the life and death of Billy Taylor. Everybody else seemed to be doing so that day.

Certainly Gibby had heard the reports that Taylor might have been the victim of a blackmailer. Now, police had a lead. The notorious con man "Dapper" Don Collins, called "the blackmailer of the century" and wanted for shooting a New York financier, had been in Los Angeles recently, reported to be scoping out marks in the film industry. Had Collins been blackmailing Taylor? And had he shot him when he refused to pay up?

Reading the papers, Gibby would have learned how different Dapper Don was from that other blackmailing Don, her tenant Osborn. "The blackmailer of the century" wore bespoke suits, dined in the finest

restaurants, and traveled in the most expensive staterooms on ocean liners. Gibby and the rest of the locusts just managed to get by.

Some blackmailers, it seemed, had all the luck.

Back inside the cathedral, the service complete, the long, high notes of Scottish bagpipers followed the casket as it was wheeled down the aisle to the vestibule. One thousand mourners walked past in a single file. When it was Mabel's turn, she took one look at Billy's waxy body, his thin lips sewn tightly together, and fainted. Her friends had to help her out to her car.

At that point, the front doors were opened and the casket was carried down the church steps. The crowd surged once more as Taylor's body was loaded into the hearse, but police managed to hold them back. As the funeral procession wound its way to Hollywood Memorial Cemetery, men standing on the side of the street doffed their hats. Construction workers on ladders at the corner of Olive and Eighth Streets stopped what they were doing and stood facing the procession, their helmets held over their hearts. At the cemetery on Santa Monica Boulevard, a mob spilled in through the gates and had to be forcefully held back. Finally, a bugler sounded taps, and Taylor's body was slid into a crypt.

The name on the plaque would read WILLIAM DEANE-TANNER.

Those craning their necks looking for movie stars had counted several. But there was one surprising omission, they realized. There had been no Mary Miles Minter.

Mary had other business that day.

Across town, at the little Spanish casita located at 2039 North Hobart Boulevard, burly men with scowling faces stood at the end of the driveway, their arms crossed over their chests. Their hard eyes dared reporters and curious spectators to try to get past them.

Mrs. Shelby had hired these private security guards to defend her daughter's residence that morning after the *Examiner* splashed Mary's love note to Taylor across its front page. "Dearest, I love you—I love you—I love you!"—followed by all those damning *x*'s.

The newspaper, Mrs. Shelby learned, had received Mary's note—as well as others written in an easily decipherable code—from Charles Eyton. Shelby, like many others, was stunned that a studio official would willingly bring such scandal upon one of his stars.

But there was a method to Eyton's madness. Now that Realart was defunct and Mary was a full-fledged Paramount star, Mrs. Shelby had been agitating for a raise for her daughter. To Mary's bosses—chief among them Adolph Zukor, who made the final money decisions—the receipts from Mary's pictures did not justify her million-dollar salary. "If [Mary's contract is] renewed," an industry watcher wrote in *Film Daily*, weeks before the Taylor scandal, "them big figgers [figures] may be missing." Mary was popular, but she was never going to be a superstar like Mary Pickford, as her early publicity had predicted.

That hadn't stopped Shelby from asking for a raise anyway. Zukor was infuriated. Here they were, still in a cost-cutting mode, trying to climb their way out of the red, and that appalling woman had the audacity to demand more money.

And so releasing Mary's love letters to Hearst's minions made a brutal kind of sense. The negative publicity made Mary damaged goods; why would they pay more for her now? Mrs. Shelby knew exactly what was going on. "The studio was using the situation," she said, "to gain a further reduction" in Mary's contract.

For Famous Players, there was another benefit in releasing Mary's letters. Taylor's visits to the city's "queer places," combined with Henry Peavey's screaming effeminacy, had left the clear suspicion—encouraged by Edward Doherty and other writers—that Taylor was homosexual. If their martyred director was going to be slandered in the press, Zukor and Lasky much preferred that he be portrayed as a womanizer than a degenerate.

Yet by indulging in such shenanigans, the studio chiefs were literally playing with Mary's life.

The revelation of her love letters, following so closely upon the reports of the pink silk nightgown, made her a prime suspect in the murder, and had finally persuaded District Attorney Woolwine, much to Eddie King's satisfaction, to call her in for an interview.

It was an indignity Woolwine had hoped to spare her. The DA was

a friend of Mrs. Shelby's. In fact, there were some, spreading gossip all over town, who believed Woolwine and Shelby had had an affair. Not many people in Tinseltown liked Charlotte Shelby, but Woolwine found her charming. Ruthless she could be, but Mary's mother was also witty and flirtatious, especially when she thought she could get more flies with honey than she could with vinegar. Besides, at forty-four, she was still very attractive, and Woolwine appreciated beautiful women.

But he could no longer ignore the daily headlines. In the descriptions of unscrupulous reporters, the boxy garment found in Taylor's apartment, which Detective Cline had thought only "resembled a nightgown," had been transformed into something pink and feminine; in some accounts, it had suddenly sprouted lace. The Hearst papers called the garment something "unknown in a man's wardrobe." Every insinuation was made to convince the public that the nightgown belonged to Mary. That was the way to sell newspapers. Edward Sands or some unknown blackmailer would never be as interesting as sexy little Mary Miles Minter. A glamorous movie star on the stand would sell thousands more copies than even Mrs. Peete or Mrs. Obenchain ever had.

Under such public pressure, Woolwine could not avoid deposing Mary, no matter how fond he was of her mother. And so, shortly before five on the afternoon of Taylor's funeral, the door to Mary's house opened. Surrounded by lawyers and private guards, the small blond figure was hustled down the driveway and into a car. Reporters shouted her name, but Mary did not look up. The guards kept the crowds back so that the car could pull into the street. Reporters followed Mary to the Hall of Records downtown.

Woolwine had decided to have his own deputy, William Doran, conduct the interview, instead of the more independent Eddie King. Knowing the detective was deeply suspicious of Mary, the DA apparently chose to shield her from more aggressive questioning.

Mary entered the conference room calmly, with none of the histrionics she'd displayed at Overholtzer's mortuary. An uncharacteristic air of dignity followed her. Her mother had undoubtedly been coaching her again.

With her lawyer at her side, Mary answered questions for several

hours. She admitted that she'd been in love with Taylor, but insisted they had not been intimate. She rejected as absurd the idea that either Dixon or Neilan had ever been serious enough about her to go after Taylor with a gun. Her childishly romantic testimony seemed straightforward and sincere.

In short, Mary convinced Doran, and through him Woolwine, of her innocence.

Immediately afterward, the district attorney's office announced that they would be issuing a complaint charging Edward Sands with the murder of William Desmond Taylor.

Delivering the statement to the press was Eddie King. Woolwine had no doubt asked him to do so as a way of bringing him in line. Yet despite his public words, King was not convinced.

That was because, as a member of the police department and not as an investigator for the DA, he'd conducted his own interview with Mary the night before. And King hadn't been quite as captivated by his subject as Doran had been.

To his friends in the press corps, King described his questioning of Mary as "long and grueling." Just what he learned, he didn't say. But he'd apparently gleaned enough that he wasn't as ready as Woolwine to exonerate Mary of all involvement in the case.

The next day, King's suspicions seemed vindicated.

Searching through Taylor's bungalow one more time, police found a lacy handkerchief with the initials MMM.

The handkerchief was almost certainly the same one Mary had switched with Taylor's, stuffing it down into his jacket pocket during her late-night visit the previous December. Just where the lacy little thing had been the past week was anyone's guess. Police had scoured the apartment several times but found it only now, on the same day they made another important discovery in the bungalow: Mabel's letters, packed down into one of Taylor's boots.

Once again, Charles Eyton's fingerprints were all over the evidence—metaphorically speaking, anyway. It was painfully obvious that Eyton had snatched the handkerchief on the morning of February 2, hoping to keep his star out of the scandal. Now, when protecting Mary was no longer his goal, he'd returned it, perhaps at the same time as Mabel's letters, for police to find.

And so the studio continued its cavalier game with Mary's life.

That little handkerchief convinced Eddie King that the diminutive blond actress was, somehow or another, implicated in Taylor's murder. If Mary was arrested now, it would largely be because of Eyton's reckless acts, sanctioned by Lasky and Zukor.

In seclusion back at her mansion, Charlotte Shelby watched the developments with mounting horror. The threat was not just against her daughter.

Sooner or later, Shelby herself would be in danger.

# THE NEED FOR VIGILANCE

Zukor loved trains. One of his first ventures in the movie business had been dressing up little storefront nickelodeons to look like the interiors of railroad cars and then setting their floors on rockers. A man out back would shake the room while images of passing terrains were projected onto the screen. Working-class audiences who could barely afford trolley fare were given the illusion of traveling across the country on a passenger train. Glamour for the masses, courtesy of Adolph Zukor—still his stock in trade.

But as the flat desert landscape flashed past his window on the Twentieth Century Limited, much as it had done during his little "Hales's Tours," Zukor wasn't in the mood for sightseeing. Steaming mad, he puffed his cigars one after another, producing nearly as much smoke and ash as the locomotive's engine.

The Taylor murder had sent him into a fury. *Variety* reported that the film chief was "at the end of his rope." He told the trade weekly it was "cleanup time" in Hollywood.

Zukor's first-class cabin was scattered with newspapers. One of the last tabloids he'd picked up before leaving was the New York *Daily News*, a relatively young paper with a rapidly growing circulation, due to its emphasis on photographs. For days the *News* had been splashing Mabel Normand and Mary Miles Minter all over its pages. But the most grievous aspect of the tabloid's coverage were the regular dispatches of Edward Doherty, which millions read. And Doherty didn't have much good to say about Hollywood.

"The murder of William Desmond Taylor has had a fearsome effect upon the movies," Doherty wrote on February 8. "It is exposing the debaucheries, the looseness, the rottenness of Hollywood." A religious conservative, Doherty knew how to press the hot buttons that incited outrage. "The volcano has erupted," he wrote. "The lava is spreading. But the debauchees keep up their mad, capricious dance, drugged, drunk, senseless, dancing into oblivion." Doherty wasn't all that different from Brother Wilbur Crafts, except that his goal was selling newspapers, not saving souls.

When all was said and done, Doherty wrote, the scandal would mean the loss of "hundreds of thousands of dollars" to the movie industry. Of course, that was the reason Zukor was steaming west. Doherty might have been a cynical extremist, but he was right about the money. Preachers were calling for boycotts from their pulpits. Zukor intended to crack his whip, and he didn't care who felt its sting.

And that included Jesse Lasky and their loose-cannon general manager, Charley Eyton.

Zukor and Lasky were regularly at odds over many details of running Famous Players, so it wasn't surprising that they would have different views on how to handle the Taylor scandal. Certainly Zukor wasn't pleased to see how frequently Eyton's name popped up in reports of the murder investigation. Removing Taylor's papers from the bungalow had been prudent on the general manager's part; admitting the fact to police had not been. As a result, Eyton had been directly threatened by authorities; according to *Variety*, he'd only "narrowly escaped trouble for himself" by finally returning Mabel's letters. With the Federal Trade Commission breathing down his back, Zukor did not want his studio suspected of obstruction.

On the afternoon of February 12, Zukor's train chugged into La Grande Station. A delegation of studio officials waited on the platform, including Lasky and Sid Grauman, representing Zukor's loyal Paramount exhibitors. Given the circumstances, his reception was modest; a few days earlier, Cecil B. DeMille had scrapped plans for his own lavish welcome-home party, figuring the time wasn't quite right for tubas and trombones.

Whisked off in a studio car toward Hollywood, Zukor could look out the window at a slate-blue sky silhouetted with palm trees and ringed

with majestic mountains. Although he was a New Yorker through and through, the movie chief liked this land of sunshine and make-believe. Hollywood had been very good to him. And now, in the film colony's hour of need, Zukor intended to return the favor.

The moralists were crying for Hollywood's destruction. A delegation of women's groups had met with President Harding, requesting that the film industry be relocated to Washington, DC, where Congress could act as babysitter. Mrs. Evelyn F. Snow, Ohio film censor and a Republican committeewoman with the ear of the president, suggested her state as the film capital instead, since Ohio sat at the geographical center of the country. Rumors abounded that Will Hays was set to order the industry east as soon as he took charge, and that Zukor was planning to close down the Hollywood plant and reopen the studio on Long Island. The only remedy to the scandals, apparently, was to destroy America's Sodom.

Zukor had had enough of such talk. "There's no more immorality in the Hollywood colony than in the New York stock exchange," he had told reporters shortly before setting out on his trip. Arriving at the studio on Sunset Boulevard, he was equally as vociferous in his defense of the industry. "We all deplore the recent unfortunate occurrences," the movie boss told the waiting reporters, "but . . . I am sure that the percentage of wholesome God-fearing men and women must be as large [in the studios] as among those following any other line of endeavor."

Then the diminutive figure in the expensive overcoat and fedora hat, flanked and shielded by the much taller Jesse Lasky and Sid Grauman, pushed his way through the mob and barricaded himself inside the studio. Not for several days would Zukor be heard from again.

Safe from the eyes and ears of the press, Zukor's lieutenants were debriefed about everything they had done.

His underlings held nothing back from their boss. To do so would have been career suicide. Creepy inspired fear among everyone in the company, even Lasky, who was known on business trips to hide his late-night revelry from his disapproving partner. If Zukor discovered that someone had kept certain details from him—especially about something

as important as the Taylor case—he would have had the offender fired, even blackballed from the industry. Hiram Abrams was proof of that.

So Lasky and Eyton laid everything on the table for Zukor.

With his own eyes the movie chief beheld the evidence of Taylor's killer.

Once again he had a chance to stanch the hemorrhaging Famous Players was suffering by going to the police. But once again he did nothing. The truth remained worse than the ongoing scandal.

Zukor blamed Lasky for letting both the Arbuckle and Taylor scandals break "all publicity records." After all, both incidents had occurred on Lasky's watch as head of production at the Hollywood studio. But though the two partners had frequently disagreed over how to handle the Arbuckle affair, here they saw eye to eye.

The steps Zukor and Lasky took in response to Taylor's death would be completely erased from history. If anything was written down, it was subsequently destroyed. They left no trail. Decades later, when Zukor's papers were prepared for posterity, there would be one notable gap in his correspondence. Every month for the year 1922 would be packed full of letters, telegrams, and memos—except for February, for which not one scrap would remain.

They didn't call him Creepy for nothing.

Yet despite the lack of documentation of his activities, Zukor was very busy that month. Ten thousand circulars, paid for and authorized by the film chief, went out to police departments all around the country, describing Edwards Sands and asking for his capture. The studio was throwing its weight behind the Sands theory—the least damaging to Taylor's (and the film industry's) reputation. Next, Zukor approved a set of talking points intended to reframe the public discussion of the crime. If the talk about drugs couldn't be quelled, then why not make Taylor an antidrug crusader? After all, he'd briefly assisted US Attorney Tom Green. Now *that* was a storyline, Zukor realized, that could work to Tinseltown's benefit.

And so, a few days after Zukor's arrival, a very different narrative began appearing in the daily newspapers. Captain Edward A. Salisbury, well-known explorer and a friend of the dead man, called a press conference at the Waldorf in New York and told reporters, "Billy Taylor threatened to make an example of the drug peddlers

in Hollywood, but they evidently 'got him' first." That Salisbury came forward exactly when he did was no coincidence. He'd just returned from the South Seas with a documentary film, and Paramount had just agreed to distribute it, at least in part. Where Adolph Zukor was involved, there were no coincidences, but plenty of quid pro quos.

Zukor also asked for help from a more surprising ally: Marcus Loew. Under similar circumstances, Zukor might not have been as generous. But Zukor's daughter's father-in-law stood up before a gathering of exhibitors and paid tribute to William Desmond Taylor as "one of the hardest fighters in the movement against the drug traffic." Taylor, Loew said, had been "instrumental in ridding Los Angeles of scores of these traffickers." Taylor had suddenly become a superhero, single-handedly cleansing the city of vermin. Reporters picked up Loew's story and ran with it, and Zukor was grudgingly grateful to his old rival, who'd once again come to his aid.

Yet for all that, investigators still suspected that Famous Players was hiding something. The district attorney's office was convinced the studio was sheltering "a number of persons who could, if they would, give information which would put the police on the right trail." One source told the *Examiner* that "highly placed people in the motion picture industry" were "pursuing their policy of silence in order to protect" someone. And no one thought they'd really go to all that trouble to protect a nobody like Edward Sands.

Who, then, was the studio shielding?

Detective Sergeant Eddie King suspected the answer was Mary Miles Minter. But Charles Eyton had given Mary's love letters to the *Examiner*. That wasn't protection. That was implication.

Once again Zukor had apparently decided, for the good of the industry, to toss one of his own to the wolves.

Mary was at the mercy of the reformers. Mrs. Caroline W. Engler of Lynn, Massachusetts, led the charge. Mrs. Engler, who "took an absorbing interest in all civic and welfare matters," had convinced her town's censor board to ban the just-released Minter film, *Tillie*. "Because of the Taylor murder and the naming of Mary Miles Minter as one of Taylor's admirers," the censor board wrote in its decision, "it would not be good policy . . . to allow Mary Miles Minter films to be shown."

Lynn, Massachusetts, was the first locality to ban Minter films. It would not be the last.

Zukor was no doubt unhappy about losing revenue from Mary's pictures. But he took no steps to defend the frightened young woman. Like Arbuckle, when the big picture was considered, Mary was expendable. Abandoning Mary was still preferable to Zukor than revealing what he had found in Taylor's papers.

This was not the man Adolph Zukor had once been—the young dreamer who had come to America believing in a land of opportunity and fairness for all. But it was the man he was now. He had started with a vision, a desire to achieve greatness for motion pictures. But now that vision had become conflated with his own personal ambition, and while the vision was still there, it was becoming harder to distinguish between the two. An attack on the movies was an attack on Adolph Zukor. The scandals, the exhibitors, the FTC investigation, Tufts: these had all left him feeling surrounded and persecuted. It wasn't just Famous Players that was under siege; it was Zukor himself.

If sacrificing Fatty Arbuckle or Mary Miles Minter would ensure his own survival, so be it. Zukor would never again be that vulnerable child, on his own, unsure of his future. He would never again be powerless or penniless.

Even if that meant letting the real killer of William Desmond Taylor go free.

At last, after more than a week in seclusion, Zukor emerged from the studio. Striding out to the waiting reporters, he announced that he had developed new guidelines for the industry. A "vigilance committee" would safeguard "the good name of its members," Zukor said. Everyone would be obliged to sign a pledge of good behavior. "I am here to see," he declared, "that those few who violate the edicts of good conduct and bring discredit and embarrassment to the many are ruled not only against but out of the ranks."

This, then, was how he justified his own actions. Arbuckle had brought discredit to the many, so he needed to be "ruled out of the ranks." It didn't matter whether he was innocent or guilty of the crime at hand. The same with Mary: if her career plummeted now, Zukor

reasoned, it was her fault, not his. She deserved whatever she got for being so indiscreet. And what if Mabel Normand were the culprit? As fond of her as Zukor had always been, if she'd been one of his employees, he would have sacrificed her the same way. After all, those tales of drugs had brought embarrassment upon the industry—and they were her doing, not his.

But sometimes, Zukor understood, exceptions did have to be made.

After spending about a week and a half in the film colony, Zukor departed for San Francisco with Sid Grauman to make plans for a gala tenth-anniversary celebration of the release of *Queen Elizabeth*. But he left Lasky with some final instructions. If they were to ensure that the truth about Taylor's death never leaked, there was one more thing they would have to do.

CHAPTER 44

# TAKING HIM FOR A FOOL

Henry Peavey just wanted to go home. The spotlight in Los Angeles, enjoyable at first, had become too glaring, and he longed to return to the winding, hilly streets of San Francisco. The press had turned him into a laughingstock. The press called Peavey a "queer person," describing him as "a wonder at concocting rice pudding and a marvel with the crochet needles." Racist writers inserted hackneyed phrases like "yes'um" and "I'se very lonesome without Mr. Taylor" into his speech when in fact he was quite well spoken, with an accent that reflected Northern California, not North Carolina. And so, fed up, the former valet requested permission from District Attorney Woolwine to step out of the limelight and head back home.

But Woolwine ordered him to stay put. He might be needed again, and the DA didn't want to have to go looking for him.

Peavey was peeved. But he had no recourse. Woolwine had been influential in getting the vagrancy charges against him dropped, and he could just as easily reinstate them.

So Peavey was in no mood when, shortly before noon on Sunday, February 19, he heard a rapping at the door of his lodging house on East Third Street. Peering out the window, he spied a couple of white guys in boater hats. Probably journalists.

Opening the door a crack, Peavey snarled, "I am not doing any talking to newspaper reporters."

"Newspaper reporters?" The men laughed. "We're not newspaper reporters. We're officers from New York and we have authority to come

down here and get you and have you go over your statements." They wanted him to go with them to the *Examiner* office and answer just one question.

Peavey was suspicious. Why would police officers take him to a newspaper office? And what question did they want to ask him there that they couldn't ask him here?

The so-called officers pleaded ignorance when Peavey tried to argue with them. They simply added, "There's a thousand dollars in it for you."

A grand was a lot of cash. Peavey had recently been hired back by his friend Vivien Cabanne, but $1,000 could completely change his life. So he put aside his suspicions and agreed to their request.

The "officers" exchanged covert smiles. Their scheme was proceeding as planned.

Meanwhile, over at the *Examiner*, a fireplug of a man named Frank Carson was gleefully awaiting Peavey's arrival.

Forty years old, balding, with beady little eyes that darted back and forth behind his round spectacles, Carson had recently arrived from the offices of Hearst's *Chicago Examiner*, determined to succeed where his West Coast counterparts had failed: he would find the killer of William Desmond Taylor. For a good story, Carson didn't let anything get in the way. In his desk he kept blank search warrants, writs, and summonses, as well as phony badges for police, coroners, and federal agents. When a story broke, Carson simply faked the appropriate document and impersonated an official, allowing him to get his scoop. "Muscle journalism," he called it.

Henry Peavey fascinated Carson. He believed the former valet knew more than he was saying. "Carson became convinced," said Florabel Muir, a reporter for the *Los Angeles Examiner* who had a front-row seat on her colleague's shenanigans, "that the secret of who fired the fatal shot could be forced out of [Peavey] under pressure." So Carson laid a trap for him, and Peavey walked right into it.

Those two "New York officers" who had shown up at his door were in actuality Carson's paid collaborators, drawn from the ranks of gangsters and con men.

A little after noon, they brought Peavey up to Carson's office in the *Examiner* building.

The valet was grumbling. Instead of being taken directly to the newspaper office, he'd been driven around town and badgered with questions. Something very fishy was going on.

Surrounded by interrogators, the thousand bucks nowhere in sight, Peavey demanded to see a lawyer.

Carson smooth-talked him. He insisted Peavey didn't need a lawyer. He just wanted to know what movie man in Hollywood was paying him to keep his mouth shut. Peavey became indignant. "Nobody has ever given me a penny for anything," he huffed.

Carson left Peavey alone in a locked room to stew for a while.

The afternoon dragged on. Peavey banged on the door and complained that he was hungry. Carson sent out for food. He went back in to grill Peavey some more.

Under further questioning, Peavey's dislike of Mabel Normand became clear. Mabel used to laugh at him, and Peavey was tired of being laughed at. He had no idea who killed Taylor, Peavey said, but if he had to lay odds, he'd bet on Mabel.

Carson knew that was ridiculous. He thought Peavey was holding out on him.

An idea came to him. A wild but—he was certain—surefire idea.

"Carson had the notion that Peavey, a Negro, would go out of his mind if he saw ghosts," Florabel Muir said. And so the newspaperman told the valet that they'd enlisted the aid of a spiritualist to get in touch with Taylor from beyond the grave.

Peavey lifted an eyebrow at him, as if he'd gone mad.

The sun was setting. "Hocus-pocus talk" filled the *Examiner* press room. Carson announced that the spiritualist had informed them that Peavey would "meet the spirit of his late master, who would advise him to tell the truth about the foul murder."

Peavey was having none of it. He kept threatening to report them to the DA.

Florabel Muir, watching from the sidelines, thought that no one in the room "was as calm and collected as the victim of the plot."

Once darkness had settled over the city, Carson gave his henchmen the signal to move. Peavey was hustled out onto the street and shoved

into a car. Carson went along for the ride, but not before nodding to another accomplice to head out as well, by another route.

Their destination was Hollywood Memorial Cemetery.

Carson's accomplice was Al Weinshank, a hulking young man who "knew how to muscle his way through almost any emergency," Muir observed. He was thick-necked and thick-headed, a gangster and bootlegger from Chicago's underworld. And this night, he'd be Carson's "meat" for the stunt they planned for Peavey.

Under cover of darkness, Weinshank snuck into the cemetery just moments before the car bearing Peavey and Carson pulled in from Santa Monica Boulevard.

Inside the automobile, Carson was feigning fear. "It makes me nervous to drive into a cemetery at night," he said. "How do you feel, Henry?"

"It doesn't bother me," Peavey replied tartly.

The car pulled up in front of the vault where Taylor had been entombed. The driver switched off the lights, and they were left in darkness. Only the moon offered any illumination as they stepped out of the car onto the cemetery lawn.

Carson couldn't understand it. He'd been sure that Peavey would be quaking in his shoes. But the valet was angry, not scared. Weren't all Negroes terrified of spooks?

They approached the mausoleum.

Suddenly, from the darkness, arose a ghostly apparition.

"Look, look, look!" Carson shouted. "It's Taylor!"

Peavey made a face in disgust as he looked over at the "ghost." It was clearly nothing more than a man with a white sheet draped over his head. And Peavey knew enough about men in white sheets to understand they were nothing but cowards and posers.

The "ghost" moaned. Peavey stood his ground. The phony specter dropped to its feet and grabbed hold of the valet's ankles.

"Run, Henry!" Carson yelled. "Run!"

Peavey spun at him. "What in the hell are you trying to make out of me, a fool?"

The man in the sheet let go of Peavey's ankles and stood up. He

spoke the valet's name and demanded he identify the killer. Peavey's expression deepened in its contempt. How peculiar that in death Mr. Taylor should acquire a Chicago accent.

Peavey strode forward and grabbed the sheeted fellow by his throat. His hands "locked on the windpipe of the ghost like an iron vise," Florabel Muir would learn. "The fingers that so adroitly manipulated the knitting needles were deceptively strong." The man under the sheet began to gasp for breath, and finally Carson had to come to his aid.

The sheet was pulled off to reveal Al Weinshank.

"Dat guy just ain't natural," Weinshank wheezed, backing away from Peavey. "He ain't scared of nothin'!"

Their scheme exposed, Carson and his men ran for the car.

Arms akimbo, eyes flashing, Peavey shouted after the fleeing newsmen, reading them the riot act and promising that the DA would hear all about this. They'd pay for kidnapping him, Peavey vowed. Really, what did these stupid white men think he was? A fool?

His dignity intact, Henry Peavey strode out of the cemetery.

Early the next morning, Carson and his entourage hightailed it back to Chicago before the district attorney could apprehend them. Although the NAACP filed a formal complaint with the *Examiner* on Peavey's behalf, Carson escaped any punishment for the kidnapping. But a few years later, Al Weinshank got his, when the forces of Al Capone gunned him down during the Saint Valentine's Day Massacre.

# MR. HAYS GOES TO WORK

On the evening of March 16, 1922, the ballroom of the Astor Hotel in New York was filled with movers and shakers in the film industry. Adolph Zukor had come back from the West Coast. Marcus Loew was also present, as were Sam Goldwyn, Lewis Selznick, and Sydney Cohen, all there to welcome the new "leader" of the movie industry: Will H. Hays.

The place was packed. More than a thousand people sat at more than a hundred tables. Secretary of Labor James Davis, Hugh Frayne of the American Federation of Labor, and Albert Lasker of the US Shipping Board were among the most prominent. William Randolph Hearst was present as well, not as a newspaper magnate—his chief editor, Arthur Brisbane, represented Hearst's print empire—but as head of Cosmopolitan Pictures, which released through Famous Players. Dozens of Wall Street moneymen were also in attendance, as were a few movie stars to add a bit of glamour: Mae Murray, Constance Talmadge, Betty Blythe.

Glamour was needed, since the man of the hour was anything but. In the place of honor sat the little birdlike figure of Will Hays, pecking at his *mignonette de sole glacé* and *pointes d'asperges*, dwarfed by the big table around him. On either side of him were the directors Sidney Olcott and John Emerson, the latter serving as toastmaster. Two chairs away sat Adolph Zukor. Whenever Emerson was up at the microphone, Zukor would lean in toward Hays to speak to him, easily and closely—as Loew, Selznick, and the others no doubt attempted to read their lips.

Hays had expected this fishbowl. Plunked down in the midst of some of the most famous faces on the planet, the modest, plainspoken midwesterner couldn't help feeling a little self-conscious. Just before he'd left Washington, Hays had consulted a dentist about fixing those chipmunk teeth of his. Clearly, the possibility of photographs alongside Douglas Fairbanks and Rudolph Valentino had daunted him, and so he'd had some kind of work done. On March 9 Hays's dentist had written to assure him that his X-rays showed "satisfactory progress." But photographs in the papers revealed that his mouth was still full of crooked chompers.

Yet Hays was also tanned and rested from his Florida vacation. He'd arrived in New York eager to start work. His new office was located in the Guaranty Trust Company building at 522 Fifth Avenue, on the corner of Forty-Fourth Street, just a block away from Adolph Zukor. In the days before Prohibition, Hays's luxurious suite had been a private dining apartment above the famous Sherry's restaurant. Merry ghosts danced on the spot where Hays was now charged with making the movies respectable.

Each morning the former postmaster general could be spotted swinging his briefcase on his way to work, arriving a little after eight, "an extremely early hour for Fifth Avenue," one observer noted, where most clerks didn't show up until nine. But Hays had a lot to learn, and very little time to learn it. "I am reminded," he wrote to a friend, "of a picture I once saw of a big seven passenger automobile going down a country road at sixty miles an hour, filled with prosperous looking people, and a little dog barking frantically at it, trying to eat it up. Underneath were the words: 'Go ahead, let him have it once—see what he will do with it.' " Hays hoped he wouldn't get run over by his new job.

His duties had been defined very broadly. He'd been hired, as Hays understood it, to do two things: "To attain and maintain the highest possible standard of motion picture production [and] to develop to the highest possible degree the spiritual, moral and educational value of the industry." What his job was not, he made clear to anyone who asked, was moral arbitration. There would be no "clean-up campaign in the sense some have described," he insisted on day one. His job was far more "practical" than that, Hays explained. Commercial and artistic concerns would drive him as much as any moral ones.

His number-one goal, Hays explained, was "developing economies within the industry." He wanted to see the movie business adopt the "sanity and conservatism . . . of the banking world." His first priorities therefore would be resolving tariff issues with the government and negotiating contracts with the exhibitors. He would not play censor. That was a role he absolutely refused to adopt.

The moralists, of course, had different ideas. They were expecting the movies' new leader to "purify" Tinseltown. But Hays believed purification, if it was to occur, would happen on its own. "If the public does indeed feel entitled to a better and higher form of motion picture amusement," he argued, "then it is up to the public to patronize only those places that least offend its taste. A man may be imbued with the ideas of a vegetarian, but he can't run a vegetarian restaurant successfully when all his patrons demand beef." In other words: let the market decide—a position that certainly pleased the producers he was working for, especially Zukor, who rose that night at the Hotel Astor to offer the warmest of welcomes to Hays.

The microphone had to be lowered, of course, before he could speak into it.

Looking out over the sea of tables, Zukor gazed upon virtually all of his colleagues, employees, and competitors, gathered together in one room. They had come to toast Hays, their new "czar," as the papers were calling him. But every last one of them knew who held the real reins of power.

In his soft, almost whispery voice, Zukor laid out the challenges and opportunities ahead for the industry. He hoped that Hays would "never have to turn red in the face on our account." Just as important, though, he implored Hays not to "permit us all to be maligned because of wrongdoing on the part of some in the industry." Those wrongdoers, he said, should be "quickly condemned and ostracized by the rest of us." Everyone knew who he was talking about. Even on this night of new beginnings, the specters of Roscoe Arbuckle, whose third trial had just gotten under way, and the myriad players in the Taylor scandal hovered over the ballroom.

After Zukor finished speaking, he headed back to his seat, pausing on the way to shake Hays's hand.

Hays had watched Zukor's every move. He knew his greatest challenge in his new role would be finding a way to accommodate Zukor without marching in lockstep with him. He'd been doing his research. A friend at the New York Trust Company had warned him that many on Wall Street were concerned about the financial extravagance of the film companies. The growing domination of one company, Famous Players, was inhibiting growth throughout the film business. Hays understood that the industry could not long sustain itself if megalomaniacs like Adolph Zukor kept acquiring more and more of it to run as their own personal fiefdoms. But Hays was working for those megalomaniacs, who were paying him a hundred grand a year.

Therein lay his dilemma.

Securing the independence he'd need to stabilize the industry, both to prevent censorship and develop sustainable economies, would be Hays's most difficult task. Clearly Adolph Zukor wasn't a man who willingly shared power.

Everything depended on what kind of accommodation could be found between these two diminutive men, whose view of the world and their place in it couldn't have been more different.

Finally it was Hays's turn to speak.

His voice was nasal and reedy. At first the audience likely cringed a bit, maybe smiled among themselves. This little elf was their new leader? But Will Hays had long ago learned to disregard the mockery. He had learned to trust himself, to believe in his mission. How else had he managed to win so many campaigns for his candidates?

His confidence was rooted in a firm moral conviction—not the hard, dogmatic morality of a Wilbur Crafts, but an ethic informed by character and principle. That made Hays a rather odd choice to lead an industry predicated on selling illusion, in which right and wrong were often determined by their relative effect on the bottom line.

But as he talked, Hays realized that the people in the ballroom were responding to him. This funny-looking creature actually had something to say. Slowly at first, then more rapidly—a technique he'd learned in grange halls and town squares across Indiana—Hays spoke to them of determination, and commitment, and honor. His words soon had the

entire ballroom transfixed. He spoke for half an hour, frequently interrupted by applause, and wrapped in a flourish of fiery rhetoric.

"The motion picture industry accepts the challenge," Hays shouted, pumping the air with his fist, "in the demand of the American public for the highest quality of art! The industry accepts the challenge in the demand of the American youth that its pictures shall give to them the right kind of entertainment and instruction! We accept the challenge in the righteous demand of the American mother that the entertainment of that youth be worthy of their value as the most potent factor in the country's future!"

People rose in approval, applauding and whistling. Some stood on their chairs.

"By our opportunities are our responsibilities measured," Hays continued. "From him to whom much is given, much is required. That responsibility I accept for the motion-picture industry right now. Our association is dedicated to the aid of the industry and the discharge of these obligations, and to that I am dedicating my life and my best years!"

The cheers echoed up to the roof.

Those in attendance were stunned by Hays's oratory powers. "Mr. Hays talked at them right from the shoulder with the force he used when he was running the Republican national campaign," a scribe from the *New York Times* observed. "Judging by the roars of applause and the way men and women, actors and actresses, jumped to their feet, they like their new boss."

Whether the reformers would agree remained to be seen. Only one thing seemed certain: unless Hays did as he was told, no one expected Adolph Zukor to tolerate such a silver-tongued pretender for very long.

# THE MORBIDLY CURIOUS

Mabel couldn't be faulted if she'd begun to think she was a jinx.

On the night of March 6, finally feeling safe enough to venture out for a social evening with some friends, she'd once again run headfirst into tragedy. At "a cozy little place where jazz music exerts its soothing effect, especially to the nerve-broken and weary," she'd met George S. Patterson, a young businessman and well-known golfer. They'd had a pleasant evening, sharing a few cocktails.

Now, a couple of days later, Mabel glanced down at her newspaper to find that, soon after leaving the party, Patterson had been killed in an accident on the San Diego highway.

Patterson had been a married man with two children, the son-in-law of a prominent railway executive, and his fleeting association with the actress immediately set tongues wagging. "Miss Normand today is receiving the sympathy of her friends," one columnist wrote, "that she should, by unfortunate coincidence, have been so near another tragedy at her re-entry into the life of the colony with a little innocent music and dancing." For some, however, reports of jazz clubs, dancing, and married men were enough to simply reaffirm their sordid impression of Mabel Normand.

No matter what she did these days, Mabel was criticized. With half a dozen friends, she had reserved a box to see *The London Follies*, a revue starring comedian Harry Tate, at the Mason Theatre. After all the horrors of the previous month, Mabel needed a little escapism, but prudes thought it was too soon for her to be out having fun. The follow-

ing Sunday—a day on which reformers wanted to ban all amusements anyway—Mabel attended the races at the Los Angeles Speedway. "She giggled all afternoon with a group of girl friends, went down into the auto pits to talk with the drivers, and pretty generally enjoyed herself," one fan magazine observed. Around the country, self-appointed arbiters of good taste looked on in scorn.

In the wake of all this, Mabel went into hiding in Altadena. If the world didn't want to see her, she'd disappear. Mack Sennett shut down production of *Suzanna* while his star took some time off. Left unsaid was whether filming would ever start up again. In Lynn, Massachusetts, Mrs. Engler, the same woman who'd convinced the local theater to ban Mary's pictures, was now calling on the owners to pull Mabel's *Molly O'*.

Alone in Altadena, Mabel tried to remember how she'd started this whole crazy ride.

Taking out pen and paper, she wrote to her parents. It was her father, after all, who'd encouraged her to go out into the world, who'd sparked her desire to be something more than ordinary. What did her father think now, after Mabel's name had been blackened by scandal and innuendo?

She told her parents not to worry. She'd get through this. She'd done nothing wrong.

Days later, Mabel's telephone rang. It was her father. Did she want him to come to California? Mabel was touched. But how could her father help her? What did he know about the world? He'd never left Staten Island, after all. He still imagined the world to be glorious and full of adventure. Mabel knew better than that. She'd seen the world; he hadn't. Better to leave him with his dreams.

To reporters, Claude Normand said, "Mabel knows enough to take care of herself."

That she did, but as her depression deepened, she found her strength put to the test. With Billy Taylor no longer around to support her, Mabel relied on a network of women to get her through—no surprise, given how men had disappointed her. Julia Brew, after years of devoted service, had married and moved on, but now there were others: Edna Purviance, who'd phoned Mabel with the news of Billy's death; Juliette Courtell, her friend and secretary; and Mrs. Edith Burns, a fifty-six-

year-old widow who'd become a kind of surrogate mother to the heart-broken actress.

It was Mrs. Burns who was tending to Mabel that winter, as a cold settled in the actress's lungs and left her unable "to talk above a whisper." Mabel's publicist blamed the protracted illness on the "morbidly curious" attention she'd been receiving since Taylor's death. "If they don't stop badgering Mabel," he told the press, "there'll be crepe hung on the door."

The cold turned into flu. The little house at 1150 Foothill Boulevard was quarantined.

"I talked with Mabel Normand last night over the telephone," Adela Rogers St. John informed her readers. "Her voice haunted me all night. She was crying. Her nurses didn't want her to talk, but she wanted to ask me if I believed she had anything to do with the Taylor murder, if anybody back here [in New York] believed it? And I told her what I believed, that no one connected her with it, no one believed she had done anything that had any connection with the shooting. And I told her that I loved her and for her to take care of herself."

The week before she got sick, Mabel had met with investigators, doing her best to answer every question they threw at her. She'd spent four hours with District Attorney Woolwine. No longer running from the press, she had posed outside his office with her feet turned in, "a typically Mabel Normand manner," and let the shutterbugs snap away.

Although Woolwine announced he believed her story completely, the press had continued to speculate. A certain actress, Wallace Smith reported, had appealed to Taylor for help in paying off extorters. "Following this theory," Smith wrote, "Taylor alone faced the hired assassin of the dope ring, when the killer, armed with the fatal revolver, entered his study."

Could one of her old drug contacts have killed Billy? Mabel must have been racked with guilt and apprehension.

The theory wasn't so far-fetched. Marjorie Berger, Taylor's tax accountant, had revealed that when he'd come into her office on the afternoon of the day he was killed, he'd been carrying "a large roll of bills"—much thicker than the flat wad of cash found later on his body. Taylor had made no deposit that day, so where was that roll of money?

Had he handed it to his killer? Or had whoever shot him lifted the roll of cash but left his jewelry and other valuables undisturbed?

Such nagging questions added to the misery that kept Mabel barricaded inside the little house in the hills of Altadena.

But then, in a sudden burst of determination, she shook off her lingering ague and depression and went back to work.

Mabel seemed to remember that she was a fighter, that she was made of tougher stuff than people gave her credit for. She'd gotten through worse than this.

Bundled into a studio car, Mabel was driven down to the San Luis Rey River in northern San Diego County, where *Suzanna* resumed filming with a herd of ten thousand longhorn cattle. The director, Richard Jones, estimated that production would be complete by the end of April. And when they were done, Mabel decided, she was going to Europe.

New York was no longer far enough away from Tinseltown.

# HER OWN BOSS

In the office of the Recorder of Deeds, in the nineteenth-century City Hall on Broadway in Los Angeles, Gibby Gibson became, with the simple stroke of a pen, her own boss.

This was what she had always wanted. No longer an outsider, she was now a mover and a shaker, the head of her own company. Patricia Palmer Productions had a wonderful ring to it. It meant she was no longer dependent on the whims of others. At last Gibby was in a position to make her own dreams come true.

If the established producers refused to make her a star, then she'd do it herself.

At her side in the old records room, surrounded by leather-bound volumes of deeds, was James Calnay, a thirty-year-old former advertising man. Like Adolph Zukor, Calnay was an enterprising immigrant from Hungary, and he imagined he could depose his illustrious countryman by waging a populist uprising against the big chains. It was the same quixotic dream that had motivated Don Osborn and Charles Seeling and countless others, and no amount of failure seemed enough to deter more dreamers from following the same path.

Calnay, like everyone else, believed he'd be the guy to beat the odds. Boasting connections to theaters throughout the United States and Canada, he'd formed the Independent Producers Distributors Syndicate. Gibby was certain Calnay was different from the others. He was the first to actually make her a producer on her own films, for one thing. Together, they planned "a series of six five-reel rural stories"

(rural settings were in vogue, following that year's breakout success, a farm drama called *Tol'able David*) and Gibby would star in every single one of them. Not only that, she was planning to roust Don Osborn out of his liquored lassitude to direct.

What gave Gibby confidence that this time around she'd make it was one simple fact: for the first time in her career, her coffers were full. She was the one funding Calnay. No one was quite sure where she'd gotten the money. Some of the locusts presumed she must have fleeced some big-time spender. Whatever the source of her capital, Gibby was sending out press releases calling herself "the youngest female producer in the independent field." Patricia Palmer was only twenty-three, after all, even if Gibby was five years older.

To prepare for her moment in the spotlight, she had moved out of the Melrose Hotel and into the second of her North Beachwood Drive properties, number 2324. It wasn't much of a house, but at least Gibby would have her own place, as movie stars were supposed to, instead of living in a hotel. The champagne flowed freely that spring and summer of 1922. With everyone living so close, it was easy for Gibby, or Don and Rose, or Leonard Clapham and his wife, Edith, to throw an impromptu champagne and jazz party. And whenever corks were popped, the locusts swarmed.

These were good times. Success, Gibby was convinced, was at last at hand.

# NO TIME TO TALK

Charlotte Shelby had known it was only a matter of time before the police came knocking at her door. Peering from her window, she could see them in her driveway now.

She was ready for them.

The formidable lady with the bee-stung lips and luxurious copper hair had been alerted by Tom Woolwine that Detectives King and Winn would be visiting her this afternoon. Shelby's long friendship with the DA—some said romance—certainly came in handy now. Forewarned, she had summoned a battery of dark-suited lawyers for the occasion. They sat behind her now, waiting for the visitors like birds of prey.

When the detectives rang the bell, Mrs. Shelby greeted them graciously. What an odd-looking pair they were. King was short, Winn was tall. King was smiling and friendly, Winn was solemn and taciturn.

They exchanged cordialities as they stood amid piles of two-by-fours and building materials: the mansion was still being renovated, so there was little room for the detectives to sit down, even if Mrs. Shelby had asked them to. With a voice like warm maple syrup, she said she regretted not having the time to speak with them. She was leaving for New York on business and had to finish packing, or she'd miss her six o'clock train. But just to show how cooperative she wanted to be, she had asked her lawyers to be there "for the purpose of answering questions."

King insisted he wouldn't take more than a few minutes of her time. He had only a few simple questions.

Mrs. Shelby glared at him. What sorts of questions?

Questions about her interactions with Taylor, King replied, during the time he was directing her daughter.

People had been talking, Shelby realized. People who hated her. People who were jealous of her and her success. How happy those miserable cretins must have been to tell tales about the times Shelby had blown up at Taylor, or the times she had threatened him.

Composing herself, Mrs. Shelby declined the detectives' request in her most charming southern accent. She was simply too busy to delay her trip, King would recall her saying, "to devote any time to an investigation about which she knew nothing."

King and Winn didn't try to detain her. They had no grounds to do so. After choosing not to speak with Shelby's attorneys, they were shown to the door.

King was not pleased. How had Shelby known they were coming? Someone must have tipped her off.

Trudging out of the house, the detective had a pretty good idea who it was.

His own boss, Thomas Woolwine. The DA was determined to keep his detectives from talking to his ladyfriend. King had increasingly clashed with Woolwine over the past several months about the case. His boss remained firm in his conviction that "whoever killed Taylor had probably been hired to do it and had no emotional connection" to the victim, as Woolwine's family would later describe his position. He no longer thought the killer was Edward Sands and, directly contradicting King's theory, he also "did not believe the murder was a crime of passion."

Faced with Woolwine's obstruction, King and Winn had visited Shelby as members of the LAPD, not as representatives of Woolwine's office. And, denied a conversation with Shelby because of the DA's interference, they decided on another tack. If they couldn't speak with the person they most wanted to interview, they'd call on her mother, the aged Julia Miles. The detectives headed over to Hobart Boulevard.

Where Mrs. Shelby had been brusque and defensive, Mrs. Miles was just the opposite—sweet and cooperative. King asked if she recalled the night Taylor was shot. Her granddaughter, Mary, had already revealed

that Mrs. Shelby was not with the family that night. Did Mrs. Miles know where her daughter had been?

The old woman gave it some thought. It was true, she said, that Shelby had not been with them. She'd been visiting friends, Mrs. Miles said, and got back to the house on New Hampshire Avenue around nine o'clock. At least, that was what Mrs. Shelby had told her.

Who were these friends that Shelby had been visiting, the detectives wanted to know, and could they offer an alibi for her whereabouts that night?

Mrs. Miles wasn't sure. And of course Mrs. Shelby wasn't talking.

Just what was the lady trying to hide, King wanted to know.

Even more critically, why was the DA helping her to hide it?

At some point after the detectives' visit, old Mrs. Miles, like her daughter, embarked on a cross-country trip.

She was heading back to Louisiana, at least temporarily. It was a long train ride for a frail seventy-year-old woman, traveling alone, steaming through Arizona, New Mexico, and Texas. Mrs. Miles claimed her trip had to do with settling family estates, but it actually had more to do with a certain item that was concealed deep down inside her luggage, something that was best not to have lying around if those pesky detectives ever returned with search warrants.

Arriving in New Orleans, Mrs. Miles transferred to another train that took her nearly three hundred more miles, up to the northeast corner of the state. Debarking at Bastrop, where the family still owned a plantation, the old woman trudged across the muddy grounds—a small, determined figure in a black dress and bonnet. Finally Mrs. Miles came to a stop at the edge of a swampy bayou. She rummaged through her bag. She withdrew a pistol.

Charlotte Shelby's .38.

The sooner this was out of their lives, the better.

Mrs. Miles flung the filthy thing away from her. The gun splashed down into the bayou. Through her rheumy old eyes, Julia Miles watched as her daughter's gun disappeared beneath the dark, murky waters.

The murder made front-page headlines for weeks, especially in the Hearst papers.
COURTESY BRUCE LONG

Detective Ed King *(right)* was a
top-notch detective, and might have
solved the Taylor case had he not
become convinced that his boss, District
Attorney Thomas Lee Woolwine
*(above)*, was protecting the killer. In fact,
Woolwine was one of the few honest
DAs in Los Angeles before World War II.

Faith and Douglas MacLean, Taylor's neighbors, in the pergola at Alvarado Court. Faith saw the killer leave Taylor's bungalow, and her testimony was key to cracking the case. COURTESY BRUCE LONG

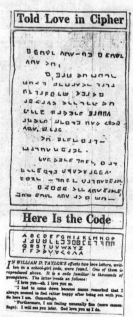

Mary's love letters to Taylor were splashed all over the newspapers. Rather than humiliating her, the publication of Mary's missives only made her devotion to Taylor stronger. COURTESY BRUCE LONG

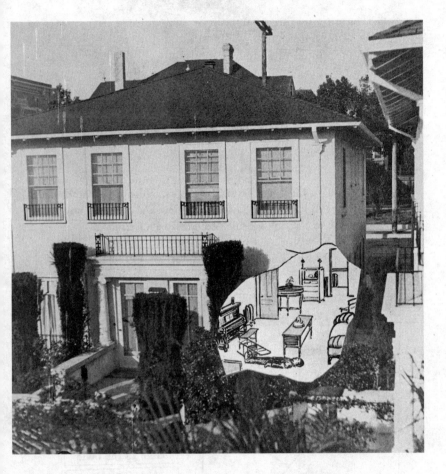

A newspaper photograph and diagram of the murder house. CORBIS

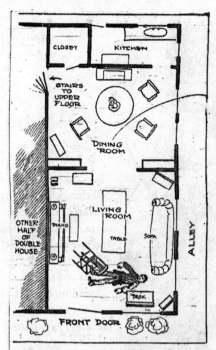

Diagram by "Examiner" staff artist showing floor plan of Taylor bungalow, position of furniture and exact spot where body was discovered, with overturned chair across one of the victim's ankles.

A fascinated public tried to solve the case on their own, using diagrams like these published in newspapers. Note that in the diagram of the courtyard *(below)*, the MacLean bungalow should not be opposite Taylor's but rather immediately catercornered to it.

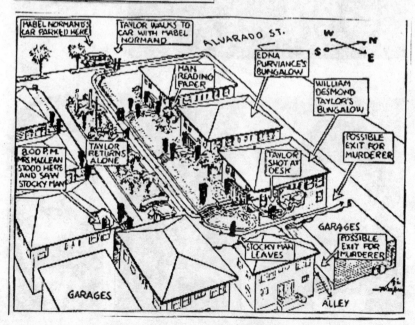

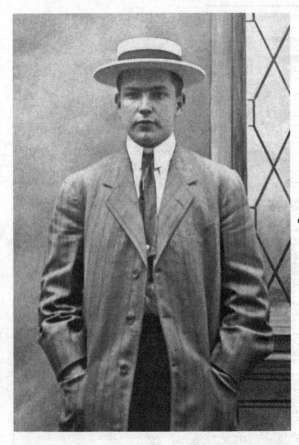

Edward Sands, aka Edward Snyder, Taylor's valet with a criminal past. Sands was the investigators' first suspect, and his image went out to police stations across the country.
COURTESY BRUCE LONG

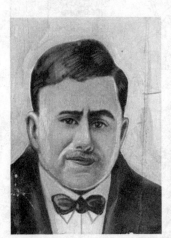

The Taylor murder and the other scandals weren't just grist for the tabloid press. They also ignited furious debate about Hollywood's role in influencing the nation's values. COURTESY BRUCE LONG

HOLLYWOOD PHOTOGRAPHS

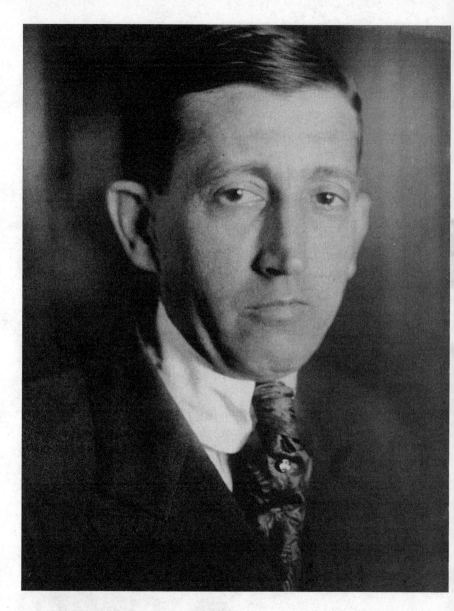

Will H. Hays was a little man with a powerful voice and an impeccable résumé, brought in by Zukor and others to convince the public that the film industry was serious about reform. But Hays, speaking here at the Famous Players–Lasky studio (Cecil B. DeMille to his right and Jesse Lasky behind him) and at the Hollywood Bowl during a barnstorming tour of the film colony in 1922 *(left)*, was never going to be content as Zukor's puppet.

# Ohio Millionaire Charges Pair
# With $100,000 Extortion Plot

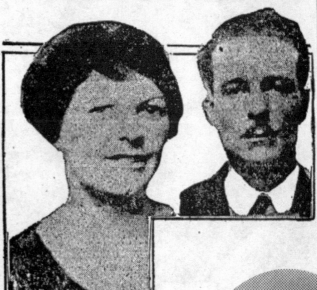

Top, Rose Putnam and Don Osborn, who, John L. Bushnell, below, charges attempted to blackmail him.

DAYTON, O., July 17.—Don Osborn and Miss Rose Putnam, his niece, today are confined in the Miami-co jail at Troy following their removal from the Dayton jail last night.

Why they were removed was not revealed by the federal authorities who issued a secret order late last evening for the removal.

The two prisoners had only about

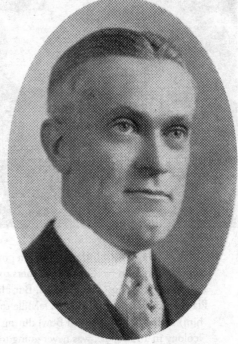

Gibby tried to make herself a star by producing her own pictures, as here in *The Web of the Law* with Ranger Bill Miller *(top)*. But by 1923 most of her income came from scams she pulled with her associates Rose Putnam, Don Osborn, and Blackie Madsen, who got caught blackmailing millionaire John Bushnell *(above)*.

Hays and Zukor eventually had to come to terms. An absolute monarch until 1922, Zukor never quite got used to sharing power. PHOTOFEST

Zukor kept a map not unlike this diagram on his desk *(left)*,
keeping track of his theaters and those of his rivals. Zukor's crown jewel,
the Paramount, opened in 1926. Directly opposite was Marcus Loew's State,
which Zukor made sure to overshadow. The Paramount stood thirty-five
stories; its opulent interior seated three thousand. PHOTOFEST

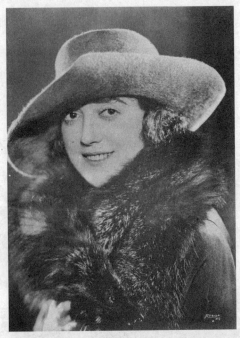

Tinseltown tried to destroy Mabel, but she escaped to New York, where she became a fashion trendsetter and habitué of literary salons and speakeasies.

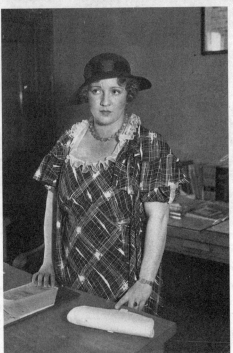

Mary wasn't as lucky. Retiring from the screen, she faced a lifetime of legal battles and humiliations. Reporters gleefully noted the increasing size of the once-diminutive actress.

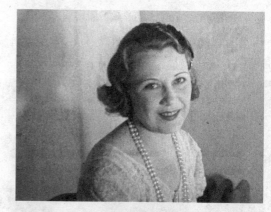

Despite all her setbacks, Gibby never quite gave up hope, keeping head shots on hand even into middle age, just in case the studios ever called. COURTESY RAY LONG

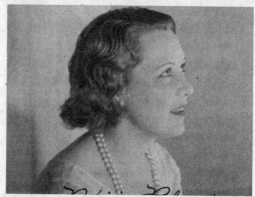

Gibby's last home, hidden behind overgrown foliage in the Hollywood Hills. COURTESY RAY LONG

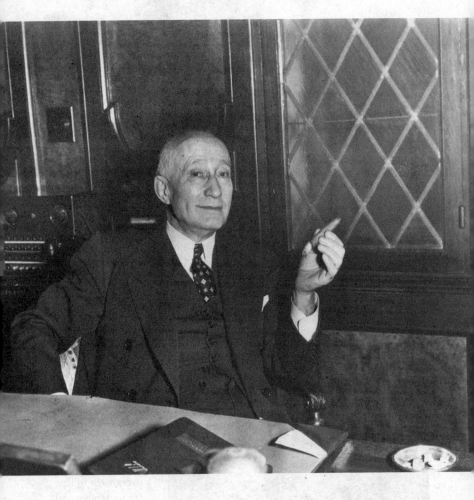

Adolph Zukor lived to be 103, never revealing all he had done to contain the scandals of the 1920s. PHOTOFEST

# A GREAT INJUSTICE HAS BEEN DONE

On April 12, in a San Francisco courtroom, the jurors in the third Arbuckle trial returned to their box just six minutes after they'd adjourned. The defense attorneys smiled tentatively, convinced that the short deliberation meant exoneration for their client. But Arbuckle, scarred by dozens of disappointments over the past seven months, stood there rock-still, a stricken look on his face.

The judge asked if a verdict had been reached. It had.

The foreman stood.

"We, the jury, find Roscoe Arbuckle not guilty."

The judge had cautioned the courtroom against demonstrating after the verdict, but Arbuckle couldn't contain his jubilation. "Every inch of his huge frame radiated happiness," one observer noted. When the judge banged his final gavel, cheers erupted in the gallery, and Arbuckle blew kisses to everyone.

But a lack of guilt was not all the jurors had found.

"Acquittal is not enough for Roscoe Arbuckle," they wrote in an extraordinary public statement passed out to reporters as they left the courthouse. "We feel a great injustice has been done him. The happening at the hotel was an unfortunate affair for which Arbuckle, so the evidence shows, was in no way responsible. We wish him success and hope that the American people will take the judgment of fourteen men and women who have sat listening for thirty-one days to the evidence, that Roscoe Arbuckle is entirely innocent and free from all blame."

Three thousand miles away, the telephone shattered the stillness in

Adolph Zukor's New York town house. Taking the phone, the mogul learned of Arbuckle's acquittal.

It was the outcome he had feared most.

Soon afterward, his phone was jangling again. Reporters, wanting a statement. But Zukor was not accommodating. For now, Zukor decided, the best response from the studio was silence.

Back in Hollywood, though, Jesse Lasky didn't get that memo. Much to his partner's displeasure, Lasky told the press he was "very pleased" by the acquittal. It was what "all persons connected with motion pictures had hoped for and believed would happen."

Not all persons. Late into the night, Zukor was on the phone with his lawyers and financial advisers, trying to determine his next step. As dawn finally arrived, the consensus was to proceed with caution.

Later that morning, Zukor finally issued a statement. Within the next thirty days, he said, Famous Players would release one of the Arbuckle pictures that they'd been holding back. It would be an experiment, Zukor explained, "for the purpose of gauging public sentiment." If the picture did well, the studio would release others. "We will not force the pictures," Zukor added, mindful of the accusations he knew were coming, "but will supply them if the public demand exists." Supply and demand. The American way. Who could object to that?

But Zukor knew as well as anyone that reason wasn't what moved the industry's critics.

On the announcement that Famous Players would release *Gasoline Gus*, the company's stock surged to nearly $4 a share. That was encouraging, but Zukor knew the truth: he was damned if he did, damned if he didn't. If audiences stayed away from Arbuckle's pictures, as the moralists predicted, he'd never make back his investment. But if audiences turned out in droves, his problems might be even worse. As the *Evening Telegraph* in Alton, Illinois, explained the next morning, "If [audiences] flock to see [Arbuckle's pictures], then it may be inferred . . . that stars may go on living the life of a tomcat, regardless of the moral laws of God and man." Decent people, the editorial argued, could only hope that the new Arbuckle releases lost money. "If these motion picture stars learn that they are to lose their income by continuing to lead such immoral lives as they do, they

might cease to occupy so much space in the reports of criminal and scandalous proceedings in the newspapers."

But what if the opposite lesson was learned?

Well before ten o'clock in the morning on Saturday, April 15—Holy Saturday, the day before Easter—lines began forming outside the Garrick Theatre in Los Angeles, stretching all the way down Broadway to the corner of Eighth Street and beyond. Men and women laughed and joked. Children ran about excitedly, impatient to see the picture. The marquee on the theater read FATTY ARBUCKLE IN GASOLINE GUS. Newspaper advertisements bannered FATTY IS BACK! and promised continuous screenings of *Gasoline Gus* from ten a.m. to eleven p.m.

"If the comedian had arranged a professional comeback himself," Grace Kingsley wrote in the *Los Angeles Times*, "he couldn't have stage-maneuvered the job as Fate did it for him." The Garrick was filled with "the fans who have waited all this time for another booming laugh, such as only Fatty can give them," Kingsley wrote. "They cheered his first appearance on the screen, and applauded when the picture was finished, and laughed in between." The Garrick did a bang-up business all day long, and the same numbers crowded in the next day, even though it was Easter Sunday.

The crowds that filled the Garrick to capacity—on the holiest days of the Christian calendar!—belied the moralists' vision of America. So did the little children who met Arbuckle at the train station with their parents, throwing their arms around his neck. The welcome Arbuckle received debunked the claim that the public would rise against him, that a majority of Americans were repulsed by the permissive, cosmopolitan, secular lifestyle Hollywood both presented and represented. If America had ever been the country the moralists described, it wasn't anymore. A world war and the changes it brought to society had seen to that.

In Chicago, the censor board took a new, progressive stand, announcing that Fatty was welcome once again on the city's screens. Films were to be judged on their individual merits, the board said, "without any reference to the private life of the actors." And while it was no surprise that *Gasoline Gus* would attract capacity crowds in big cities like Chicago and Los Angeles, Paramount exchanges were getting enthusiastic responses from all around the country. In the little city of Washington,

Indiana, the Liberty Theatre polled its audiences that weekend—and the vote was 1,066 to 140 in favor of Arbuckle. From Great Falls, Montana, came an appeal from a theater manager asking for "the privilege to be the first [in the region] to show an Arbuckle photoplay." One Paramount agent noted ironically, "Practically all the same managers who ordered the films cancelled out of their theaters when Arbuckle became involved in the Rappé case are the first to ask that his productions be reissued now."

Buoyed by such support, Famous Players scheduled a gala New York premiere for *Gasoline Gus* at the Rivoli Theatre on April 23.

But the moralists weren't conceding defeat quite yet.

"The public knows full well," wrote the *Kokomo Tribune*, in Will Hays's home state of Indiana, "even if Arbuckle has been acquitted, that the party he gave was an affair of disgusting debauchery and unspeakable licentiousness." That alone, the moralists believed, should be enough to bar him from the screen.

In an open letter to Will Hays, the Lord's Day Alliance, Wilbur Crafts's organization, implored the new head of the MPPDA to use his authority "to intervene and prevent the outrage to the moral sensitivities to the citizens of this country threatened by the proposal to again exhibit Arbuckle films." And "in case it should be that the exercise of such authority" was not within the bounds of Hays's power at the MPPDA (it wasn't), then the group urged him to use his "great personal influence for the accomplishment of this end."

Others weren't willing to wait for Hays. In Sheboygan, Wisconsin, the local paper pressured its common council to ban Arbuckle films. In Hartford, Connecticut, after calls from religious organizations, theater owners pledged that Fatty's face would never again be seen on their screens. This included the Majestic Theatre, a Paramount licensee. Zukor had meant it when he said he wouldn't "force" the pictures on his theaters; he knew what kind of backlash that would cause. For practically the first time in his career, he ceded a shred of authority to his exhibitors: Arbuckle pictures would be released to Paramount theaters, but no one would be compelled to accept them.

That was still not good enough for Zukor's antagonists.

The Lord's Day Alliance threatened to protest outside theaters that dared screen *Gasoline Gus*. Petitions from conservative religious

groups piled up on Hays's desk, overwhelming his first weeks on the job. To get the results they wanted, reformers made sure to stack local theaters whenever public debates over Arbuckle were scheduled; there would be no more of those embarrassing polls if they could help it. In St. Louis, the boos were louder than the applause when one theater asked its patrons whether they ought to show Arbuckle. The powerful Federation of Women's Clubs sent its members into battle, targeting any theater that presented Arbuckle films. A group of Chicago women disregarded their own censor board and stormed the screen at the Blackstone Theatre when an old Arbuckle two-reeler appeared, forcing the owners to shut down the exhibition.

And in Washington, the Federal Trade Commission took note of just how unmanageable, how unregulated, the film industry had become.

Only days after his "experiment" of releasing Arbuckle's film, Zukor knew what he had to do. The pushback from the reformers was not going to end. They would mobilize; they would boycott; they would tear films out of projectors if they had to. They would bring down government regulation. The reformers had won.

Even though Zukor had ten thousand contracts with theaters across the country to show *Gasoline Gus*—even though the film was pumping a steady supply of nickels, dimes, and quarters into his coffers, on schedule to recoup the million dollars he had feared lost—he would have to turn off the tap. He had to willingly give up all that income—another first for Zukor's career.

Arbuckle's comeback had to be halted. It was the only way. And only one person could make that happen.

On Tuesday, April 18, Will Hays was summoned to a meeting with Zukor at the Famous Players office, a block and a half down Fifth Avenue. Despite being what wags called the "highest paid executive the avenue knows," Hays obeyed the order from Zukor and made the trip.

Jesse Lasky and Nicholas Schenck, representing his brother Joe, were also summoned. Once they were all present, Zukor made his wishes clear: with all the agitation and threats of boycotts, Arbuckle's films had to be banned.

The men were shocked. But the public wanted Fatty! *Gasoline Gus* was making money!

Zukor silenced the arguments. The industry could not be seen as pandering to the public's lowest common denominator—the only explanation the moralists could give for the thousands who were flocking to see *Gasoline Gus* and demanding more Arbuckle pictures. That would leave them vulnerable to threats far greater than any temporary loss of income. The headlines about the Taylor murder had only recently died down. If they didn't move to stop Arbuckle's comeback, they'd be mired in controversy for months to come—controversy that could only encourage the government to move against them.

Zukor knew what was needed: a statement banishing Arbuckle from the screen. He turned to the new man in the room, the man they'd chosen to protect the industry.

Hays blanched.

This was not why he had been hired. He had frequently insisted that he would not be put in the position "of being a judge of the morals of those who are in the industry." As a Christian, Hays recoiled at the idea of passing judgment, of casting stones. Arbuckle had been found innocent in a court of law, he argued. Who was Will Hays to second-guess that? The poor soul was also "well-nigh bankrupt," Hays had heard. How could he "stand in the man's way of earning a living in the only business he knew"?

Hays wanted nothing to do with such a plan. If such a ban was going to be issued, Hays believed, the man to do it was Zukor, on behalf of Paramount.

Zukor could have done it. Technically, in fact, he alone—not Hays—had the power to ban Arbuckle's films. But then Zukor would have had to face the wrath, and potentially the lawsuits, of those who held the ten thousand Arbuckle contracts. Even worse, a Zukor-imposed ban would have damaged the credibility of the MPPDA. If anyone other than Hays made the decision to ban Arbuckle, Zukor argued, the movie czar would be exposed as a puppet—a charge some had already leveled, and one Hays deeply resented. If he didn't take the lead on this issue, Zukor told Hays, the moralists were ready to emasculate him. And a castrated leader would have zero power to effect any of the other industry changes they all wanted.

Against such reasoning, Hays had no argument.

The press coverage would say it was Hays who had "prevailed upon" Zukor and Schenck to ban Arbuckle. How Hays must have cringed to read the stories. Years later, in his memoirs, he'd say that Zukor's decision to ban Arbuckle had been noble: he had put the good of the entire industry ahead of the potential profits he might make from the comedian's pictures—and paid the price for it, as stock in Famous Players dropped precipitously the day the ban was announced.

But that was hogwash. One of Zukor's core beliefs was that the market should decide everything. If audiences nationwide flocked to Arbuckle's pictures the way they had in Los Angeles, he (and Hays) could have told their critics, "That's the American way." Yet faced with threats of boycotts and regulation and the possibility of undermining the power of the MPPDA, Zukor had abandoned one of his most cherished business tenets. Hays did his best to make that decision seem honorable. But he also made clear to posterity that it was not he who made it.

At the time, however, Hays had no choice. On a blank Famous Players–Lasky interoffice memorandum, he scrawled a draft of what Zukor wanted him to say. "After consultation at length with Mr. Nicholas Schenck, representing Mr. Joseph Schenck, the producers, and Mr. Adolph Zukor and Mr. Jesse Lasky, of the Famous Players–Lasky Corporation, the distributors, I will state that at my request they have canceled all showings and all bookings of the Arbuckle films. They do this that the whole matter may have the consideration that its importance warrants, and the action is taken notwithstanding the fact that they had nearly ten thousand contracts in force for the Arbuckle pictures."

Hays then made the short walk back to his office, memo in hand. So this was what his job would be: a glorified secretary to Adolph Zukor, rubber-stamping Famous Players policy. The pundits were right: it hadn't taken Zukor very long to flex his muscles, exposing Hays's leadership as an industry ruse. Just two months after taking office, Hays had been forced to deny his better nature and obey his overlord's bidding.

After instructing his assistant to type up the draft and send it out, Hays tried to slip away unseen. But a group of newsmen caught him, "hat and coat in hand," and started pummeling him with questions. How did he justify this ban, given Arbuckle's acquittal and the jury's

statement condemning the injustice against him? What happened to Hays's insistence that he was no censor?

Turning to face his pursuers, Hays tried quoting the MPPDA's mission statement, blathering about "moral and artistic standards." But his words were hollow. His heart wasn't in them. "Beyond that," Hays muttered, "I cannot say anything just now."

He hurried away.

Zukor made no statement. This was Hays's moment, as he had intended it to be.

The press spun the ban as the "first move in the announced campaign to 'clean up' the industry," just as Zukor had hoped. That would please the moralists. That should convince them—for a while, anyway—that Hays held moral authority over all of them.

In Hollywood, the ban came as a great surprise to everyone, including the man himself. When reporters banged on his door to give him the news, Arbuckle's face dropped. "Gosh," he said. "I thought I was well-started on my comeback."

So had Will Hays. In his office the next day, the film czar sent off a letter to friends. He was "very homesick for you all," he wrote. Heartsick too, no doubt.

The Arbuckle ban was a game-changer. No one was safe. "The action is regarded by high officials in the industry," the *New York Times* observed, "to mean that other characters who have figured in so-called Hollywood scandals would be driven out as objectionable to the public." Who was next, then? Mabel? Mary?

They all now lived in fear of Will Hays.

# A QUESTION OF MOTIVES

The man Jesse Winn had just brought in for questioning was handsome, slender, dark, and very nervous. Sitting opposite him in the interrogation room, Eddie King doubted very strongly that this latest suspect in the Taylor case had anything to do with the crime. He was starting to get a sense of who the killer might be, and it was not this man.

Still, as the DA's lead investigator on the case, King had a job to do, so he went through the motions of interrogating the trembling figure sitting across from him. His name was Honore Connette. Well-dressed and erudite, Connette was thirty-nine years old, unmarried, and a newspaper scribe, working at various times for the *Los Angeles Times* and the *Long Beach Press*. Most recently, however, he'd been writing for the *Hilo Tribune* in Hawaii. While in the island territory, Connette had drawn attention to himself by telling some outrageous stories about William Desmond Taylor. To a fellow reporter, Connette had insisted that Taylor's murderer was not a woman, as so many papers were implying. When asked how he could be so sure, Connette had implied that he knew a lot of people in the film colony—and their secrets.

Connette had been an actor before going into journalism. The Indiana native had toured the country in *The Poor Little Rich Girl*, playing the "first society man." After the show's run, he had settled down in Los Angeles, along with one of his castmates, James Bryson, who had played the "second society man." Bryson went on to become part of Don Osborn's clique, writing bad checks and carrying on with Rose Putnam—until, of course, Osborn put a stop to that.

Connette had done better for himself than his old friend, landing his newspaper gigs as well as some bit parts in movies. At one point he had worked as an extra for William Desmond Taylor. The two had shared a conversation about books, Connette told King.

Somehow, Connette seemed to have picked up some knowledge of Taylor's death—and for a while he blabbed about it to anyone who would listen. For the *Hilo Tribune* he wrote articles suggesting that Taylor's killer was planning to disappear into the Orient. Finally, when his talk raised too much suspicion, Connette's editors turned him over to the police. Jesse Winn had met his ship in San Francisco, and in searching the traveler's bags he had found something very interesting.

A .38-caliber revolver, the same kind of gun used to kill Taylor. And one cartridge was missing.

King sat staring into the man's dark eyes. Revolver notwithstanding, he was still convinced that Connette had nothing to do with the case. What possible motive would Honore Connette, a newspaper reporter who'd barely known Taylor, have had to commit murder?

And for King, motive was everything.

Three months after the murder, investigators still had no solid leads. 7000 HOLLYWOOD RUMORS DISSOLVE AS POLICE FLOP IN TAYLOR CASE, *Variety* charged. But King intended to debunk that headline. He believed he was close to figuring out the case.

His early dismissal of Edward Sands as the culprit was now accepted by most—though not all—of the other investigators. The detectives had received a police report that a sailor fitting Sands's description, going by the name of Snyder—Sands's real name—had signed up for the revenue cutter *Bear* the previous November, which certainly fit the pattern of Sands's life. The report also said that the same man had been spotted in the municipal woodyard in Oakland, California, on February 1—which, if true, would discredit Earl Tiffany's wife's claim that she had seen Sands that same day in Los Angeles. It would also exonerate Sands of Taylor's murder. As far as King was concerned, the testimony of the Oakland police carried more weight than that of Mrs. Earl Tiffany.

Only one person had the motive to kill Taylor, in the detective's opinion. It wasn't Edward Sands. And it sure as heck wasn't Honore Connette.

Still, King was obliged to investigate Connette as thoroughly as he could. The actor Gareth Hughes, a friend of Connette's, was called into the DA's office. Hughes revealed that the newspaperman had been very depressed following the death of his mother the previous January, and had started drinking heavily. He'd also become addicted to Veronal, a barbiturate sleeping aid. Connette's talk about Taylor could only have been a fever dream, a fantasy, Hughes believed. King chalked him up as just one more crackpot obsessed with the Taylor case.

By this time, Connette was trying frantically to walk back all the tales he'd told about the murder. In "a moment of levity," the frightened newspaper reporter now claimed, he'd tried to impress a newspaper rival in Hilo. "I suppose I drank a bit," he told investigators, "and said things while under the influence of liquor upon which the preposterous situation in which I now find myself could have been built."

Just to be sure, Connette was hustled into a police car and driven over to Alvarado Court, where he was presented to Faith MacLean. The weary woman took a long look at him and concluded that, no, he was not the man she had seen. And presumably a test of the bullets in Connette's gun revealed that they did not match the one that had killed Taylor.

The newspaper writer was released. No further tabs were kept on him.

King was tired of such foolishness. It was time, he believed, that they arrest the real killer. But first, he knew, he was going to need proof.

He asked Woolwine to allow him to interview the suspect he had in mind. But his request was turned down. It wasn't the first time that the DA had stopped King from following his instincts. He'd tried to stop him when he suspected Mary Miles Minter, but King had found a way around that and interviewed her anyway.

And he'd find a way around this obstacle as well. No matter his boss's opposition, King was determined to crack this oyster. Before the end of the year, the detective vowed, William Desmond Taylor's murderer would be standing trial.

# A COMPANY OF OUTLAWS

In the distance, the snow-covered Grand Tetons blued the horizon. Gazing through a pair of binoculars, Charlotte Shelby watched her daughter move across the wide graben valley. She was like a hunter tracking an antelope, waiting for the right moment to shoot to kill.

It was a hot day in July. Shelby had accompanied the cast and crew of Mary's latest picture, *The Cowboy and the Lady*, on location to Jackson Hole, Wyoming. It was Mary's first time back in front of the cameras since all that nasty publicity about Taylor.

The scandal had changed her daughter, Shelby felt. Mary wasn't the same girl. She was acting up, misbehaving, "not cooperating with the studio," in Shelby's opinion. And that was dangerous. Shelby no longer worried about what salary Zukor might offer when he renewed Mary's contract. Now she worried whether he'd renew it all.

Shelby's eyes followed her daughter. The film was Mary's first western, and she was required to ride a horse. With utter recklessness, she was galloping across the valley, as if daring the horse to throw her and break her neck. What had gotten into the child? Mary was insisting on doing things her way, no matter the orders of her director, Charles Maigne. This was not like her. Normally, on location, Mary was "a good trouper," Shelby said. Why this sudden, willful change of character?

Watching her daughter's every move, Shelby thought she had it figured out.

"By stages so gradual as to be imperceptible," Shelby would later

write, Mary "was aligning herself more and more with the least desir-
able of the motley crew that made up the company." Encouraged by
their unruly, rebellious ways out there in the Wild West, Mary "grew
steadily more resentful and defiant" of her mother. When Shelby spoke,
Mary no longer quaked.

The chief instigator of Mary's rebellion, much to her mother's dis-
may, was her costar, a spitfire by the name of Patricia Palmer. Mary
had known Palmer for years. They'd met when Mary was just thirteen,
when both were feted at a ball hosted by the Indianapolis Motion Pic-
ture Exhibitors League. Back then, Palmer was still known as Margaret
Gibson, and no doubt Mrs. Shelby was well aware of the reasons Gibby
had changed her name. Little wonder why she was so displeased to see
Mary now falling under the spell of the older actress.

A thousand miles from Hollywood, the company was cut off from
civilization in every direction. Back in the days of cattle rustlers, Jack-
son Hole had been considered an ideal place for outlaws to hide out
from law enforcement.

Now the outlaws had returned to Jackson Hole.

Mary liked these risk takers, these plain talkers. She took to eat-
ing catsup on toast and staying up late at night, disregarding Shelby's
wishes. She may even have snuck a swig of bootleg rum. How wonder-
ful to be among such exciting people in the presence of the majestic
Tetons. Mary thought the mountains "more beautiful than the Swiss
Alps," which she'd seen on her tour of Europe the previous summer.

At night, after Shelby went to bed, Mary would sit with the rest
of the company on the veranda of their dude ranch outside the little
town of Jackson. She may well have poured out her heart to her new
friends. After all, Gibby had known Mr. Taylor quite well, too. They
had been good friends, when they were both just starting out in the
business. No doubt Mary wanted to hear all of Gibby's memories of
Mr. Taylor.

Out there in the quietude, the man entombed in Hollywood Memo-
rial Cemetery was never far from Mary's thoughts. Her diary was filled
with her musings of their great, tragic love. "I've stood in the stillness
of the night with the blazing stars overhead listening for him," Mary
wrote. "He is out there, beyond. Our love is as a white hot star that has
met the heavens with its glory."

To her fellow cast members, she evinced no embarrassment over the scandal. Indeed, seeing her letters published in the *Examiner* had seemed to comfort her, to keep her love alive. "Many of those letters were written two years before he died," Mary said in wonder. "And he kept them." The thought lodged itself in her brain. He kept them. "Surely he must have loved me deeply, sincerely," Mary concluded, "to have kept them for so long."

Under the big western moon, Mary's new friends may well have nodded in agreement.

The company was a curious lot. They weren't the usual faces who populated the supporting casts of Paramount films. Viora Daniel's last work, like Gibby's, had been at the Christie studio. Leonard Clapham was a neighbor of Gibby's from Beachwood Drive, a friend of Don Osborn's who, until now, had appeared mostly in low-budget fare for Universal. And how delighted Gibby was to have been hired for a picture at the biggest studio in Hollywood.

The status-conscious Mrs. Shelby, however, shuddered at these downmarket players. She, like everyone else, wondered why Patricia Palmer, with all her troubled history, had been given a contract by Mr. Lasky and Mr. Zukor, who were usually far more discriminating.

Gibby, of course, was ecstatic.

At long last, her name was appearing under the Paramount banner—the most glamorous brand in Tinseltown. And just in time, too, since her plan to make her own pictures had been temporarily put on hold. She'd broken her contract with James Calnay after discovering he was an embezzler; later that year a warrant would be issued for his arrest, and he'd eventually serve time in Leavenworth prison for fraud. But Gibby didn't despair. Even as she went searching for a new producing partner, she had been given the chance to costar in a Paramount film, which would certainly keep the cash flowing and raise her profile and prestige.

How good her life had suddenly become. Patricia Palmer—a Paramount star!

No one in Hollywood could quite comprehend it.

Least of all Charlotte Shelby.

As Mary fell deeper under the influence of her costars, her mother's worries deepened. The daily harassments of reporters and investigators that had plagued them both after Taylor's murder had finally abated, and Shelby was thankful for that. But she was also aware that the nightmare could come back. One reckless moment, and everything could come crashing in on them. The police would return, asking more questions. That fear gnawed at Shelby.

The sooner they got home from Wyoming, the better.

On August 15 Maigne called his final cut, and the company prepared to return to Los Angeles. They boarded the Oregon Short Line Railroad in Jackson.

At Victor, Idaho, the train stopped momentarily. Mary, Gibby, and some others decided to take advantage of the warm afternoon and gathered outside on the open platform of their special Pullman car. Not far away, a switch engine was backing up. Thinking he had plenty of room to turn around, the driver was traveling about fifteen miles an hour. Looking the other way, Mary, Gibby, and the others never saw the engine coming. But they certainly heard and felt it.

In an awful scrape of metal against metal, the engine rammed into their car. Gibby was flung onto her back. Mary was thrown into a glass window. The pretty little actress threw her arms up to cover her face, instinctively protecting her most valuable asset. But her arms were studded with shards of glass and dripping with blood.

Since there were no doctors in Victor, the train sped on to the town of Ashton, forty-three miles away. There, shocked and bleeding, Mary and the others were treated by a railroad physician. But Mary's wounds were too deep for the makeshift operating room in the little dirt-road town. So on for another seven hours the train chugged, reaching Pocatello around ten at night. Mary was rushed to the hospital and given fourteen stitches.

Finally, at midnight, the company set off for home.

The next morning, Mary was all smiles. "These things are bound to happen," she gamely told a reporter who came on board during a stopover in Salt Lake City. While Gibby and the others were resting from

their injuries, Mary held forth at the breakfast table, devouring her catsup on toast. "I will continue on with my work," she said. "Fourteen stitches will not stop me."

If Charlotte Shelby, banished to her berth, had been eavesdropping, she might have wondered just what would.

# THE SAVIOR

As the car he was riding in reached the top of Cahuenga Boulevard, Will Hays couldn't quite believe his eyes.

Thirty thousand people filled the newly built Hollywood Bowl, cheering for him and shouting his name. White flowers fell from a battalion of passing airplanes like snowflakes in July. The boom of a cannon announced Hays's arrival.

All of this, for him.

Not for some political candidate whose campaign he was managing. Not for some statesman or movie star. Him. Little bat-eared, bucktoothed Will Hays, who'd never turned any heads. Him. They were cheering for him.

Hays stepped out of the car. The Bowl's small wooden stage was surrounded by a smattering of benches that were filled with movie stars and studio executives: Gloria Swanson, the Talmadge sisters, Joe Schenck. Wallace Reid was there, too, probably strung out on morphine, which might have helped make the blazing sun tolerable.

The vast majority of the throng, however, stood on tiptoe throughout the vast, dusty amphitheater, trying to get a glimpse of the stage. For an hour and a half they'd sweltered there, though many had stood even longer in line outside the Bowl, just to make sure they got in to see the man the newspapers were calling "the Caesar of the Cinema."

Hays's handlers hustled him up the back stairs of the stage. "Slipping almost unnoticed by the crowd," one observer recounted, "Hays' sudden appearance immediately in front of the immense gathering, together

with his friendly gestures of welcome, acted as a signal for the turning loose of all the noise that could be obtained from human lungs."

Hays was overcome.

He'd been in Hollywood now for six days, arriving late on the California Limited on July 23. Ever since, he'd been meeting with industry officials and touring the studios—starting with Famous Players, of course, but hitting them all, from Universal City to Culver City, from big to small, just to show he played no favorites. From the roof of every studio flapped banners proclaiming WELCOME WILL HAYS. Nearly every theater was festooned in red, white, and blue bunting. SUPREME FILM DICTATOR HERE TO SEE AND LEARN, read the *Los Angeles Times* headline. Tinseltown was giving Hays the kind of rush usually reserved for European royalty.

But the "supreme dictator" wasn't really so supreme. That had become all too clear to Hays. In the weeks before his trip, he had allowed Adolph Zukor to dictate all his plans. "I wish you would let me have your ideas about my going to California," Hays had written to Zukor. Requests for speeches and visits were coming in, but before he agreed to anything, he solicited Zukor's "real judgment" on each invitation.

And what Zukor arranged for Hays was a visit that was showy and symbolic. No meetings of any substance, just propaganda and public relations. Hollywood was heralding the arrival of its savior. Hays was there to meet and greet, to win hearts and minds. Now, at the end of the week, he'd shaken so many hands that he had to send out for arnica, a homeopathic remedy, for his sore arm. He gave no interviews to hard-core journalists, but he did sit down with the beautiful actress Helen Ferguson, who wrote a stirring piece about him for the *Los Angeles Times*. "Unquenchable enthusiasm shone from his keen, kind eyes," Ferguson declared, "when I expressed the thought that upon the screen rested the task of bringing into closer understanding the antagonistic nations . . . and of unifying men."

Forget just hearts and minds: he was there to win over people's souls. Over the past week, Hays's role was marketed to the public as spiritually uplifting, even quasi divine. Every action the film czar took during his week in Hollywood highlighted his messianic mission, from the banners waving from roofs and street posts to the assemblage of the multitudes at the Hollywood Bowl. During his tour of the studios, some

workers literally dropped to their knees before him. The symbolism was just what Zukor and the other film chiefs wanted.

After all the troubles the industry had faced the last few years, the world was awaiting a verdict on the future of Hollywood from its appointed savior. Hays was prepared to give it to them.

At one studio, he watched the filming of a tender scene from an upcoming melodrama: an old woman on her deathbed bidding good-bye to a grandchild. Stepping outside with tears in his eyes, Hays was besieged by reporters wanting to know what he thought of "America's Sodom." His hands gesturing wildly as usual, the film czar insisted he'd seen nothing but clean pictures being produced in Hollywood, and every person he'd met in the film colony had been decent and up-standing. "For the life of me," Hays declared, "I cannot see the horrors of Hollywood."

That sentence alone was worth the price of the trip. In fact, it summed up the whole point of why he'd come. For all the platitudes about the movies' great potential and the un-American dangers of censorship that Hays had delivered at various gatherings since he'd been on the coast, all he'd really needed to say was that one simple sentence.

"I cannot see the horrors of Hollywood."

He had to hope that those who needed to hear it were listening.

The cheers for him at the Hollywood Bowl went on for a full fifteen minutes.

Then the pumped-up "little Napoleon of the Movies," as one news-paper described him, shouted out to his followers. "Is Metro here? Is Lasky here?" On he went, calling out the names of more than a dozen studios. In turn, delegations from each cheered back at him wildly. Famous Players–Lasky, with seven hundred employees in attendance, was the loudest.

"Come on, let's go!" Hays whooped, before delivering his usual pep-rally speech about all "the wonderful things planned for the pictures," with even more adrenaline than usual.

How good it was to be there, in the California sun, surrounded by people cheering for him. How good it was to be out of Washington, which had exploded in partisan warfare now that the Harding adminis-

tration was caught up in a bribery scandal over leasing naval petroleum reserves in Teapot Dome, Wyoming. That kind of crooked dealing and backstabbing was exactly why Hays had wanted out of politics.

He'd found the same roguery in Hollywood. He'd known his new job would have its share of pressures, but he'd had no idea how vicious it could get. The Arbuckle ban still weighed heavily on Hays's conscience.

But everything was politics. For the past five months, he'd been cutting deals and pulling strings for his new masters much as he had his old. In May Hays had earned the gratitude of the industry by preventing another scandal just as the Arbuckle and Taylor headlines were fading away. Ed Roberts, a fan magazine editor, had published an eighty-page booklet, available by mail order, called *The Sins of Hollywood*. Behind a cover featuring a horned, tailed, and cloven-hoofed Satan cranking a motion picture camera, Roberts breathlessly exposed dope parties, orgies, and various other lewd goings-on in the film colony. No names were used, but the aliases were easily punctured: the cocaine-snorting, morphine-injecting "Walter" was clearly Wallace Reid; the party-throwing "Rostrand" was obviously Roscoe Arbuckle; and the battling couple "Jack" and "Molly" were plainly Mack Sennett and Mabel Normand. The booklet was selling briskly.

This couldn't go on. In the hands of the church ladies, such a booklet could be lethal. But how to stop it?

Hays had the answer. He picked up the phone and called deputy US Attorney Mark L. Herron, who'd been "an active young Republican" during Hays's tenure as party chairman. Herron's appointment to the state Republican committee had been made with Hays's approval, and Hays had likely also recommended him when Attorney General Daugherty appointed him to the state attorney's office in March 1921. So Herron owed Hays. Whatever the new film czar needed, Herron was only too glad to oblige.

Accordingly, within days, *The Sins of Hollywood* was declared obscene and its distribution by mail banned on order of Mark Herron. The order was enforced by Los Angeles postal inspector Clark E. Webster, another Republican and a colleague of Hays's from his time as postmaster general. A warrant was then issued for Roberts's arrest.

These things didn't just happen. *The Sins of Hollywood* was obscure enough not to have drawn the unsolicited attention of the authorities.

But with Hays's network of connections, the offensive little booklet quickly disappeared.

As far as Adolph Zukor was concerned, that was why Hays had been hired.

But for all the glory, for all the cheering crowds at the Hollywood Bowl, Hays remained uneasy about being perceived as the producers' lackey, their attack dog. To last in this position, he needed to establish an autonomous role for himself.

That was why, in the months leading up to his trip west, Hays had been busy putting together a plan. If his plan worked, he would not only end the reformers' criticisms of the movies, but also guarantee himself a measure of independence from the long arm of Adolph Zukor.

For now, Hays was calling it his Public Relations Committee. His plan required the personal investment of civic, religious, and educational leaders in the MPPDA, in much the same way he'd once enticed outside groups to become involved in the post office. To join his committee, Hays had invited the national leaders of the Chamber of Commerce, the Parent-Teachers Associations, the Federation of Women's Clubs, the Boy Scouts, the Girl Scouts, the YMCA, the Daughters of the American Revolution, the American Federation of Labor, the National Catholic Welfare Council, the Federal Council of Churches of Christ, the American Legion, the Salvation Army, the Jewish Welfare Board, and dozens of others that, to his mind, represented a cross-section of decent, law-abiding America.

If the people in these organizations believed they had a say in how the industry operated, Hays reasoned, they'd be less inclined to criticize it. It was a strategy of diversion and co-option: "If we can preserve and increase their sympathy, and I believe we can," Hays wrote to Zukor, "the results can be incalculable."

Hays was sincere in believing that such a system would benefit everyone: the film industry itself, as well as those who wished to reform it. If his means were a bit Machiavellian, he believed his ends were good and honorable.

But best of all, Hays hoped, the Public Relations Committee would make him strong enough to take on Adolph Zukor.

———

Stepping off the stage of the Hollywood Bowl, Hays had every reason to feel confident about the work he was doing.

If only the shadow of Roscoe Arbuckle didn't loom over everything.

Hays's entire success so far—the trust he'd achieved, the strength of his position—had all been accomplished on the back of that one poor, unhappy man. If Hays hadn't banned Arbuckle from the screen, the movies' much-heralded savior would have been through before he started.

There was no way a man like Will Hays didn't feel guilt over that.

He'd timed his visit to the film colony well. Arbuckle had just left for a vaudeville tour of Europe, where his films had never been banned and continued to do great business. The former comedian had written to Hays, asking if such work was the best he could hope for from now on. The movie czar had struggled over his response, scratching out phrases and rewording passages. He'd been inclined to use the salutation "My dear Mr. Arbuckle," but then thought better of it and nixed the "my." Clearly Hays felt great compassion for Arbuckle, but he could not say or imply anything that countered what Zukor or the rest of the MPPDA had decided.

The final letter was a masterpiece of political discretion, penned by a master politician.

"In this whole matter," Hays wrote, "those who are giving it thought will try very earnestly to take that action which will square exactly with their duty to the industry, their duty to you, their duty to themselves and their duty to the public, whose servant the industry is, and in doing this, I assure you all phases of the matter will be given the most careful and charitable consideration."

In the most roundabout way possible, Hays was telling Arbuckle that yes, for now, a vaudeville tour of Europe was the best he could do, but that he should not give up all hope.

Hays was in a bind. He wanted to help Arbuckle, but how could he hope to do anything when he was still receiving letters like the one from W. D. McGuire, head of the National Board of Review, describing the outraged reaction when the Georgia Federation of Women's Clubs found a theater in Dalton exhibiting an Arbuckle picture? "What is the matter with Will Hays?" the club's president had written to McGuire, who made sure to forward the remark to Hays himself. The picture in

question was an old one, not one of Arbuckle's recent unreleased titles, and McGuire urged the film czar to expand his ban to every picture the comedian had ever made, lest he be "discredited in a way that would seriously affect" his performance.

Hays wrote back saying he would not ban old Arbuckle pictures. Enough was enough.

He knew the public wanted their Fatty back. If those unreleased pictures were freed from their vaults, American theaters would be just as packed as their European counterparts. Hays had been receiving "a vast load" of mail on the subject, and "four out of five" wanted Arbuckle reinstated. But if the idea of lifting the ban crossed his mind from time to time, all he had to do was look to the recent brouhaha in Seattle to see what would happen. One theater owner had tried screening an old Arbuckle film, only to have a delegation of local church ladies occupy the theater, threatening to yank it from the projector. The local censor board had backed them up—citing Hays's own ban.

However charitable Hays felt toward Arbuckle, his hands were tied.

For his vaguely optimistic letter, Arbuckle's wife, Minta, wrote to thank Hays. Her husband was "very grateful" for Hays's "personal belief in him," she wrote, and had "benefited greatly by that knowledge."

With kind words she was killing Hays.

Traveling back to New York, he tried to put his guilt out of his mind and focus. He had a cause to champion, a mission to lead. He needed to rally a headstrong band of opposing forces behind him in unity. It was the only way the film industry could survive in its present form.

And if he wanted to survive, he had to find a way to become independent of Zukor.

# THE SKY'S THE LIMIT

Meanwhile, in New York, Zukor was winning his own war.

Striding through the ancient, crumbling Putnam Building with his team of architects—the firm of Rapp & Rapp from Chicago, the leading designers of theaters in the country—Zukor explained exactly what he wanted for his new palace. He wanted big. He wanted grand. But mostly, he wanted tall. He turned to his architects and told them the new building should have twenty stories.

Four higher, that was, than Marcus Loew's building.

As the summer of 1922 turned to fall, Zukor was feeling cocky. He'd survived a year of hell. Shaky finances. Tufts. Arbuckle. Taylor. In each crisis, Zukor had taken extraordinary measures to contain the fallout, but the measures had worked. He was safe.

Even some volatile changes on his board and among his stockholders hadn't lessened Zukor's powers. "Through all these changes and shifts," *Variety* wrote, "the leadership of Zukor has persisted." That seemed to be the one given in the film industry these days.

Best of all, the FTC complaint seemed to have evaporated into thin air. Moving forward with his Broadway palace might have been seen by some as an act of hubris on Zukor's part; he was flaunting his power and control even as the government continued to investigate him. But clearly his lawyers had stymied the Feds. There had been no follow-up, no amended complaint, to the defense they had presented on Zukor's behalf.

So the time was right to start building his monument to himself.

The economy was on an upswing. The gross national product was back to where it had been before the recession. Unemployment was way down, and in a sign Zukor took as a huge indicator of better times, so was union membership, plummeting 5 percent between 1921 and 1922. If workers would only trust corporate leaders like himself, and not those union rabble-rousers, things would be so much better, Zukor firmly believed.

And Famous Players–Lasky was stronger than ever. "A beehive is a slow and halting concern compared to the Lasky studio these days," Grace Kingsley observed in Los Angeles. More companies were at work on the lot than had been in years. Although earnings were actually slightly down, a lingering effect of the recession—Zukor went so far as to call it a depression—Famous Players was back in the black, due to its significant reduction in liabilities. "We believe the depth of the depression has long since been passed," Zukor announced confidently.

With his architects at his side, Zukor's customary whisper grew louder and faster as he described what he wanted in his new headquarters. He would outdo Loew in every way. The new Paramount Theater would dwarf the State, seating four thousand to Loew's thirty-six hundred. That would make the Paramount larger than the Metropolitan Opera House or Carnegie Hall, and equal to the world's largest movie theater, the independent Capitol on Fifty-First Street. The project would cost $10 million, making Loew's State look distinctly second-rate.

Construction could start in a matter of months—as soon as the lease with Shanley's restaurant, which now occupied the first floor of the Putnam Building, expired. In leaner days, back before he'd made his movie fortune, Zukor and his fellow movie dreamers, Marcus Loew among them, used to gather at Shanley's near midnight and "sit up to all hours building castles in the air."

Now he was building that castle in the air for real, and on the very same spot.

As the weeks wore on, Zukor's mood only got better.

For all his doubts about Will Hays, he was grateful to his hand-picked czar. By the fall of 1922 it was clear that Hays's Public Relations

Committee was a masterstroke. Bringing the Chamber of Commerce, the Boy Scouts, the Girl Scouts, the American Legion, and especially the Federation of Women's Clubs onboard had worked just as Hays had envisioned, allowing them all to make suggestions and feel their voices were being heard. Hays set up a regular meeting schedule for them, and hired Colonel Jason S. Joy of the American Red Cross to head up the committee. But what really appeased the committee members, as Zukor well knew, were the free movies they got to show at their conventions and the chance to meet Wally Reid or Gloria Swanson when their leaders came to Hollywood.

Even more deviously, Hays had made sure to win over key members of the various organizations, so that when they held their membership meetings, his loyalists could take the floor and speak in defense of the film industry. That way, when their remarks were recorded, Hays could circulate them "to create the perception of a group divided" and argue that not everyone on the PTA or the Girl Scouts, for example, was hostile to the movies.

How cunning Hays was. A man after Zukor's own heart.

Most impressive, Hays had launched a charm offensive with exhibitors, delighting Zukor with the civil war it triggered. Hays had won over Jimmy Walker, exacerbating an existing fault line between the flamboyant senator and Sydney Cohen. With Walker now cooperating with the producers on the long-simmering issue of contracts, an infuriated Cohen had led a mutiny that tore the exhibitors' organization in half. In just six months on the job, Hays had caused Zukor's opponents to self-destruct.

For Zukor, it was a wonderful spectacle to observe.

But while Zukor was grateful to Hays, he saw no reason to be unctuous about it. When Carl Laemmle from Universal wrote to Zukor, suggesting they underwrite the high income taxes Hays was burdened with, the Famous Players chief responded with a firm no. "Your attitude in this matter is appreciated," he wrote to Laemmle, but "the consensus of opinion is that the present time is not opportune to carry out your suggestion."

The consensus of opinion, of course, was his own.

Sitting on the veranda of his country estate, Zukor puffed his cigar contentedly. After all his worries, everything seemed to be going his way. Even Marcus Loew, sitting beside him, no longer seemed quite such a threat, even if Zukor still felt the need to boast that the turnips and squash in his garden were much bigger than his neighbor's. Loew just laughed.

The two moguls sat in their rocking chairs as the sun set over the trees of the Hudson River Valley. Their veranda conversations usually steered far away from movies. It was safer that way. These days they smoked their cigars and chomped raw green beans while their wives sat indoors, talking excitedly about the baby Mickey was going to have.

Zukor and Loew were about to become grandparents.

Since joining forces to bring Hays on board, the two men had found increasing common ground. As head of Metro, Loew was now a producer as much as he was an exhibitor—and, with his chain of theaters growing every day, he was just as vulnerable to an antitrust ruling by the FTC as Zukor was. How much better it was to work together than compete. And the announcement of Mickey's pregnancy had only further softened the rivalry.

But not completely.

When he'd gotten the news, Loew had sent Zukor a box of cigars. Not to be outdone, Zukor sent Loew two boxes. Loew responded with three. And so it went.

"Always insisting on the last word," Loew said, describing Zukor with an affectionate laugh.

Zukor never seemed to notice that, for all of Loew's competition with him, he never seemed to take it quite as seriously as Zukor did. Loew found Zukor's need to have the last word amusing, even endearing. What was the harm if he needed to believe he grew the biggest turnips? If Zukor ever gave it a thought, he might have realized that all these years, their rivalry had been pretty one-sided.

But even if it did occur to him, Zukor wasn't going to stop trying to come out on top.

As he proved on the night of October 26, 1922, when word came that Mickey's baby was born. Both grandfathers were in Chicago at the time, and immediately took an overnight train back to New York. Pulling into

the station early the next morning, the two men "laid a bet on who would be first to reach the hospital." Zukor knew that Loew, dandy that he was, would take the time to go home first and shave. "I didn't," he boasted, "and I beat him."

Of course he did.

Looking down at the infant, Jane Constance Loew, cooing in his arms, Zukor no doubt hoped she'd take after her mother's side.

# THE SPIRITS SPEAK

Eddie King steered his motorcycle across Los Angeles to Central Station. Everyone else seemed to have forgotten about the dead man sprawled out on his living room floor with a bullet in his neck, but not King. Exasperated that the Taylor investigation had fizzled out, King was on a mission. He was now convinced that he knew the killer's identity. He just had to find enough evidence to make an arrest.

He still faced opposition from Woolwine. But the DA had finally announced that he was running for governor, and these days he was often out on the campaign trail. That gave King a freer hand to do what he pleased.

At the police station, he took Jesse Winn aside to make a plan. King's partner shared his conclusion about the solution to the crime. Their epiphany had come gradually, growing out of their belief that Mary Miles Minter was somehow involved. But it was Woolwine's behavior that really sealed the deal for the detectives.

From the start, it was clear that Woolwine was protecting Mary. But, as King thought about it, he suspected Woolwine's real concern wasn't protecting Mary as much as it was protecting her mother, the woman many whispered he'd had an affair with.

But what was he protecting her from?

By now, King had heard enough stories about Charlotte Shelby to be fully aware of her intense dislike and suspicion of Taylor. The strong-willed woman had thought the director was corrupting her daughter and was afraid he might lure away her golden goose. She also had a

ferocious temper. She'd verbally assaulted and threatened Taylor more than once.

And her gun—given to her by Woolwine himself after she'd expressed fears over her family's security—was a .38, the same type used in the killing.

King ached to inspect Shelby's gun. One of the best known gunsmiths in the country, a man who had devoted his life to the study of firearms, had identified the bullet extracted from Taylor's body as an older type of ammunition that had not been manufactured for twelve or fifteen years. "As a matter of fact," the *Los Angeles Examiner* reported, "there perhaps cannot be found one pistol in thousands in Los Angeles loaded with the ancient brand of ammunition which was taken from Taylor's body."

If the bullets in Shelby's gun matched, King was certain they'd have their killer.

There were rumors now that Shelby and Mary were feuding. Did their quarrel involve Taylor? King knew that mother and daughter had fought about the director before. If Mary had discovered that her mother had killed the man she loved, she might break down and talk.

So, behind closed doors with Winn, King cooked up a plan.

Shelby was shrewd. She'd kept a low profile since Taylor's death, and expertly stonewalled them when they'd tried to interview her before. So they needed a scheme to draw her out, to make her talk. And King had a doozy of an idea.

Soon the two detectives were zigzagging through downtown Los Angeles on their motorcycles, heading into the theater district. Nick Harris, private detective, kept an office on the top floor of the Pantages Theatre at Seventh and Hill Streets. Harris was an old friend of King's, and a longtime collaborator with the police department. When the cops were unable to catch a man named James "Bluebeard" Watson, who'd married eighteen women and killed at least seven of them, Harris had been the one to nab him. He'd also worked closely with King in solving the celebrated Wetherell kidnapping case, winning a gold badge from the department for his efforts.

Sometimes an outsider like Harris was needed—especially when unorthodox action was called for. That was precisely why King and Winn had come calling this day.

Sitting down with Harris, the detectives asked him for a favor. They wanted him to call the editor of the *Los Angeles Times* and tell him that "a funny thing had just occurred." Harris was to make up a story about a spiritualist phoning his office—on a day when, by sheer coincidence, King and Winn just happened to be there.

Harris had many spiritualist sources, so it was a believable story. The private dick was very superstitious himself: he always put his left shoe on first and would never handle a pen after it had been used by someone else. But what was this spiritualist supposed to be calling about?

King told Harris to say that the spiritualist had had a vision of the murderer of William Desmond Taylor. The murderer, the spiritualist claimed, was "a woman with a very beautiful daughter." And the motive for the murder was that Taylor had been "too familiar with the daughter." In desperation, the mother had killed him.

It was a simple enough ruse, and Harris was willing. But King had a further twist to add. It wasn't enough to simply make Shelby nervous; they had to prod her into acting. Without any action on her part, King would have no reason to go after her.

So he told Harris to add that the spiritualist was giving the mother two weeks' notice to come forward on her own. The mother needed "to explain to the public that she was the murderer of Taylor, and why she had committed the murder." If the mother failed to come forward after two weeks, however, the spiritualist would take matters into her own hands and announce the name of Taylor's killer herself.

Harris picked up the phone and rang the newspaper.

If this worked, King might be able to make an arrest before Halloween.

Of course, there were kinks in King's theory, and he knew it. Charlotte Shelby did not in any way match the description Faith MacLean had given of the person she'd witnessed leaving Taylor's house. With her aristocratic features and luxurious copper hair, Charlotte Shelby

was hardly the rough "motion picture burglar" type Maclean described seeing. But what if the man was actually a woman dressed in men's clothes?

MacLean had used a phrase that kept running through King's mind. She'd described the man she'd seen as "funny looking"—as if he wasn't what he seemed. The answer to the riddle had struck King all at once. "Wasn't that person a woman disguised as a man?" he had asked a gathering of reporters. Many had started to nod, as if to say, "Aha! Of course!"

Besides, King added, "That act of rearranging the body, the clothes, was characteristic of a woman moved to show a final tenderness after the death shot." But Shelby—tender? To Taylor?

No, not Shelby. Mary.

King believed that Shelby had walked in and discovered Mary in Taylor's apartment. He didn't believe Mary's story that she was home reading from a book to her sister and her grandmother on the night of the murder. She had gone to Taylor's, and Shelby had followed her, concealing her gun, just as she had done once before, according to her secretary. And when she had caught the two lovebirds together, she'd shot and killed Taylor, just as she had always threatened to do. That left Mary to lovingly tend to the body before Shelby rushed her out of the house.

But Faith MacLean had seen only one person leave Taylor's apartment. One more inconsistency in King's theory.

The detective admitted he didn't have all the answers yet. But he was certain he was on to something. The first step, he knew, was to draw Charlotte Shelby out of her seclusion and make her act. Then he could zero in and start asking her the questions he needed to get the full truth.

Only by gathering enough information could King force Woolwine into supporting an indictment. His boss's opposition was based on more than just his friendship with Shelby, King suspected. Woolwine also feared a tearful Charlotte Shelby or Mary Miles Minter on the witness stand would prevent him from winning his case. Convicting a woman was notoriously difficult in 1922. Woolwine had just failed spectacularly to get a conviction against Madalynn Obenchain, who had murdered her fiancé. Juries had taken pity on the pretty young

woman, and deadlocked repeatedly. Woolwine couldn't risk another high-profile failure—not if he wanted to win the governor's race.

But King was a detective, not a politician. Those weren't his worries. All he cared about was justice for the dead man on the floor.

On October 4, the morning after Nick Harris's phone call to the *Los Angeles Times*, Charlotte Shelby sat comfortably in her newly refurbished mansion at Seventh and New Hampshire, which she'd grandly dubbed Casa Margarita. But her peaceful morning was about to be shattered. Shelby looked down at the headline in the newspaper and her blood ran cold.

### SPIRIT HAS REAL DOPE ON KILLING

She read on. "Yesterday afternoon an unknown medium telephoned to the office of Private Detective Nick Harris, declared that Taylor's murderer was a woman, the mother of a girl who Taylor had wronged, and that the spirits were determined to have the mystery cleared up. Harris himself vouches for the authenticity of the telephone call, as do three [*sic*] police detectives, who were in his office at the time."

The spirits went on to say "that William Desmond Taylor was not murdered by a man but that he was shot by a woman disguised as a man and who is prominently known in Los Angeles."

The prominent Mrs. Shelby picked up the phone to call her lawyer.

King was in his office at the Hall of Records when an attorney came bursting in, newspaper clippings in his hand. The city's afternoon paper, the *Los Angeles Record*, had repeated the story of the spiritualist's call to Harris, adding the fact that "E. C. King, on the district attorney's staff, has been working on a similar theory since the killing."

Striding directly over to King, the attorney demanded answers to several questions. He wanted to know the name of the spiritualist, where she was located, and if she had mentioned "the name of the woman with the beautiful daughter."

"I explained to him," said King, "that all I knew about it was merely what had happened while we were in Mr. Harris' office." That wasn't enough to satisfy the attorney, and he returned the next day to ask more questions. Again, detectives had nothing to tell him.

Not once did the attorney mention any client. But it was easy enough for King to confirm their suspicion—that the outraged fellow was one of Charlotte Shelby's personal lawyers.

"There was no one else," King said, "who ever made inquiry about this news item."

To King, this case was solved.

# LAST CHANCE

Los Angeles City Hall straddled Second and Third Streets like a crouching old woman, shrinking against the taller, newer structures rising all around. Gibby was once again passing under the building's arched entrance. Last time she'd been there, she'd been forming her own company, filled with optimism, convinced her dreams were finally coming true. Now, in the fall of 1922, her business at City Hall was decidedly less hopeful.

The good news was, she'd found new partners for her independent venture. Tom Gibson (no relation) and Elmer Dyer were far more honest and aboveboard than James Calnay. But that hadn't made them any more successful. And so the three partners had come to City Hall to hock the picture they had just made—the picture into which they'd each poured considerable blood, sweat, and tears, not to mention every last penny they had.

Gibby was broke again. She'd blown through all the money she'd had earlier in the year. How much dough it must have seemed at the time, and how rapidly it had disappeared. She'd bought herself a car and her mother a fur coat—just a sampling of the nice things they had coming to them. The rest she'd invested in *The Web of the Law*, a five-reel picture she'd made with Gibson and Dyer. But producing her own pictures, Gibby discovered to her great dismay, was far more expensive than she had anticipated.

All wasn't lost, however, as Gibby's partners told her. They'd found a creditor who was willing to loan them $1,800, payable within a year's

time at 8 percent interest, using as collateral a negative of *The Web of the Law*. If they couldn't pay up, their creditor would own the picture.

Gibby had tried to play by the rules. She had taken her money and formed a company—everything legal, everything accounted for. If producers considered her too old to be a star—Gibby was almost twenty-nine—then she'd prove them wrong by becoming a producer herself and making her own pictures. And she had, following the Hollywood playbook exactly in the process. *The Web of the Law* had everything it was supposed to: action, adventure, great western scenery, love, sex. If it had been a Famous Players film, Gibby was convinced, it would have been a huge hit.

But a picture can't be a hit if no theaters will show it. *The Web of the Law*—so carefully shot, directed, and edited—languished in its tin can where no one would see it. The exhibition stranglehold held by Adolph Zukor and the others was just too powerful. And so the film's three producers had come to City Hall like beggars, signing away their ambitions with a promissory note they knew they could never redeem.

Gibby had tried playing by the rules. She really had. Several times now.

But honesty had gotten her nowhere.

Back on Beachwood Drive, she hoped to find other ways to make money.

At the moment, however, Don Osborn's bunco business was moribund. After their high-flying spring, all of the locusts seemed down in the dumps. In July, Blackie Madsen had gotten nabbed for a scam in Long Beach and spent some time in the slammer. After that, the gang decided to lie low for a while. And so everyone was in need of some cash as Christmas approached.

Osborn was even more destitute than Gibby. His beloved Rose had turned out to be a rather demanding common-law wife. She wanted new dresses and fancy hats all the time, and Osborn had promised her trips to Cuba and Europe. But the biggest expense in recent weeks had been the cash he'd had to cough up after Rose got pregnant. Abortions didn't come cheap. Now Osborn had no choice but to get back to work.

So when Blackie was sprung, the team of Osborn and Madsen

quickly got back in business. That late fall and winter, Gibby was involved in "a series of petty bunco jobs" with the two miscreants, according to later federal reports.

Rose Putnam would say that Osborn was "feeling very confident" that season. For whatever reason, Osborn seemed to think they could get away with anything. And so he went after the biggest pigeon he could find. No more chump change. This time, he told Rose, he wanted a millionaire. And he had one in mind.

In fact, he'd had this sucker in his crosshairs ever since Rose had come to Los Angeles to live. Before falling under Osborn's sway, his pretty niece had led quite the checkered love life. It was time, Osborn figured, to put that history to good use.

Back in her hometown of Brattleboro, Vermont, Rose Putnam had dreamed of life beyond those pastoral hills. Seeing no way out, she'd married a man eleven years her senior, a foreman at the Estey Organ Factory, and had promptly found herself bored to death. While her husband was off fighting the war, the restless Rose had taken comfort in the arms of a neighbor, wealthy Beatty Balestier, who happened to be the brother-in-law of author Rudyard Kipling. That family connection guaranteed the affair would draw major headlines in the local newspaper after Rose's husband discovered it, and the errant wife was run out of town on a rail.

Rose fled to Boston. There, at the apartment of another young woman who enjoyed the company of wealthy older men, she made the acquaintance of John L. Bushnell of Springfield, Ohio. Bushnell was forty-six years old, the son of a former governor, and the president of the First National Bank of Springfield. He was rich—beyond rich—and moved in the highest ranks of society. His Thoroughbred prize horses—with names like The Governor and June Maid—won medals competing against the steppers of Vanderbilts and Astors.

Bushnell was also married, with three children. Rose hadn't let that inconvenient little detail get in the way of a good time. She let Bushnell show her the town, and in return she showed him a few things herself.

Several months later, after Rose had settled in Los Angeles, Bushnell wrote asking her to join him in New Orleans for the annual horse races

at the Fair Grounds. Bored with her job at Hamburger's department store, she jumped at the chance. One hundred dollars soon arrived to cover a first-class train ticket and expenses.

Osborn, who hadn't yet expressed his romantic feelings for his niece, objected to the trip, but Rose brushed him off. She took the train to Beaumont, Texas, where Bushnell had met her. There they'd spent the night at a hotel, registered as man and wife. As an investigator would note prosaically later, "Bushnell had sexual relations with her there."

The fun was just beginning. The next night the pair took the train to New Orleans, occupying the lower berth together. Arriving in the Big Easy, they registered at the Gruenwald Hotel as Mr. and Mrs. John L. Bushnell. Rose enjoyed the masquerade. In the basement of the posh hotel was the Cave, a jazz nightclub known for its waterfalls, stalactites, and bootleg gin. Rose danced, drank, and wore pretty clothes. Bushnell took her on a tour of the charming French Quarter, buying her expensive meals and gifts. To Rose, this was living.

When the weekend ended, however, Rose returned to Los Angeles and the monotonous grind of her daily life. That seemed to be the end of Bushnell.

But now her usually possessive uncle and lover was suggesting that Rose write to Bushnell again. Remembering how much money the millionaire had spent on her, Rose happily complied.

Gibby had no millionaire in her sights. But she had something almost as good. If she ever wanted to get *The Web of the Law* out of hock, there was only one option.

She went back to Famous Players and asked Jesse Lasky to put her in another movie.

Remarkably, Lasky agreed.

Just why was anyone's guess, but in the fall of 1922 Patricia Palmer was cast in a second Famous Players picture, to start shooting in late November. And it wasn't some low-budget programmer, either. *Mr. Billings Spends His Dime* was set to star box-office champ Wallace Reid, and every picture with Reid was a major release.

With an utterly undistinguished filmography, a record for prostitu-

tion, and a desire to form a company that would compete with Famous Players, Gibby should have been a pariah in Lasky's office. But instead she had now been hired for a second major feature at the biggest, most prestigious studio in the industry.

Gibby seemed to be the absolute luckiest actress in Hollywood.

# EVIDENCE MISSING

Making his way to the property room at police headquarters, Eddie King was feeling encouraged. Things were finally proceeding on the Taylor case. The item about the spiritualist had accelerated a very convincing theory, and most of King's fellow detectives were now convinced that Charlotte Shelby was their culprit. With Mary's love for the dead man common knowledge, the cops finally had a motive that made sense.

King expected to make an arrest at any time. Even though the "spiritualist" had never made good on the threat to name names, the detective was certain Shelby was desperate enough that she'd tip her hand at some point. So, to prepare the case against her, King and Winn decided to have another look at the physical evidence.

But when they peered around the property room, Taylor's clothing was gone. His jacket had definitely been there at one point—King had tested the burn marks on it himself—but now the detectives discovered everything had been sent back to the Overholtzer mortuary. How could Woolwine have allowed it? This rose to the level of tampering with evidence.

King and Winn hopped on their motorcycles and arrived at the mortuary just in time. "They were about to burn the clothing," King would recall, "as it was covered with blood, and they considered it of no value."

The detectives brought the garments back to the police station.

King had never been allowed a thorough examination of the dead man's clothes, other than to test the bullet holes. Now that Woolwine

was in the final, fevered days of his gubernatorial campaign, King had the freedom to do so.

Inspecting the fabric with the aid of a bright light and a magnifying glass, he made a very interesting discovery under the collar of the coat.

Three long, blond hairs.

Clearly not Taylor's.

With a tweezer the detective removed the hairs and placed them in a sealed envelope.

Now he just needed to match them to someone's head.

At the moment, Mary Miles Minter was making a picture at the Famous Players–Lasky studio on Sunset Boulevard. In and out of the busy studio all day long were charwomen and delivery boys, many of them glad to make an extra dollar running errands or doing favors.

Pulling up alongside the studio on his motorcycle, King spotted a good candidate for his errand. With the promise of some cash, he gave a delivery boy instructions to sneak into Mary's dressing room, pull a few hairs from her hairbrush, and bring them back out to him.

A short time later, King got what he needed. Mary was none the wiser.

Back at the station, the detective called in a follicular expert to compare the two sets of hairs. With the aid of a microscope, the expert declared that the hairs taken from Taylor's jacket and the hairs taken from Mary's brush came from the same woman.

To King, it seemed obvious now: Mary had been in an embrace with Taylor, her head resting on his chest, when her mother walked in and pulled the trigger.

It was time to talk with little Miss Mary again.

Trooping back to the Hall of Records, Mary insisted "she could add nothing to her previous statements." Since King kept no record of what Mary revealed during this particular visit, whether she told him about her late-night Christmas Eve visit to Taylor—which could have explained the hairs—would never be known. But King knew that Henry Peavey brushed his employer's clothes frequently. Could the meticulous valet really have missed those hairs for five full weeks?

Possibly. But King decided it wasn't likely.

In King's opinion, the hairs were enough evidence to warrant a full-scale investigation. Both Mary and her mother needed to be subjected to intensive questioning. More people were coming forward now to tell stories of Shelby's threats and temper. She was a shrew. She was mean-spirited and vengeful. She flew off the handle at the slightest provocation. She'd assaulted Monte Blue when she'd caught him with Mary. She'd made enemies right and left.

In Tinseltown, Charlotte Shelby made for a very popular suspect.

But not in the district attorney's office.

Shortly after this, Woolwine ordered King to cease and desist in his attempts to interview Mary and Shelby.

There was no arguing with him. The district attorney was in a foul mood. He'd lost his campaign for governor, crushed by his Republican opponent, Friend Richardson, by more than 100,000 votes. And Thomas Lee Woolwine, the Fightin' Prosecutor, wasn't used to losing. So he took out his disappointment on his staff. When he told King to back off Shelby, it was a direct order.

King was flabbergasted. He had come so close.

In dismay, he watched as Woolwine confiscated all the evidence in the Taylor case and brought it to his office. Everything was now under his control: Taylor's clothes, the pink nightgown, the handkerchief with the initials MMM, the letters, the photos, the jewelry. Even the blond hairs King had so carefully sealed away. All of it was placed in a cabinet under lock and key; no one could touch it without going through Woolwine.

And then, not long after that, the evidence disappeared again.

When King requested to see it, he found the cabinet in Woolwine's office nearly empty. All that was left was Taylor's jacket and vest.

Now King was certain that Woolwine was protecting Mary and her mother.

And from the detective's point of view, only the guilty required protection.

# TRIGGER HAPPY

The Atchison, Topeka and Santa Fe Railway steamed through the Great Plains en route to Chicago. In a first-class cabin, Don Osborn and Blackie Madsen were riding in style, smoking cigars and sampling the canapés brought around by porters. They had left Los Angeles on November 28. If everything went according to their plan, they'd be returning very rich men.

Tucked away in Blackie's sack were a bundle of letters—letters that were worth a great deal to the man who had written them. Osborn and Madsen were planning to visit this man and make a deal with him in exchange for the letters.

John L. Bushnell, president of the First National Bank of Springfield, Ohio, did not know they were coming. He was expecting to see his beautiful ladylove Rose Putnam.

How Osborn despised the man, whose lily-white, delicately manicured hands had once caressed Rose's flesh. Every time another letter arrived at Beachwood Drive postmarked Ohio, Osborn burned with jealousy. But the correspondence had been necessary for his plan. On orders from Osborn and Madsen, Rose had written to the fifty-year-old banker and rekindled their romance. In reply, Bushnell had sent her little gifts of money. Rose made sure to keep every note the millionaire wrote her, in which he poured his heart out about how "unhappily situated" he was in "relations with his wife."

Finally Bushnell had suggested that Rose come east to see him. He offered to set her up in an apartment in Columbus, a little more than

an hour's drive from Springfield. Rose replied that she'd make plans to leave as soon as possible. Bushnell sent her $300 for her trip, which Osborn and Madsen used to float their posh accommodations and Cuban cigars.

When they arrived in Chicago, the two blackmailers booked a weekend at the stately Monarch Hotel on North Clark Street. From the front desk, Madsen sent several telegrams in Rose's name, assuring Bushnell that his paramour would soon be in his arms.

The craggy-faced con artist had a lot of laughs at the millionaire's expense.

Blackie Madsen was a very cruel man.

He was also edgy and hot-tempered, which left Osborn worried. He knew that Madsen was unpredictable. His old revolver, which dated back to the Spanish-American War, was permanently lodged at his hip. A number of unfortunate souls had learned the hard way that Blackie Madsen had an itchy trigger finger.

Osborn hoped Bushnell wouldn't be one of them.

For their plan to succeed, they needed Bushnell alive and cooperative. Osborn could only hope their millionaire banker didn't get Blackie mad.

On the afternoon of December 4, 1922, they set out from Chicago for Springfield. It was a cloudy, chilly day. A cold mist stippled the windows of the train as the two blackmailers headed eastward. They sat in different compartments; from now on, they traveled separately. They couldn't risk being spotted together.

While Osborn had masterminded the plan, it was Blackie Madsen who'd pushed him into it. Madsen was always nudging Osborn to go bigger, take more risks. Osborn, like Gibby, wanted success and money and nice things. But Madsen, in contrast, simply knew no other way to live. Cheating and swindling were his way of life. Hustling came as naturally to him as eating or sleeping, and he needed it just as much to survive.

Blackie Madsen was fifty years old. He stood between five six and five eight and was noticeably bow-legged—walking "with his feet out," as the many police reports written about him over the years usually put it. Recently he'd grown a bushy gray mustache. His dark eyes and dark

complexion—some people thought he was perpetually sunburned— had given him his nickname.

Madsen, of course, was an alias. Hailing from a respectable midwestern family, he was born Ross Garnet Sheridan. His father had been a stock dealer in Iowa, affluent enough to employ a servant to help his wife in the house. "His early youth," one reporter wrote, "was spent amidst refinement and cultured surroundings."

But when Sheridan père died, the family fractured. With too many bills to pay and no money to pay them, Mrs. Harriett Sheridan moved her two sons and one daughter to Independence, Missouri, where eighteen-year-old Ross took a job as an agent for the Midland Accident Insurance Company. His attempt to help support the family turned into a crash course in con artistry. During Sheridan's tenure, the company was investigated by the state and found to have pocketed half of its advertised capital.

Meanwhile Harriett launched a career for herself as a journalist, writing for Chicago newspapers and becoming "highly respected" in her field. But much of her time was spent despairing over Ross, who at twenty-five was constantly finding himself in minor skirmishes with the law. When the United States declared war on Spain in April 1898, Ross signed up for a three-year stint in the army. It wasn't a good fit. Sheridan never liked being told what to do, and less than a year into his service, he was dishonorably discharged.

Bitter at the government, Sheridan at least got to keep his gun.

A few years later, that proved dangerous.

Thrown over by his ladylove, the beautiful Clara Williams, Sheridan watched in fury as she attached herself to one Arista "Writ" Berkey, a barber from Geuda Springs, Kansas. "It was known that the two men were jealous of each other," a reporter wrote, "and the tales that were carried back and forth by their friends only fanned the flame of jealousy." Sheridan learned that Berkey had vowed to "do" him if he ever spoke to Clara again.

Ross Sheridan was not someone who walked away from a threat like that.

On October 28, 1901, Sheridan was lurking on the streets of Independence, waiting for his quarry. Late in the afternoon, he spotted Berkey and Williams strolling up Osage Street, a parasol shielding

Clara's pretty head from the sun. At a safe distance, Sheridan followed them to the depot of the electric trolley that ran to nearby Kansas City.

"I did not intend to shoot him," Sheridan would later explain. "All I wanted to do was to call him down." His pride was at stake. He could not let Berkey think that he had scared him off.

But when Sheridan approached the couple, Berkey reacted defensively. He seemed to reach for his own gun. Instinctively, Sheridan grabbed his and fired.

The bullet blasted through Berkey's right arm, smashing into his side and lodging near the fifth rib. The street erupted into screams. Bleeding profusely, Berkey ran across the street with Clara to take refuge in an ice cream parlor. Sheridan tried to flee, but was quickly surrounded by citizens, who backed him against a wall. They would have lynched him right there, stringing him from a lamppost, but he held them off with his gun until the marshal arrived.

Charged with felonious assault on an unarmed man, Sheridan was held for six months at the old Jackson County jail, clinging to a plea of self-defense. But finally he realized such a plea was useless: Berkey's friends all insisted he'd had no gun. Sheridan pleaded guilty, and on April 19, 1902, he was sentenced to two years in prison.

When he was released, he got his gun back.

He headed west, eventually joining his mother and his law-abiding younger brother Hugh in Los Angeles, where they had relocated after the Berkey scandal. The family lived first at 720 South Westlake Avenue, and then moved to 725 South Alvarado Street.

After a while, the ever-restless Sheridan bolted for San Diego, where his young hophead girlfriend, May Ryan, made him forget all about Clara Williams. May's arrest record for drugs and prostitution was almost as long as Sheridan's for bunco jobs and counterfeiting. Sheridan was "one of a bunch of three that have been trimming suckers on a match game," a 1916 arrest report noted. A year later he was written up as "a known bunco" who "had a phony roll on his person." Sheridan went by a variety of aliases, including Cole and Ashton.

He finally became Blackie Madsen after returning to Los Angeles

about a year earlier. The move back was likely occasioned by the death of his brother Hugh in June 1921. Madsen was pretty coldhearted, but he had a soft spot for his mother, who'd shed so many tears over him. Now that she was alone, Blackie would at least be nearby. He and May moved into the Louvre Apartments on East Washington Street, but their primary social life was up in the hills of Beachwood Drive with Don and Rose.

What a celebration they'd have if he and Osborn came back with the kind of payola they anticipated from Bushnell.

So long as the banker didn't pull any fast ones on him, like that damn Writ Berkey.

In Springfield, Osborn registered at the Shawnee Hotel at the corner of Main and Limestone Streets; Madsen checked in at the Arcade at High Street and Fountain Avenue. Once again, Bushnell's money paid their way.

Within hours of their arrival, Osborn put their plan into action.

The day was cold and blustery, so different from Southern California. Osborn walked the half block from his hotel to the First National Bank, on the first floor of the Bushnell Building. The five-story Beaux Arts structure, ornamented with lions' heads, anthemions, and cherubs, had been built by Asa S. Bushnell, the fortieth governor of Ohio and the father of Osborn's intended patsy. Every morning on his way into work, the younger Bushnell walked beneath his father's initials, carved in a circle like those of a king on top of his building.

Osborn made his way inside.

Asking to see the president, he gave his name as H. L. Putnam. When asked if Mr. Bushnell knew him, Osborn replied that he was the brother of Rose Putnam. He was certain that Mr. Bushnell would make the time to see him.

He was right. Osborn was quickly ushered into Bushnell's private office.

The banker's appearance was austere and patrician. He had a high forehead, a prominent chin, and gray hair parted in the middle and

slicked back. At five-seven, he had to crane his neck to look up at the six-foot-three Osborn.

How different the two men were.

On the wall of Bushnell's office hung his diploma from Princeton. In addition to the bank, he was also president of the Champion Construction Company and the Springfield, Troy and Piqua Railroad, built by his father. He'd just gotten back from the spectacular National Horse Show in New York, where Reginald Vanderbilt's stallion Fortitude had won the top honors and Bushnell had been elected to another term on the board of directors. He lived with his wife, three children, and an army of servants in a home described in city catalogs as "one of Springfield's most beautiful and luxurious residences."

The two men studied each other.

Bushnell asked where Rose was. Osborn went into his act, feigning fear and concern. He said that Rose was being held by federal agents in the town of Lima, seventy miles away. The agents had been shadowing them ever since they'd left Los Angeles, Osborn said. They were investigating the trip Rose had taken with Bushnell more than a year earlier to New Orleans. The agents believed that Bushnell's actions had violated the Mann Act.

In that moment, the bottom dropped out of Bushnell's privileged world.

The White Slave Traffic Act, better known as the Mann Act, had been passed in 1910 to prohibit the interstate transport of women for "immoral purposes." Its intent was to combat prostitution rings, but its ambiguous language was frequently used to criminalize consensual sex. If convicted, Bushnell would face prison time, as well as personal and financial ruin.

But Osborn offered him a way out. The agents holding Rose might drop their investigation if Bushnell was willing to "put up something." Bushnell asked how much money the agents wanted. Osborn pretended ignorance, explaining that he'd have to ask an agent to meet them and make an offer. They arranged to meet later that day at the Shawnee Hotel.

Shortly thereafter, a coded message was left at the Arcade for Madsen, who then went into his own act.

He met Bushnell and Osborn at the appointed time and place, wear-

ing a gray suit with red pinstripes. Madsen introduced himself as Robbins, "a special agent and inspector of the United States Department of Justice." He tried to set Bushnell's mind at ease. He wasn't anxious to prosecute the case, he said, and suggested he "might be able to arrange things."

Bushnell, cutting to the chase, asked how much money he wanted. Ten thousand dollars, "Robbins" replied. In exchange, he'd give Bushnell all the letters and telegrams he'd sent to Rose. The banker accepted the deal. He told them to meet him the next day outside the Pennsylvania train station.

At their respective hotels that night, Osborn and Madsen kept their fingers crossed that their scheme would work.

Bushnell showed up as promised. Snapping open his briefcase, he revealed the money wrapped in paper. Ten thousand dollars in various denominations. As "Robbins" took the cash from him, the banker noticed the blue star tattooed on his wrist. Wasn't it odd for a government agent to have such a tattoo? Then he demanded the return of his letters.

Madsen handed over a bundle of papers. Bushnell didn't need to go through them to know his letters weren't all there. He became angry. This wasn't what he'd been promised!

Madsen snarled at him to calm down. Another agent had the remainder of the correspondence in Chicago, and he'd send it to him in the mail.

The banker glared at Madsen. This was starting to seem fishy. As a federal agent, Bushnell asked, wasn't he afraid to take a bribe?

Madsen didn't reply. He didn't like being confronted.

For a moment, hostility crackled between the two men. No doubt thinking of the gun on Blackie's hip, Osborn tensed.

Bushnell continued to provoke. How would "Robbins" explain the case being dismissed to his superiors in Washington? The banker moved aggressively close to Madsen's face. He needed assurances that this whole deal was final.

Osborn watched Madsen anxiously. Would he pull his gun? Would he blow Bushnell away for pushing him too far?

But Madsen checked his anger. He told Bushnell not to worry, that "they had a way of explaining these things." Bushnell finally backed off.

Now it was Osborn who pushed things. Feeling greedy, he told the

banker he was going to need some cash to get Rose home. Bushnell opened his wallet and handed him fifty bucks.

They hurried off their separate ways.

On the Atchison, Topeka and Santa Fe to Los Angeles, Osborn and Madsen whooped it up. They were rich! Ten thousand smackers!

Back in Tinseltown, they couldn't help bragging to all the locusts about their scheme. What a patsy Bushnell was! It was like taking candy from a baby—right down to that last fifty bucks. Rose called Bushnell a cheapskate for thinking he could get in good with them for a lousy fifty bucks.

Best of all: there was more where that came from. They still had several letters from Bushnell—the makings for a second shakedown after they blew through this first ten grand. Gibby told him not spend it all; she wanted Osborn to invest some of it in her new production company. She'd make him a famous director, she promised.

As his ex-wife had said, though, Osborn wasn't the sort of man who liked to work. If he could make this much money by squeezing millionaires, who needed a studio job?

The parties at Beachwood Drive grew bigger and louder. Hot jazz, cold hooch.

But one locust had finally had enough.

At last one man's conscience was stirred. The time had come, he decided, to put an end to Don Osborn's parties.

# A COLD-BLOODED BUSINESS

But where was Mabel? Nobody seemed to know.

As the holidays approached, Mabel was supposed to be in Hollywood, but she wasn't. Since returning from Europe, she'd pretty much become incognito. Though she was expected at the Sennett studio the first week of December to start work on her new picture, she hadn't shown. Nor was she at the Ritz, her usual New York haunt.

No one thought to look for her in a little artist's studio in Greenwich Village, where she'd been hiding out for several weeks, shopping for herself and making her own meals. Until the weather got too cold, Mabel had been dirtying her hands in the neighborhood garden where local artists "planted, sowed and reaped together." She'd loved every minute of it.

More than a dozen years earlier, when Mabel first left Staten Island, she'd lived in little Manhattan ateliers not so different from this one. Moving among painters, poets, and musicians, she'd been happy. Maybe if she had remained in New York, working as an artist's model, instead of chasing after Sennett to Hollywood, she would have remained happy. Living in a community of free spirits like herself, she might have become a writer instead of an actress. A poet, even. Mabel rather liked the image of herself as a Greenwich Village bohemian.

Ever since she'd returned from Europe, Mabel had been a changed person. Her priorities were different. She had seen the world, as her father had encouraged her—and she had discovered that not everything revolved around production budgets or press releases. Not everyone was

preoccupied by the latest Hollywood scandal. From London to Paris to Rome she had traipsed, encountering history and culture and real people living real lives. In the process, Mabel had come alive herself.

Her luck, Mabel believed, had changed. And she proved it in the casinos of Monte Carlo, where everything she touched had "turned into gold."

When she got back to New York, she had settled into a friend's apartment in Greenwich Village. Ever since, she'd lived simply. She read books. She gardened. She took walks. Reporters were looking for her, but no one knew where she was. Mabel liked that.

Still, she knew she'd have to go back to Tinseltown eventually. How she wished she could hop on a ship instead and sail back across the Atlantic. To a friend she'd met in London, Mabel wrote on December 10: "You all made me so wonderfully happy and welcome. Many times I'm rather lonesome and wish I could have that glorious day all over again."

To her friend she lamented she'd be working in Hollywood over Christmas. But her heart, she said, would be in London.

Three thousand miles away, Mary was proving just as difficult to find.

An intrepid newswoman from the *Los Angeles Times* returned frequently to ring the bell at Casa Margarita, only to be told that Mary wasn't at home. One day the little star would be at the studio, the next she'd be shooting on location. The reporter sensed she was getting the runaround. She'd heard rumors that Mary and Mrs. Shelby had been quarreling. It was clear that Mary had moved out of her mother's home. But where she had gone was anyone's guess.

In fact, the actress had a found a cozy bungalow at the end of long and winding Argyle Street, half a mile away from Gibby Gibson in the Hollywood Hills. She had a magnificent view of downtown Los Angeles. For the first time in her life, Mary was on her own, finally free to "give parties and plan dinners." Best of all, she was free of Shelby.

Mother and daughter had indeed been arguing more than ever. Ever since the newspapers had run that story about the psychic, people all over town had been looking suspiciously at Shelby and whispering behind her back. The scuttlebutt, understandably, made Shelby cross. She stormed around the house like a Louisiana cyclone, taking her temper

out on Mary. Her troubles were all Mary's fault, Shelby declared. If Mary hadn't been so damn lovesick over Mr. Taylor, none of these problems would be plaguing them now.

So Mary had washed her hands of that despot, that pinchpenny, that murderer of little girls' dolls and dreams. She'd set up her own household on Argyle. Although she didn't have much furniture—basically just a grand piano and lots of gilt-framed mirrors—it was still the first step in her new adult life. In just a little more than four months, Mary would be of age. Twenty-one years old. How she was looking forward to taking control of her business affairs.

But then Mr. Lasky dropped the bomb.

Famous Players–Lasky would not be renewing Mary's contract when she finished her current picture.

When the *Times* reporter finally found Mary at the top of Argyle Drive, the movie actress was tight-lipped about her discharge and her future plans. All she would say was that she was happy.

And she was. Mary had longed to be free of both her mother and the studio. Now she had her wish. She could come and go whenever she pleased, see whoever she wanted. Finally Mary was living her own life. If only Mr. Taylor had been there to enjoy it with her!

When asked how she'd pay her bills, Mary chose not to think about them. Like the child she was, she simply assumed there would always be enough money. Now that she was on her own, she told herself that everything would work out somehow. "Tragedy and scandal," Mary declared, had been banished from her life. Now there was only "light and love."

But tragedy and scandal weren't banished everywhere.

On the afternoon of December 15, 1922, the mother-in-law of Wallace Reid, Famous Players' top male star, sat down with a reporter from the *Los Angeles Times*.

On behalf of her son-in-law, Alice Davenport admitted that the rumors that had "spread from coast to coast during the last two years" were true. Wally was indeed struggling with narcotics addiction. He'd checked himself into a sanitarium, where he was "perilously weak" but determined to get better. They were admitting all this, Davenport said,

because it was the only way to quiet the rumors and separate facts from falsehoods. She stressed that Wally's story was hardly a scandal; his "determination to stage a comeback, both personally and on the screen, [was] unshaken, and his will power and cheerfulness unimpaired." Being upfront and honest about his problems, Davenport hoped, would convince the public—including the church ladies—to support Wally in his hour of need, and not condemn him.

But then Davenport let slip some graphic details that could only have horrified the reformers. She described the "wild liquor parties" that were common at Reid's place, which was "more like a roadhouse," his mother-in-law said. Wally's friends were there drinking "at all times of the day and night." Reid's wife corroborated her mother's account in a separate statement, adding that Wally had morphine delivered to him daily. "He had to have it," Mrs. Reid said.

All across the country, the moralists sat up straight in their chairs. So the stories of wild, drug-and-booze-filled parties weren't hyperbole after all! They were all true!

And if the stories were true for Wally Reid, they must have been true for others as well.

In New York, Mabel panicked in her little Village apartment.

Evidently she'd gotten advance word that Wally would be making a public confession of his drug use. Likely Alice Davenport, an old friend, had phoned her as a courtesy before giving her statement to the *Times*. However she learned it, the news must have horrified Mabel. Given all the stories about her own drug problems, she knew the press would find her somehow. Her happy Greenwich Village idyll was over.

For all the Reid family's hopes that the public would show compassion toward Wally, Mabel knew exactly what was coming. With Roscoe's trials and Billy's murder finally fading from the headlines, the scandal sheets were hungry for something new, and Wally had just given it to them.

Once, a long time ago, Mabel had considered the men and women of the press her friends. But the scandals of the past two years had sold more newspapers and magazines than anyone had ever thought possible. "With some dailies it's getting to be a cold-blooded business, about as brutal as it can be," *Variety* observed. Entertainment reporters had become "skillful libel dodgers." Editors no longer worried about

whether a story was actually libelous, only about the best way to word it to protect themselves against a libel suit.

But to blame the press was facile. Just as movie producers had always insisted they only made sex pictures because their audiences wanted them, the press ran scandal stories because the public devoured them. Newspapers had become "brutal in their methods," *Variety* pointed out, because "maintaining sensationalism" held readers. "Actors are no longer heralded for their work," complained one anonymous performer, "but for their divorces and their misdeeds."

Mabel knew that Wally Reid's confession was going to mobilize a new army of moralists. She wished she could never return to Hollywood. Oh, to be in London, where she would be safe!

At the eleventh hour, Mabel asked herself: Why the hell not?

The morning the headlines broke about Wally's addiction, Mabel was hurrying down Fourteenth Street. The *New York Times* would note that several passengers booked passage to Southampton onboard the *Majestic* at the last minute, right there on the pier. Mabel, to her great satisfaction, wasn't recognized. She slipped onto the ship unmolested, leaving reporters hunting for celebrities to content themselves with Pearl White, queen of the serials.

The *Majestic* was the last ship to leave New York in time to make it to England for Christmas. Steaming out of the harbor at ten o'clock in the morning, the ship was cheered by a crowd of fifteen hundred.

Hunkered down in her stateroom, unknown to anyone, Mabel breathed a sigh of relief.

# NO HAPPY ENDINGS

This trip wasn't turning out the way Will Hays had hoped.

His second visit to Hollywood was supposed to have been as successful as his first. Granted, there wouldn't be as much "silver-tongued orating." This was a nuts-and-bolts trip: Hays was there for "business and business alone." Too many dinners and speeches would have distracted from his meetings with studio accountants and sales reps. Such a schedule would also have exhausted Mrs. Hays, who had gathered the strength to accompany her husband to the West Coast, along with their nine-year-old son. Hays—and perhaps Adolph Zukor—had felt it was time for the world to see him with his wife at his side. Helen did her best to smile for the cameras.

But no one was smiling on this day.

Hays and Jesse Lasky made their way to the Banksia Place Sanitarium on Santa Monica Boulevard across from Kingsley Drive, a quiet green hideaway of cottages and rose gardens. Cautioned to speak quietly, the two men were ushered into the room where Wallace Reid was convalescing. The husk in the bed looked nothing like the strapping hero of the screen. Reid was sixty pounds lighter than when Hays met him on his first visit to Hollywood. The actor's cheekbones threatened to poke through his yellow skin.

Their visit lasted only a few minutes. Reid was in no condition to hold a conversation. He was in and out of consciousness, suffering from pneumonia. When Hays and Lasky emerged from the sanitarium, the reporters who'd followed them there volleyed off some questions, but

got no answers. Hays was too overcome to speak. His spokesman said simply that the film czar had extended to Reid and his wife "his sympathy, his hopes for a speedy recovery and his best wishes for a happy new year."

That seemed extraordinarily wishful thinking.

Mabel had been wise to flee. The newspapers had exploded with coverage about Reid's drug confession. Compassion wasn't completely absent, but there was plenty of censure as well. The usual names made the usual denunciations. The Methodist Preachers Association urged an official investigation into the drug traffic within the film industry. Canon William Sheafe Chase declared that Reid's illness was "God's intercession" in Hollywood's sinful life. After several relatively quiet months on the scandal front, the papers were once again filled with so-called exposés about the barbaric private lives of movie people.

Some reports claimed that Hays was personally involved in investigating and cracking down on the drug traffic. In reality, Hays had simply promised cooperation with "those in authority and those who have the matter in charge." Meanwhile, what he could do was call for sensitivity. "If Reid's condition is a result of indulgence in narcotics," Hays told the press, "it's a matter to be prayed over. The poor boy should be dealt with as a diseased person—not be censured, shunned. Rather, let us all sanely and sympathetically try to help him."

But Hays knew that sanity and sympathy were often in short supply among the critics of Hollywood. Such coldheartedness would complicate other tasks as well.

Despite his public utterances, Hays's trip to Hollywood wasn't just about sales taxes and accounting offices. He'd made the journey across the country for another reason, a personal mission of his own. He'd come to help another young man, whose straits were not as immediately critical as Reid's, but possibly just as dire.

At long last, Hays was hoping to address Roscoe Arbuckle's situation. The poor man had been on his conscience for too long. But now the gaunt, sallow-faced Reid, fighting for his life at the Banksia Place Sanitarium, had just made Hays's task a thousand times more difficult.

It was Hays's idea to help Arbuckle. And his idea only.

He was flexing his muscles. His authority was growing. In November, thanks in large part to his efforts, Massachusetts voters had beaten back a censorship referendum by a whopping 553,173 to 208,252, the first time censorship had failed at the ballot box. Until that point, reformers had always been able to claim that the public wanted such laws. The upset in Massachusetts destroyed that argument, and Hays rightly took much of the credit. He'd provided literature and manpower, and he'd enlisted the support of the American Legion and various women's groups to help defeat the bill. This victory gave him added clout when dealing with the members of the MPPDA, including Adolph Zukor.

He'd also successfully negotiated a new contract with exhibitors, thanks to the alliance he'd forged with Jimmy Walker. Without Hays, the war between producers and exhibitors might have continued to escalate, crippling the industry. But now he had managed that, too.

By the fall of 1922, Hays's power no longer proceeded from Zukor alone.

In the privacy of his offices, the film czar was imagining a world in which Famous Players and its autocratic chief didn't hold all the cards. In his discussions with exhibitors, distributors, and other players, Hays had been trying to figure out a way to establish "neutral channels," in which the various branches of the industry could work independently yet complementarily. If he had his way, Hays would have "divorced production and distribution" to save money. This, of course, was anathema to Adolph Zukor.

But what if there came a day when other film studios might be at least as powerful as Famous Players? That day might be sooner than anyone thought, since the Federal Trade Commission had finally announced the start of its hearings into the company's business practices, much to Zukor's indignation. With that in mind, Hays had asked his assistants to put together a top-secret memo for him, outlining various consolidations that might occur in a post–Famous Players industry.

Several possible scenarios were imagined. If Metro joined with First National Pictures, their combined chain of theaters would be "very formidable." Or if Metro went with Goldwyn, the resulting combine would be a real counterweight to the power of Zukor and Famous Players.

Hays realized that if anyone was ever going to force Zukor to share power, it would be Marcus Loew. Hays liked Loew. As chair of the MPPDA membership committee, the Metro chief was a frequent visitor in Hays's office. The two men talked policy and strategy, but also made jokes and shot the breeze. How different Loew was from Zukor, who eschewed small talk.

In subtle ways, Hays had been encouraging Loew to think about taking the next step. He provided him with data on the financial structure of First National. He inquired with interest when Jesse Lasky, weary of his secondary role in Famous Players, had reached out to talk with Loew about a merger. Nothing came of the idea, but wouldn't that have been interesting? Hays certainly thought so.

By encouraging Loew to expand, Hays was preparing for his own future. He liked the position of strength he'd gained from the victory in Massachusetts. And so, at long last, he also felt confident enough to try to help Arbuckle.

The decision back in April to blackball Fatty had been "unjust," Hays believed. After "long deliberation," he had decided it wasn't his place— nor anyone else's—to judge a man and keep him from his chance in life. "In a spirit of American fair play, and I hope of Christian charity," Hays recalled in his memoir, "I proposed that he be given that chance."

Cautiously, he broached the idea with Zukor.

Almost certainly, Zukor's first response was skeptical. Why stir things up? Especially now, as the FTC was looming down on them? But as always, Zukor weighed ideas against the bottom line. Hays suggested that maybe, at long last, some of the money Famous Players had lost on Arbuckle could be won back.

Eight months after the ban, calls for Arbuckle's return were increasing. Public sentiment seemed to be coalescing on his side. Even Matthew Brady, the DA who had originally tried to get Arbuckle hanged, now supported giving the comedian another chance. "I believe that every fair thinking man and woman should encourage the return of Fatty Arbuckle to the screen," Brady declared.

Zukor also couldn't ignore the advice coming from Wall Street. Investors working with one of Arbuckle's own attorneys, Gavin McNab, were reportedly waiting to invest "unlimited amounts of capital" in the comedian's comeback. In Europe, Arbuckle's films were "going stronger

than any other American star." If others were going to make money on Arbuckle, Hays argued, why shouldn't Zukor? The idea of someone else making a nickel off his property was surely a convincing argument for the film chief.

So Zukor signaled his tentative approval for Hays to proceed. But his endorsement no doubt came with a caveat: Tread carefully.

Hays was optimistic. He was also naive. "It seemed a relatively commonplace decision to me," he said, "and I anticipated no such excitement as ensued."

On December 20, 1922, the day after his visit to Reid, Hays summoned reporters to meet him at his suite in the Ambassador Hotel. They were expecting to hear a statement about the drug traffic in Los Angeles, or an update on Wally.

But Hays had a very different message to deliver.

In the spirit of Christmas, he said, "Roscoe Arbuckle is to have another chance to go to work and make good if he can." Jaws dropped. Reporters stopped writing midsentence, not sure what they had just heard.

Hays went on. "Every man in the right and at the proper time is entitled to his chance to make good. I hope we can start the New Year with no yesterdays. Live and let live is not enough. We will try to live and help live." The ban on Arbuckle, he announced, would be lifted as of January 1, 1923.

Reporters scrambled to find the nearest phone to call in the news to their editors. Fatty was coming back!

Hays, meanwhile, boarded the California Limited with his family. He beamed as he waved good-bye to the crowds who had gathered to see the travelers off. Even Helen managed a small smile in their direction. For the first time in eight months, Hays's conscience was clear.

But as word spread across the wires, appearing in the evening papers all across the country, reaction was swift. By the time Hays's train stopped in Kansas City the next morning, he was presented with a stack of telegrams.

Mrs. J. C. Urquhart, president of the Los Angeles district of the Fed-

eration of Women's Clubs, was one of the first to react. As soon as she heard the news, Mrs. Urquhart had convened a meeting of her group and adopted a motion condemning Hays's action. The ladies declared they would never support any film that Arbuckle made, and they expected their sisters across the country to follow suit. "With a membership of more than 2 million," Mrs. Urquhart boasted to the press, "I do not think any film which we do not commend will succeed."

Hays tried not to worry too much. After all, he had a representative from the national group on his Public Relations Committee. Surely he'd be able to reason with her.

But nearly all of the cables delivered to him in Kansas City expressed outrage. The mayors of Indianapolis and Detroit announced that they would forbid any Arbuckle picture to play in their cities. In addition, the Pennsylvania and New Jersey chapters of the Motion Picture Theater Owners of America, allies of Sydney Cohen, still bitter over the split in their organization, voted to condemn Hays, calling him a pawn of the producers "who are helping to pay his salary."

Hays had expected some negative reaction. But surely, he thought, that was the worst of it.

His train sped on to Chicago.

When he arrived, dozens more statements of opposition were waiting for him at the telegraph office. A raft of newspaper editorials condemned Hays's decision, drowning out the handful that praised his attempt to do the right thing. Too late Hays realized how bad his timing had been. Just days after the stories about Reid, the arbiters of public opinion were in no mood to be forgiving. Hays called it "an unfortunate coincidence," but it was more than that. It was a serious strategic blunder, and by the time Hays stepped off the train in Indiana, where he and his family would be celebrating Christmas and where another armload of angry cables awaited, he knew it.

The *New York Times* editorialized: "Arbuckle was acquitted by a jury, but an odor still clings to him." Hays had been hired to "deodorize the movies," but this move "would do more to create sentiment for censorship than the original Arbuckle scandal itself."

Taking refuge at his home in Sullivan, Hays hoped the outrage would dissipate over the holidays. He likened it to the Dreyfus affair in France.

But the denunciations continued through Christmas. "Newspaper editorials and civic leagues presented me with every public building in the country," Hays quipped, "brick by brick."

Had he just squandered all the power and goodwill he had built up? "There are times," Hays mused, "when if everyone is shouting loudly enough, a man may begin to doubt the rightness of his own decisions."

With the cries of the moralists echoing in his ears, Hays was anxious about seeing his conservative family at the holiday celebrations. "The one thing I felt I could not stand at the moment," he said, "was the disapproval of my home folks." Gathering his courage, he entered the parlor. The first person he saw was his "straitlaced" Aunt Sally.

The old woman, a stern, ascetic Presbyterian, turned to look at him. Her wrinkled face broke into a smile. "Will!" she exclaimed. "I'm proud of you!"

"That Christmas," Hays would write, "in spite of the storm of protest outside, I was kind of proud of myself."

At least he had one less critic. On December 27, in a hospital in Washington, DC, Wilbur Crafts died of a sudden onset of pneumonia. It was as if the return of Roscoe Arbuckle, that "product of the gutters," had been too much of a shock for the old man.

Brother Crafts had fallen in the midst of battle. But there were many others ready to pick up his cross and his sword and fight on.

Returning to his office in New York after the first of the year, Hays braced himself to deal with his adversaries. To his great dismay, he discovered that the brickbats weren't just coming from far-flung newspapers and city officials. He was facing a revolt from his own Public Relations Committee as well, the very body he had hoped would bolster his independent power.

The committee had gone over Hays's head and issued its own statement, denouncing the return of Arbuckle. Mrs. Woodallen Chapman, the delegate from the all-important Federation of Women's Clubs, released to the press a copy of the telegram of protest she had sent to Hays.

"This organization," she said, "stands ready to assist any individual to habilitate himself, but not at the expense of the ideals of the nation."

Hays had thought that putting the Women's Clubs on his committee would help him to contain them. But their Los Angeles chapter turned out not to be an isolated case. The entire national federation voted to boycott any picture made by Arbuckle.

The revolt of the Public Relations Committee exposed just how fragile Hays's coalition really was. Julius Barnes, the representative from the US Chamber of Commerce, resigned. Hays watched in horror as the careful trust he'd built up with the reformers crumbled. "For a dark moment," he wrote, "it looked as if all our good work for a year past, and all the fine relationships we had built and the confidence we had gained, might be smashed beyond hope of salvage."

Of course, if Arbuckle's fate had been put to a public ballot, he would have been welcomed back with open arms. Every time working people, young people, blacks, and immigrants were offered a say in the matter, Fatty triumphed. The *Kansas City Journal* had just polled its readers, and the results came back ten to one in favor of the comedian. The same thing happened when the Blackstone Theatre in Detroit asked its audiences to vote.

Yet Arbuckle's fate didn't rest with the entire public. It was decided in white, middle-class drawing rooms where the Federation of Women's Clubs took their votes, and in church halls where ministers whipped their flocks into outrages over Hollywood. The *Film Daily* complained, "The wild eyed reformers, the Ku Klux Krowd, said the screen was too clean for Fatty. When will these googly-eyed folk realize that the great big American public will give its own answer?" But the trade paper was definitely in the minority.

Hays was a religious man, an elder in his church. But he abhorred these self-righteous, self-appointed arbiters of morality. He called them "the Anvil Chorus," pointing out that every new development in history had drawn the fear and suspicion of people like them. The telegraph had been condemned because the printed word was not supposed to be disseminated "in any form among the humbler people." The bicycle and the automobile had been called "agencies of the devil," railroads even worse. "If God had designed that his intelligent creatures should travel

at the frightful speed of fifteen miles an hour," Hays said, mocking the religionist view, "He would clearly have foretold it through His holy prophets."

But he couldn't very well mock the Anvil Chorus now—not when they were waiting for him in the next room.

With a deep breath, Hays walked into the meeting with the Public Relations Committee. Reporters in the hallway pressed their ears up against the door.

"I am sorry if my decision has been misunderstood," Hays said, asking the committee to consider "the individual Arbuckle," whose "conduct in the last nine months has evidenced an honest and successful effort to do right." How could they truly stand in judgment of him?

Hays glanced around the room. A few of those in attendance nodded in agreement. Hugh Frayne of the American Federation of Labor, James West of the Boy Scouts, and Mrs. Oliver Harriman of the Camp Fire Girls seemed to be on his side.

But most of the rest were scowling.

Mrs. Herbert Hoover, wife of the secretary of commerce and a national representative of the Girl Scouts, thought it would "be very harmful for the younger generation, and perhaps for all generations, to see Roscoe Arbuckle on the screen again." Charles A. McMahon, from the National Catholic Welfare Council, thought the committee needed to issue a clear statement that Arbuckle would "not be further employed as an active exponent of the screen art."

Once again, Hays was faced with a choice. To stand firm would destroy everything else he hoped to accomplish. To concede nothing would have meant the end of the Public Relations Committee, and possibly the end of the MPPDA.

So when the doors opened and the reporters shouted for news, Hays told them a compromise had been reached. Arbuckle could return to work, but he could never again perform in front of the cameras. He could work as a director or a writer, but not as an actor. Not everyone on the committee was happy about the settlement—some had wanted him consigned to mopping floors somewhere—but for now the committee's public squabbling had ended.

Headlines bannered: HAYS BACKS DOWN. That wasn't exactly what

had happened, but that was what the headlines needed to say, to stop the swell of official public outrage.

Arbuckle accepted the decision gracefully, and Hays used the comedian's conciliatory statement to his advantage. He argued that they'd reached a solution satisfactory to everyone.

But Hays knew the compromise was empty: Arbuckle would never be able to direct or write a picture. The Federation of Women's Clubs was still vowing to boycott any film he made, whether he was in front of the camera or behind it. The National Board of Review announced that it would exclude any film directed by Arbuckle from its list of recommended films, which many communities used to decide what to show in local theaters. What good was making a picture, Hays knew, if it would be rejected on principle the moment it was released?

As much as he tried to say otherwise, Hays knew this story could have no equitable conclusion. Apparently happy endings were allowed only on the screen.

On January 18, 1923, Wallace Reid died, not long after the actress Juanita Hansen, best known for adventure serials, was arrested for cocaine possession. DRUG WARS IN HOLLYWOOD! bannered the scandal sheets. Good thing Mabel was still in London.

Under such conditions, there was no way Famous Players was ever going to release those three Arbuckle films moldering in their tin cans. At a meeting with his board members, Zukor announced that the pictures would be permanently shelved, written off as "a complete loss." Theatrical producer Arthur Hammerstein offered Zukor $1 million for the films, knowing he could make a lot more than that releasing them to theaters. But Zukor, mindful of appearances, turned the offer down and went willingly into the hole.

Strange times, indeed.

# RAISING CAPITAL

Slowing her car down as she approached the Mexican border, Gibby produced her documents to show the guard. Her passenger, an electrician from Burbank named George Lasher, did the same. The border guard cast a cold eye over them. Gibby held her breath.

Finally the guard returned their documents and waved them on. It was January 29, 1923, and Gibby and her latest beau were headed to Tijuana.

For Gibby, the jaunt was more than just a holiday. It was the opportunity to raise some much-needed capital for her upcoming pictures. Being a movie producer was hard work, she'd learned. She had to be constantly on the alert for a chance to bring in some cash.

Gibby had been thrilled by the dough Osborn had brought back from Ohio. Ten thousand clams! A real convenient piece of legislation, that Mann Act. Gibby kept it in mind as she zoomed across the border.

She'd met Lasher at Osborn's, where he'd been doing some electrical work. Thirty-two years old, Lasher was a tall, gangly, blue-eyed redhead. As a youth, he'd spent time in prison for petty theft. Recently he'd come into some money from selling a house. Lasher also had a wife and two children. In other words, he was exactly the sort of man Gibby was looking for.

She'd instantly turned on the charm, putting everything she'd learned in Little Tokyo to good use. Lasher was besotted. "Why, sure I

fell [for her]," he'd admit. "You know what a feller's after when a dame with eyes like that hooks him."

Reaching Tijuana, the pair dropped off their bags at the apartment of Edward Rucker, a musician Gibby had met at the café at the Cadillac Hotel, the same place where Osborn had found Rose with James Bryson. Rucker was black, thirty-five years old, and in on Gibby's scheme. He knew a good scam when he saw one.

Rucker took Gibby and George over to his new place of employment, the Vernon Club, on the main street of Old Town Tijuana, where he introduced them as Mr. and Mrs. George Lasher.

Gibby knew exactly what she was doing. This was serious business, not the lark Osborn and Madsen had enjoyed out in Ohio. Gibby was making sure she didn't lose her new film productions the way she'd lost *The Web of the Law*. She had a new partner, Max O. Miller, the general manager of Miller Ice Cream in Oakland, and they had some great ideas for pictures. Miller was backing a stereoscopic camera lens that promised to give movies a more three-dimensional appearance—"rounded out," as Miller described it. At last, Gibby had a real, innovative plan—something that was guaranteed to get attention and achieve success! Films in 3D!

And this time George Lasher was going to help make sure Gibby's dreams came true.

At the Vernon Club, they started to drink. A couple of women joined them at their table, flirting with Lasher. The electrician from Burbank suddenly felt like a real Casanova.

The Vernon was a small, dark place that smelled of beer and urine. Heroin and cocaine exchanged hands in the alley out back. Up at the bar, prostitutes flashed legs and cleavage. Most of the crowd was American. Rucker got up onstage and sang a few naughty songs for the crowd.

Filled with bravado, Lasher leaned over to Gibby. "I'll bet you a thousand dollars that I can drink more than you," he said, his words slurry.

Gibby saw her opening. She took Lasher up on his wager. The idiot had no idea how well she could hold her liquor.

Withdrawing her billfold, Gibby wrote Lasher a check for $1,000.

Sliding the check across the table, she told the electrician to write her one as well.

Foolishly, Lasher complied.

One of the other women at the table was watching the transaction with shrewd eyes. She leaned in to Gibby and remarked on "the little game she had going." The woman cautioned her that someone might snatch her check away from Lasher. Gibby told her she didn't care, because she didn't have $1,000 in the bank.

But, she suspected, Lasher did.

The electrician from Burbank got drunker, more disoriented. When he wasn't looking, Gibby reached across the table and poured some "knockout drops" into his drink.

Around midnight, Lasher staggered outside to vomit.

That was Edward Rucker's chance to slink over to the table. Gibby, cool and collected despite all the alcohol she'd consumed, endorsed Lasher's check and handed it over to her friend. The woman watching the scheme asked Gibby if she was certain Lasher's check was good.

Lasher would make sure it was good, Gibby told her. After all, he was a married man, and she wasn't "stepping out for nothing."

In the harsh light of the next morning, Lasher sat up in bed with a start. Where was his check? He was panic-stricken. Gibby made a great show of looking everywhere for it, but concluded the check must have been stolen. Maybe one of the other women at the table had taken it, she suggested. Lasher was distraught. They had to get back to Los Angeles right away and stop payment. His wife could not find out about that check!

They zoomed across the border. Lasher tracked down Jim Dallas, the proprietor of the Vernon, who'd taken the check to cash it in Los Angeles after fronting the money to Rucker. When Lasher showed up and told his story, Dallas realized they'd both been snookered.

Incredibly, Lasher wasn't angry with Gibby, at least not for long. She had a way with men. There were likely tears, kisses, and professions of love. Plus, she admitted, she really, really needed the money for this new film of hers to become a hit, to prove to all those men who were holding the industry hostage that the little people, like herself, could succeed too.

Lasher melted. A couple of days after the incident with Jim Dallas, he gave Gibby $75 to help her buy a new car. Shortly thereafter came another "loan" for $250, then another $800. Gibby was grateful. How generous Lasher was to her.

He'd be even more generous, she knew, if she ever needed to play her ace in the hole and remind him about a little law called the Mann Act.

In the spring of 1923, Gibby was preparing to head up to Oakland to start shooting the 3D picture for Max Miller. It was to be called *A Pair of Hellions*, and her costar would be "Ranger" Bill Miller, who'd also played opposite her in *The Web of the Law*. As both producer and star, Gibby had a lot riding on the film. Lasher's $800 came in handy. Don Osborn, still flush with Bushnell's cash, had also paid her $585 for the equity in the house he was living in. For the first time in her short producing career, Gibby seemed to have everything under control.

But then Lasher's wife showed up at Gibby's house and found them together.

Christine Lasher was spitting mad. When Gibby's mother heard the women screaming, she threatened to have Lasher arrested if he and his wife didn't beat it. Lasher was incensed: "The girl's ma" had always known he was a married man, he said later, and still she had "smiled her consent" when he took Gibby out for the evening.

Lasher went home with his wife. Gibby was out of a sugar daddy, just when she needed one most. Or maybe she wasn't.

Not long after, Lasher received a call from Don Osborn.

Osborn had a piece of friendly advice: Lasher might consider paying Gibby a "considerable sum of money," enough that she could share with her mother. Otherwise, Mrs. Gibson was so upset she might just bring charges against him for violating the Mann Act.

Lasher was horrified. Osborn reported back to Gibby that the sucker seemed scared enough to come through with the cash.

At the house on Beachwood Drive, they all laughed at what a sap Lasher was. As bad as John Bushnell! Rich or poor, suckers were all the same. The funding for Gibby's new movie was practically in the bag.

But one of the locusts was through laughing.

Fred Moore had grown weary of his friends' con games. A movie extra

and vaudeville player, Moore had become disgusted by their cavalier disregard for other people. When he learned they were planning their second shakedown of Bushnell, he knew he needed to do something. How many other patsies were out there, just waiting to get scammed?

The young man penned a letter to Bushnell.

"I am a stranger to you, sir, but by reading this letter you will undoubtedly say that I am a friend worth having," Moore wrote. He proceeded to expose the entire scheme, revealing Osborn to be both Rose's "pimp" and her uncle. He advised Bushnell not to call the police just yet. These crooks were dangerous, Moore said, and he feared for his life if they found out he was ratting on them. To be safe, he was using a pseudonym, Earl Frank Dustin, and could only be reached through general delivery.

But if they worked together, Moore assured Bushnell, they could bring Osborn and Rose and the whole lot of them to justice.

# A NEW MAN ON THE JOB

One day in early March 1923, District Attorney Woolwine stepped shakily out of the elevator and headed to his office in the Hall of Records. Employees noted how badly he was trembling. The mighty Fightin' Prosecutor hadn't been the same since his devastating defeat in the governor's race. Once Woolwine had seemed indestructible; now he walked down the hallway with a cane. His face was sunken, and he'd lost a great deal of weight.

He called his staff, including Eddie King, into his office. "I know I am a sick man," Woolwine admitted to them. "I have been sick for months. I know I need a rest, but I would rather die in office than tender my resignation now."

That was classic Woolwine. A fighter to the end. But in fact he'd already delegated many of his duties to his chief deputy, Asa Keyes. And Detective Sergeant King, as sorry as he was for his boss's ill health, could not have been more pleased about that.

If Keyes became district attorney, King felt sure, he could revive the Taylor investigation. He'd be allowed to pursue leads that Woolwine had discouraged or outright forbidden.

In the past five months, the only work King had been able to log on the case had been interviewing "cranks," as he called them. The American public remained so fascinated by the Taylor murder that many craved some kind of personal connection to it. Dozens had fantasized their way into the case, parading into King's office and sitting in front of him with sad, vacant eyes, claiming they'd witnessed the murder or even pulled the trigger themselves. Some even claimed

they'd seen Taylor very much alive, strolling down the street. A year after the murder, King's list of cranks exceeded a thousand names.

Meanwhile, he'd been unable to follow up with the two people who mattered.

Mary Miles Minter's dismissal from Famous Players–Lasky had raised suspicions. True, her pictures hadn't lived up to their hype, but might there have been something more nefarious going on? "People on the inside of the game" were insisting that Mary had not "voluntarily given up fame and fortune," as the studio claimed. She'd been driven off the screen, they declared, "by a force which held her in thrall—a force which she had offended in some unknown way."

King was convinced that the higher-ups at Famous Players–Lasky knew the identity of Taylor's killer. Had the studio decided to wash its hands of Mary because of her involvement in the crime? Did the papers that Charles Eyton had stolen from the crime scene implicate Charlotte Shelby? To King, it all made perfect sense.

Shelby had the motive. She had the weapon. And she had no alibi for the night of the murder: no one could positively state where she had been at 7:45 in the evening on February 1.

Charlotte Shelby, dressed as a man. That had to be the answer. Maybe she was wearing boots that made her seem taller. And maybe the shadow of her cap made her face look rough and her nose more prominent to Faith MacLean.

Such a theory might be difficult to prove. But at least Asa Keyes would let King try.

On June 6 Woolwine, admitting that his once-fabled "wrought-iron constitution" had failed him and that he was suffering from stomach and intestinal cancer, submitted his resignation to the county board of supervisors. Effective immediately, Asa Keyes became the new district attorney for Los Angeles.

A week later Mary and her mother, who'd been estranged for several months, suddenly reconciled. With their protector gone, they seemed to panic. The two women obtained passports and planned to sail off on an extended tour of Asia.

The fact did not go unnoticed by Detective Sergeant King.

# UNFAIR COMPETITION

On the morning of June 13, 1923, dozens of people packed into the Engineering Societies Building at 29 West Thirty-Ninth Street in New York. The day was cloudy and unsettled. Strong winds rattled the glass in the enormous windows of Assembly Room 3. The government's case against Adolph Zukor was finally in full swing.

The counsel for the Federal Trade Commission, W. Hayes Fuller, gaveled the hearing into order and called the witness so many onlookers had crammed into the room to see.

Sydney S. Cohen took his seat at the front table.

The FTC hearings against Famous Players–Lasky had been going on for two months. But Cohen was the witness everyone had been waiting for. Who better to describe Zukor's unfair trade practices but the leader of the exhibitors he'd tried to put out of business?

The spectators sat at the edge of their seats, expecting fireworks.

But the president of the Motion Picture Theater Owners of America was calm and collected, speaking in a college-educated cadence Zukor despised. When asked to give his opinion of the case against Famous Players, Cohen thought for a moment. Once, he said, exhibitors had viewed Zukor as their friend. But as the Famous Players chief forced more and more of them out of business, he'd become their "most dangerous enemy." Cohen recounted the pledge Zukor had made to destroy him and the MPTOA, and how his emissary, Will Hays, had splintered their group in half, pitting exhibitor against exhibitor.

Fuller asked what had happened to change Zukor so dramatically in the past decade.

Cohen didn't need to think long. "Wall Street," he answered. Zukor's alliance with Wall Street had left him obsessed with growing his company's profits, at the cost of everything else.

Fuller's grizzled face cracked into a grin. The fifty-three-year-old lawyer didn't often smile. He was a tall, rangy Oklahoman who picked his words carefully and always spoke with authority. This was exactly the sort of testimony he'd been hoping for from Cohen.

Across the room, defending the film concern and its president, was Robert T. Swaine, thirty-seven, rising star of the law firm of Cravath, Henderson, Leffingwell, and DeGersdorff. Smooth, suave, and a little bit cocky, Swaine was "so well dressed he doesn't look well dressed," *Variety* thought, and "handsome enough to be a picture star." For the past two months, the contrast between Fuller and Swaine had made for some lively courtroom theatrics.

When Cohen complained about Zukor's control over the first-run Broadway theaters, Swaine saw an opening for attack. Why didn't Cohen just build his own first-run Broadway house then?

Cohen smirked. He'd love to, he replied. But there was one problem: all the available property on Broadway between Forty-Second and Fifty-First Streets had already been snatched up by—"yes, sir, you guessed it"—Famous Players–Lasky.

Prosecutor Fuller's weathered face broke into another smile.

For his part, Zukor paid little outward attention, behaving as if the hearings on Thirty-Ninth Street weren't happening at all. He sailed off for Europe, convening a meeting on a balcony in Nice overlooking the Mediterranean to plan a counterattack against the Shubert organization's attempt to expand its Broadway empire. The gall of Shubert—trying to control an entire industry!

Zukor's brazenness didn't stop there. When he returned to New York, he made a great show of releasing the blueprints for his skyscraper. Now that Shanley's lease had expired, he was moving ahead with demolition on the old building and starting work on his new tower.

But his swagger was a masquerade. As the first hearings got under way, Famous Players stocks had plunged. And sitting in the audience, day in and day out, was Canon William Sheafe Chase, who'd assumed

Wilbur Crafts's role as the movie industry's chief critic. Chase took notes and issued a series of statements in reaction to the proceedings, declaring that any government regulation of the movies should include a morality clause.

A parade of Zukor's enemies made their way to Thirty-Ninth Street to give testimony. W. W. Hodkinson detailed how Zukor had maneuvered him out of Paramount to seize control of the distribution end of the business. Independent producer Al Lichtman compared Zukor to a crooked gambler in the old West, whose business was backed up by gunmen. H. D. H. Connick, who'd worked for Zukor before being eased out when his loyalty was questioned, thought his former boss had wanted "weekly receipts as large as possible" in order to "dominate the industry."

Swaine saw the remarks as an opportunity and jumped to his feet. He asked the witness if he would define "domination" as "superiority."

Connick replied that he would.

The young lawyer beamed. "Then you would say, wouldn't you, that Caruso dominated the opera field?"

Connick shot him a look. "God Almighty had a lot to do with Caruso, but he had nothing to do with Famous Players."

Swaine's confidence melted. Once again, prosecutor Fuller was smiling.

But there was one celebrity witness who hadn't been called. At the end of one hearing, a reporter asked Fuller when Marcus Loew might testify. "The same day we put Zukor on the stand," the prosecutor responded dryly.

By now, it was clear to the FTC that Zukor and Loew, rivals and antagonists, were also associates and collaborators. In many ways, Loew could have been charged with the same overreach as Zukor. He owned nearly as many theaters and had his own ambitious plans for expansion. The two former partners found themselves colluding more often these days as their interests aligned. Sidney Kent, Paramount general manager, admitted under oath that Loew houses "received certain preferences in the booking of [Paramount] pictures." So now the government was also trying to prove that Loew "held a sort of corner on Paramount

film in New York." It was clear that if the two fathers-in-law ever offi-
cially merged their companies, they would control more than half the
motion-picture industry between them.

But any camaraderie Zukor might have been feeling for his old rival
quickly evaporated with Sydney Cohen's testimony.

Cohen was asked about his relations with Loew. A little more than
a year earlier, Cohen revealed, Loew had asked the exhibitors' organi-
zation to "take over Metro," fearing the studio would "be done for" if
Zukor's ambitions weren't stopped.

Zukor was furious. He knew that sneaky rat couldn't be trusted!
That dandy had been negotiating with some of his bitterest enemies,
those ill-bred theater owners!

Confronted with Cohen's statement, Loew tried to shrug it off. That
was then, he said, and this was now. He wouldn't make the same re-
quest today.

But for Zukor, it was just further evidence that he could trust no one.
He was in this for himself and his company only. He had to watch his
back at all times.

Every obstacle he'd faced these past three years he had overcome,
even the ones he'd feared might sink him. Arbuckle was finally history.
And the truth of the Taylor murder, Zukor believed, had been obliter-
ated forever.

But would he survive these infernal government hearings?

When Zukor worried, he walked. Sometimes he walked from mid-
night to sunrise, all over the city, from his office to downtown and then
back again. And when he walked, he plotted. He strategized. He fig-
ured out how to win. "When the Sioux started ghost-dancing, it meant
trouble along the Big Horn," one contemporary of Zukor's observed.
"When Zukor starts walking, it's time for everybody on the reservation
to look out."

Zukor was not a man who dealt well with fear or ambiguity. As
the hearings dragged on, he lost his vision of the future. Would the
government strip him of everything? Would he wake up one morning
and find his bank accounts empty, his companies shuttered, his access
to important people gone? Would he once again be that defenseless
orphan with nothing to his name?

The hearings rolled on, indifferent to Zukor's schedule, leaving him

constantly wondering when or if he might be called to the stand. In July the commission reconvened in Philadelphia, to meet with exhibitors and distributors there. Later it moved south to Atlanta, and by late summer up to Boston, with more cities still on the docket. The nightmare promised to drag out endlessly.

At an industry dinner at the Waldorf Astoria, Zukor's primary Wall Street angel, Otto Kahn, angrily defended Famous Players. Democracy was wrong, Kahn declared, when "it countenances government commissions giving to endless innuendo and irresponsible gossip the place and the scope that belong to trustworthy testimony." Democracy was also wrong, he said, when "it tolerates unwarranted assault on the reputation of businessmen with the resulting damage to the good name and fair fame of business both here and in foreign lands."

For men like Kahn and Zukor, it seemed, there was such a thing as too much democracy.

Zukor had always been paranoid about losing power. But even the paranoid sometimes had real enemies. That summer of 1923, Zukor walked the leather off his shoes.

A block north on Fifth Avenue, though he didn't know it yet, Zukor had another reason to worry.

Will Hays picked up the telephone and rang Marcus Loew.

He'd heard the Metro chief was having a meeting with Louis B. Mayer, the plucky independent producer who was coming to New York from Hollywood to scope out possibilities for a merger. Mayer knew that his only chance of becoming a power player in the industry was to become big enough to compete with Famous Players. To do that, however, he'd need partners. And so, among others, he was meeting with Loew.

Just what advice Hays gave Loew, neither of them ever recorded. But if Loew let on that he was considering joining forces with Mayer, Hays certainly signaled his blessing.

# TRAPPED LIKE RATS

On the hot, humid morning of Tuesday, July 10, 1923, John L. Bushnell passed beneath his father's monarchial crest into the Springfield National Bank in Ohio and realized the moment he'd been dreading for the past eight months was now upon him.

Waiting in the lobby were Rose Putnam and her brother. Or rather, as Bushnell now knew from Fred Moore's letter, her *uncle*, Don Osborn.

Rose looked exquisite in a black dress, her face covered in net. A squirrel fur, incongruous on such a hot day, hung across her shoulders down to her knees.

Bushnell turned and ran.

Osborn followed. "Do you remember me?" he shouted.

The banker stopped in his tracks and looked around. Yes, he remembered him. "But you are not the man you represented yourself to be," Bushnell said.

Osborn insisted they speak at once.

Reluctantly, Bushnell returned to the bank with Osborn. He brought his two visitors into his private office, instructing his secretary to hold all his calls.

Rose said nothing. She just sat there looking lovely and vulnerable.

"The federal men are back," Osborn told the banker. It was going to be "necessary to fix things up" with more money. This time, Osborn said, the Feds wanted fifty grand.

Bushnell was appalled.

Osborn warned the banker that if the Feds didn't get what they wanted, they'd haul him down to New Orleans and charge him with the Mann Act. Pointing over at Rose, who was weeping, he added that they'd drag her along as a witness. Bushnell didn't want to put Rose through that, did he?

The millionaire had known this second shakedown was coming. The letter from Fred Moore—Earl Frank Dustin to him—was still in his safe. As a result, Osborn's theatrics had little effect on him.

When Osborn asked him what he going to do, Bushnell replied, "Nothing."

Osborn became red in the face. He couldn't believe what he was hearing. Did Bushnell want to end up in the penitentiary? What about Rose? How could he put her through all this? He called Rose "sweet and pure and all that sort of bunk," Bushnell later recalled.

But the banker just shrugged his shoulders.

Osborn got angrier. He told Bushnell that the officer who'd accompanied him in November "had been laughed at for the small amount of money he had obtained." The higher-ups had refused to turn over the balance of the letters. Did Bushnell want them to end up in the hands of his wife?

The banker kept his cool, explaining he was "not in a position to do anything at this time" as he'd recently suffered some financial losses.

Osborn seemed ready to snap. "If you're not doing anything," he seethed, "I will do something." He leveled his eyes with Bushnell's. "I can kill you."

This much Bushnell hadn't expected. He told Osborn to take it slow.

All six feet three inches of Osborn loomed over him. "There is nothing to prevent me from killing you," the blackmailer said, "if you don't fix things up."

Bushnell promised he'd try to figure something out. He told Osborn to return to the bank at 1:30 that afternoon.

Osborn had no other choice. If he wanted the money, he'd have to come back. He and Rose left the bank.

No doubt Bushnell let out a very long breath.

When he was sure they were gone, he placed a telephone call and told the man who answered to get over to the bank right away.

Back at the Shawnee Hotel, Blackie Madsen's ruddy face creased in suspicion. Just what did Bushnell have up his sleeve? Why did he want Osborn to bring the federal agents back with him to the bank that afternoon? Why couldn't he just give Osborn the money? After two decades of scams and con jobs, Blackie could always sniff out a trap.

But what else could they do? They couldn't just leave now. Osborn was desperate to get his hands on more of Bushnell's money. How fast that ten grand had disappeared! Back in Hollywood, he'd been forced into some honest work as a director's assistant with the Sanford Production Company, a low-budget independent. He'd just finished a picture called *Shell-Shocked Sammy*, photographed by Gibby's old partner Elmer Dyer and featuring their buddy Leonard Clapham. But Osborn didn't like to work. How much easier, and more lucrative, it was to bilk money from pigeons like Bushnell.

Osborn had left Los Angeles with Rose and Madsen on July 2. In Chicago they'd met up with John A. Ryan, a fellow conspirator who ran a gambling den in Los Angeles, paying police part of the proceeds so they'd leave him alone. Ryan would play the part of the second federal agent, come to put the screws on Bushnell.

But the banker's insistence on meeting the agents left Madsen uneasy. Why would someone who was afraid of being arrested over the Mann Act want to meet the guys who might actually do the arresting? Madsen told Osborn to go back by himself to the bank. If the sucker still didn't cough up the cash, he and Ryan would arrive later and rough him up a little bit.

Osborn agreed and made his way back downtown.

But when he was ushered into Bushnell's office, the banker wasn't alone. Osborn was introduced to a private eye named Nicholas Fischer. In that moment he knew he'd walked into a trap. Osborn had thought Bushnell was so worried about being exposed that he would never have brought a third party into the situation—especially not a private dick. But of course he had no clew about Fred Moore's letter.

Fischer started badgering Osborn for the names of the federal agents. If the Feds were so anxious to get Bushnell, Fischer wanted to know, why hadn't they come to the bank themselves? When Osborn couldn't come up with a good answer, the detective told him the jig was up and pulled out a pair of handcuffs.

Cornered like an animal, Osborn fought back like one as well. He lunged at Fischer, reaching for his throat. But then the hard nose of the detective's pistol pressed into his gut. Fischer told Osborn to back off, and to keep his hands in the air as he phoned the police.

Calmly triumphant, Bushnell requested that "handcuffs not be used because of the attention they would attract." He was sure Osborn would go quietly, wouldn't he?

Osborn steamed. He was led out through the bank, Fischer's gun pressed discreetly against the small of his back.

For the trio waiting at the Shawnee Hotel, the afternoon dragged on. The sun dropped lower in the sky. Shadows lengthened across the room.

Blackie Madsen knew something was up.

Itchy and uncomfortable, he told Rose that he and Ryan would go see what was happening. Until she heard from them, she should stay in her room.

Rose agreed. For the next several hours, she waited alone.

At police headquarters, FBI agent Earl J. Connelley, just thirty years old, arrived from Cincinnati, having been summoned by Nicholas Fischer. Connelley's first job was to interrogate Osborn. The prisoner was alternately indignant, anguished, and bemused. He'd just been following orders, Osborn claimed. A man named Blackie Madsen was the mastermind of the scheme. And if Connelley wanted to catch him, he'd better hurry.

The agent wasn't fooled; he knew right from the start that Osborn was "the brains of the organization." But he asked where they could find this Madsen.

The Shawnee, Osborn told them.

Minutes later, police arrived at the hotel.

Neither Madsen nor Ryan were in their rooms. The officers staked out the front of the hotel, watching everyone who came out and everyone who went in.

Sometime around quarter past seven that evening, the phone rang in Rose's room.

It was Madsen. He told her to meet him on Limestone Street around the corner from the hotel. Rose quickly agreed.

Outside, the shadows of dusk were filling up the block around the hotel. A few feet ahead of her, Rose spotted Madsen lurking, but he gestured for her not to stop as she passed. "Go on," he whispered harshly as she drew near. Rose kept walking right past him.

Eventually she turned around and headed back the way she had come. Madsen was gone. Anxious, Rose continued to walk up and down the street for forty-five minutes. But Madsen did not return. Finally, when darkness had settled completely, Rose went back inside the hotel.

Connelley had been watching her the whole time.

In the morning Rose was taken into custody. Connelley also seized the contents of Madsen's and Ryan's rooms, including a gold-plated badge in the shape of a star inscribed "U.S. Department of Justice Inspector." But the two conspirators had escaped.

On July 15, and for several days thereafter, newspapers across the country bannered the arrest of Osborn and Putnam and the manhunt for Madsen and Ryan. Meanwhile, the FBI was going through reports from its various provincial offices, considering the possibility that Bushnell's shakedown was not an isolated case. Moore's letter had convinced the Feds that Osborn's gang might have had other victims, some perhaps prominent.

In Los Angeles, special agent Leon Bone took a look at some of the film colony's unsolved blackmail cases. He learned that "numerous prominent motion picture people" had been victimized by "an organized group of blackmailers in Los Angeles . . . about the time of the Roscoe Arbuckle scandal, when motion picture people . . . were dodging publicity of all kinds." One case in particular drew Bone's attention.

Could Osborn's gang "have been implicated in the murder of William Desmond Taylor, noted motion picture director who was slain about a year and a half ago?" Bone sent the inquiry over to the district attorney's office.

The FBI communication would have landed on the desk of Eddie

King, in charge of the Taylor investigation for the DA's office. But Detective Sergeant King apparently gave it little heed; in none of his later writings about the case would he mention any federal inquiry. While it was true that gaps in Taylor's assets might have suggested blackmail, there was no connection that King, or anyone else, could see between the late director and a two-bit con artist like Osborn. The two men came from very separate worlds. Just because the press called Osborn a "movie director" didn't mean he moved in Taylor's circles. Osborn had never been employed by any of the studios where Taylor worked, and they seemed to know no one in common. There was simply no evidence that their paths had ever crossed. King apparently dismissed the inquiry from the FBI as irrelevant.

He wasn't about to waste his time tracking down some crazy lead from the Feds when, under a new district attorney, he might soon be able to arrest Charlotte Shelby.

# COMING OUT OF HIDING

In the summer of 1923, giant letters were being hoisted up the steep sides of the Hollywood Hills with enormous cables. People gathered below to stare, to point, to wonder what was going on. One by one the letters came together, rambling across the rugged terrain. Finally they spelled out HOLLYWOODLAND, the name of a new housing development at the head of Beachwood Drive being financed by Harry Chandler, the owner of the *Los Angeles Times*. Each letter stood thirty feet wide by fifty feet tall and was studded with electric lightbulbs. To the great surprise of those who lived in the hills, one night the sign began to flash on and off in segments: first HOLLY, then WOOD, then LAND, before lighting up entirely.

Living so close, Gibby would have had to pull her blinds down to prevent the flashing lights from disturbing her at night. With the arrests of Don Osborn and Rose Putnam in Ohio, she may have preferred to hide out for a while anyway.

But others were done hiding.

That summer, Mabel was back in town. She'd kept her distance for several months after Wally Reid's death, unnerved by the prospect of new tabloid attention. But now, finishing her latest film for Mack Sennett, the comedienne seemed gay and cavalier—"as happy as Easter morning," Sennett thought.

Could it be true? Was Mabel finally back to her old self?

"Every day in every way," she assured Sennett, "I'm getting sassier and sassier."

Sennett could hear the to-hell-with-you back in her voice, and he was glad. For the first time in a very long while, the ex-lovers were getting along. They seemed to have gone back in time to those carefree days before the drugs, the betrayals, and the scandals. They laughed together, socialized together. Mabel even attended a birthday party for her old pal Mae Busch, the same woman she'd found in Sennett's bed all those years ago, igniting the infamous fistfight and spurring the onset of Mabel's depression. But the past was past. Mabel had moved on.

Sennett had a hard time accepting that, however. He wanted to get back with Mabel romantically as well as professionally. He hoped for just one glance, one flutter of her long black eyelashes. But none of that was forthcoming. Instead, Mabel offered him a business deal.

She'd star in his new picture for $3,000 a week.

"Good Lord, Mabel," Sennett responded.

"And twenty-five percent of the net profits," she added.

For all the hard bargaining, Sennett was delighted. "She was swinging the rope and I was doing the jumping," he said. "It felt good. Like old times."

The picture they made was called *The Extra Girl*. And what a picture it was. A year and a half after Billy's death, Mabel felt free enough to laugh a little at what she'd been through. This was the old Mabel, the one who spit jokes from the corner of her mouth like tobacco juice. While the most memorable scene would be Mabel leading a lion around the lot on a rope (she gamely filmed the stunt while director Richard Jones held a pitchfork just off camera), it was in the film's many subtle in-jokes where Mabel's state of mind came through. Playing the leading man in the madcap movie-within-the-movie was an actor named William Desmond—named onscreen in a title card, just to make sure the audience got the reference. In another scene, Mabel wields a gun, holding off the villain. This, too, was likely no coincidence. For more than a year the public had been imagining Mabel holding a gun. Now here she was for all to see, brandishing the weapon as she saves her family and triumphs over evil.

The subliminal message, Mabel trusted, would not be lost on the public when the film was released later that year.

But there would always be scolds eager to judge her for living as zestfully as she did, for enjoying her cocktails more than a "respectable"

woman should. Mabel found such criticism tiring, and patently unfair, because it wasn't applied equally to men. No one could deny that Mabel liked her gin, but her companion, Mrs. Burns, insisted she drank only enough at parties to be considered a "good sport." When a man was a "good sport" in that way, he was hailed as a bon vivant, a hail-fellow-well-met. Mabel was called a libertine or a drunk.

It infuriated her. She wasn't missing work. She wasn't back on the cocaine. Wasn't it better to be out having fun than to be holed up in her room as she had been, afraid to venture outside, living in constant fear of the next morning's paper or the blue lights of a police car?

If people were going to talk about her, Mabel decided, she was through sitting back and taking it. From now on, she was fighting back.

So when she picked up the newspaper and saw that Mary Miles Minter was jabbering on about Taylor again—and bringing up Mabel's name in the process—she saw red. Mary was quoted as asking Mabel what she knew about the murder. That little nitwit! What did she think she was doing, bringing all that back up again? Mabel immediately issued a statement, saying she couldn't understand why Mary was re-gurgitating all this unhappiness. "It is too bad," Mabel said, "that my name should be dragged into this on account of the family squabbles between Miss Minter and her mother."

Any sympathy and compassion she'd once felt for poor little mis-guided Mary likely evaporated that day.

Mary's garrulousness that summer took many people by surprise. The former movie star just wouldn't shut up.

She wanted back in the public eye. Not because she missed the fame and the slog of making movies, but because she was trying to make it on her own, and—jobless, penniless, motherless—was having a hard time paying her bills. Her reconciliation with her mother had been brief; they'd started squabbling again, their planned trip to Asia scuttled be-fore it began. Now twenty-one years old, Mary was threatening to sue Shelby for some of the millions she'd made while still a minor. That was her money, Mary insisted, not Shelby's. But until she could reach

a settlement with her mother—and Mary knew how stubborn Shelby could be when it came to money—Mary was living in Pasadena with friends. And she needed a job.

A comeback wasn't going to be easy, however, when no one wanted to hire her.

So Mary got creative. With the help of her friend, the screenwriter Jeanie McPherson, who knew a thing or two about dramatic plot twists, she devised a plan. Living in Mary's former home on Argyle was the Swedish actress Sigrid Holmquist, whose career had stalled and who probably didn't mind a little publicity herself. On August 12 McPherson approached members of the press with a sensational story.

Someone had tried to murder Mary!

Murder had kept Mary's name in the headlines before, so why not again? McPherson's story went like this: While Holmquist and some friends were dining on an outdoor terrace, a shot had rung out, barely missing the actress and superficially wounding a guest in the wrist. Mary, of course, was the gunman's real target; in the half-light of dusk, Holmquist might easily have been mistaken for her. There could be only one explanation: someone was trying to keep Mary from telling what she knew about Taylor's death.

But after a flurry of news reports, the story was dropped. "Police do not take the matter seriously," *Variety* reported, "preferring to look upon it as a 'plant' for publicity purposes."

Thwarted, Mary found other ways to keep her name in the papers. Reporters had always wanted her to talk about Taylor, so now she obliged them, gushing over their great love and handing over her "scarlet, silken-covered" diary to the *Los Angeles Record*. She even wrote a piece herself for the *Los Angeles Times*, disclosing her great, secret love affair with Taylor.

Disputing earlier public comments that Taylor had considered her a "mere child," Mary now declared that the only reason they had never wed was because Shelby had forced them to hide and pretend—"as if our love were some unclean thing that could not be avowed publicly."

And why was Shelby so intent on foiling her daughter's great love?

Mary surprised many with her answer. "Mother liked William Desmond Taylor very much," she declared. "It was not until Mother

discovered that Mr. Taylor cared more for me than he did for her that she became bitter towards him."

Mrs. Shelby, sweet on Taylor? This was the first anyone had heard of such a thing. A whole new round of gossip exploded, and Charlotte Shelby was given one more motivation to commit murder: jealousy.

What was going on with Mary that summer? So many people—her friends, her former employers, reporters who'd been covering her for years—found her statements wild and erratic. In fact, Mary's words may have not been entirely rational. When she finally left her temporary haven in Pasadena, she left behind some rather curious mementos of her stay. Moving some books on a shelf, her hosts discovered several "vials of dope" that they "certainly hadn't put there" themselves.

Mary had apparently been using heroin.

Free at last of her mother's control, partying late into the night with her friends, Mary had picked up some bad habits. She said things that summer about Taylor, herself, and her mother that she might never have thought of, let alone spoken, in another frame of mind.

Shelby was horrified by the reports, waving off reporters who came to her door. "Please leave me alone in my sorrow and grief," she wailed.

And, she might have added, her terror.

When one reporter told Mary that her claims cast increased suspicion of her mother's culpability in Taylor's death, the actress professed bewilderment. The thought had never occurred to her, Mary said.

Few believed her. Least of all Detective Sergeant King, who took Mary's loquacious few weeks in August as a kind of indirect confession. As soon as District Attorney Keyes gave the word, King was prepared to arrest Charlotte Shelby for the murder of William Desmond Taylor.

# THE END OF THE ROAD

Seagulls swooped over the crashing Pacific as a young man made his way across the Venice Beach boardwalk toward the columned portico of St. Mark's Hotel. His name was Larry Outlaw—appropriately enough, as he'd been in and out of prison for burglary a number of times in his thirty years. At the moment, however, he was going by the more respectable-sounding Lawrence MacLean, and he was on an errand that might bring him the kind of dough none of his petty burglaries had ever scored.

He'd been hired by a goon named John Ryan, who'd been involved in the shakedown of an Ohio millionaire and was now on the lam. MacLean was to meet another mug by the name of Blackie Madsen at the St. Mark's and pick up a batch of letters from him—letters that the millionaire would supposedly pay $30,000 to get back. MacLean was told he could keep a third of that.

The young man rapped on the door. Madsen opened it a crack, asked for a code word, then handed over the letters. Before the door closed again, MacLean got a glimpse of the squalor inside the hotel room, and the crazy, hopped-up eyes of May Ryan.

Madsen clung to the belief that Bushnell would pay anything for the remainder of his letters to Rose. In the press, the banker was insisting on his complete innocence. If the letters were published, they'd prove him to be a liar and destroy his marriage and his reputation. Madsen was convinced Bushnell would pay whatever they demanded.

And when the blackmailer got his cash, he had very specific plans for

it, plans that didn't include paying Ryan or young MacLean. The bulk of the thirty grand would be used as bail for Osborn and Rose, allowing them to get out of jail and escape with Madsen to Mexico.

Either Madsen was the most loyal friend ever, or Osborn had something on him.

Blackie Madsen was not a sentimental man. The only reason he was planning to spring Osborn with Bushnell's money was that if he didn't, Osborn would sing. Osborn clearly had something on Madsen, and he was vindictive; no way would he go to prison without ratting out disloyal partners. He'd probably insisted on an agreement even before the first shakedown: if one of them got caught, the other would engineer an escape. Or else the one in prison would reveal everything he knew about the other. It was the only way to explain why Madsen stuck around and didn't flee himself.

Whatever secret the two blackmailers shared, it must have been a doozy—one so serious that the Feds would have pursued them even over international borders.

In his jail cell in the tiny town of Troy, Ohio, Osborn was confident that Madsen would soon have him back walking the streets. After pleading not guilty, he was cocky, cracking jokes with the guards and flirting with the lady reporters who came to see him. Osborn seemed completely "undaunted by the fact that a possible long residence behind barred doors and windows awaited him." That was because Osborn believed he'd never stand trial. He was absolutely certain that Madsen would orchestrate another shakedown, and soon they'd have the money they needed for bail. Smarter than his adversaries as always, Osborn planned to have the last laugh.

On Beachwood Drive, FBI agent Connelley and his Los Angeles counterpart Owen Meehan were knocking on the locusts' doors. Everyone claimed to be shocked and horrified when they learned of the actions of Don and Rose. "You can imagine the position Osborn has put us in," Leonard Clapham bemoaned, "in the community and with the neighbors." It was "most embarrassing" for him and his wife, Clapham said, as well as Leo Maloney and his wife, to have been associated with such low-lifers. If the federal agents tracked down Osborn, Clapham

said, they should "tell him that it [would] not be wise for him or Rose Putnam to show their faces in this neighborhood or Los Angeles again!"

From between her closed blinds, Gibby may well have watched the agents walk up and down North Beachwood Drive. No doubt she breathed a sigh of relief when they failed to knock on her door.

Once again, she was in a terrible bind. On June 6, *A Pair of Hellions* had been given a gala premiere at the Franklin Theatre in Oakland, with a glittering personal appearance by Patricia Palmer, who identified herself as "a former Paramount star." They might not have had the funds to make it in 3D as they'd hoped, but *Hellions* was still a big feature; Gibby had ridden her horse expertly and showed off some lovely gowns in the bargain.

But Max O. Miller Productions had no cash for a follow-up picture, and so far *Hellions* hadn't exactly set the state's rights market on fire. Once again, Gibby was broke.

Then, all at once, things got even worse.

Out driving with a new friend, Arthur McGinness, Gibby was startled when a man leaped up onto her running board and tried to seize control of the steering wheel.

It was George Lasher.

He forced her to pull over. Lasher insisted that Gibby meet him at his office. When she complied, she was told, in the presence of Lasher's wife, that unless she forked over $1,000 by September 4, the police would learn all about the racket she and Osborn had going.

Who was blackmailing who now?

Unbeknownst to Gibby, Lasher had written to John Bushnell after reading about him in the newspapers, spilling the beans about Osborn's connection to Patricia Palmer, movie star. "I intend to expose the gang anyway," he told the banker, "but I am trying to get my money back first." Lasher was being as dishonest with Gibby as she had been with him; he seemed to take great pleasure in the turnabout. Even if Gibby got him the grand, Lasher still intended to turn her in.

She might not have known everything that was afoot, but Gibby recognized the danger she was in. She had no money to pay Lasher. After all her schemes, this, finally, could be the end of the road.

There was only one thing she could do. Only one way she could get some money to pay him and keep him quiet.

Gibby went back to Jesse Lasky and asked for another job.

And for a third time, defying all logic, Lasky said yes.

Accompanied by John Ryan, Lawrence MacLean took the letters to Ohio. Also in on the scheme was one Herbert I. Ross, a notorious check forger. The trio made arrangements to meet Bushnell at a hotel and exchange the letters for the thirty grand. Their mood was confident. The banker seemed eager to comply and put an end to all of this.

But just as the blackmailers were about to make the exchange, federal agents came swarming out of every door and elevator. They grabbed Ross and slapped handcuffs on him. Ryan and MacLean managed to slip out a back door and hightailed it to safety, Rose's letters still stashed down inside MacLean's coat.

When word reached him of the fiasco in Ohio, Blackie Madsen knew it was over.

He packed a bag and ran. He'd find some place deep down in Mexico to hide out. Now that the plan had backfired, he feared Osborn might start singing at any time.

In his temporary office in the Hall of Records, provided to him courtesy of District Attorney Keyes, Agent Connelley read the report that was coming across the wire. Clicking and clacking with every letter, the teletype machine spelled out the note that Bushnell had received from George Lasher—the one that had just foiled a third attempted shakedown of the millionaire in Ohio. Connelley read each line with growing interest. It seemed this guy Lasher had been the victim of a similar swindle by one of Osborn's associates, an actress named Patricia Palmer.

Connelley had seen that name before.

He pulled out his reports and began leafing back through them.

Patricia Palmer was Osborn's landlady. She lived down the street from him on Beachwood Drive.

Apparently Connelley would need to visit her after all.

# READJUSTMENTS

On October 15, just as Agent Connelley was making plans to investigate Patricia Palmer in Los Angeles, the great ship *Leviathan* was steaming into New York Harbor, gliding past the Statue of Liberty and rounding the tip of Manhattan as it completed its transatlantic voyage from Southampton. Onboard was Will H. Hays, rested and relaxed after three weeks abroad.

Hays's trip had been largely a holiday, a much-needed break. Since taking the reins of the MPPDA a year and a half earlier, he'd spent nearly all of his time putting out fires, one after another. It had been an extremely difficult year—and not just professionally. Not long before his trip, Hays had decided on a legal separation from his wife. He was no longer able to continue the charade of their marriage. Helen, thankfully, wasn't planning on contesting it; in their eventual divorce, she would even agree to give Hays custody of their son. But their separation needed to be conducted with extreme discretion. Under no circumstances could the church ladies discover that the movies' moral guardian had left his wife.

By necessity, Hays lived a rather solitary existence. Back in Washington, he'd occasionally been able to assuage his loneliness with the company of a lady friend. That was no longer an option—not with Canon Chase and the church ladies watching Hays's every move.

So after eighteen months without a vacation, he had jumped at the chance to get away, sailing off for England at the invitation of George Brinton McClellan Harvey, ambassador to the Court of St. James and a

longtime political ally. The two old friends had gone on shooting expeditions in the north of England, smoking many cigars and consuming copious amounts of brandy, which was refreshingly legal in the mother country.

Of course, if Hays had wanted a complete holiday, he could have gone back to Florida, where his only distractions would have been a beach lounge and a pair of snorkeling fins. But as the head of the MPPDA, even if he shunned public appointments, he was obliged to be "wined and dined" by British film industry leaders in private. Hays's American clients expected him to come home with a deal to make the importation of American films into Britain easier; his British hosts hoped he might facilitate the exhibition of more of their features on American screens.

As always, Hays spent his days in a constant attempt to please all sides.

Some observers wondered if it was all a ruse—if after the contentious past eighteen months Hays was unhappy with his movie job and wanted out. Was he meeting with Harvey to discuss taking over the ambassadorship? Or was he contemplating a return to politics? On August 2 President Harding had died in office, and many of his more hardline conservative supporters weren't sure of his successor, Calvin Coolidge. A fight for the nomination might well break out at the presidential convention the following year, and some party operatives were publicly calling for Hays's return. The presence of several Republican lawmakers onboard the *Leviathan* with Hays—Senator Edwin Ladd of North Dakota and Representative James A. Frear of Wisconsin, among others—only fueled the talk.

But Hays had no intentions of going anywhere. As he sailed back into New York, he was ready to recommit himself to his job. His work was finally beginning to pay off. At last he could envision a time when Adolph Zukor no longer controlled his every move.

After the debacle of trying to lift the Arbuckle ban, Hays had moved swiftly to consolidate his power on the Public Relations Committee once again. The members who had opposed him most stridently had since resigned; many of the vacancies were filled with people with whom he had personal connections. Hays had also worked hard at developing even closer relationships with such producers as Joseph Schenck, Sam Goldwyn, and Marcus Loew, who were, at least nominally, as

important to the MPPDA as Zukor. At the moment, Hays was going to bat for Goldwyn in resolving some exhibitor problems; in London, he'd been a particular advocate for Loew's Metro Pictures.

By the later part of 1923 Hays had clearly rebounded from his darkest hour. Though he'd been vilified after the Arbuckle episode, now he was walking tall—quite a thrill for a man who barely cleared five feet—as the hero who'd saved the film industry from censorship. That season, the *Film Daily* observed, "Motion picture people have no great fear of what the various state legislatures will do so far as censorship is concerned. The Hays victory in Massachusetts has had its effect." A year on, no censorship campaign had succeeded at the state or federal level; few had even been attempted. The fact that the trades were calling the win in Massachusetts "the Hays victory" spoke volumes.

As the film czar stepped off the *Leviathan* onto the pier, he was planning his next moves to consolidate his power.

He and Joseph Schenck were discussing a "readjustment" of the industry—a necessary move, they argued, for long-term economic growth and prosperity. Exorbitant star salaries needed to be lassoed and brought under control, but Hays made it known that he had other extravagances in his sights. Such talk could only have put Adolph Zukor on edge. He was not the sort to be lectured about how he spent his money.

Schenck boldly told the press that "the Will Hays organization will play an important part in this readjustment." In fact, Schenck said, "this new era" would return "the Will Hays organization to the place it originally was destined to hold in the industry." An *independent* place, in other words, free of Zukor's control.

It was perhaps no surprise, then, that Hays received a summons from Zukor shortly after he returned from England.

Encountering reporters on Fifth Avenue, Hays presumed Zukor wanted "to discuss his recent trip abroad."

He was, most likely, surprised by what was really on Zukor's mind.

# UNEXPECTED DEVELOPMENTS

On the afternoon of October 27, 1923, the same day Will Hays was summoned to Adolph Zukor's office in New York, Gibby Gibson stood in the little courthouse that overlooked the gracious green in Santa Ana, California, and signed her name to the certificate in front of her. She was now officially a married woman.

Her new husband scribbled his signature as well. He was Arthur McGinness, a North Dakota native two years Gibby's senior, and a plasterer at the shipyards. Gibby hadn't known him very long. But McGinness had been there the day George Lasher had jumped on her running board and started making threats against her. McGinness had heard quite a bit that day, and subsequently he'd learned quite a few of Gibby's secrets.

So she'd married him. Courts couldn't order a husband to testify against his wife.

Gibby had just finished shooting *To the Ladies*, the third big-budget picture Jesse Lasky had assigned her. This was another prestige production for Gibby, adapted from a George S. Kaufman Broadway play and directed by James Cruze, who'd helmed one of the year's most successful films, *The Covered Wagon*. Though Gibby had only a small part, she hoped the money would hold off Lasher for a while.

Yet Lasher was no longer her biggest problem. Almost immediately after she shot her last scene for *To the Ladies*, Gibby got word, probably through George Weh, that FBI agents were asking questions about her.

Agents Connelley and Meehan were now convinced that Patricia Palmer was a key player in Osborn's "blackmail ring which had mulcted prominent and wealthy men of more than $3,000,000 during the past few years." Gibby figured it was only a matter of time before she was arrested, so she needed to act fast. Grabbing Arthur McGinness, she'd sped down to Santa Ana and married him. Then she returned home to wait.

She didn't have to wait long.

On the afternoon of November 2, several police cars pulled up in front of Gibby's house. From the window, she watched as the officers, accompanied by federal agents, strode up to her front door. She accepted the warrant for her arrest without any argument. The officers thought the calm she displayed was "almost startling."

"Mother," Gibby called over her shoulder, "these gentlemen are officers. I'll have to go with them."

"Are you going to jail?" Celia Gibson asked her daughter.

"I suppose so," Gibby replied.

She was led away in handcuffs.

Two thousand miles away, in the federal courthouse in Cincinnati, Ohio, Don Osborn and Rose Putnam were preparing for prison. Osborn's smirk had faded from his face pretty quickly after investigators started questioning him about Patricia Palmer. Realizing that Gibby's arrest was imminent and fearing the details she might reveal, Osborn told prosecutors that both he and Rose would change their pleas from not guilty to guilty.

On the morning of October 30, Judge Smith Hickenlooper sentenced Osborn to twenty-one months in the federal penitentiary in Atlanta. Rose got just six months and was permitted to serve it back in her familiar cell in Troy.

Now that it was all over and he was heading to prison, Osborn had regained some of his old swagger. To the marshal accompanying him on the train to Atlanta, the erstwhile con artist announced he planned to write a movie scenario based on his experiences. On the train south, he pulled out a pen and "became very busy, reeling off about twenty pages," the marshal observed. Not only would Osborn "write a number

of scenarios while locked up," but he also said he "intended to make a lot of money by so doing."

Don Osborn always had a plan to make a lot of money. Just because he was going to jail was no reason to change that.

Meanwhile, in a Los Angeles cell, Gibby waited for news of her own fate.

She was charged with violating Section 145 of the Federal Criminal Code—extortion. Her bail was set at $2,500, which she was unable to make. Her lawyer was Patrick J. Cooney, a Calexico lawyer who often took on hard-luck border-town cases like hers.

"It's just a put-up job," Gibby said, weeping angry, bitter tears as she was arraigned before federal commissioner Stephen G. Long. "This is simply a matter of personal spite, and they haven't got anything on me at all." It was like a replay of six years earlier after she was pinched in Little Tokyo.

Interrogated by Connelley and by US Attorney Joe Burke, Gibby was alternately humorous and sarcastic, but always very careful. While she clearly knew more than she was admitting, there was little hard evidence linking her directly to Osborn's schemes. Yet Jim Dallas, the Tijuana club proprietor, had corroborated Lasher's story of the attempted extortion. That much of the Feds' case against Gibby seemed solid.

But just as things looked bleak, word came that someone had posted her bail. To her great surprise and relief, Gibby was released.

The identity of her guardian angel was a mystery. But whoever had sprung her from jail had apparently also paid for a new, high-powered attorney to defend her. In swooped white-pompadoured Frank Dominguez, the same lawyer who'd represented Gibby after Little Tokyo—and who had defended Roscoe Arbuckle some years later. As always, Dominguez entered the room strutting and bellowing, demanding that all charges against his client be dismissed. He was a rich man's lawyer and a friend of the film industry. Unlike Cooney, Dominguez was also a Republican—a potentially significant detail when the federal attorneys prosecuting the case were Republicans, too.

One of them, in fact, was Mark L. Herron, the Will Hays appointee who'd helped the film czar halt distribution of *The Sins of Hollywood*

about a year before. Now Herron was in charge of prosecuting Patricia Palmer, aka Margaret Gibson, a featured player in the forthcoming Paramount release *To the Ladies*. "She gained the limelight several years ago," one exposé revealed, "when, under the name of Margaret Gibson, she was arrested in a raid on a Japanese rooming-house. She was charged with vagrancy, but was acquitted of the charge in Police Court." While Gibby had appeared in some important pictures, another paper noted, she had "never attained stardom in the films."

Talk about rubbing it in.

Despite Dominguez's bluff and swagger, the case seemed stacked against Gibby. This time she was going down. But then something else surprising happened.

On November 5, three days after Gibby's arrest, Agent Connelley was called into Attorney Burke's office. When Gibby was first taken into custody, Burke had been "of the opinion that there was sufficient evidence" of her guilt. Now, however, the prosecutor's opinion had changed. And the reason for that change, apparently, was the man sitting next to him: his chief deputy, Mark L. Herron.

Herron told Connelley that he had examined his reports very carefully, "and from the evidence set forth and the statement made by Margaret Gibson, he did not deem it advisable to proceed with this case, in view of the fact that there was insufficient evidence."

Connelley was flummoxed. The evidence was far from insufficient. He'd gotten Gibby to admit enough about Tijuana that an indictment would be easy to obtain. Plus, he had Jim Dallas's statement. Even if they couldn't prove her direct involvement in Osborn's various schemes, they could still nail her with Tijuana.

But Herron wanted her released. The government, he argued, "would find itself in the position of attempting to prosecute a woman upon the uncorroborated testimony of a man [Lasher] who had admittedly . . . violated the Mann Act." Once again, Herron seemed to be willfully disregarding the corroborating testimony of Jim Dallas, and he showed no interest in rounding up Edward Rucker, Gibby's musician accomplice, who could have further confirmed Lasher's account. Herron seemed anxious to end the matter as quickly as possible and let Gibby off the hook.

For three days Connelley stewed. He made no move to dismiss the charges. But finally, unable to countermand a US attorney, he agreed to Herron's recommendation.

On November 5 Commissioner Long dismissed the case against Margaret Gibson.

In the courtroom, the actress burst into tears of joy upon learning the news. Dominguez thundered, "This poor girl has lost her job, her mother is seriously ill in bed, and now we are politely informed that it was all a mistake."

Gaveling the case closed, Commissioner Long said he regretted that the unfortunate business had proceeded as far as it had.

"Good public policy" was the reason Mark Herron gave to drop Gibby's prosecution.

But was it public policy or public relations he was concerned about?

On the day after Herron delivered his decision to drop the charges, Jesse Lasky boarded a train for New York. He told reporters he would be meeting with Adolph Zukor "on a whole variety of subjects."

Some suspected that Lasky had been Gibby's benefactor, posting her bail and hiring Dominguez to defend her. After all, until a few weeks earlier, she'd been a Lasky employee. If the producer had indeed provided for her, then he was being extremely generous to someone who was, after all, merely a former supporting player. But Lasky's generosity to Gibby had been demonstrated before.

Still, even Jesse Lasky didn't have the clout to sway the opinion of a US attorney, to get a federal case dismissed against a defendant who was clearly guilty.

But someone else did.

Will Hays.

Mark Herron wasn't the only one in the federal courthouse beholden to Hays. So, too, was Chief US Attorney Joseph Burke, who'd been commissioned by President Harding in 1921. Both Burke and Herron had been active members of what opponents had criticized as "the federal brigade"—Republican federal appointees who had worked closely with the party machine to reelect senator Hiram Johnson in 1922. And

that party machine, of course, had been led by national chairman Will Hays.

So if Hays had determined that Margaret Gibson should be exonerated, for the good of the industry, he had two party loyalists in place who could have made that happen.

But why would Lasky—or Zukor himself, if his summons of Hays just days before had anything to do with it—have asked the film czar to intervene in the case of a minor actress who was no longer even one of their employees?

Certainly a new scandal involving a blackmailer and former prostitute appearing in an upcoming Paramount release would not have been good for the movie industry. But such drastic action on Hays's part—pressuring federal attorneys to dismiss a case—could only have been considered in a true emergency. What was it about Margaret Gibson that compelled the heads of Famous Players–Lasky to move heaven and earth to keep her safe—and, presumably, silent?

The only explanation for Gibby walking out of the courtroom a free woman on November 8, 1923, was that someone had pulled strings for her.

Hays had compromised his integrity before for the good of the industry. With a heavy heart, he had apparently done so again—but only under the direst of circumstances, and most likely, only under direct pressure from Zukor.

How it must have rankled him.

More than ever, Hays longed to be free of Creepy's control.

# MANHUNT

On the eleventh floor of the Hall of Records in downtown Los Angeles, Eddie King sat uncomfortably in one of the regular weekly meetings held by District Attorney Asa Keyes. This was an opportunity for the deputies to update the department on cases they were investigating. When Detective King's turn came, he flipped through his files, reporting on his work on the unsolved murder of wealthy industrialist Fred Oesterreich, which had occupied his time of late.

It was early February 1924. Even as King spoke, he regretted having nothing new to report on the Taylor case. It had been two full years since the director was found dead on his living room floor. King's wife said that Taylor's murder obsessed the detective "night and day." And for all of King's hopes that Keyes would be more aggressive than Woolwine in pursuing the case, the new DA had declared that there was nothing new to investigate.

To King, of course, that was absurd. He had presented to Keyes all the evidence he'd accumulated against Charlotte Shelby: the gun, her weak alibi, the testimony of acquaintances, the suspicious behavior of her daughter and her attorneys. But still the new DA, like his predecessor, had not moved forward on the investigation.

King was extremely frustrated. Why was Keyes so timid about acting against this woman? Could the rumors that Shelby was paying off Keyes be true? Was yet a second DA in the pocket of Mary Miles Minter's abominable mother?

But in his report that day in February, King didn't raise any of his doubts or suspicions. He simply hoped that the moment Shelby made a wrong move—which was inevitable, King believed—he'd be able to make an arrest.

Finishing his review of his work, King sat back to listen as the rest of the detectives gave their reports.

Charles Reimer was head of the bunco squad. Some interesting things had been happening under his watch.

Reimer informed his colleagues that he'd been approached by Owen Meehan of the FBI for assistance in finding two fugitives, Blackie Madsen and John Ryan, whose names might have rung bells for King if he remembered the report, some six months earlier, about the John L. Bushnell blackmail case. For a brief moment, the Feds had wondered about a possible connection to the Taylor murder, but King had apparently disregarded that lead.

Now it seemed the FBI had its sights on Madsen, and the bureau was asking Keyes to place a former con artist on his payroll to help smoke the offender out of his hole. Keyes agreed, and the stool pigeon was put to work under Reimer's direct supervision. Reimer promised to report back to his colleagues any progress on the case.

Madsen wasn't in Los Angeles, however. He'd fled weeks earlier, and was hiding out in Juarez, Mexico. But, as FBI agents in Texas discovered, he also kept a post office box across the border in El Paso for unknown reasons. Inquiring at the post office, the agents learned that a package had recently arrived for Madsen from 2514 West Sixth Street, Los Angeles, the home of a Mrs. Harriett Sheridan. Who was Harriett Sheridan, the Feds wanted to know, and what was her connection to Madsen?

The phone on Charles Reimer's desk rang. The FBI was calling with another request for help. A female agent was needed to visit Mrs. Sheridan's house and make some inquiries. Since the bureau had only three female agents, and none were in Los Angeles, the Feds hoped Asa Keyes would assign one of his women to the case. The DA agreed.

Eddie King would have learned of these developments during the

department's weekly meetings, but apparently the case had no interest for him. Why should it? Why should King care about the search for some two-bit goon?

On demure, jacaranda-shaded West Sixth Street, the female agent from the DA's office climbed the steps of Mrs. Harriett Sheridan's house, a clipboard under her arm. She knocked on the door. From a discreet distance, FBI agent L. C. Wheeler kept an eye on the proceedings.

A small, stout woman with a prominent nose opened the door.

The DA's investigator went into her act. She was taking a school census, and she needed the name of everyone who lived in the neighborhood and the ages of their children. Mrs. Sheridan replied that she had no children of school age. Be that as it may, the female detective insisted she still needed the name of everyone, just to be complete. Finally Mrs. Sheridan relented, and gave her son's name as Ross. But, as the detective would note in her report, "she was very cautious in touching upon anything relating to his present whereabouts."

Still, they'd learned something. Comparing Mrs. Sheridan with a photograph of Blackie Madsen, the detectives concluded she was, without a doubt, Madsen's mother. "The resemblance is certainly very strong," Wheeler wrote in his report.

An order was placed at the Westlake post office to make tracings of all mail received by Mrs. Sheridan. The tracings would be compared to samples of Madsen's writing in the FBI files. As soon as a positive identification could be made, the agents planned to arrest Madsen the next time he appeared in El Paso. Why he risked crossing the border to send and receive mail from his mother, the agents weren't sure, but they were certainly glad he did.

As it turned out, they didn't need to go all the way to El Paso to get him.

Blackie Madsen had always had a soft spot for his mother. She suffered from chronic nephritis, enduring frequent pain and swelling in her extremities. She was all alone now, too. Worried about her, Madsen snuck back into Los Angeles at the end of February.

He was spotted by the stool pigeon on the district attorney's payroll. Immediately a manhunt fanned out across Los Angeles to bring Madsen in.

They got him at his mother's house. At 4:30 in the afternoon on March 1, 1924, Madsen was spotted walking up Sixth Street, wearing a heavy pair of dark tortoiseshell glasses. When he entered the house, Charles Reimer called in a police backup, and the house was quickly surrounded. With FBI agent Owen Meehan covering the front, Reimer snuck around back, kicking in the door and surprising Madsen in the kitchen. As Mrs. Sheridan screamed, Meehan burst through the front door. Grabbing Madsen by the arm, he took a look at his wrist.

A blue star tattoo.

He had his man.

Madsen was forced to turn over his gun, that old .38 that dated back to the Spanish War.

A week or so later, Reimer reported to the department about his successful partnership with the FBI. Through hard work and cooperation, they'd gotten their man. District Attorney Keyes expressed his approval and said he hoped they'd have many more fruitful associations with the Feds in the future.

Eddie King didn't have as much to say in his report as Reimer. The Oesterreich case dragged on, he said, and as usual there was nothing new to report about Taylor. But he quietly resolved to keep working on the case.

In federal custody, Blackie Madsen rode the rails back to Ohio for arraignment. At first he kept quiet, refusing to admit to anything. After all, he had a long record. The Feds had arrested him for blackmailing Bushnell, but who knew what else they might have on him? So for several days, Madsen didn't utter a word.

Three days after his arrest, however, he'd figured out the situation. He told agents that he was now "ready to talk." Waiving his hearing in Los Angeles, Madsen agreed to be removed to Ohio to stand trial in federal court there. He knew if the Feds allowed him to waive his hearing and head straight for Ohio, the Bushnell shakedowns were all he would be charged with.

For that, he was looking at two years probably, tops. Madsen could deal with that.

"Believe he will plead guilty if handled carefully," Agent Wheeler cabled agents in Cincinnati as the prisoner traveled east in the custody of federal marshals.

If Madsen needed any further prodding to cop a guilty plea, he got it on March 31 when Rose Putnam was released from jail. A month had been chopped off her sentence for good behavior. Surely Madsen must have wondered if Rose had been let out early so she could testify against him in a trial. After all, she knew an awful lot. Six days later, Madsen pleaded guilty as charged. Facing the judge along with him were Ryan and MacLean, who'd been apprehended separately, the last of Rose's letters finally being returned to Bushnell.

These "menaces of society," the prosecutor argued, should be tossed in jail and the judge should "throw away the key." Judge Hickenlooper agreed that a severe sentence was in order. For the first shakedown, Madsen was given two years; for the failed second attempt, he got a year and a day, to be served consecutively.

On the afternoon of April 5, 1924, Blackie Madsen, his hands and wrists shackled, set off on the train for Atlanta, where he would join Don Osborn behind bars. He'd be away longer than he'd expected. But all things considered, three years and one day wasn't so bad.

# CLOSING THE CASE

# THREE DAMES NO LONGER
## SO DESPERATE

The Roaring Twenties might not have reached full thunder by 1924, but the din was definitely getting louder. The economy was expanding. For the third year in a row, the gross national product had risen. Earnings were trending upward, and full employment had been reestablished. The national mood was optimistic, even a bit brash.

Yet while many others in Tinseltown were jumping up onto tabletops and shimmying to the Charleston, the three desperate dames of 1920 were feeling a little less frolicsome, even if they weren't nearly as desperate as they had been. A better word to describe Mabel might have been determined. Mary, delusional. Gibby, defeated.

Mabel's determination was evident as she sat in the witness box of a Los Angeles trial in June 1924, dueling with the smarmy defense attorney S. S. Hahn, Joe Pepa's brother-in-law. She was testifying in the assault trial of her chauffeur, an unhinged character named Horace Greer, who had shot and wounded a friend of hers, wealthy playboy Courtland Dines, on New Year's Day while Mabel and Edna Purviance were present. The resulting scandal had given the newspapers their biggest boost since Wally Reid died a year earlier.

CHAUFFEUR SHOOTS MAN IN PRESENCE OF FILM STARS, trumpeted the headlines, and once again Mabel's name was in big black ink. The parallels with the Taylor case abounded: Greer, like Edward Sands, had a criminal past, and he'd been using an assumed name. As before, two beautiful actresses were involved. And if the police were right, a love

triangle was once again at the center of it all. "An unvoiced, passionate love for his movie queen employer and jealousy of her host is believed by the police to have caused Horace A. Greer, the driver, to shoot Dines," wrote Edward Doherty, reprising his role as Mabel's chief persecutor.

Another newspaper scolded: "Dear Mabel may be very sweet, but her actions are not such as to make the public believe it. The quicker she is removed from filmdom, the better."

This time, no one waited for Will Hays to act. Across the country, theaters quickly instituted bans on Mabel's pictures. NORMAND CASE UPROAR was *Variety*'s headline as the list of embargoes grew. In Memphis, Mabel's films were banned for all time; the prohibition was quickly copied in Manchester, New Hampshire, and Columbus, Ohio. Within days, theaters were falling like dominoes. Topeka. Sacramento. Hartford, Connecticut.

Yet in the face of it all, Mabel no longer retreated. She held her ground, insisting she should not be held accountable for the actions of a mentally unstable employee. In court, she refused to be bullied by Hahn. At one point, as Hahn deliberately twisted her words, "the Normand temper slipped its moorings," one reporter noted, and Mabel lashed out.

"You haven't any right to cross-examine me like that," she snapped. "What do you want to be so mean to me for?"

When the prosecution objected that Hahn was badgering the witness, the judge smiled. "This witness seems perfectly able to take care of herself," he said.

And she was. When Hahn asked Mabel if she'd told Greer to shoot Dines, she exploded. "For heaven's sake—no! Why should I tell anybody to plug anybody, anyhow?"

Greer was acquitted, Dines recovered, but Mabel, for all her courage, was through in Hollywood. Attempting a goodwill tour on Sennett's advice, she was invited to speak to a committee of the Federation of Women's Clubs in Chicago. En route, she received word that higher-ups had rescinded the invitation. Arriving at the station as an unwanted guest, Mabel was besieged on the platform by reporters brandishing a statement from Mrs. George Palmer, the club's president. "The majority of Illinois club women wish to see neither the actress in person, nor on the screen," Mrs. Palmer declared.

Mabel stood on the train platform, choking back the humiliation. "Will you do something for me?" she asked the reporters. "I want you to thank the few lovely women in Chicago who have stood by me."

A class act, Mabel Normand turned her back on them all, and never again played the Hollywood game.

When, a few months later, an opportunistic woman by the apt name of Mrs. Church sued Mabel for alienation of affection in her divorce case, Mabel struck back hard. "There is a limit to all human endurance and I have reached mine," she said, and slapped a libel suit against the woman. Too often, Mabel told reporters, she and others—she was thinking of Roscoe—had let charges against them go unanswered. No longer. "I've made up my mind to quit being good natured about all this dirt being dished out about me. They've just got to quit kickin' my name around."

Though the court dismissed Mabel's suit on a technicality, her action did force Mrs. Church to withdraw her own suit and resubmit a new one against her husband, this time without any mention of Mabel. The move generated headlines of a very different sort. MABEL IS CLEARED. MABEL IS EXONERATED.

Five years, she'd been waiting to read those words.

She might have been finished as a movie star, but Mabel adjusted. She took classes, learned French. She bought a house with a garden. She moved back to New York for good—back to the real world, away from all the tinsel. She went on the stage.

It took courage to try something new, to start over without a playbook. It took guts to walk out in front of an audience instead of a camera, and to speak lines out loud instead of pantomiming them. In the past, if Mabel had blown a scene, she could have counted on her director to call, "Cut." Now she was walking a tightrope in front of a theater full of people, and she'd been given only the briefest theatrical training. Within weeks of her arrival, Mabel was thrust out onto the stage, starring in producer A. H. Woods's farce *The Little Mouse*.

The show opened in Stamford, Connecticut, and played in Washington, DC, and Asbury Park, New Jersey, before closing in Providence, Rhode Island, in September 1925, never making it to Broadway. A

myth would arise that *The Little Mouse* was an abject failure, and that the disaster could be laid at Mabel's doorstep, since her health and vitality had been destroyed by drugs and scandal. In fact, the play wasn't as bad as all that, or at least Mabel wasn't. She was greeted with an ovation every time she walked onstage—and the applause returned at each curtain call. The main criticism of her was that she didn't speak loudly enough, perhaps inevitable for a silent-picture star. In a slow theatrical season, *The Little Mouse* did better than most tryouts. Mabel's name proved to be "magic at the box offices of the road," the *New York Times* reported.

Yet from this point on, myths and distortions would obscure the reality of Mabel's life. She must have been a flop in *The Little Mouse*, people concluded. She must have been terribly unhappy, a failure, a tragic alcoholic. For some reason, people seemed to need to believe the worst about Mabel; her story had to be a tragedy. Even decades later, her otherwise sympathetic biographer would paint her last years as those of a sad, pathetic drunk.

But on what evidence? True, Mabel was a regular at Texas Guinan's soirees at the 300 Club at 151 West Fifty-Fourth Street, where fan dancers and bootleg liquor abounded. But so were such giants of the New York theater and literary scene as George Gershwin, Al Jolson, Jeanne Eagels, and Edmund Wilson. If Mabel knocked back her share of sidecars and bee's knees in the cafés and salons of New York—and sometimes more than her share—that hardly made her a drunk. It certainly didn't make her tragic.

What it made her, at last, was happy. Julia Brew had come back to live with her, and take care of her, and Mabel thrived in her beloved New York. Remaining under contract to Woods, Mabel no longer had to worry about money. She brought in $1,550 a week, and while some of that surely went to her bootlegger—some of everybody's salary did—a good deal more went to books and theater tickets. She entertained the writer Carl Van Vechten, the painter Miguel Covarrubias, the journalist Heywood Broun, and the poet Edna St. Vincent Millay.

How proud Billy Taylor would have been of his protégée. For that matter, how proud her father would have been. Mabel had made a place for herself, finally, in the big wide world.

In October 1925 fashion columnist Betsy Schuyler spotted the for-

mer star at the premiere of the Maxwell Anderson play *The Buccaneer*, drawing all eyes to her as she glittered in a white chiffon gown, white cape, and rhinestones. And at a party for the actress Irene Rich around the same time, a reporter from *Photoplay* noticed Mabel in an ermine wrap, "looking well and happy."

She didn't stay well forever. In 1927 Mabel was diagnosed with tuberculosis. Clearly she'd been suffering with the disease for years—the reason she was sick so often, and why people thought she was still using drugs when she wasn't. Yet even as her health declined, Mabel persevered. She made some well-received comedy shorts for Hal Roach and survived a brief, impulsive marriage to fellow merrymaker Lew Cody. Mostly she kept up her rounds of salons and sophisticated speakeasies, writing poetry and exchanging letters about art with the illustrator James Montgomery Flagg.

Mabel had escaped the confines of Tinseltown. She had fought back, spoken her truth, and reclaimed her life from those who thought they could buy it, sell it, judge it, consume it.

The same could not be said for Gibby and Mary.

"Don't get too big," the director Allan Dwan was known to warn his friends. "Let the other fellow get the kudos if he wants it. You can last forever at the bottom—or in the middle—but you get to the top and you're doomed."

Gibby should have counted her blessings that she'd never made it to the top. Her fall would have been that much more steep and injurious. As it was, she simply slipped into obscurity, going back to work for Al Christie on the Corner of Last Hope, playing bits and uncredited walk-ons. Now and then she secured a minor character part in a minor independent film. But any plans to produce her own pictures were abandoned.

Her marriage to Arthur McGinness didn't last, now that she no longer needed to fear his testifying against her. The parties that had once lit up the night along Beachwood Drive became echoes of the past. With Osborn and Madsen in jail, the locusts scattered like vermin after a spray of pesticide. Leonard Clapham still lived nearby, starting a new life as Tom London. Gibby might have warned him not to invest too

much hope in a simple name change, but the two were likely keeping their distance by now.

And yet, every couple of years, she still paid for new headshots, emblazoned with the name "Patricia Palmer" across the bottom, even as her face filled out and she developed a double chin. Gibby hadn't given up, not altogether.

Hope, after all, dies hard. But in fact her mother would pass away without ever getting the nice things Gibby had promised her on that rocky mountain road so long ago.

And Mary? Like Mabel, she left Hollywood for New York, hoping to carve out a new career for herself on the stage. After all, she'd been a great star of the New York theater when she was a little girl. People still remembered her, Mary insisted. Lots of them!

At the train station, a reporter asked her when she would be coming back to Hollywood.

"I hope never," Mary replied.

Yet one thing was certain. No matter where she fled, Detective Sergeant King would keep her in his sights.

# END OF AN ERA

Out at the windswept corner of Forty-Third and Broadway, Adolph Zukor, now fifty-two years old, gestured dramatically at the foremen and pointed up toward the clouds. Throughout the fall and winter of 1925, the Paramount Building grew taller every day behind giant scaffolding. Muffs on his ears during the colder months, Zukor stopped by often to check on the progress and hurry the workers along. The skyscraper was now slated to have thirty-five floors, dwarfing Loew's sixteen. That included a six-story tower boasting the largest office clock in New York. Every hour a set of chimes, cast in Europe, would sound over Times Square. Zukor's magnificent monument would complete the ring of skyscrapers around the square, fringed until recently by one- and two-story frame buildings.

The film chief was feeling emboldened. It had become clear to everyone that he would survive the Federal Trade Commission assault against him. After two years of hearings, the government still hadn't proven any illegality on the part of Famous Players. Shrewdly, Zukor had made a major concession by ending his policy of block booking, eliminating one of the FTC's major complaints against him. Besides, with so many other producers now expanding into exhibition, and exhibitor chains like First National financing new films, it was increasingly difficult to single Famous Players out. Observers predicted it would be years before the commission could win a judgment against the company, and maybe not even then.

And so Zukor had resumed what he'd been busy doing before the

government stuck its nose into his business: acquiring more theaters. In November 1923, Famous Players took full control of Sid Grauman's theaters on the West Coast; many more theaters followed in the succeeding months and years. The government had been Zukor's biggest worry. Now, feeling safe, he was giving the raspberry to the relentless federal prosecutors.

Yet for all his bluster, his autocratic reign over the movies had ended. And the one who had ended it was Marcus Loew.

In April 1924, Zukor's longtime rival had formed a giant combine that would "surpass in capitalization, influence and physical scope any other film organization in the world." Loew's Metro Pictures had merged with a host of others—with Goldwyn, with Louis B. Mayer's eponymous company, and with William Randolph Hearst's Cosmopolitan Pictures—creating a company worth an astonishing $65 million in combined authorized capital stock. Not only had the new MGM, as the industry was calling it, immediately become a financial powerhouse, but its formation gave Marcus Loew control of more theaters nationwide than Zukor. And MGM produced and distributed about as many films a year as Famous Players–Lasky.

In one fell swoop, Loew had become Zukor's equal.

Film War Looms as New Combine Seeks Supremacy, read one headline. "A war to wrest supremacy in the film world from Famous Players–Lasky is freely predicted now that Metro, Goldwyn, Mayer and Cosmopolitan have united under Marcus Loew, making him a powerful figure rivaled only by Adolph Zukor," the syndicated article declared.

In some ways, Loew was more than Zukor's equal; he was his superior. In March 1924 came a new *Variety* headline: Radio Is Box Office Danger. Increasing numbers of people were choosing to stay at home and listen to concerts and prizefights on the newfangled squawk box instead of going out to the movies. Loew had anticipated radio's power in a way Zukor hadn't. He'd purchased radio station WHN and relocated its transmitting station to high above his State Theatre on Broadway, where he regularly broadcast his movie premieres as well as the sounds of Al Jolson and Eddie Cantor.

For once, someone other than Zukor was ahead of the curve.

Yet when he was finally corralled into testifying at the FTC hearings, Loew had said nothing to damage his rival. In fact, he had steadfastly defended Zukor against charges of industry control. What a peculiar man! What motivated him? Zukor couldn't figure Loew out.

A few years earlier, sitting with his rival on his country estate veranda, Zukor had mused about the nature of competition, about the need for dogs to eat dogs lest "they get eaten first." Loew didn't necessarily disagree in most cases. But he surprised Zukor with a rather different perspective. Sometimes, Loew said, what Zukor thought was competition was really "just the other fellow doing his business."

Zukor had no idea what he was talking about.

Those veranda chats were in the past now. The Hudson River Valley was no longer good enough for Marcus Loew. Now that he was the head of MGM, he'd purchased Pembroke, a sprawling multimillion-dollar estate in Glen Cove, Long Island, with twelve master bedrooms, twelve baths, a mosaic tile swimming pool seventy feet in circumference, and a garage that accommodated twenty cars. Set on forty-six acres, much of it on the water, the mansion was called by some in real estate "the most beautiful home in the world." Loew had the residence of a king, making Zukor look like a country squire in comparison.

But Zukor would show him. The Paramount Building was almost done.

With the coming of MGM, the push to finish Zukor's signature headquarters took on a new urgency. "Zukor is about the wisest manipulator in pictures," *Variety* noted. "It is pride in being the biggest man in the picture industry and Zukor is going to keep that status as long as possible." His skyscraper would tell the world that no one would ever be bigger than he.

At the last minute, he made sure the plans included a radio station.

On May 19, 1926, the cornerstone was laid, using a gold trowel wielded by the mayor of New York—none other than Jimmy Walker, Zukor's old nemesis and now fast friend. Will Hays was there too, smiling his crooked smile from ear to floppy ear.

Hays seemed content to indulge Zukor's illusions of grandeur. Let

him have the highest skyscraper. Let him maintain the pretense that he was still the most powerful man in the industry. But Hays had helped ensure that was no longer true.

When Hays had signed the renewal of his contract on April 1, 1924, he'd known that Marcus Loew's merger was in the works, and that Zukor's reign was about to end. Hays had encouraged Loew in the move, staying in the loop through J. Robert Rudin, Loew's attorney and an adviser to the MPPDA. He was cheered by MGM's quick success: by its second year, Loew's studio was the biggest moneymaker in the industry, with profits over $6 million. Never again would Zukor hold the kind of power he had enjoyed from 1920 to 1924. And that diminution ensured Hays's elevation.

The little film czar now stood apart, dependent upon the studios for funding but increasingly independent of them in most other matters. Hays had succeeded splendidly in his primary objective, forestalling outside regulation by disarming the opposition through his brilliant public relations campaign. To tamp down any lingering calls for censorship, he'd developed what he called "the Formula," a loose set of guidelines based on Lasky's fourteen points, whereby producers were asked—not required—to submit questionable scripts to Hays's office for review. Although the Formula had no teeth for enforcement, it did disarm critics like Canon Chase. No wonder the board of the MPPDA had renewed Hays's contract. The original agreement had run until 1925. But the new contract that the film czar signed so enthusiastically in April 1924 extended his tenure through 1928.

Despite all the rumors, Will Hays wasn't going away.

Neither was Zukor, though he'd have to get used to sharing power.

And not just with Hays and Loew. In August 1925, to offset the FTC's repeated assertions that Famous Players "conspired to seize control of and monopolize the motion picture industry," Zukor had found it prudent to take on some partners. Transferring management of his theaters to the theatrical company Balaban & Katz of Chicago was a shrewd move, once again muddying the FTC's argument against him. Neither a merger nor a sale, the arrangement merely gave Balaban & Katz managerial control over Paramount theaters, with

money continuing to flow vertically into Zukor's coffers. But he had also gained collaborators in Barney Balaban and Sam Katz who were far more independent and influential than his nominal partner, Jesse Lasky, ever was.

Zukor had relished his rule as an absolute monarch. But that was in the past. Being part of an oligarchy would take some getting used to.

At least he'd sit higher than any of them in the sky.

On August 2, 1926, the Paramount Building reached its peak when its highest girder, 450 feet above street level, was swung into place. Extra police had to be called out to control the crowds that gathered in the square to witness the milestone. At noon exactly, whistles blew and two marines walked out onto the beams of the thirty-fifth floor and hoisted the Stars and Stripes on the flagpole. Far below, a US Navy band played the national anthem. Zukor blinked back tears.

The building opened in October, but the real gala came on November 19, with the theater's official premiere. Guests flowed into the marble lobby under an enormous dome of solid gold. Socialites, Wall Street money men, and Broadway impresarios stared up in awe at a magnificent chandelier of bronze and crystal. During the day a gargantuan ornamental window flooded the lobby with sunlight that reflected majestically off all the gold and crystal. At night, the hall sparkled with thousands of colored electric lights.

The theater itself was grander than anything New York had seen before—grander than even Loew's State, which had so impressed everybody back in the day. The French Renaissance auditorium was draped in red and gold satin damask. The great Wurlitzer organ, one of the largest in the world, occupied four chambers on both sides of the elaborate proscenium arch, overlaid and intertwined with crystal. Thomas Edison was there for the opening, looking a bit dazed to see his little novelty housed in such sumptuous surroundings.

The crowd featured a pantheon of New York's elite: Florenz Ziegfeld. Conde Nast. Frank Crowninshield. Arthur Hammerstein. Irving Berlin. Otto Kahn. Charles M. Schwab. Senator-elect Robert Wagner. Mayor Walker. Four thousand guests in all, the maximum number of seats allowed by law—matching the Capitol, which was now in Loew's

control after his acquisition of Goldwyn's chain. The stalemate couldn't have been lost on Zukor. If only he could have crammed in four thousand and one.

Still, in its first day of official operation, the Paramount admitted fifteen thousand paying customers from morning until night, collecting first-day receipts of an astonishing $8,000.

He might not be the sole emperor of Tinseltown anymore, but Adolph Zukor had the biggest, grandest palace of them all.

Some of the joy in that, however, was diminished by an unexpected factor: Marcus Loew's health was failing. Suffering from heart trouble, Zukor's granddaughter's other grandfather missed the opening of the Paramount. Instead he sent the man to whom he'd handed over MGM, Nicholas Schenck, who'd been with Zukor and Hays the infamous day they'd banned Fatty Arbuckle from the screen. But those days were long gone. The scandals had all been forgotten. There were new stars and new directors and new pictures. In a few years, it was said, movies might even talk and sing. A technological revolution was in the air.

Marcus Loew wouldn't live to see it.

On September 4, 1927, Zukor paid his old adversary a visit at his magnificent Long Island estate. He knew that Loew was failing, and he sat at his bedside for some time. A nurse was in constant attendance. Finally Zukor told the frail man in the shiny satin robe—dandy to the end!—that he would see him again soon, and made his farewells.

At six o'clock the next morning, Loew died in his sleep from a heart seizure.

Zukor received the news a short time later. He was overcome. "All I can say now," he told a reporter who called, "is that I feel his loss more than that of any man in the world."

Loew had been there from the start with Zukor. No one else but Lottie went back as far with him. But as they'd both climbed the ladder to success, Loew had been loved by those around him, while Zukor had been feared. The *Film Daily* eulogized the MGM chief as leaving "a heritage of reputation, of honesty, of kindliness, and of charity." *Photoplay* thought that Loew's honesty often seemed "like a beacon in a dark

world." The humorist Will Rogers quipped that that Loew "would have been a credit even to a respectable business."

Will Hays was deeply moved by Loew's death. "A man is great or small," he said, "as he rises above or sinks below his generation. Marcus Loew had characteristics of real greatness."

Zukor read all the accolades for his old friend. Many of them singled Loew out as exceptional in a world of cutthroats and sharks. Several thousand of Loew's employees signed an enormous card expressing their belief that they had "worked *with* him, not for him."

Zukor knew his employees would never say the same.

At Loew's house, trying to console the dead man's family, Zukor was useless. "I can't find words to express my feelings," he said helplessly. Of course that was something he'd never been good at, whether he was asking forgiveness from Lottie or answering letters from a distraught Roscoe Arbuckle. Zukor's strategy had always been emotional avoidance at all costs.

But there he stood, at Loew's funeral on September 9, one of a couple dozen pallbearers, listening to Rabbi Aaron Eiseman speak about the man they'd come to bury. "A man of humanity, modesty and meekness," the rabbi called Loew. "With all his power, wealth, success, and aggrandizement, he remained the simple, unostentatious, humble and democratic character." Zukor might have nitpicked about *unostentatious*, remembering Loew's bold ties and fancy cloaks, but the rabbi wasn't talking about clothes. He was referring to Loew's generosity of spirit, his concern for others, his lack of self-importance. "He never forgot the days of poverty and want," Eiseman continued. "He never withheld the helping hand to others."

Adolph Zukor had spent the past two decades competing with Marcus Loew. But Loew had never been competing with him, at least not in the same way. Marcus was just "the other fellow doing his business." He'd made it to the pinnacle. He'd achieved all the same wealth and power that Zukor had. And when it was all over, he was hailed by hundreds of people who had loved him.

That was one accomplishment Zukor could never match.

# "WE ARE MAKING REAL PROGRESS"

Eddie King could not have been happier. Not only had District Attorney Keyes promoted him to lieutenant, but in the fall of 1925 he'd finally agreed to formally reopen the Taylor investigation. The evidence King had compiled against Charlotte Shelby was compelling enough, Keyes said, to warrant another look.

Hopping on his motorcycle, an exuberant King zipped around town, pressing each witness to remember as much as he or she could about the events of three and four years earlier. Over the next several months, statements were taken from, among others, Charles Eyton, Shelby's former secretary Charlotte Whitney, and Taylor's accountant, Marjorie Berger. Once again, King was struck by the specificity of Shelby's threats against Taylor.

But it was Berger who provided the clew that excited investigators the most.

Sitting in her cluttered office, the prim accountant bristled when told that Shelby had claimed to have learned of Taylor's death through her. "My God, the next thing they will say I murdered him," Berger complained. "*I* was the first to give [the news] to her? Absolutely not." In fact, Berger insisted, it was Shelby who told *her* about the murder, during a telephone conversation around seven thirty on the morning of the murder.

*Seven thirty.* King and the other detectives looked at each other. If that was true, Shelby had known about Taylor's death even before Henry Peavey discovered the body!

King couldn't resist letting his pals in the press know that a new investigation was under way. And so in March 1926 the murder of William Desmond Taylor was back in the headlines: TAYLOR MYSTERY NOT A MYSTERY IN HOLLYWOOD. The gist of most of the stories was plain: the killer was known to police, and she was a woman. "We are making real progress," Keyes told reporters. An arrest was expected at any time.

The DA insisted that they finally get an official statement from Shelby. She could no longer find ways of wiggling out of it. Drawing herself up indignantly, Shelby complied with Keyes's order. She answered every question the detectives asked her, although her account of events differed radically from what everyone else was saying.

"Mr. Taylor was the most perfectly poised man, such a proper man," Shelby said, extolling the dead man's virtues. When a detective asked her about Mary's relationship with the director, Shelby denied ever noticing "any awakening of a friendship or love" between them. In fact, when the two were out together, she always felt that Mary was "under a good influence." Confronted with the report that she'd brought a gun to Taylor's house, Shelby called it absurd. She had never had any quarrel with the man. They were the best of friends!

How smoothly she lied.

Only when detectives asked about her gun's whereabouts was Shelby forced to admit the truth. Her mother had thrown it away—though she didn't say where or how.

Certainly Mrs. Shelby seemed to be hiding something. Rumors quickly spread that a "prominent Los Angeles society woman" was close to being indicted.

In the midst of all this, Keyes's briefcase was stolen, and reporters learned about the blond hairs that had been found on Taylor's coat, a fact that had never been revealed to the public. Those hairs—coupled with stories of that pink nightgown, which had disappeared during Woolwine's tenure—seemed to cinch it for many people. The solution to the mystery was plain: Charlotte Shelby had killed Taylor after discovering that Mary was having an affair with him. Her motives ranged from fear of losing her meal ticket to jealousy because of her own love for the director. Murder aficionados, a considerable audience by 1926, could take their pick.

Of course, Mary had to be interviewed again as well. When detectives found her, they encountered a very different young woman from the one they had interviewed four years earlier.

Still fighting her mother for the fortune she felt was rightfully hers, Mary was now twenty-four, living in New York by herself. She had fed her loneliness and resentment with food. The tiny blond southern sexpot had plumped like a boudin sausage on a Cajun grill, the inevitable consequence of sitting around all day with nothing to do, popping chocolates and pastries into her mouth. All her bodices had to be let out. Her puffy fingers refused to surrender her rings. A second chin had dropped below the first.

Mary had entertained a series of beaux, all of them older than she was, as she'd moved from place to place. None of her beaux lasted. Sometimes she returned to Los Angeles, as she did when her grandmother died, but she was no longer seeking any work on the screen. Having failed in her bid to retake the New York stage, Mary contented herself with giving parties and launching into flowery accounts of her love affair with Mr. Taylor at every opportunity. "I know that he loved me," she told the detectives who interviewed her in the spring of 1926. Mr. Taylor wanted to marry her, Mary said, if only her monstrous mother hadn't gotten in the way.

The detectives asked if Shelby would have killed Taylor to keep him away from her. Mary thought about the question. "She may have said, 'I'll kill him! I'll kill him!'" she replied. "Mrs. Shelby was like that, always going to kill somebody."

King and the other detectives believed that was just what Mrs. Shelby had done.

Yet no arrest was made. The problem, as Keyes knew, was that for all the circumstantial evidence against Shelby, they could never bring an indictment without explaining the one major, looming inconsistency in their case against her. Charlotte Shelby simply did not match in any way the description given by any of the eyewitnesses. And without the gun, the detectives had no physical evidence linking her to the crime.

King stewed, furious that Shelby had slipped from his grasp once again.

Indeed, when an indictment came down in the fall of 1928, it wasn't against Shelby, but against Keyes himself, who was charged with "willful and corrupt" misconduct in the office of district attorney. The following February, Keyes was found guilty of accepting bribes and sentenced to jail. The files of the Taylor case were once again locked away in the vault.

Frustrated, Eddie King wrote a piece called "I Know Who Killed William Desmond Taylor" for a magazine called *True Detective Mysteries*. In the piece, published in late 1930, he all but named Charlotte Shelby as the murderer.

Fate went on conspiring against the nefarious lady.

Seven years later, when almost everyone had forgotten about the case, King got another chance to make an arrest. Like Mary, Shelby's older daughter Margaret had also turned against her mother. Fighting Shelby for money, Margaret was now singing a very different song than the one she'd crooned to detectives in the past. In earlier interviews, Margaret had always insisted her mother had nothing to do with the murder. But now she told investigators she had lied. She had reason to believe her mother killed Taylor.

Although offering no hard evidence, Margaret did reveal how afraid Shelby had been of Asa Keyes after Thomas Woolwine resigned. Margaret also declared that in the hours before Taylor's murder, Shelby had locked Mary in her room, which disputed Mary's own account of reading downstairs with the family. Margaret said Mary had snuck out later that night, and hadn't returned home until eight thirty. King was galvanized by this latest information. Margaret's story fit precisely the scenario he had long imagined—that Mary had gone to Taylor's on the night of the murder, and Shelby had found her there. Margaret also revealed that her grandmother had tossed Shelby's gun into a Louisiana bayou. The accusations were enough to reopen the case once more.

The new DA, Buron Fitts, took a series of statements. Interviewed again, secretary Charlotte Whitney corroborated Margaret's contention that Mary had been locked in her room, adding that Mary had told her

that she'd been about to elope with Taylor when her mother discovered the plan and put her under lock and key.

Even more damning evidence was forthcoming. Chauncey Eaton, Shelby's chauffeur, revealed that although his employer's gun might be corroding at the bottom of a swamp, the bullets might still exist. Soon after Taylor's death, Shelby had asked Eaton to remove the ammunition from the gun, afraid that in her grief Mary might attempt suicide, this time for real. So Eaton had placed the shells on a beam in the basement of Casa Margarita. As far as he knew, they were still there.

Instantly three cars filled with detectives were squealing through the streets toward Shelby's former home. Fifteen years was a long time for anything to sit undisturbed, but District Attorney Fitts sent his men out to the house regardless. The current owners let them in, and miraculously, when a detective ran his fingers along the beam, the cartridges were there.

And they were of the same old-style ammunition that had killed Taylor!

Charlotte Shelby, King figured, was finally done for.

In the spring of 1937 a grand jury was convened to reopen the investigation. The jurors heard testimony from Mary, Margaret, and their mother. Mary came waddling in, now close to two hundred pounds, her once pretty face bloated and creased. Although she had no love for her mother, Mary told the grand jury that any accusation against Shelby in this case was completely absurd. Her sister Margaret was a raging alcoholic, Mary explained, embroiled in civil litigation against her mother, and willing to say anything to make Shelby look bad in the eyes of the law. She had not been locked in her room, Mary insisted, on the night of Taylor's murder. The story she told at the time was the true one. As for Charlotte Whitney, she was a disgruntled former employee, repeating hearsay and gossip from fifteen years ago.

The last witness was Mrs. Shelby herself. At last the tenacious lady, her copper hair now shot through with gray, brought with her an alibi for the night of Taylor's murder. The actor Carl Stockdale swore that he had been with Shelby at her home on the night of February 1 between 7:00 and 9:00 P.M. With icy disdain, Shelby answered every one of the panel's questions, repeatedly asserting her innocence. Afterward, the jury disbanded. They handed down no indictments, but neither did they offer any exonerations.

Shelby had had enough. "I demand a complete exoneration in this case or an indictment for the murder of William Desmond Taylor," she declared. She'd welcome such a move, Shelby said, as it would finally give her an opportunity to end the ceaseless speculation about her. "I did not kill William Desmond Taylor," she told the press. "I do not know the person who did kill him. I do not know any person who would have the slightest reason or motive to kill him." Her eyes were hard as she faced the reporters. "One of the worst tortures for any person, particularly a woman, is to go through life with a cloud of malicious innuendo constantly hovering over her like a spectre. Why must William Desmond Taylor's murder follow me through the years? I want to live the rest of my life in happiness and peace, if I may be permitted to do so."

Her words seemed to have the desired effect. Despite Eddie King's objections, on September 29, 1938, District Attorney Fitts closed the case on the murder of William Desmond Taylor. It would never be opened again.

When Mabel Normand had died of tuberculosis on February 23, 1930, far too young at thirty-seven, she'd reportedly looked up at her companion, Julia Brew, and said, "I do hate to go without knowing what happened to poor Billy Taylor."

# EPILOGUE

# A CONFESSION

The late-afternoon sun suffused the hills, turning picture windows pink and brightening the crumbling HOLLYWOOD sign. Still standing after forty-one years, the sign's lightbulbs were long gone, as was as its final syllable, LAND. The third o had fallen down. The city below reflected the same deterioration. A permanent umbrella of brown smog hung over massive intersecting freeways that had obliterated entire neighborhoods. Most of the orange groves were long gone. Genteel Alvarado Court now moldered in disrepair. In a few years it would be torn down to make way for a shopping plaza.

On Hollywood Boulevard, the locusts now ruled. Movie premieres had been replaced with drug deals. And across the backlots of the once-thrumming movie studios, a terrible silence prevailed. The system Adolph Zukor and Marcus Loew had worked so diligently to create was in its final days.

Up in the Hollywood Hills, another death was about to take place.

At a little past four in the afternoon, Ray Long, thirty-one, arrived at his parents' house on Glen Oak Street. But before he could reach the front door, his attention was drawn to some commotion down the road, at a little house covered with ivy and bougainvillea. Neighbors were rushing toward the place, so Ray wandered that way as well.

He knew the house. The reclusive old lady who lived there, a Mrs. Lewis, had been his parents' neighbor for the past fifteen years. Ray knew very little about Mrs. Lewis, except that she was a widow living off a pension from her late husband, who'd worked for an oil company. Rarely did Mrs. Lewis venture off her property. She had no car. Her groceries were delivered to her. Sometimes Ray had seen her poking her head out of the door to pay the delivery boy. No one else ever came to visit Mrs. Lewis. Her only companion was her cat, Rajah.

Ray's mother, Mary, had taken Mrs. Lewis under her wing, the same

way she cared for the neighborhood stray cats and dogs. Occasionally Mrs. Lewis would come to their house to watch television. The old woman didn't have much to say to the Long children, but she always seemed pleasant and levelheaded.

Ray walked up the steps to Mrs. Lewis's back door.

He was taken aback by what he found inside. The tiny old woman was writhing on the kitchen floor, "obviously in a great deal of pain." She was talking rapidly, muttering words Ray didn't understand. His mother was there as well, and she explained that Mrs. Lewis had suffered a heart attack. An ambulance was on its way.

Ray knelt beside the old woman. Her eyes were frantic, her hands clawing the air.

"A priest!" she rasped. "I need a priest!"

Ray knew that Mrs. Lewis was a Catholic convert. She told him she needed to "confess her sins."

Sins? What possible sins could this demure old lady have committed?

"I killed William Desmond Taylor," Mrs. Lewis said, in a clear, terrified voice, her eyes latching onto Ray's.

The name meant nothing to the young man. Forty-two years later, the murder that had gripped the world's imagination was unknown to a younger generation.

Ray tried to comfort Mrs. Lewis, but she was inconsolable.

"A priest," she begged him. "I killed William Desmond Taylor!"

Finally the ambulance arrived, and Mrs. Lewis was lifted onto a stretcher and carried down the back stairs. She was brought to the Sunset Boulevard Hospital, where she died at 5:20 in the afternoon.

When Ray asked his mother what Mrs. Lewis had been ranting about, she claimed she didn't know and refused to discuss it further. It was best, she said, to just forget that sad day.

But Ray didn't forget.

Mrs. Lewis had named Mrs. Long as her executor. The old woman had left $500 to her veterinarian to take care of Rajah, as well as a few other small bequests. But when her estate was probated, it was discovered there was no cash left. So Mrs. Long and her husband generously

borrowed the money to honor their neighbor's last wishes. In exchange, they received Mrs. Lewis's little home and its contents.

As he went through the late woman's belongings, Ray found little of value. "She obviously lived at, or below, the poverty line," he came to realize. The house was no more than a thousand square feet, filled with cheap furniture. However, a small trunk in the corner caught Ray's eye. He pried open the lid.

Inside, he discovered several old letters, most written by Mrs. Lewis's deceased husband, bearing postmarks from Singapore and Ceylon. Underneath the letters, however, were far more interesting items: a stash of black-and-white glossy stills from a series of old movies. Silent movies, from the looks of them. There were also headshots of a beautiful woman.

Across one was written the name "Patricia Palmer."

Ray showed the photos to his mother. Who, he demanded to know, was their neighbor?

Mrs. Long looked at the photographs. She explained that Mrs. Lewis had been an actress in the movies. She didn't know a lot about her career. But she had worked under the name Patricia Palmer.

But what had her dying words meant? Ray had not forgotten them, and he suspected his mother knew more than she had previously admitted. What had Mrs. Lewis meant by saying that she'd killed William Desmond Taylor, whoever he was?

Mrs. Long explained that Taylor had been a movie director, and that his murder had been quite the sensation in 1922. The case remained unsolved. And, Mrs. Long admitted, on the very night before she died, their neighbor had made a similar claim.

Pat Lewis had come to the Longs' house to watch *Ralph Story's Los Angeles*, a program on KNXT, Channel 2. With a dry wit, Story hosted reports about the city's history, the more offbeat and unusual the better. And this night he was revisiting the murder of William Desmond Taylor.

At the mention of the dead man's name, Mrs. Lewis had become unhinged.

"I was the one who killed him!" she told Mrs. Long. "I killed Taylor! I thought it was all forgotten!" She rushed around the house, crying.

Mrs. Long hadn't known what to make of their neighbor's hysterics. Her husband, Edward Long, had been a detective with the Los Angeles Police Department until he retired; he'd joined the force in November 1924, two and a half years after Taylor's death and a year after Patricia Palmer's arrest for extortion. He knew the media circus that had followed the case in the 1920s, and knew they might see something like that again if new information was reported. Not wanting to draw attention to themselves or to their neighbor, and not knowing whether her statements had any veracity, the Longs decided the best thing was to say nothing about Mrs. Lewis's wild claim even when she repeated it the next day with her last, dying breaths.

But their son couldn't forget what he had heard.

In the years that followed, Ray Long dug up facts on the case. More than a decade passed before he learned very much. By then a small cottage industry had grown up around the Taylor murder. Fans of classic film as well as amateur detectives wrote articles in film journals, trying to sift through all the clews. Reading as much as he could find, Ray discovered that while Taylor's murder remained officially unsolved, a general consensus had developed that he'd been shot by Charlotte Shelby, the mother of Mary Miles Minter, another former silent screen star, but that Shelby had gotten away with the crime.

This was certainly the conclusion drawn by the director King Vidor, who had known Taylor and many of the principals in the case, and who spent some time in the late 1960s and early 1970s researching the case for a possible movie. Eventually Vidor's research was novelized in *A Cast of Killers*, a best-selling book by Sidney D. Kirkpatrick that was published in 1986. In 1990 Robert Giroux countered Kirkpatrick's conclusions in *A Deed of Death*, arguing that Taylor's killer was actually the hired assassin of a drug gang, angry at him for disrupting their lucrative trade. Fourteen years later Charles Higham's *Murder in Hollywood* postulated that it wasn't Shelby but Mary herself who had pulled the trigger in a fatal embrace.

No one ever mentioned Pat Lewis—or Patricia Palmer—or Margaret "Gibby" Gibson, which, as Ray Long soon discovered, was his neighbor's real name.

Finally Ray took his story to the one person who might make sense of it. In 1985 Bruce Long (no relation), a longtime aficionado of the Taylor mystery, had started publishing *Taylorology*, an intermittent fanzine dedicated to the case. In 1993 the fanzine went online, and would eventually run some one hundred issues. Under one banner the website gathered virtually every article ever written about the murder, as well as offering expert analysis and the kind of common-sense detective work even many of the original gumshoes had missed. If anyone could determine if and how Margaret Gibson had been involved in the murder of William Desmond Taylor, it was Bruce Long.

Within just a few months of publishing Ray Long's account, Bruce Long and his shrewd band of Taylorologists had uncovered accounts of Gibby's various arrests. Speculation ensued.

That was where I came in, snared by the mystery and hoping to rectify the errors I'd made when I briefly referenced the case in my book *Behind the Screen: How Gays and Lesbians Shaped Hollywood*. I started researching in old court records, as well as in the archives of the FBI.

At long last, the suggestion made by FBI agent Leon Bone—that Los Angeles detectives consider the possibility that Don Osborn's gang was involved in Taylor's death—was being followed up. When Bone first made the recommendation, it was brushed aside. Nearly eighty years later, I thought it might prove the answer to Hollywood's most notorious unsolved murder.

Eddie King had first suspected that Charlotte Shelby was the killer for one reason: because district attorney Thomas Woolwine refused to investigate her. Detective Lieutenant King thought the DA was covering up a friend's guilt. In fact, it appears that Woolwine did want to protect Shelby, but not for the reasons King assumed. Woolwine recognized the vultures circling above Mary and Shelby. The newspapers, especially the Hearst publications, desperately wanted a woman to be the culprit, certain that would make for higher sales. So Woolwine did his best to protect his friends—not because Shelby was guilty, but because it was obvious that neither she nor Mary had anything to do with the crime.

Woolwine saw the evidence against Shelby for what it was: purely circumstantial. But the sheer abundance of it was enough to blindside King and dozens of seasoned detectives. The motive seemed to be there; Shelby had threatened to kill Taylor in the past; she had no strong alibi for her whereabouts on the night of the murder; and the weapon appeared to match. Finally, the blond hairs on Taylor's lapel provided Shelby with a reason for her final desperate act.

Certainly Shelby was aware of all this circumstantial evidence, and that was why she tried, sometimes awkwardly, to keep detectives at arm's length. "She was frightened by the Taylor murder case," her daughter Margaret told investigators in 1937. "She told me they were pinning it pretty close to her. She was awfully worried."

She had reason to be. Shelby knew she made a very popular suspect in Tinseltown, where nearly everyone hated her. She also knew the newspapers were clamoring for a woman to splash across their front pages. No wonder she sent her mother to Louisiana to toss the gun into the swamp. No wonder she tried to lie low and stonewall the detectives. No wonder she got ill whenever Mary started talking and drawing attention to herself.

Charlotte Shelby was tried and convicted in the court of public opinion. By 1925, the prevailing wisdom was that she had killed Taylor while disguised as a man. "The image was too cinematic to resist and Hollywood embraced it," wrote Betty Harper Fussell, biographer of Mabel Normand, some decades later. Yet for all its dramatic potential, the suggestion was completely illogical. People who insisted Shelby was the killer seemed to willfully disregard Faith MacLean's eyewitness testimony of seeing the killer leave Taylor's house. "To conform to Mrs. MacLean's description," Fussell went on, "Mother Shelby would have had to strap on elevator shoes six to eight inches high and strap sixty to seventy pounds of padding to her body." But what was logic when "pitted against the power of a double-barreled image—the seduced virgin and the vengeful virago?"

It would have made one heck of a King Vidor movie, though.

Other facts debunk the theory as well. Margaret was a hopeless alcoholic when she made the claims against her mother, who she was suing for money and trying to discredit. Not long after her testimony, Margaret was institutionalized. Meanwhile, Mary herself, whose love

for Taylor endured, never believed her mother was guilty, even when she was angriest at her. If she'd believed her mother had killed her great love, wouldn't she have lashed out at her? Plus Shelby actually welcomed and encouraged the 1937 grand jury inquiry, hardly the typical reaction of a guilty person. Allegations that she knew of Taylor's death before it was public knowledge are convincingly countered by contemporary newspaper accounts, which record that Mary and her mother did not learn of the murder until much later in the morning.

As for the hairs on Taylor's jacket? If the expert was correct, and they did indeed come from Mary's head, that much is easily explained by her midnight visit to Taylor in December—the same in which she gave him her handkerchief, which the press made so much of—when by her own testimony she rested her head against his chest. Henry Peavey claimed he cleaned and brushed Taylor's jackets frequently, which is why many theorized that Mary must have been back to visit Taylor shortly before his death; surely by the time of Taylor's death, a month later, Peavey's brush would have cleared away any hair Mary had left behind in December. But is it really so difficult to believe that Peavey may simply have missed two hairs on a piece of gabardine?

Finally, Charlotte Shelby's own character exonerates her. Certainly she was cruel and hotheaded. Without a doubt, she had threatened Taylor. But as passionate as she was, she was also shrewd. One didn't achieve the kind of success she had secured for herself and her daughter by being rash. Shelby knew how to play the game. Would she have risked everything by dressing as a man and confronting Taylor with a gun? Wouldn't she have gone to Jesse Lasky or Charles Eyton and asked them to handle it? Sneaking into Taylor's apartment while he was outside bidding Mabel good night, and then drawing a gun on him when he returned, would have been an extremely reckless move on Shelby's part. And if there was one thing Charlotte Shelby was not, it was reckless.

As for that pink nightgown, it was the press that declared it was a woman's garment. No one seemed to consider that Taylor, with his appreciation for fine clothes, might choose to sleep in a silk nightshirt himself.

The only truly compelling bit of evidence against Charlotte Shelby wasn't, as Eddie King insisted, motivation, but rather ammunition. The bullets of

Shelby's gun matched the type that killed Taylor. Experts speculated there might not be "one pistol in thousands" anywhere in the city that used the same "ancient brand of ammunition" that had lodged itself in Taylor's neck.

In fact, there may have been one other pistol with such old bullets—as the introduction of Margaret Gibson as a suspect in the case would reveal.

Only one other person was ever considered seriously as a suspect, and that was Edward Sands. Yet while some detectives clung for many years, even decades, to their belief that Sands committed the crime, others dismissed the theory quickly. As Eddie King argued, it made little sense for Sands to return to Los Angeles and risk arrest. Even if it could be argued—as it was—that Sands had come back to get some money from Taylor, then shot him in the heat of an argument, the fact remained that Faith Mac-Lean would have recognized him. And she was certain the man she saw wasn't Sands. King said that "in his gut" he never believed it was Sands.

To his credit, King was also troubled by the fact that Charlotte Shelby didn't match MacLean's description. He was a good enough detective not to simply disregard evidence when it didn't fit his preferred theory. That was why he had a photograph of Carl Stockdale shown to MacLean. The evidence of the gun and the matching bullets had convinced King of Shelby's culpability, but it remained possible that she had sent someone else to do the dirty work. Could she have used Stockdale, who belatedly came forward as her alibi for the night of the crime?

MacLean studied the photograph of Stockdale. After some contemplation, she said Stockdale did look like the man she had seen so briefly that night. King was encouraged.

But of course, not only was Stockdale Shelby's alibi, but she was his.

It's well to remember Thomas Woolwine's opinion of the case: Whoever killed Taylor probably did so without any emotional connection to him. Woolwine agreed with Detective King that the murder was likely an impulsive act. But he never saw it as a crime of passion.

A chance burglar, perhaps. Or someone who was operating completely under the radar of the police.

King believed that if detectives had been able to get back all of Tay-

lor's papers from the Famous Players studio after Charles Eyton had absconded with them, they might have found evidence of another suspect.

Gibby's dying confession, as it turned out, was the next best thing to Adolph Zukor handing over Taylor's papers to the police.

At the end, as she breathed her last on the floor of her little house, Gibby's guilty conscience pleaded for some kind of absolution after more than four tortured decades. In her loneliness and her poverty, her Catholic faith had come to sustain her; she would leave money to Blessed Sacrament Church on Sunset Boulevard for a requiem Mass to be said for her soul. So in those last few minutes of her life, what she feared was eternal damnation for having killed William Desmond Taylor.

But, as with Shelby, the notion that Gibby herself pulled the trigger stretches the imagination. At five feet one, Gibby was even shorter than Shelby; her size would have been apparent to Faith MacLean, whether the killer was dressed as a man or not.

A tortured conscience, however, could come from other things.

Gibby might not have killed Taylor with her own hand. But if she was the one who set into motion the events that led to Taylor's death, she might have held herself just as responsible.

And this seems to be what happened.

Don Osborn was looking for new blackmail targets.

Gibby suggested William Desmond Taylor.

And when Osborn started blackmailing Taylor, it ended in murder.

Gibby knew Billy Taylor. She may have known any number of his secrets, from the reason for his termination at Vitagraph to his relationship with George Hopkins. She may also have known about his compromising situation with Mary, or Mabel's drug problems, or the fact that Taylor had abandoned his wife and child.

What we know for certain is that sometime in 1921, Gibby started collaborating with Don Osborn in various blackmail plots. During that same period, Taylor's last few months alive, evidence suggests that he was being blackmailed. Gibby could have provided Osborn with information to use in blackmailing Taylor.

But Don Osborn didn't kill Taylor. Just as Faith MacLean would

have noticed if the person leaving the director's bungalow was unusually short, she would also have noticed if the person had been very tall. Osborn was six feet three.

We do know, however, that a noticeably tall man *was* spotted at Taylor's bungalow on the Monday before the murder. Taylor's neighbor Neil Harrington saw two men come to Taylor's front door; when no one answered, the men tried to peer through the director's windows. Harrington said that one of the men was "much smaller than the other." A medium-height person standing beside someone who was six three would indeed look "much smaller." And Osborn's partner in blackmail, Blackie Madsen, stood about five-seven or five-eight.

It seems likely that it was Osborn and Madsen who Harrington saw at Taylor's apartment, come to pressure him into coughing up some hush money—much as they would approach John Bushnell ten months later.

The two blackmailers returned to Alvarado Court on the night of February 1.

As always, Madsen had his gun. The old .38-caliber he'd carried since the Spanish-American War. And if he'd kept the gun that long, possibly he had old ammunition for it.

Madsen would have had no trouble finding Alvarado Court; his mother lived right around the block from Taylor, on West Sixth Street. But Osborn, stepping off the streetcar, seems not to have remembered the exact address; Floyd Hartley, the gas station owner, told the police he gave directions to a man he described as in his twenties and dark. Learning the address, Osborn headed toward Taylor's to meet Madsen.

A short while later, en route from his mother's house, Madsen was spotted by Mrs. Marie Stone, who was on her way to babysit for her granddaughter. Mrs. Stone would notice Blackie's ruddy skin, which is specifically described in the FBI reports, as well as his thick earlobes, evident in FBI photos. For a moment, Mrs. Stone had thought he might have been Edward Sands. Why? Because both Sands and Madsen were bowlegged.

Hiding in the shadows, Osborn and Madsen realized they couldn't approach Taylor right away. His valet was still home, and Mabel Normand had come to visit. The two blackmailers waited separately; Christina Jewett, the MacLeans' maid, would hear only one man loitering in the alley. And of course Faith MacLean saw only one man come out of Taylor's house.

Madsen recognized his opportunity when Taylor walked Mabel to her car. He slipped into the bungalow alone. Either he and Osborn had planned it that way, or there simply wasn't enough time to summon Osborn. Perhaps they'd agreed that Madsen should play the role of some kind of backup agent, as he would do some months later with Bushnell.

Whatever happened next was brief. When Taylor reentered the apartment, Madsen was waiting for him. Perhaps he'd hidden in the telephone nook under the stairs, surprising Taylor when he came through the door. Perhaps, seeing Madsen emerge from under the stairs, Taylor reacted instinctively—aggressively—making the same sort of impulsive move Writ Berkey had made two decades earlier. And just as he had done on the streets of Independence, Missouri, Madsen had responded just as instinctively by pulling out his gun.

And what had Taylor done to cause such a reaction? A careful consideration of the crime scene provides the answer.

Coming in through the front door and spotting Madsen, the angry director had reached for whatever was closest to him: the chair that he kept against the wall. He grabbed the chair and lifted it into the air, intending to strike Madsen with it. His arms were raised over his head.

Madsen, his gun drawn, fired impulsively, just as he had done in Independence.

Taylor fell, the chair with him.

As Eddie King would prove, the powder burns on Taylor's clothing indicated he'd been shot up close, no more than two inches away from his killer. So when Taylor fell, bringing the chair with him, he fell on top of Madsen.

The only way for Madsen to regain his feet was to shove Taylor and the chair off him. In the process, he stood the chair athwart Taylor's left foot. As the director's face turned blue and he struggled to take his last breaths, Madsen turned him flat on his back so that he could pat him down for valuables. That would account for the neat condition in which the corpse would be found, instead of the crumpled appearance expected in someone felled by a gunshot.

Madsen took the roll of money but left everything else, since he knew the shot must have been heard by neighbors. He had to get out fast. Someone would likely be there soon. He didn't have time to pry rings off fingers.

Still, Madsen was a cool enough operator to know he couldn't just run out of the house. He left Taylor's apartment casually, closing the door carefully behind him. He even looked over at Faith MacLean, who'd come to her door, and gave her a smile.

Madsen fit perfectly the description MacLean would give of the man leaving Taylor's apartment. He was the right height. He had a prominent nose. He was "not fat but stocky." He definitely had a "rough" sort of appearance. As his FBI mug shots would prove, he looked so much like "a motion-picture burglar" that he might have been sent over by Central Casting. When MacLean was shown the photograph of Carl Stockdale, she said it looked like the man she had seen. With their craggy faces and prominent noses, Stockdale and Madsen definitely resembled each other.

According to FBI reports, Madsen sometimes wore a mustache, sometimes not. When John Bushnell encountered him ten months after Taylor was killed, Madsen was sporting a gray mustache. Of course he was. He'd grown it to help disguise himself, as Faith MacLean's account in all the newspapers had described a clean-shaven man.

The fact that Madsen hung around after Osborn was arrested, instead of escaping to Mexico when he had the chance, suggests that Osborn had something on him. Osborn could well have turned state's evidence and ratted out Madsen as Taylor's killer if Madsen had left him to take the rap by himself. Only when Madsen's plot to get him sprung failed did Osborn accept his three-year sentence; it was a lot better than hanging.

Murder bound Osborn and Madsen together. When Osborn told Bushnell that he would kill him if he didn't come up with the money, it was no idle threat. He and Madsen had killed before. Rose Putnam said that Osborn was feeling "very confident" that fall when he and Madsen set out to blackmail Bushnell. And why wouldn't he feel confident?

He'd gotten away with murder.

But what of Gibby? She was the spark to light the match, but what about after the deed was done? Was she involved after the fact? Did she know for certain that Osborn and Madsen were responsible for Taylor's death?

Did she, upon learning that Taylor was dead, take off in her car,

overcome with the same sense of guilt she would display at the end of her life? Did she drive frantically up the coastal highway to Ventura? The driver of that car was never identified by police.

No doubt Madsen and Osborn did their best to keep the secret to themselves, but the locusts must have suspected something. Word traveled quickly in underground circles, and soon even Honore Connette, likely through James Bryson, had heard the rumors. It was easy to dismiss Connette as a crank, but when I discovered his connection to Bryson, his wagging tongue in the weeks after the murder suddenly seemed more relevant, and further convinced me of the role played by the Osborn gang.

Yet even if Osborn never admitted the killing directly to Gibby, she was smart enough to figure things out. And that knowledge would have given her extraordinary power with Taylor's studio, Famous Players–Lasky, in those desperate months of early 1922.

The only way to understand the repeated favors Jesse Lasky did for Gibby is either some kind of blackmail on her part or a deal worked out between her and the studio. Something in Taylor's papers, kept in the Famous Players safe and no doubt eventually destroyed, must have implicated Gibby. Here's my speculation: Called into the studio after her name was discovered in Taylor's papers, Gibby revealed what she knew. With the ongoing Arbuckle scandal, the last thing Lasky and Zukor wanted was publicity linking an ex-prostitute to the blackmailers of their esteemed director. It really would have made things a hundred times worse: the arrests of Gibby and Osborn would have exposed the seamy underbelly of Tinseltown and confirmed the worst fears of the reformers and church ladies. So Gibby was given a contract to ensure her silence.

Lasky and Zukor already had the blueprint for such an arrangement. Four years before the murder, DeMille had directed a hugely successful Famous Players film called *Old Wives for New*, in which a murder was covered up by powerful corporate executives. The woman who actually committed the crime was protected by these influential men, who concocted and encouraged rumors to throw suspicion on others. For the executives, allowing a killer to escape justice was preferable to the "Hydra head of scandal," as one title card put it.

Hollywood knew how to manipulate a crime. Their scenarists had been doing it for years.

So Gibby was given a job. As was Leonard Clapham, one of the other gang members who'd been particularly close to Osborn and apparently knew a great deal. Their proximity to Taylor's murder and their willingness to keep mum significantly advanced their careers, lifting them out of low-budget independent films and securing them positions at Famous Players.

Gibby, however, was reckless. When she herself was finally implicated during the final attempted shakedown of John Bushnell, she turned once again to Lasky for help. Lasky had the power and the money to hire Frank Dominguez to represent her. Without Lasky's intercession, Gibby might have turned state's evidence to avoid prosecution and revealed what she knew about Taylor's murder. And if she had done so, the scandal that would have enveloped Hollywood at that particular moment would have been Hydra-headed indeed.

So Will Hays was summoned and, through his political influence, the charges against Gibby were dropped.

Gibby had called in her last chip with the studio, however. For the next decade, she would struggle, making appearances in a few pictures when casting agents took pity on her. But even in her late thirties she still had charm for men, and Elbert E. Lewis, a short, slender, divorced accountant for Standard-Vacuum Oil, fell head over heels in love with her. For a brief moment, Gibby finally got the nice things she'd always wanted, courtesy of Lewis. She called him "Daddy," even though he was three years her junior.

When Standard-Vacuum transferred Lewis to Asia, Gibby found it prudent to follow him. There were rumblings that district attorney Buron Fitts was planning to reopen the Taylor case, which he did a little over a year later, when he convened the grand jury. Gibby seemed ready to live out her life in Asia, marrying Elbert Lewis at the American consulate in Singapore in 1935. But two years later, in Shanghai, she developed a bladder infection. Adequate medical treatment wasn't available in the war-torn city, so, five months before the Japanese invaded, Gibby—now known as Pat Lewis—sailed back to the United States. Elbert followed, but he returned to Asia not long thereafter. In April 1942, while staying at the Taj Mahal in Bombay, Gibby's steadfast husband died of a heart attack in his sleep.

There was another husband named Arce after that, but he was soon

gone, and Gibby bought her little house at 6135 Glen Oak, not far from the place on Beachwood where she and Osborn had partied and cooked up their schemes. But her life now was very different.

For all her great dreams, for all her plans and intrigues, this was where Margaret Gibson ended up, in a little frame house with a few sticks of furniture. She lived near the poverty line, hiding out from the world with her cat, venturing only rarely outside. Alone and paranoid, the once ambitious movie actress was terrified every time someone knocked on her door. Year by year, her conscience ate away at her. Nice things no longer seemed all that important.

In the end, Gibby would have settled for peace of mind.

# WHAT HAPPENED TO EVERYONE ELSE

Don Osborn served out his sentence and returned to California, where one of the locusts, Leo Maloney, had started his own studio in the San Bernardino Mountains. Maloney hired Osborn as a production manager for a couple of low-budget pictures in 1927—including a film called *Yellow Contraband* about a heroin smuggler named Blackie. Leonard Clapham, now known as Tom London, was featured in both of Osborn's films. So much for Clapham and Maloney telling the FBI they never wanted to see Osborn again. In 1930 Osborn was working as a labor union organizer, and in the 1940s, as a traveling salesman. He died in 1950, at fifty-four, of throat cancer.

Rose Putnam moved back in with her parents, who had relocated to Long Beach, California. In her mid-forties she married Sylvester Wilcox, a solicitor for a freight company, and they resided in Glendale. Rose died in 1961, in Riverside, at the age of seventy-two.

Blackie Madsen got out of the clink and reclaimed his real name, Ross Sheridan. He roamed around the Northwest for a while, living in Oregon and marrying a woman in Vancouver, Washington, in 1928. Heading back to El Paso, he worked as a cattleman and made frequent trips over the Mexican border. He continued to woo the ladies, marrying twenty-one-year-old Maria Saucedo in Juarez in 1935, when he was sixty-two. At some point, Sheridan was stabbed or maybe shot. The attack didn't kill him—at least not right away. One lung was perforated and never fully healed, leaving his breathing impaired. Eventually the condition sent him staggering and wheezing back to Los Angeles, where he died at Los Angeles County General Hospital in 1938, at the age of sixty-four. Blackie's ashes were interred beside his mother and his brother in Hollywood Memorial Cemetery.

Just a short distance away from the grave of the man he killed, William Desmond Taylor.

George Hopkins, Taylor's lover, went on to a remarkable career as one of Hollywood's most celebrated set decorators. Some of the great American movies were styled by Hopkins: *Casablanca*, *Mildred Pierce*, *Life with Father*, *Strangers on a Train*, *A Streetcar Named Desire*, *A Star Is Born*, *East of Eden*, *Auntie Mame*, *My Fair Lady*, *Inside Daisy Clover*, *Who's Afraid of Virginia Woolf?*, *Hello, Dolly!*, and *The Day of the Locust*. He died in 1985, at the age of eighty-eight.

Henry Peavey finally got his wish to move back to San Francisco, but his health rapidly declined. By 1930 he was living at the Napa State Hospital. He died of syphilis there the next year, at the age of forty-nine.

No trace of Edward Sands was ever found.

Detective Lieutenant Edgar King officially retired from the Los Angeles Police Department and became a permanent investigator for the district attorney's office. He apprehended Kid McCoy, the prizefighter turned murderer, and helped track down and capture Otto Sanhuber, the "ghost in the attic" who killed Fred Oesterreich. Although he always regretted not capturing Taylor's killer, spending his life convinced of Charlotte Shelby's guilt, King got a great deal right in his investigation. He nailed the distance of the killer to the victim; he correctly described how Taylor grabbed the chair to defend himself, which resulted in his arms being raised over his head when he was shot; he figured out that Taylor had collapsed on top of his killer. Had Charles Eyton not stolen Taylor's papers after the murder, I believe King would have solved this crime long ago. Eddie King died in 1965, aged eighty-eight.

Charlotte Shelby finally shared Mary's fortune with her. In fact, she had invested her daughter's earnings quite well, enough that they both lived very comfortably for the rest of their lives. Despite all their squabbles and legal battles, the two eventually reconciled, and Shelby spent her last days living in Mary's house, a reversal of their original roles. Elegant and formidable even into old age, Shelby remained bitter about all the years of accusations and slander. In 1942 she hired a ghostwriter to pen a roman à clef, which she titled *Twisted by Knaves*. The unpublished

manuscript tells the story of Taylor's murder, but makes it clear that Shelby had no idea who did it. She died in 1957 at the age of seventy-nine, in the home of her daughter.

Mary Miles Minter never made another movie. In the age of the talkies, she came to represent a mawkish, overly sentimental era, though the 1920s had been anything but. People remembered Mary and her lacy, pipe-curled companions as saccharine and simplistic, hardly doing justice to the vibrant, passionate personalities of the era. But with so few silent films surviving, Mary—and Mabel and Gibby, too—would exist for most people only as memories framed in heart-shaped iris shots.

Mary had wanted the freedom to live her life as she pleased. She got that chance, for a while, dwelling among the fashionable set in New York. But people found her slightly off, living in a world of funhouse mirrors. Between Mary's bizarre upbringing and the indignities of the Taylor investigation, that really wasn't too surprising. People laughed at her behind her back and whispered about the scandal. Never having learned how to be an adult, Mary trusted people she shouldn't have, including a broker who defrauded her out of $200,000.

Moving back to California, the former star lived in Beverly Hills, growing fatter and more eccentric. Mary dabbled in interior decoration, but mostly she and her mother lived off trusts. At the age of fifty-five, just a few weeks after her mother's funeral, Mary finally wed. Her husband was Brandon O'Hildebrandt, a wealthy real estate developer. O'Hildebrandt made sure Mary stayed comfortable, even if they rarely saw each other. Their neighbors across the street on Adelaide Drive, high above the beach in Santa Monica, were the playwright and author Christopher Isherwood and his life partner, the artist Don Bachardy. Never once did Bachardy see Mary's husband or have any sense of him.

Mary, on the other hand, was impossible to miss. "She was enormous," Bachardy remembered. She would scold him for driving too fast down their street, apparently forgetting the days when she zipped around Los Angeles in her little blue runabout, a car she no longer could have fit into. Once, inviting Bachardy and Isherwood inside, she hinted that the playwright might want to pen her biography. "So many erroneous things have been written," she said. Isherwood demurred.

After her husband died in 1965, Mary became even more reclusive, never leaving the house. Only a few visitors, such as the film historian

Kevin Brownlow, were allowed inside. On the walls hung portraits of herself in her younger days. Still wearing the curls and lacy dresses of her early years, Mary talked endlessly to visitors in long, meandering, sentimental streams of consciousness. She had become Norma Desmond, or Baby Jane Hudson.

But mention the Taylor case, and the fire would return to her eyes. Why must this be the first thing people remembered about her? Why was that the only thing anyone ever wanted to talk to her about?

And yet she'd wax poetic about the late director, calling him her only love despite her eight-year marriage to O'Hildebrandt. If anyone suggested she knew something about Taylor's murder, she'd turn red and angry. Like her mother, Mary had had enough of such talk. In 1970 she sued CBS and the producer Rod Serling, after Serling suggested on television that Mary had been involved in the murder.

The years passed. Mary suffered increasingly from diabetes.

Late one night in January 1981, she was awakened by a masked intruder. The terrified seventy-eight-year-old woman was gagged and bound, breaking her wrist in the struggle. The thief took $300,000 worth of antique china, silver, and jewelry. Eventually police arrested Mary's caretaker, a thirty-nine-year-old woman, for masterminding the crime. After all this time, Mary still hadn't learned whom she could trust and whom she couldn't.

She died on August 4, 1984, at the age of eighty-two. The very first line of Mary's obituary mentioned her connection to the sixty-two-year-old Taylor murder.

Of course it did.

Will Hays survived his own mini-scandal in June 1929, when his divorce was finally granted and became public knowledge. A short time later, it was rumored that he was involved with a divorcée, Mrs. Virginia Lake. But Hays had learned how to let criticism roll off him, especially from the Anvil Chorus. He ended the scuttlebutt in 1930 when he married the eminently respectable Jessie Stutesman, widow of the former ambassador to Bolivia and daughter of a prominent Indiana family.

As a new push for censorship arose in the early sound era, led this

time by Catholic priests and laymen instead of Protestant clergymen and church ladies, Hays was compelled to establish the Production Code Administration. The code was a draconian self-censorship protocol that went far beyond his original Formula, sterilizing American films for the next thirty-plus years. It is ironic that "the Hays Office" would become synonymous with a puritanical, moralistic worldview, when the man himself was progressive and pragmatic.

Will Hays should be remembered not as Hollywood's censor but as one of its greatest practitioners of public relations. As the power of Adolph Zukor waned, Hays became "an apostle of progress, an optimistic advocate of new media, and a skilled user of publicity," in the opinion of Indiana historian Stephen Vaughn. With his successful Public Relations Committee and various other creative outreaches to the public, Hays saved the film industry from federal regulation and secured its place as the foremost means of communication in the twentieth century. He remained at the helm of the MPPDA until 1945. Hays died in his hometown of Sullivan, Indiana, in 1954, aged seventy-four.

Adolph Zukor seemed to let out a long, deep breath once he made it to the top of his skyscraper. The days of his greatest power were past. But he had achieved his monument, which still stands today. The giant clock on the side of the building is still ticking, and Paramount still has offices inside, though Zukor's theater was shut down in 1964 and demolished in 1967.

The addition of Balaban & Katz to the company and the expenses of its theater chain eventually saddled Paramount with a crushing debt—so much so that, by the early sound era, the company Zukor had once kept so lean and tight was bankrupt. Paramount would bounce back, and magnificently, but it wasn't Zukor who led the revival. The board of directors appointed Barney Balaban to take over as head of the company, and Zukor agreed to "step upstairs into an advisory role." There he spent the next forty years, dispensing words of wisdom from on high.

In his unfinished novel *The Last Tycoon*, F. Scott Fitzgerald would write that Hollywood could only be understood "dimly and in flashes." Fewer than half a dozen people, he said, had "ever been able to keep the

whole equation of pictures in their heads." Zukor was one of those few. He created a system that worked brilliantly for nearly three decades, and then proved adaptable enough to accommodate the technological changes that challenged it. The vertically integrated model Zukor established "would change only in the means of presentation," one studio historian observed. In 1953, when the movie studios were worried about the rise of television, Zukor saw no need for panic. "Rather than lose the public because television is here," he argued, "wouldn't it be smart to adopt television as our instrument?" So Paramount did, opening television studios that offset the losses in its movie divisions.

Even though he did not know what was to come, Zukor's system survived television, video, DVDs, and even the Internet, accommodating them all as new venues for the presentation of moving pictures. That's what came of keeping "the whole equation" in his head.

Not until 1948 did the government finally force the movie studios—all of them, not just Paramount—to divest themselves of their theater chains. By then Zukor was happily ensconced as chairman emeritus. In 1953 he published a memoir, *The Public Is Never Wrong*, which he dedicated to his wife Lottie. The book is free of any real introspection, though it shares some good stories of the early days. About the scandals he had done his utmost to contain and control, Zukor said little. Without further comment or a hint of sympathy, he wrote, "To the day of [Arbuckle's] death in 1933, the storm had not abated sufficiently so that he could make another picture." He offered no details of his part in that storm. Of the Taylor case, Zukor said it made for "good reading," and recalled the fodder it gave to "dozens of special correspondents" who painted Hollywood as "a wicked, wicked city." Of Taylor's papers, or the actions he'd taken after reading them, Zukor said nothing. He took that secret with him to the grave.

Zukor had never been one for soul-searching; that was Marcus Loew territory. He spent his golden years peacefully, relying on Lottie for company, seemingly free of regret. One day in 1956, when Zukor was eighty-three, Lottie insisted on making him one of her special Hungarian meals all by herself, served on their best china. Zukor would say they "never had such a time." The next day Lottie suffered a stroke that eventually killed her. Zukor took her death "very philosophically," his son Eugene said, "because he remembered their last night together."

Zukor would live another twenty years, spending his winters in Los Angeles to be near Eugene. Almost every day he was driven to the Paramount lot, slowly ascending the stairs to his office, going over the company's financial reports with a careful eye.

For his hundredth birthday, Zukor was feted with a gala party. Twelve hundred people filled the ballroom at the Beverly Hilton. Charles Bluhdorn, chairman of Gulf & Western, Paramount's new owners, declared that Zukor "exemplified the American dream."

The little man with the unblinking eyes sat in his chair, looking out at all the people who had come to pay their respects. When Marcus Loew died, his funeral had brought out all of his peers, but Zukor's peers were long dead. Most of the people who had come for his party were too young to have seen a first-run silent picture. They didn't remember William Desmond Taylor, or Roscoe Arbuckle, or Mabel Normand, or Jesse Lasky, or Will Hays, or Brother Wilbur Crafts. They had little understanding of the changes Zukor had seen and wrought. He had started with a handful of penny arcades, and lived long enough to see the age of the blockbuster. *Jaws* was in the nation's theaters during the last year of the old man's life.

"Moses lived to a hundred and twenty," the rabbi at his birthday party said.

Creepy just smiled.

He died in 1976, at the age of one hundred and three.

# ACKNOWLEDGMENTS

I could not have written this book without the extraordinary work of Bruce Long. Three decades ago Bruce started discovering, assembling, analyzing, and making available material on the Taylor murder. This book is one of many that owes him an incalculable debt: every study of American silent film benefits from the material Bruce has compiled in his book *William Desmond Taylor: A Dossier*, and on his remarkable and compulsively readable site, taylorology.com.

Recognition must also go to Sidney D. Kirkpatrick and the late Robert Giroux and Charles Higham, authors of previous books on the Taylor murder. While I believe that my solution to the long-unsolved crime is the correct one—and the only one not contradicted by the available evidence—each of these three previous writers conducted invaluable research that informed my understanding of my subjects and the times they lived in. I am deeply indebted to all of them.

My thanks to the historians, librarians, and archivists who helped me uncover so many artifacts from nearly a century ago. In alphabetical order: Louise Corliss, Vermont State Archives; Simon Elliott, UCLA Library Special Collections; Natalie Fritz, Clark County Historical Society, Springfield, Ohio; Sandra Garcia-Myers, Cinematic Arts Library, University of Southern California; Barbara Hall, Margaret Herrick Library, Academy of Motion Picture Arts and Sciences, Beverly Hills, California; David Hardy, Records Management Division, Federal Bureau of Investigation; David W. Jackson, Jackson County Historical Society, Independence, Missouri; Ginny Kilander, American Heritage Center, University of Wyoming; Glenn V. Longacre, National Archives, Chicago; Harry Miller, Wisconsin Historical Society; Joann Nichols, Brattleboro Historical Society, Vermont; Albert Palacios, Harry Ransom Center, University of Texas, Austin; Galen Wilson, National Archives, Federal Records Center, Dayton, Ohio; and various archivists from the New York Public Library, main branch as well as the Performing Arts

Library in Lincoln Center; the Los Angeles County Archives; and the Boston Public Library.

Also of enormous help were the Mabel Normand Sourcebook, painstakingly compiled by William Thomas Sherman and hosted at mn-hp.com, and the site Looking for Mabel Normand by Marilyn Slater.

A special thank-you to Tim, Pat, and June Duran, who shared memories of their grandfather and great-grandfather, Detective Lieutenant Eddie King; Nicole Westwood, for the photograph of Thomas Lee Woolwine; Jeffrey Shallit, who shared his research about his great-uncle, Lawrence (Outlaw) MacLean; Peter Crown, who shared his research about his grandfather, Sydney Cohen; and of course, Ray Long, without whose sharp memory and willingness to come forward we would never have known about Margaret Gibson and her connection to Taylor.

Thanks also to Catherine Lindstrom, Patrick McGilligan, Lisa E. Morrow Koogler, and David Williams for providing information and research assistance.

Finally, gratitude to my editor, Cal Morgan, for believing in this project from the start; Milan Bozic and Leah Carlson-Stanisic, for the beautiful design of the book; Kathleen Baumer, for pulling everything together expertly; my resolute agent, Malaga Baldi; and my husband, Dr. Tim Huber, my first and best critic as always.

# NOTES

Most of my citations are from primary sources. In addition to letters, telegrams, newspaper accounts, production files, police records, witness statements, and other documents, I have also used a wide variety of contemporary material to bring Hollywood in the early 1920s back to life. When I describe the yellow paint of the Wallace Apartments, for example, or the old chandelier in the Melrose Hotel, it's based on photographs (sometimes old postcards) that depict such places. When I mention the partly dirt roads of downtown Los Angeles, my descriptions come from maps and city records. When I remark on the weather on a particular day, I'm using weather reports published in local newspapers. It would be impossible to document each time a photograph or weather report or other background source is used. Witness statements, inquest testimony, and probate files, however, can be found at taylorology.com.

The numerous manuscript collections that I utilized at various archives are all cited in the following notes.

## ABBREVIATIONS

| | |
|---|---|
| **AMPAS** | Sennett Collection, Academy of Motion Picture Arts and Sciences, Beverly Hills, CA. |
| **Brownlow interview** | Interview with Mary Miles Minter by Kevin Brownlow, March 27, 1971, King Vidor Papers. |
| **FBI case file** | Federal Bureau of Investigation, case file on Don Osborn et al., October 21, 1923. |
| **Higham transcript** | Interview with Mary Miles Minter by Charles Higham, given to Bruce Long, transcribed by Long. |
| **MPPDA** | Digital Archives of the Motion Picture Producers and Distributors Association. |
| **NBR** | National Board of Review Collection, NYPL. |

**NYPL**              Zukor file, New York Public Library.

**Osborn, 1923**     Testimony, *United States vs. Don Osborn et al.,* District Court of
                     the United States, Southern District of Ohio (1923).

**WHH**              Will H. Hays papers, Boston Public Library.

## PROLOGUE: A COLD MORNING IN SOUTHERN CALIFORNIA

3        the vehicle emerged from the shadows: *Oakland Tribune,* February 16, 1922; *Ox-
         nard Daily Courier,* February 16, 1922; *Sacramento Bee,* February 18, 1922.

4        "spent to keep him comfortable": *Los Angeles Times,* February 3, 1922.

4        the Owl Drug at the corner of Fifth: Peavey testimony, coroner's inquest, Febru-
         ary 4, 1922.

5        he paid $1: Taylor probate file, creditor's claim, Henry Peavey, February 25, 1922.

5        The valet's troubles had begun: "Peavey's arrest followed assorted acts of indecency
         several days ago in Westlake Park." *Los Angeles Times,* February 3, 1922. Westlake
         Park was later renamed MacArthur Park.

6        "worked for a lot of men": *Los Angeles Examiner,* February 3, 1922.

7        "I've got to read all these": *Los Angeles Times,* February 3, 1922.

7        his usual morning routine: *Los Angeles Examiner,* February 3, 1922; *Los Angeles
         Record,* February 3, 1922.

## CHAPTER 1: A MAN CALLED CREEPY

11       "long like an Indian chief's": Neal Gabler, *An Empire of Their Own: How the Jews
         Invented Hollywood* (New York: Crown, 1988).

11       his employees called him Creepy: Zukor had this nickname while still working
         with Marcus Loew, thus before 1912. *Motion Picture Herald,* February 6, 1937.

12       spent $4.4 million for the old Putnam Building: *New York Tribune,* October 21,
         1920; *New York Times,* June 3, 1922.

13       the fourth largest industry: This was a claim frequently made by the film in-
         dustry in the years from 1920 to 1924. The auto industry was known to boast
         that it was the third largest industry (as in the *New York Times,* July 7, 1918),
         so it's possible the film industry was using that as a way to quantify and com-
         pare its earnings. In fact, retail clothing manufacturers also called themselves
         the nation's fourth largest industry; *New York Times,* July 4, 1920. While
         preparing position papers for himself when he became head of the MPPDA in
         1922, Will H. Hays crossed out "fourth" and wrote in "one of the" largest in-
         dustries in the country. Digital Archives of the Motion Picture Producers and
         Distributors Association, Flinders Institute for Research in the Humanities
         (hereafter MPPDA).

13       three quarters of a billion dollars: Industry economic statistics are taken from a
         report prepared by the MPPDA, 1922.

13       returns of 500 to 700 percent: *New York Evening World,* January 24, 1922.

13       total assets of $49 million: August 1922, Will H. Hays papers, which I used at the
         Boston Public Library.

14       Its stock-market value: *Variety,* July 30, 1920.

14       "As a consequence": *Variety,* August 6, 1920.

14     "Mr. Zukor finds out anything": Unsourced clipping, n.d. [1919], Zukor file, New York Public Library (hereafter NYPL).

15     "beautiful dark eyes": Adolph Zukor, *The Public Is Never Wrong* (New York: Putnam, 1953).

16     "The revelries began at once": *New York Evening World*, May 30, 1921.

16     Mr. Fred Lord: For more details on the extortion case and the night at Mishawum Manor, see *Boston Globe*, June 9, July 12, July 13, 1921; *New York Times*, June 25, June 26, July 12, July 13, 1921.

## CHAPTER 2: BABYLON

19     the census had counted: *Variety*, February 10, 1922.

20     "sudden and grandiose rise": *New York Times*, December 13, 1925.

20     "the church of the future": *New York Times*, December 13, 1925.

## CHAPTER 3: THREE DESPERATE DAMES

21     She had a train to catch: On August 25, 1920, the *Los Angeles Times* reported that Normand "left yesterday" for New York.

23     "If they will tide you over": A. Scott Berg, *Goldwyn: A Biography* (New York: Knopf, 1989).

23     "harassed," St. John thought: *Photoplay*, August 1921.

23     "six best cellars": *Los Angeles Herald*, December 8, 1920.

24     On a late summer day: "Patricia Palmer" spoke about "walking the streets" (an interesting choice of words, given her arrest) on "hot summer afternoons," handing out her resumé and photos to "everyone she knew in the business who might give her a job." Unsourced clip, September 15, 1920, Robinson Locke Collection, NYPL.

25     "Before Western girls are sent": *Cincinnati Commercial Tribune*, July 19, 1914. For more information on Vitagraph and the world of which Gibby and Taylor were a part, see Anthony Slide, *The Big V: A History of the Vitagraph Company* (Scarecrow Press, 1987).

27     "made no secret": Mary Miles Minter, witness statement, March 4, 1926.

27     "They fought all the time": Charlotte Whitney, witness statement, November 28, 1925.

27     The director was being promoted: Realart films were "lower budget [for a] lower rental bracket," as producer Jesse Lasky described them in his memoir *I Blow My Own Horn* (New York: Doubleday, 1957). So the move for Taylor was definitely a promotion. "Films directed and produced by Taylor will be trademarked 'William D. Taylor Productions,'" the *Los Angeles Herald* reported on December 18, 1919, "and given the same prominence and publicity that now is given those of Cecil B. De Mille."

## CHAPTER 4: THE ORATOR

29     "bony look of a stone bishop": Charles Higham, *Murder in Hollywood* (Madison: University of Wisconsin Press, 2006).

29     "even a bit of jewelry"; "quiet, like a camouflaged": *Rocky Mountain News*, February 12, 1922.

30    "great sadness" in his life: *Los Angeles Examiner*, February 4, 1922.

30    "Give the public real human pictures": *Los Angeles Express*, December 17, 1919.

31    RUMORS OF DRUG AND WINE PARTIES: *Los Angeles Times*, September 11, 1920.

31    GAY REVELS IN UNDERWORLD: *Syracuse Herald*, September 12, 1920.

31    "sinister rumors of cocaine orgies": *Los Angeles Times*, September 11, 1920.

31    "stars and stagehands": *Los Angeles Record*, September 27, 1920.

32    "The motion picture is doing": Wire reports, as in the *Paris (KY) Bourbon News*, June 9, 1920.

32    "Film subject matter": Zukor, *Public Is Never Wrong*.

33    "a woman making baby clothes": *New York Times*, April 21, 1920.

33    "Sweet little Clarine Seymour": Details of the memorial service come from the *Los Angeles Times*, September 27, 1920; *Los Angeles Herald*, September 24, 1920; *Los Angeles Record*, September 27, 1920; *Los Angeles Examiner*, September 27, 1920; *Camera!*, February 4, 1922; and syndicated wire service reports, as in the *Billings (MT) Gazette*, December 5, 1920.

33    "William Taylor's beautiful tribute": *Los Angeles Examiner*, September 27, 1920.

34    "His sympathy": *Camera!*, February 4, 1922.

## CHAPTER 5: A RACE TO THE TOP

35    Another movie mogul: Details of Marcus Loew's building were announced in the *New York Times* on September 23, 1920, but stories had appeared earlier, as on February 6 and 8.

36    "a dandy in a high hat": Zukor, *Public Is Never Wrong*.

36    "I wear 'em to impress 'em": Will Irwin, *The House That Shadows Built* (New York: Doubleday, Doran, 1928).

36    "a jolly mixer type": *Photoplay*, August 1927.

37    "had lost his head": Zukor, *Public Is Never Wrong*.

37    "I have had the help": *Photoplay*, August 1927.

37    a lavish wedding: *New York Times*, January 7, 1920.

37    "Then you did not let blood": *New York Times*, November 2, 1933.

38    the combined annual income of all American producers: *Wall Street Journal*, December 11, 1919.

38    "Cohen must be destroyed": *New York Evening World*, June 19, 1923.

39    "drive the exhibitor out of the game": *New York Times*, June 10, 1920.

40    "We are told the wages of sin": *Kentucky Irish American*, September 25, 1920.

40    "show altogether too much": *Philadelphia Evening Public Ledger*, October 26, 1920.

40    "It may be time": *Boston American*, September 30, 1920.

## CHAPTER 6: MABEL

42    Olive Thomas's casket rested on a bier: My account of Olive's funeral comes from the *New York Evening World*, September 28, 1920; New York *Daily News*, September 29, 1920; and other newspaper accounts.

43    "Mabel wanted to be smart": Betty Harper Fussell, *Mabel: Hollywood's First I-Don't-Care Girl* (Boston: Ticknor & Fields, 1982).

| | |
|---|---|
| 44 | "a shadow of her former self": Hedda Hopper, *From Under My Hat* (New York: Doubleday, 1952). |
| 44 | signed her letters "Blessed Baby": *Los Angeles Examiner*, February 6, 1922. |
| 44 | "comradeship and understanding": *Los Angeles Express*, February 6, 1922. |
| 44 | she had confessed her addiction: According to US Attorney Tom Green, Taylor told him that Mabel "had confessed her habit to him shortly after meeting him and had asked him to do everything possible to save her." *New York American*, February 24, 1922. |
| 44 | "From her French father": Fussell, *Mabel*. |
| 45 | "a complexion that makes you": The original manuscript of Marion's memoir, *Off with Their Heads: A Serio-Comic Tale of Hollywood*, cited in Cari Beauchamp, *Without Lying Down: Frances Marion and the Powerful Women of Early Hollywood* (Berkeley: University of California Press, 1998). |
| 45 | "Skittery as a waterbug": Mack Sennett, *King of Comedy: The Lively Arts* (New York: Doubleday, 1954). |
| 46 | "she refused to have anything": Telegram to Mack Sennett from Arthur Butler Graham, July 13, 1917, Sennett Collection, Academy of Motion Picture Arts and Sciences, Beverly Hills, CA (hereafter AMPAS). |
| 47 | "never in the least forward": *Rocky Mountain News*, February 12, 1922. |
| 47 | "exhausted the incandescence": Fussell, *Mabel*. |

## CHAPTER 7: GIBBY

| | |
|---|---|
| 48 | that the cops were looking for Joe Pepa: *Los Angeles Times*, November 7, 1920. |
| 49 | "Her life has been one long": Unsourced clipping, 1914, fan scrapbook kept by Edna G. Vercoe, AMPAS. |
| 49 | "a house of ill fame": My account is culled from *Los Angeles Times*, August 26, August 28, August 30, September 14, September 19, September 20, 1917; *Los Angeles Herald*, September 14, September 19, 1917. |
| 49 | a downtown taproom: Federal Bureau of Investigation, case file on Don Osborn, et al., October 21, 1923 (hereafter FBI case file). |
| 49 | suing the department for $15,863: *Los Angeles Times*, February 1, 1917. |
| 49 | Suspecting him of smuggling opium: *Los Angeles Times*, November 6, November 8, 1916. |
| 50 | two Chicago businessmen: *Los Angeles Times*, December 1, December 5, 1916; *Day Book* (Chicago), December 1, 1916; *Chicago Tribune*, October 25, October 26, 1915. |
| 50 | Betty died after her stint: *Los Angeles Times*, January 4, January 5, January 12, 1917. |
| 50 | "acute yellow atrophy": Los Angeles death records, Registrar-Recorder, County Clerk. |
| 50 | "he would never be convicted": *Los Angeles Times*, September 29, 1917. |
| 51 | "furnished rooms": Los Angeles city directory, 1917. |
| 51 | The neighborhood was rough: A search of "Commercial Street" in the digital archives of the *Los Angeles Times* brings up considerable criminal activity. For examples contemporary with Gibby's arrest, see *Los Angeles Times*, September 9, September 18, September 21, 1917. |

51 Hahn told Lola Rodriguez: *Los Angeles Times*, November 11, 1917. Hahn was nearly disbarred over the charge.

51 "The top was quite low": *Los Angeles Times*, September 19, 1917.

51 "Japanese men entered": *Los Angeles Times*, September 19, 1917.

51 Gibby was cool as an April breeze: My account of Gibby's arrest comes from the *Los Angeles Times*, August 26, August 28, August 30, September 14, September 19, 1917; *Los Angeles Herald*, September 14, September 19, 1917.

52 "one of the most entertaining": *Los Angeles Times*, July 25, 1916.

52 Gardner came off like a starchy scold: *Los Angeles Times*, September 19, 1917.

52 "this little girl": *Los Angeles Herald*, September 15, 1917.

52 "severely arraigned her": *Los Angeles Times*, September 19, 1917.

53 "forming a halo": *Los Angeles Herald*, September 15, 1917.

53 "started to leave the witness stand": *Los Angeles Times*, September 28, September 29, 1917.

53 "Underworld gunmen": *Los Angeles Times*, September 18, 1917.

53 there were whispers: A column in *Photo-Play Journal*, October 1920, made the connection, which no doubt disturbed Gibby greatly.

54 rather ingloriously fired: *Moving Picture World*, April 18, 1914.

## CHAPTER 8: MARY

55 eight-cylinder Cadillac roadster: Details of Mary's car come from *Los Angeles Times*, April 18, 1920; *Los Angeles Express*, May 22, 1920.

55 "scraps of paper": *Los Angeles Express*, September 23, 1920.

56 They'd just returned: *Los Angeles Times*, August 14, 1920. The article reported that they'd left on August 13 and were planning to stay for three weeks. That means they would have returned about September 3. According to Leroy Sanderson's overview of the Taylor case, dated June 13, 1941, Mary's fake suicide attempt occurred in the "late summer." Prior to August 13 doesn't seem to qualify as "late summer." Also, Charlotte Whitney left Shelby's employ in the early fall, reported by Sanderson to be "soon after" Mary's fake suicide stunt. That is why I have placed this incident here.

56 "as a glorified servant girl": *Los Angeles Herald*, August 10, 1923.

56 "find a suitable millionaire's": *Los Angeles Times*, October 14, 1919.

56 "when to go to bed": Interview with Mary Miles Minter by Charles Higham, given to Bruce Long, transcribed by Long (hereafter Higham transcript).

57 Lilla Pearl Miles: US Census, 1880.

57 "where Negroes knelt": Interview with Mary Miles Minter, by Kevin Brownlow, March 27, 1971, King Vidor Papers, AMPAS (hereafter Brownlow interview).

57 "When I was a baby": *Los Angeles Times*, August 10, 1923.

58 "These things have an effect": *Los Angeles Herald*, August 14, 1923.

58 "They never would let me": *Los Angeles Times*, August 15, 1923.

58 "the little girl with the biggest": *Los Angeles Times*, June 27, 1919.

58 "matured very quickly": *Los Angeles Herald*, August 14, 1923; *Los Angeles Times*, August 15, 1923.

59 Standing with Kirkwood: The "marriage ceremony" between Mary and Kirk-

wood was described in grand jury testimony in 1937, as reported in the *Los Angeles Herald-Express*, May 7, 1937. It is corroborated by a memorandum written by Detective Leroy Sanderson, who had read the letters between Mary and Kirkwood. See Bruce Long, *William Desmond Taylor: A Dossier* (Lanham, MD: Scarecrow Press, 2004).

60      "Heart hungry as I was": *Los Angeles Times*, August 15, 1923.

60      "I recognized them": *Los Angeles Herald*, August 14, 1923.

61      "The man was too wonderful": Brownlow interview.

61      "a nice little girl": Harry Fellows, witness statement, February 9, 1922.

61      she was May: Mary Miles Minter, statement to the district attorney, February 7, 1922.

61      "I can't give you": Minter, Brownlow interview.

61      "He reciprocated my love": *Los Angeles Herald*, August 14, 1923; *Los Angeles Times*, August 15, 1923.

61      "If I ever catch you hanging": Whitney, witness statement.

62      "to kiss and fondle her": *Los Angeles Herald*, August 10, 1923.

62      "Do you really mean that?": I've taken the following account from the witness statements of Whitney, November 28, 1925, and Charlotte Shelby, April 9, 1926.

## CHAPTER 9: RIVALS AND THREATS

64      to watch the presidential election returns: *New York Tribune*, November 3, 1920.

64      Uptown at the Ritz: *Variety*, November 9, 1920.

65      "There is no question": *New York World*, October 29, 1920.

66      Abrams working for United Artists: *Variety*, January 28, 1921.

66      "because all the people": Zukor, *Public Is Never Wrong*.

66      "never a danger": Adolph Zukor, interview by Ezra Stone, William E. Weiner Oral History Library of the American Jewish Committee, NYPL.

66      "a self-indulgence": Zukor, *Public Is Never Wrong*.

67      "the story of a man": Gabler, *Empire of Their Own*.

67      "his gratitude": *New York Times*, November 19, 1926.

68      On the various affiliated Committees for Better Films: The names of these women were drawn from various papers in the National Board of Review Collection, NYPL.

68      one of the first policewomen: For O'Grady's career, see *New York Times*, August 16, 1918; February 27, 1919; March 9, 1919; September 11, 1920; April 6, 1921.

69      "must have the power": *New York Times*, May 29, 1919.

69      a tragedy occurred: *New York Tribune*, November 15, 1920.

70      "too strenuous": *New York Times*, December 14, 1920.

## CHAPTER 10: GOOD-TIME GIRL

71      the Glen Springs Sanatorium: On November 11, 1920, *Variety* reported: "Mabel Normand is recovering from her nervous breakdown at the Glen Springs Sanatorium near Elmira, N.Y."

71      "went to bed when the moon": *New York Morning Telegraph*, November 28, 1920.

72        up to $2,000 a month: The figure comes from US Attorney Tom Green, in *New York American*, February 24, 1922.

72        Once, on a train: Berg, *Goldwyn.*

72        "Look at him": Frances Marion, *Off with Their Heads: A Serio-Comic Tale of Hollywood* (New York: Macmillan, 1972).

73        "a movie star at Seventh and Vermont": Julia Brew's story comes from Fussell, *Mabel.* Although she is quoted as saying "a movie star at Seventh and Ventura," Mabel actually lived at Seventh and Vermont, so I have changed the quote accordingly.

74        "Mabel Normand has a pair of callused": *New York Morning Telegraph*, October 17, 1920.

## CHAPTER 11: LOCUSTS

75        They'd gotten to know each other: Testimony, *United States vs. Don Osborn, et al.,* District Court of the United States, Southern District of Ohio (1923) (hereafter *Osborn*, 1923).

76        Williams renewed his contract: Details of Williams's contract renewal with Pathé are stated in his biographical entry in William Allen Johnston, *Motion Picture Studio Directory, 1921* (New York: Motion Picture News, 1921).

76        He was six foot three: Description of Don Osborn comes from the FBI records of the case against him, his World War I draft registration, and newspaper photographs. Although the FBI description says that Osborn had brown eyes, I've trusted the draft registration, which says they were blue, since it was compiled during an in-person interview.

77        When he was nineteen, Osborn had masterminded: *Los Angeles Times*, March 8, 1914.

77        suing for child support: FBI case file, November 2, 1923.

77        registered for the draft: Registration card, Don F. Osborn, June 5, 1917.

77        name would not be found: The Triangle records held by the Wisconsin Historical Society and the New York Public Library were exhaustively checked for any mention of Osborn.

77        "drinking parties": George Weh, statement, August 2, 1923, FBI case file.

78        "the prettiest working girl in the city": *Chicago Tribune*, March 31, 1912. Also see March 3, 1912; December 11, 1913; US Census, 1900, 1910, Chicago.

78        "the kind of man who liked to work": Mabelle Osborn (Rae Potter) to Don Osborn, July 31, 1923, FBI case file.

78        "longed for the love": *Los Angeles Times*, May 14, May 15, 1919.

78        the opening of the Mission Theatre: *Los Angeles Times*, November 14, 1920; December 2, 1920; *Los Angeles Express*, December 11, 1920.

## CHAPTER 12: THE MADDEST WOMAN

80        "I am very, very happy": Mary Miles Minter to Adolph Zukor, October 11, 1920, Zukor Collection, AMPAS.

81        "until the end of my life": Higham transcript.

82        "that halfbreed Indian": Shelby, witness statement. Charlotte Whitney also recalled the incident in her statement, though she placed it in Mary's dressing room. Shelby's statement, by and large, is more accurate, so I've gone with her account.

This anecdote is sometimes told with Shelby driving the car herself. But in her interview with Kevin Brownlow, Mary reported that her mother didn't drive.

82 "big, fast roadster": *Los Angeles Examiner*, December 26, 1929.

83 "Who is there?": Details of this encounter come from a long interview with Charlotte Shelby published in the *Los Angeles Examiner*, December 26, 1929.

83 Charlotte Whitney noticed: Whitney, witness statement.

## CHAPTER 13: IMPUDENT THINGS

84 "with all the trimmin's": *Los Angeles Express*, November 24, 1920.

85 "The heads of the motion picture": *Los Angeles Express*, November 1, 1920.

86 Greeting him was his valet: My description of Sands comes from the *Daily Bulletin*, February 7, 1922, a publication of the Los Angeles Police Department; the more detailed police description sent to the press, as published in the *Los Angeles Times*, February 8, 1922; Sands's World War I draft registration card; and Earl Tiffany, witness statement, February 17, 1922. Mary's description comes from the Higham transcript, as well as the Brownlow interview. There are some contradictions in these accounts. The *Bulletin* description, presumably provided by people who knew Sands, reported him as having a "light complexion." But Tiffany called Sands "ruddy," which he clarified to mean "healthy looking, very healthy." Tiffany also reported that Sands had blond hair, where the *Bulletin* and the draft registration both state he had brown hair, making me question Tiffany's reliability. I have gone with the description provided by the *Bulletin*.

87 had dynamited a hill: *Los Angeles Herald*, July 17, 1920.

87 And in one fantasy: Hopkins described this scene in his unpublished memoir, "Caught in the Act," shown to me by Charles Higham.

87 "[Taylor] was always seeking": *Philadelphia Inquirer*, February 4, 1922.

87 "The men would lie in silk": This comes from one of Edward Doherty's sensational syndicated dispatches, as in the *New York Daily News*, February 9, 1922.

87 "visiting the queer places": *Philadelphia Inquirer*, February 4, 1922.

87 how his heart had raced: Hopkins, "Caught in the Act."

88 the director's melancholic moods: *Los Angeles Examiner*, February 6, 1922.

88 other gay couplings: For context regarding the gay subculture in Hollywood at the time, see William J. Mann, *Behind the Screen: How Gays and Lesbians Shaped Hollywood, 1910–1969* (New York: Viking, 2001).

## CHAPTER 14: DOPE FIENDS

89 "Looking like the Mabel": *Los Angeles Times*, December 24, 1920.

89 "How did you do it?": *Photoplay*, August 1921.

90 interrupted by a knock at the back door: There is some controversy over when the anecdote of Taylor ejecting Mabel's dealer from her house actually occurred—and indeed, whether it occurred at all. I believe it did, as it was reported by a well-respected US Attorney, Tom Green. I also believe that it occurred sometime in very late 1920 or very early 1921, as Green said that Taylor had told him that the actress friend he was trying to protect "had been presumed to be cured of the drug habit"; *New York American*, February 24, 1922. This would place the incident after Mabel's stay at Watkins Glen. Green would tell reporters soon after

Taylor's murder that his meeting with the director had been about "a year and a half" earlier—which, if taken literally, would place it before Watkins Glen. So I have presumed Green was offering only a rough estimate, and I have accordingly placed the incident here, soon after Mabel's return to Los Angeles in December 1920. See also *Los Angeles Examiner*, February 24, 1922.

91      Adela Rogers St. Johns recalled: Fussell, *Mabel*.

91      By going to Green: Eyton's identity is deduced here by statements later made by Green. A man came to his office from "a certain industrial plant" where William D. Taylor was employed; *Los Angeles Examiner*, February 24, 1922. This clearly refers to Famous Players–Lasky, and so the man, as Bruce Long notes in his *Dossier*, must either have been studio chief Jesse Lasky or general manager Charles Eyton. From my study of Lasky's letters, this does not appear to be something the studio chief would have done himself. Such a chore would more likely have been delegated to Eyton, who was in charge of studio management.

92      "It was then Green learned": *New York American*, February 24, 1922; *Los Angeles Examiner*, February 24, 1922.

92      "Before she's through": *Chicago American*, February 11, 1922. Although this report, by the notoriously sensational Wallace Smith, did not specifically state that the federal agent investigating the drug gang in Hollywood was associated with Tom Green, it seems very likely that he must have been, as it would have been at the same time as Green's investigation.

93      "If I had been a farmer": Sennett, *King of Comedy*.

93      "a big romantic comedy": *Los Angeles Record*, February 3, 1921.

93      Her deal was for: Given that *Molly O'* was made in the spring of 1921, and Mabel's long-term contract with Sennett, preserved in the Sennett Collection, AMPAS, was not agreed to until July (and did not commence until September 15), the deal for *Molly O'* must have been separate. Mabel was clearly not working under contract when she made *Molly O'*. Some contemporary reports (such as *Variety*, February 11, 1921) indicated that the deal with Sennett was for "a number of productions." But that agreement would not be concluded until sometime in the summer, when Mabel decided that she was comfortable signing with Sennett long-term again. The *Variety* report also gave the million-dollar figure.

## CHAPTER 15: GREATER THAN LOVE

95      "very modern and daring": Osborn described the project he and Gibby wanted to produce in court depositions, *Osborn*, October 20, 1923.

95      Although Elsie dies early: The plot of *Greater Than Love* was outlined in the *Chicago Daily Tribune*, August 3, 1921. The film appears to be lost.

95      But Osborn was feeling: In his court deposition, Osborn described banks "discouraging independent production on the grounds of theaters being held by trusts." Other would-be producers described similar frustrations, as Senator Jimmy Walker would describe in his speech to exhibitors in June 1921. *Wid's Daily*, June 3, 1921.

97      "made inquiries about setting up": Unsourced clipping, October 10, 1921, Patricia Palmer file, NYPL. Gibby said she had prepared outlines and budgets, but the producer (who she did not name, though it seems likely, given the timing, to have been Read) did not back her. This must have been the same project Osborn mentioned in the court record. As Gibby also stated to the reporter that she

had brought forward the proposal on her own, her partners having "not come through," I have concluded that Osborn dropped the ball, given his preoccupation with Rose and his emerging blackmail schemes.

## CHAPTER 16: THE SEX THRILL

99    At his five-hundred-acre estate: Zukor's estate and trap gun were described in the *New York Times*, May 3, 1921.

100   "the devil and 500 non-Christian Jews": *Variety*, December 31, 1920.

100   "I do not ask autocratic": *Variety*, March 4, 1921.

100   "The sex thrill": Various newspaper reports, including the *Mansfield (OH) News*, January 18, 1921; *Kingston (NY) Daily Freeman*, January 19, 1921; and *Uniontown (PA) Daily News Standard*, January 19, 1921.

101   the California legislature: *Los Angeles Times*, January 8, 1921.

102   "No picture showing sex attraction": *Variety*, February 25, 1921. The trade paper published the complete code of rules as provided by Lasky.

105   "an attack upon the sanctity": W. D. McGuire to Harry Durant, Famous Players–Lasky, June 13, 1921, National Board of Review Collection, NYPL (hereafter NBR).

105   "to cleanse the 'substance' ": *New York Evening World*, March 15, 1921; *New York Tribune*, March 21, 1921.

106   "If [a producer] cannot": W. D. McGuire to Adolph Zukor, June 9, 1921, NBR.

106   "un-American, dangerous, misguided": *New York Times*, February 15, 1920.

107   On the night of May 1: *New York Evening World*, May 3, 1921.

107   on board the SS *Aquitania*: *New York Tribune*, March 23, 1921.

## CHAPTER 17: PRYING EYES

108   "Let's go up": Earl Tiffany, witness statement, February 17, 1922.

108   It was a big, boxy thing: Detective Herman Cline would recall a garment "resembling a nightgown" being found in Taylor's dresser, and said it was "filmy" and "flesh-colored"; *Los Angeles Times*, February 4, 1937. It took the sensationalist writer Edward Doherty to turn something "resembling a nightgown" into a "dainty pink silk nightie"; *New York News*, February 6, 1922. Wallace Smith, Doherty's comrade in purple prose, added, without any basis in fact, that it was "frilled with lace"; *Chicago American*, February 6, 1922. This was picked up by other papers, including the *Los Angeles Times*, which pluralized the nightshirt into "silken things so strange to a man's wardrobe"; February 7, 1922. None of these newspapermen actually saw the garment. (And it certainly had no initials; that appears to have been a press invention.) If Cline said it only "resembled" a nightgown, then it could very well have been a large nightshirt; the fact that it was made of silk merely confirms Taylor's love of fine clothes. It seems unlikely that the garment belonged to any of the women Sands suspected: neither Mabel nor Mary ever spent the night at Taylor's, and Gerber and Taylor had been broken up for some time. So if Sands was correct that the nightshirt was being used, it seems almost certain that it was Taylor wearing it. In fact, a photo exists of Taylor wearing what might very well be the garment in question, a long, boxy, light-colored nightshirt. The black-and-white photo is reproduced in Charles Higham, *Murder*

*in Hollywood.*

109    "in a trick manner," "paid particular attention": *Los Angeles Times*, February 6, 1922.

109    The valet told Tiffany: Tiffany, witness statement.

109    Columnist Hazel Shelly: *Motion Picture Classic*, June 1921.

109    would soon be christened: The Cocoanut Grove officially opened at the Ambassador on May 25, 1921. *Los Angeles Times*, May 26, 1921.

109    "the precious cargo": *Los Angeles Times*, March 1, 1970.

110    "Mabel Normand has caught": *Los Angeles Times*, September 2, 1921.

110    born in Ohio: 1900 and 1910 US Census; World War I draft registration. For Sands's background, I also consulted Higham, *Murder in Hollywood*, which contained material shared with the author from Sands's family.

110    While on board: Court-martial proceedings of Edward F. Snyder, November 22, 1915, US Navy, reproduced on Taylorology, www.taylorology.com. Other information pertaining to Sands's military career comes from his various US Navy and US Army files, National Personnel Records Center, St. Louis.

111    "servant for life": *Los Angeles Examiner*, February 26, 1922.

111    "there never was a more devoted man": *Los Angeles Times*, February 3, 1922.

111    "defrocked priest": Hopkins, "Caught in the Act."

111    "In every way possible": Tiffany, witness statement.

112    the .45-caliber Colt revolver he carried around: Sands's friend George S. Brettner confirmed that the valet had a Colt .45; *Los Angeles Times*, February 10, 1922.

112    "Without a word": *Chicago Herald-Examiner*, February 10, 1922.

## CHAPTER 18: SO THIS IS WHAT IS GOING ON

113    "I wrote letters": *Los Angeles Herald*, August 14, 1923; *Los Angeles Times*, August 15, 1923.

114    "Oh, there is little Mary": Minter, witness statement, February 7, 1922.

115    "as if she were about to cry": Tiffany, witness statement.

115    "all of the time": My description of Hopkins's relationship with Taylor, as well as the anecdote about the performance of *Otello*, comes from Hopkins, "Caught in the Act," and from notes made by Charles Higham, who was in possession of the memoir.

115    "Everyone has been telling": *Los Angeles Times*, April 5, 1921.

## CHAPTER 19: FIVE THOUSAND FEET OF IMMORALITY

118    On his desk lay a financial statement: A description of Famous Players' finances, including a hand-drawn chart, was sent to Zukor from George G. Dominick on June 24, 1921. Zukor Collection.

119    "Motion pictures is the only industry": *Los Angeles Herald*, July 15, 1921.

120    "a clean sweep": *New York Times*, April 6, 1921.

120    "sex plays moral lessons": *New York Tribune*, April 6, 1921.

121    "Her idea of such a lady": *New York Times*, February 8, 1921.

121    "narrow-minded bigots": *New York Tribune*, April 6, 1921.

121    "matter had been handled": *New York Times*, June 2, 1921.

122    "one of the greatest legal battles": *Boston Globe*, May 28, 1921.

122    "to defraud certain men": *Boston Globe*, May 28, 1921.

123    "Well, so we move again": Gabler, *Empire of Their Own*.

## CHAPTER 20: BUNCO BABE

125    Gibby watched the man: Rose Putnam told police that their "first marks were traveling salesmen pointed out" to them at the Melrose Hotel in the spring of 1921. She did not say that it was Gibby who pointed them out to her, but the reference to the Melrose makes Gibby's involvement likely. Given their involvement in each other's schemes later, and Gibby's residence at the Melrose, I believe this is a fair assumption. FBI case files, October 1923.

127    "Patricia Palmer is back": *Philadelphia Evening Public Ledger*, June 18, 1921.

127    Rae would come home: Mabelle Anderson (Rae Potter Osborn), FBI case files, August 11, 1923.

127    Madsen was on the lam: FBI case files, August 11, 1923. Madsen was being sought for the crime, which had occurred on May 15, 1919. At the time, he went by the alias John C. Sheridan.

128    "looking around for victims": FBI case files, August 1, 1923.

128    every contact she'd ever had: Gibby told a reporter she approached "everyone she knew in the business who might give her a job"; unsourced clip, September 15, 1920, Locke Collection. Since Taylor was one of her most important contacts, I have taken her at her word and assumed she approached him and asked for his help. Obviously, looking at her filmography, he either did not assist her or his help was ineffective.

129    When he directed Judge Ben Lindsey: *Los Angeles Examiner*, February 5, 1922.

129    In May of that year: *Rocky Mountain News*, May 1, 1910.

130    Taylor would insist that he had quit: *Los Angeles Tribune*, July 6, 1914.

130    proved otherwise: *Moving Picture World*, April 18, 1914. It is true that at the same time that Taylor was let go with two weeks' notice, two other players, as well as a scenarist and a number of backstage employees, were also fired. While that could argue for a simple trim of the budget, it is hard to understand why the company would lay off Taylor just as *Captain Alvarez*, a very important picture, was about to be released.

130    One of her acquaintances: "Starke Patterson [*sic*] and Patricia Palmer out for the day at Venice Beach," *New York Mirror*, n.d. [1920], Locke Collection. For more information on Patteson, see US Census, 1920, 1930, 1940.

## CHAPTER 21: AMONG THE LIONS

131    revealed as two of the men: *Boston Globe*, June 25, 1921.

132    "Try and keep me": *Wid's Daily*, June 22, 1921.

133    "trustification" of the industry: *Wid's Daily*, June 3, 1921.

133    "were not very well liked": Adolph Zukor, interview by Stone.

134    "a liar and a crook": *Wid's Daily*, June 22, 1921.

134    George B. Christian: Details on the Christian controversy were reported in the

*New York Times*, February 17, February 21, 1924; *Wall Street Journal*, February 18, 1924; *Variety*, February 21, 1924.

135    "protect the exhibitor": *Wid's Daily*, June 29, 1921.

135    "accorded convention courtesies": *Appleton (WI) Post-Crescent*, June 28, 1921.

136    "It took a damned big man": *Wid's Daily*, June 29, 1921.

136    "that little man": *Exhibitors Trade Review*, December 3, 1921.

137    "There was nothing": William Brady, *Showman: My Life Story* (New York: Dutton, 1937).

138    "the face and eyes": Robert Grau, *The Theatre of Science: A Volume of Progress and Achievement in the Motion Picture Industry* (New York: B. Blom, 1914).

## CHAPTER 22: DEPRAVITY

140    "I went on to bed": FBI case file, August 11, 1923.

## CHAPTER 23: QUESTIONS OF LOYALTY

142    The McFarlan was a wreck: Details of Sands's theft and damage come from the *Los Angeles Record*, July 26, 1921; *Los Angeles Herald*, July 26, 1921; *Variety*, August 5, 1921.

143    threatening now to keep a diary: *Los Angeles Times*, February 4, 1922.

143    "a lovelight in his eyes": *Los Angeles Herald*, August 14, 1923; *Los Angeles Times*, August 15, 1923.

144    Late one August night: *Los Angeles Examiner*, February 12, 1922.

144    "A funny colored boy": *Los Angeles Examiner*, February 11, 1922.

144    "the assurance of one": *Los Angeles Examiner*, February 5, 1922.

144    The valet had come highly recommended: Peavey told reporters that he had worked for Mrs. Cabanne and that her mother had made the pants; *Los Angeles Record*, February 13, 1922. Christy Cabanne's wife in 1922 was his second spouse, Millicent Fisher. But she was living in New York, and in 1920, when Peavey, according to the US Census, came to Los Angeles, they were not yet married. As indicated in the census and in Peavey's World War I registration record, he hailed from the Berkeley–Oakland–San Francisco area; Cabanne's first wife, Vivien, was from Berkeley, where her mother worked as a seamstress.

145    Taylor paid his valet: Taylor probate file, creditor's claim, Henry Peavey, February 25, 1922.

## CHAPTER 24: A CLUSTER OF CALAMITIES

146    He'd come out tonight: *New York Tribune*, September 4, September 8, 1921; *New York Morning Telegraph*, September 11, 1921.

146    "Unless Marcus Loew": *New York Times*, September 4, 1921.

147    "in the interests of Metro Pictures": Marcus Loew to the Department of State, August 26, 1921, Arthur Loew US passport application.

147    Loew's new State Theatre: *New York Times*, August 30, August 31, September 4, 1921.

147    the Tufts trial had gotten under way: *Boston Globe*, July 11, July 12, July 13, August 10, August 11, August 12, August 14, 1921; *Hutchinson (KS) News*, July 12, 1921; *Atlanta Constitution*, July 12, 1921; various newspaper articles, Nathan

Tufts trial file, Boston Public Library.

147  "As a result of conspiracies": *Wall Street Journal*, August 31, 1921, September 2, 1921; *New York Times*, September 1, 1921.

148  "gobbling up" the industry: Zukor, *Public Is Never Wrong*.

149  "The general view was that": *Variety*, September 9, 1921.

149  Fatty Arbuckle Explains Death: *New York Evening World*, September 10, 1921.

## CHAPTER 25: A PRODUCT OF THE GUTTERS

150  Mabel Normand rang her old friend Mintrattie: *New York Journal*, September 14, 1921.

150  Mabel had nicknames: Minta Durfee, interview by Don Schneider and Stephen Normand, July 21, 1974, located at the Mabel Normand Source Book, www.mn-hp.com.

151  There were also rumors: For details and background on the Arbuckle arrest and trial, see David Yallop, *The Day the Laughter Stopped* (London: Transworld, 1991) and Stuart Oderman, *Roscoe "Fatty" Arbuckle* (Jefferson, NC: McFarland, 2005).

151  "A product of the gutters": *Kokomo (IN) Daily Tribune*, September 15, 1921.

152  "Picture the scene for yourself": As in the *Kokomo Daily Tribune*, September 15, 1921.

152  "in view of public feeling": *Variety*, September 16, 1921.

152  "a fire bell to awaken the public": *Anniston (AL) Star*, September 24, 1921.

153  "There is a dope ring": *Variety*, September 23, 1921.

153  "she photographed without": Sennett, *King of Comedy*.

153  she'd been sick in bed: Mabel Normand to William D. Taylor, telegram, June 26, 1921. The telegram was published in the *Los Angeles Examiner*, February 21, 1922, presumably discovered by reporters snooping through the murder scene or leaked by the studio for some reason.

154  On the night of September 15: *New York Morning Telegraph*, September 18, 1921.

154  Bursting into tears: *Variety*, September 23, 1921.

## CHAPTER 26: RIDING FOR A FALL

156  "At this time, when business": *Variety*, September 23, 1921.

156  So far he'd said nothing: *Los Angeles Times*, September 13, 1921.

156  "To have shown them": Zukor, *Public Is Never Wrong*.

157  At the age of fifteen: Zukor, *Publis Is Never Wrong*.

159  "I may say barely enough": Wire reports, as in *Salt Lake Tribune*, September 29, 1921.

160  "that famous party": *Kokomo (IN) Daily Tribune*, September 15, 1921.

160  "When something happens": Roscoe Arbuckle to Joseph Schenck, October 1, 1921, Zukor Collection.

160  "A man is kept busy": Zukor, *Public Is Never Wrong*.

## CHAPTER 27: BAD CHECKS

163  *Across the Border* had not been screened: Although announced in the trades as avail-

able in January 1922, *Across the Border* did not turn up on any screen until April, according to a digitized search of thousands of newspapers, and then only periodically thereafter. The film was still showing in second-class theaters into 1923.

164   Bryson and Rose had spent the night: George Weh provided testimony to the FBI in a report dated October 25, 1923. Although he claimed that the Cadillac Hotel incident occurred in the winter of 1922, "about the first part," meaning sometime between January and March, I believe he was off by a few months, as by that time Rose and Osborn were living together, and they were not at the time of this incident.

164   "dirty filthy evidence": Mrs. Mabelle Osborn to Don Osborn, July 31, 1923, transcribed in FBI case files, August 2, 1923.

164   They were leaving for San Diego: According to Bryson's death record, April 22, 1922, Peoria, Arizona, he was married at the time of his death. Did he marry after the episode with Osborn and Putnam, or was he going to commit bigamy with Rose? The record also indicates he was suffering from tuberculosis at the time of the incident.

## CHAPTER 28: THE HIGHEST POSSIBLE STANDARDS

166   "magnitude and importance": Will H. Hays to Adolph Zukor, December 12, 1921, Zukor Collection.

166   "We realize that in order": Adolph Zukor, et al., to Will H. Hays, December 2, 1921, reproduced in Terry Ramsaye, *A Million and One Nights: A History of the Motion Picture* (New York: Simon & Schuster, 1926).

167   "the pleasant talks": Will H. Hays to Adolph Zukor, December 12, 1921, Zukor Collection.

167   "You could put him": *Film Daily*, January 9, 1922.

167   "added up to public relations": Will H. Hays, *The Memoirs of Will H. Hays* (Garden City, NY: Doubleday, 1955). For more on Hays's time at the post office, see also Stephen Vaughn, "The Devil's Advocate: Will H. Hays and the Campaign to Make the Movies Respectable," *Indiana Magazine of History* 101 (June 2005).

167   "as it must appeal to any man": Will H. Hays to Adolph Zukor, December 12, 1921, Zukor Collection.

169   "Word comes from Los Angeles": "The Morals of Hollywood," originally published in the *Dearborn (MI) Independent*, December 10, 1921.

169   "I have always believed": *Memoirs of Will H. Hays*.

169   "Box office receipts": *New York Times*, July 23, 1922.

170   four or five times greater: *Wall Street Journal*, January 12, 1922.

170   "I knew that if I accepted": *Memoirs of Will H. Hays*.

170   "We have decided nothing": *New York Evening World*, December 8, 1921.

171   "would fill the *Encyclopedia Britannica*": Draft of speech, May 1922, Will H. Hays papers, which I used at the Boston Public Library (referred to hereafter as WHH).

171   "And precisely because": *Memoirs of Will H. Hays*.

## CHAPTER 29: ON EDGE

172   "not the slightest idea": *Los Angeles Times*, February 3, 1922.

172   One morning, as Peavey: *New York Telegraph*, January 8, 1922.

173     "In a freak of despondency": Minter, statement to the district attorney. In this
        statement, too, Mary talked about her relationship with Neilan and said that, in
        early December, she had not spoken to Taylor for any length in three months.

173     "it was over": Minter, statement to the district attorney.

174     just as the thought was crossing her mind: Mary described this accidental meeting
        with Taylor in the *Los Angeles Times*, August 15, 1923. The article stated that it
        was "a few nights afterward" that she went to his house, but in her statement to
        the district attorney's office, she was clear that she made the visit the same night,
        December 23.

174     Taylor had come downtown: Taylor's probate file reveals he purchased the hip case
        at Feagan's on December 23 for $25.00.

174     "This is something": *Los Angeles Times*, August 15, 1923.

174     "It is rather late": Minter, statement to the district attorney. For the most part, I
        have based my description of this episode on this statement, as it was given just a
        little over a month after the event. The account in the *Los Angeles Times* from 1923
        was provided by Mary a year and a half later, and contains much of the melodra-
        matic purple prose she was known for. Her 1922 statement, by contrast, seems
        very honest and straightforward.

175     Mary's midnight visit had deeply disturbed him: I have made this presumption
        because of the way Taylor described Mary's visit to Marshall Neilan a few weeks
        later, as found in Mary's statement to the district attorney. Taylor seemed to be
        expressing his honest feelings, brought out by having too much to drink. He told
        Neilan that, essentially, Mary had hit on him—that she had tried to seduce him
        the night she came to his apartment. According to Neilan, Taylor said that Mary
        had "undressed" in his apartment. But this is thirdhand information, from Taylor
        through Neilan through Mary. Still, Taylor had clearly been, in contemporary
        terminology, "freaked out" by Mary's visit, and was telling his friends how un-
        comfortable he had felt. I do not believe there was a second visit to Taylor's apart-
        ment in which Mary removed her clothes. If Mary had gone to Taylor's apartment
        after December 23, I think she would have mentioned it. Her February 7, 1922,
        statement is just too honest and straightforward for me to believe otherwise.

175     "So sorry to inconvenience": This letter was reported in many newspapers, as in
        the *Long Beach Telegram*, February 2, 1922, and a facsimile was published in the
        *Los Angeles Examiner*, February 23, 1922.

## CHAPTER 30: A WORK SO IMPORTANT

177     "I want to be William": *Memoirs of Will H. Hays*.

178     "We know we have secured": Statement draft, January 16, 1922, WHH.

178     Almost immediately: *New York Times*, January 16, 1922.

## CHAPTER 31: A GHASTLY STRAIN

179     In the early-morning hours: Mabel described this night in an official statement
        to Woolwine, though the statement has now been lost. Portions of it, however,
        were included in Sennett's *King of Comedy*. Mabel stated the party was held at the
        Alexandria Hotel. According to Howard Fellows, however, the Cocoanut Grove
        was the scene of the festivities. As Fellows was the driver, I've gone with the Grove.
        Howard Fellows, witness statement.

180    "very much excited": *Los Angeles Examiner*, February 8, 1922.

180    he laid out $1,250: Taylor's probate file.

180    During the second week of January: *Los Angeles Record*, January 13, 1922.

180    witnessed something he couldn't explain: *Los Angeles Examiner*, February 4, 1922.

181    "extremely reserved and diffident": *Los Angeles Examiner*, February 5, 1922.

181    "If I ever lay my hands": *Los Angeles Examiner*, February 4, 1922.

181    Ross had known Taylor: *Rocky Mountain News*, February 12, 1922.

182    "much smaller than the other": *Los Angeles Examiner*, February 3 and 12, 1922.

## CHAPTER 32: A HOUSE IN THE HILLS

183    Her part in the two-reel comedy: I'm grateful to Bruce Long's intensive research on the filming of *Cold Feet* in Truckee, California, documented with items from the *Los Angeles Herald*, February 20, 1922, and the *Oakland Tribune*, February 19, 1922, among others.

184    "cheap liquor": FBI report, October 25, 1923.

184    "a weak, diseased, decayed": Mrs. Mabelle Osborn to Don Osborn, July 31, 1923, reproduced in FBI report, August 2, 1923.

185    "a gang of eleven": George Lasher to John Bushnell, August 28, 1923, FBI report, October 25, 1923.

## CHAPTER 33: LAST DAY

186    While her chauffeur: I am indebted to Long's *Taylor: A Dossier* for compiling and collating all of Mabel's various statements of her visit to Taylor on that last night into one comprehensive account.

186    Floyd Hartley, the station's owner: *Los Angeles Times*, February 4, 1922. Also the Los Angeles city directory, 1921, 1922.

188    "surprisingly, tenderly understood": *Photoplay*, August 1921.

188    Mrs. Marie Stone: *Los Angeles Examiner*, February 12, 1922; US Census; Los Angeles city directories.

189    Catercorner from his apartment: MacLean gave his account of that morning a number of times, primarily in his witness statement of February 9, 1922, which survives in both the excerpted version and in *King of Comedy*, but also in various newspaper accounts.

189    "come from the corner": Christina Jewett, witness statement, February 9, 1922.

## CHAPTER 34: A SHOT

191    "a shattering report": *San Francisco Examiner*, February 6, 1922. My account is also supplemented by MacLean, witness statement, February 9, 1922.

## CHAPTER 35: THE DEAD MAN ON THE FLOOR

195    when she'd returned home around midnight: *Los Angeles Examiner*, February 3, 1922.

195    she picked up the telephone: Charles Maigne, witness statement, February 9, 1922. It is from Maigne that we know Purviance called Normand after hearing Peavey's cries.

195    Jesserun had been sick in bed: *Los Angeles Examiner*, February 3, 1922.

196     "absolutely stiff": Verne Dumas, witness statement, February 9, 1922.

196     "Mr. Taylor is dead": MacLean, witness statement, February 9, 1922, cited in *King of Comedy*.

196     dangled from a book, *Moon-Calf*: *Los Angeles Record*, February 2, 1922.

196     His checkbook was open: *Los Angeles Times*, February 4, 1922.

197     locked automatically: *Los Angeles Times*, February 3, 1922.

197     "was a little bit kicked up": Peavey, witness statement, February 4, 1922.

197     "I don't believe the man fell": Harrington, witness statement, February 9, 1922.

197     "wondering how on earth": Maigne, witness statement, February 9, 1922.

197     Jesserun admitted he'd heard the sound: *Los Angeles Record*, February 2, 1922. This is the source also for Jesserun seeing Taylor's lights burning all night. Several witnesses also gave statements that included their understanding that Jesserun had heard the shot.

197     "Murder": MacLean, witness statement, February 9, 1922. MacLean said he remembered the speaker as "a man from the house across the street from us" who had gone "over to Mr. Taylor's." As no account offers any other names than Harrington and Dumas as neighbors who entered Taylor's apartment that morning, I have concluded the man who said "Murder" must have been one of them. Indeed, the apartment of Harrington and Dumas was across the alley and courtyard from the MacLean's apartment, though on the same eastern side of the complex.

198     hand of the corpse was outstretched: There has been much confusion over this point. Other writers have interpreted Zeigler's comment, given in his statement at the coroner's inquest, February 4, 1922, as meaning that one *arm* was outstretched. But this was not what Zeigler said: "His hands, one of them apparently to the side of the body, and the other lying outstretched." No one else mentioned an outstretched arm; all other testimony reported that Taylor's arms were straight at his sides. A hand turned at the wrist may have been easy to miss by untrained eyes. Zeigler, more experienced in observation, took note of it, however. It may or may not have been an important detail—but it was definitely not an outstretched arm.

198     Zeigler had telephoned a doctor: This was stated plainly by Charles Eyton in his statement at the inquest, February 4, 1922.

198     Maigne noticed that the stack of canceled checks: Maigne, witness statement, February 9, 1922.

199     Well acquainted with the studio executive: Eyton, in his statement at the inquest, said the first man he noticed upon his arrival at Taylor's apartment was Zeigler, "whom I have known for a number of years."

200     Pulling them aside: In his statement of February 9, 1922, Harry Fellows said that he, Hoyt, and Maigne went upstairs. They would only have done so on instructions from Eyton. In his statement of November 30, 1925, Eyton said he "did not go through the house," but seemed to indicate Fellows, Maigne, and Hoyt.

200     "We got all the literature and things like that": Fellows, witness statement. Fellows also said that he handed the package of papers to Van Trees, who then gave them to his mother, Crawford-Ivers, from whom Fellows later retrieved them and brought them to Eyton at the studio.

200     Hopkins accepted another batch: Hopkins, "Caught in the Act." Hopkins also wrote of Crawford-Ivers and the hatpin.

200     "Charley," he pleaded: Eyton, witness statement, November 30, 1925.

200     the deputy coroner, William MacDonald, finally arrived: McDonald's examination was described by Eyton in his statement, November 30, 1925. Biographical details on McDonald come from the 1920 US Census.

201     "I should say it was a stomach hemorrhage": I have taken this quote, although changing it, from Frank Bartholomew's memoir, *Bart: Memoirs of Frank H. Bartholomew* (Sonoma, CA: Vine Brook Press, 1983). The reporter recalled the deputy coroner being told that Taylor had died of a heart attack. But several contemporary witness statements recalled that initial diagnosis as a stomach hemorrhage. I've concluded that Bartholomew remembered correctly the deputy coroner's sarcastic statement, but after sixty years, got the "heart attack" part wrong.

## CHAPTER 36: REACTIONS

204     "their pallor showing": *Los Angeles Express*, February 2, 1922.

204     Among the actors at the studio: Although Christie and members of the *Cold Feet* company had gone to Truckee, California, for location shooting by February 1, as an item in the *Los Angeles Record* makes clear, Gibby does not seem to have accompanied them. A careful consideration of the shooting script for *Cold Feet*, found in the Al Christie papers at the American Heritage Center, University of Wyoming, reveals that Patricia Palmer did not appear in any of the exterior location scenes. So she could well have been at the studio.

204     "thrown into a deep well": *Film Daily*, February 18, 1922.

205     "Taylor has been murdered": *Los Angeles Times*, August 15, 1923.

205     Mary didn't answer: In addition to Mary's newspaper interviews, I have used the Higham transcript in my description of Mary's reaction to learning of Taylor's death.

205     "laughing all the evening": Minter, statement to the district attorney. Walter Traprock was a pseudonym for George Shepard Chappell.

206     leaping up onto the running board: Chauncey Eaton, witness testimony, 1937, as reported in the Sanderson overview of the Taylor case, reproduced in Long, *Taylor: A Dossier*.

206     "Mr. Taylor's death comes": *Los Angeles Times*, February 3, 1922.

206     "Through a cowardly": *San Francisco Chronicle*, February 3, 1922.

206     Eyton began going through: The order in which studio officials learned of the contents of Taylor's papers is conjecture on my part. However, the chain of command went from Eyton to Lasky to Zukor, as other records indicate.

207     Mary jumped out: My account of Mary's postmurder visit to Alvarado Court comes from the *Los Angeles Times*, February 3, 1922, and *Los Angeles Examiner*, February 3, 1922.

207     "His blood!": *Los Angeles Record*, February 2, 1922.

208     "a thousand of them": I've based my account of Mary's visits to the undertaker and to Mabel on the Higham transcript.

## CHAPTER 37: KING OF THE COPS

211     hauled off and punched a defense lawyer: *Los Angeles Times*, March 18 and 19, 1922.

211     "carnival of extravagance": *Los Angeles Times*, October 1, 1921; January 5, 1922.

212     "The 'bumping off'": Edgar King, "I Know Who Killed William Desmond Taylor," *True Detective Mysteries*, September and October 1930, reproduced in Long, *Taylor: A Dossier*.

212     "solved more major crime mysteries": *Los Angeles Times*, March 12, 1924.

212     entered the victim's left side: Coroner's inquest, February 4, 1922.

213      Taylor had met with his daughter: Police discovered evidence of Taylor's abandoned family probably late on February 2, although the first reports in the press did not appear until February 4.

213      But King wasn't so sure: For my description of King's thinking and methods, I have gleaned as much as possible from King, "I Know Who." I am also grateful to his family for providing context and additional details and insights.

214      Besides, their only eyewitness: *San Francisco Examiner*, February 6, 1922.

214      "He was dressed like": MacLean, witness statement. Although this no longer survives, it was reproduced in Sennett, *King of Comedy*.

215      Two streetcar operators; "inclined to think": *Los Angeles Times*, February 4, 1922.

216      JEALOUS MAN HUNTED: *Los Angeles Examiner*, February 3, 1922.

216      POLICE CONVINCED EITHER WOMAN: *San Francisco Examiner*, February 3, 1922.

216      offered King a lead of his own: King, "I Know Who."

217      "the smallest man in stature": *Los Angeles Times*, March 12, 1924.

217      Six years earlier: *Los Angeles Times*, April 30, 1916.

218      "handled any hop": See the statement of Earl Tiffany, February 17, 1922.

218      "From cellar to attic": King, "I Know Who."

## CHAPTER 38: THE MORAL FAILURES OF ONE CONCERN

220      hurrying to meet Cecil B. DeMille: *New York Morning Telegraph*, February 4, 1922; *New York Times*, February 4, 1922; *New York Tribune*, February 4, 1922.

220      "I have just heard": *Los Angeles Times*, February 4, 1922.

221      "The murder of any screen director": Zukor, *Public Is Never Wrong*.

222      "It is police experience": *Los Angeles Examiner*, February 4, 1922.

223      "It is a shame": Unsourced clipping, February 5, 1922, William Desmond Taylor file, NYPL.

223      "The police theory that a woman": *Los Angeles Record*, February 4, 1922.

223      "resources of time and money": *San Francisco Chronicle*, February 3, 1922.

223      "Only a while ago": *Fort Wayne (IN) Journal-Gazette*, February 12, 1922, courtesy Bruce Long.

224      "This fearsome scandal": *Uniontown (PA) News Standard*, February 11, 1922, courtesy Bruce Long.

224      "mad pursuit of twentieth-century": *Danville (VA) Bee*, February 6, 1922, courtesy Bruce Long.

224      "The thing to get excited": *Fargo (ND) Forum*, February 18, 1922.

224      "The motion picture industry": *McKean (PA) Democrat*, February 10, 1922, courtesy Bruce Long.

224      On the day Taylor's body: Roland Roloff [*sic*] to Will Hays, February 3, 1922, WHH.

224      "absolutely no plans": *Washington Times*, February 9, 1922.

225      "a production program that eclipses": *Variety*, February 3, 1922.

225      The national economy: US Census, Historical Statistics of the United States, 1976.

225      company's net income had plunged: August 1922, WHH.

## CHAPTER 39: "DO YOU THINK THAT I KILLED MR. TAYLOR?"

227    Mary stepped gingerly: Higham transcript.

228    "as a mere child": *Los Angeles Examiner*, February 4, 1922.

228    That evening, unable to sleep: Minter, statement to the district attorney.

## CHAPTER 40: POWDER BURNS

231    In the shooting gallery: *Los Angeles Examiner*, February 6, 1922.

232    "rather than continue": *Los Angeles Herald*, February 6, 1922.

232    "woman supplied the incentive": *Phoenix Gazette*, February 4, 1922.

233    Crowds had started: The inquest was described in detail by the *Los Angeles Examiner*, February 5, 1922, and *Los Angeles Times*, February 5, 1922.

233    "Hey, mac!": Unsourced item, William Desmond Taylor file, NYPL.

234    "who adhered to the belief": *Los Angeles Herald*, February 6, 1922.

235    "If it would help": King, "I Know Who." Although King wrote that Hoyt's visit to Taylor was on the night before the murder, it's possible he or Hoyt had their days mixed up. W. A. Robertson in his statement to police of February 9 said that Hoyt was present when Taylor told a similar story about Minter on Saturday, January 28, a night when Taylor was out with Hoyt and Robertson, first at the Los Angeles Athletic Club and then at the Annandale Country Club. *Los Angeles Times*, February 5, 1922.

236    the city's first "speed cop": *Los Angeles Times*, March 12, 1924.

236    luxurious touring car: *Los Angeles Times*, February 4, 1922; *Los Angeles Examiner*, February 4, 1922.

236    "may have had knowledge": *Los Angeles Herald*, February 6, 1922.

237    "I can't see why": *New York Daily News*, February 6, 1922.

237    "short and heavyset": *Los Angeles Examiner*, February 4, 1922.

## CHAPTER 41: EVIDENCE FOUND

238    "piled high with papers": *Los Angeles Times*, February 6, 1922.

238    "letters and personal belongings": My account of King's detective work comes from King, "I Know Who," and e-mails with his family.

238    everyone knew that Eyton had them: It was reported in *Variety*, February 10, 1922, that "a studio official" had taken Mabel's letters.

239    Famous Players could not appear: That police were threatening Eyton seems clear from many of the newspaper accounts. *Variety* reported it plainly on February 10, 1922, though the paper did not name Eyton: "Authorities made a direct threat and he then placed the letters in a shoe of Taylor's."

## CHAPTER 42: DAMES EVEN MORE DESPERATE

240    "Never before in the history": My description of Taylor's funeral comes from the *Los Angeles Examiner*, February 8, 1922; *Los Angeles Times*, February 8, 1922; and other local coverage.

241    "correct any false impressions": *Exhibitors Trade Review*, February 18, 1922.

242    "the 'hop' feasts": *New York Daily News*, February 8, 1922.

242    "Get it straight, please": *Los Angeles Examiner*, February 6, 1922.

243    "compelled to handle": *Los Angeles Examiner*, February 8, 1922.

243    "the blackmailer of the century": *Philadelphia Inquirer*, February 5, 1922.

244    Mrs. Shelby had hired: *Los Angeles Record*, February 8, 1922.

245    "If [Mary's contract is] renewed": *Film Daily*, January 3, 1922.

245    "The studio was using the situation": *Oakland Tribune*, July 1, 1933. This was from a deposition made by Leslie Henry, a former employee of Charlotte Shelby. See Bruce Long, "Why Were Minter's Love Letters Given to the Public?" on Taylorology.

246    "unknown in a man's wardrobe": *Los Angeles Examiner*, February 6, 1922.

247    "long and grueling": *St. Louis Globe Democrat*, February 7, 1922.

## CHAPTER 43: THE NEED FOR VIGILANCE

249    "at the end of his rope": *Variety*, February 10, 1922.

250    "narrowly escaped trouble": *Variety*, February 10, 1922.

250    Cecil B. DeMille had scrapped: *Los Angeles Times*, February 10, 1922.

251    Mrs. Evelyn F. Snow: *Variety*, February 3, 1922.

251    "There's no more immorality": *New Castle (PA) News*, February 7, 1922.

251    "We all deplore": *New Castle News*, February 14, 1922.

251    Not for several days: "Adolph Zukor, president of Famous Players–Lasky Corporation, by whom Taylor was employed, arrived in Los Angeles yesterday afternoon. Zukor immediately went into seclusion and refused to be interviewed on any subject yesterday." *Los Angeles Examiner*, February 13, 1922.

252    "all publicity records": *Variety*, October 6, 1922.

252    Ten thousand circulars: *Los Angeles Express*, February 7, 1922.

252    *that* was a storyline: See Bruce Long, "Did Drug Gangsters Kill Taylor?" in *William Desmond Taylor: A Dossier*.

252    "Billy Taylor threatened": *New York Evening World*, February 14, 1922.

253    "one of the hardest fighters": *Moving Picture World*, March 4, 1922.

253    "a number of persons": *San Francisco Examiner*, February 9, 1922.

253    "took an absorbing interest": *Boston Globe*, April 21, 1918.

253    "Because of the Taylor murder": *Boston Globe*, February 14, 1922; see also *Variety*, February 17, 1922.

254    "vigilance committee": *New Castle (PA) News*, February 15, 1922.

255    After spending about a week: Edwin Schallert's column, *Los Angeles Times*, February 23, 1922.

## CHAPTER 44: TAKING HIM FOR A FOOL

256    "a wonder at concocting": *Denver Post*, March 3, 1922.

256    the former valet requested: *Los Angeles Times*, February 6, 1922.

256    "I am not doing": *Los Angeles Times*, February 22, 1922.

257    a fireplug of a man: Details on Carson come from Florabel Muir, *Headline Happy* (New York: Henry Holt, 1950); *New York Times*, March 20, 1941; *Time*, March

31, 1941. Although Muir gave the impression that she went along on the jaunt to the cemetery, contemporary reports and Peavey's statements do not give any evidence of a woman being present outside the *Examiner* office.

258     Under further questioning: *San Francisco Examiner*, February 21, 1922.

260     the NAACP filed: *Chicago Defender*, March 11, 1922.

## CHAPTER 45: MR. HAYS GOES TO WORK

262     "satisfactory progress": Dr. Mark O. Davis to Will Hays, March 9, 1922, WHH.

262     "an extremely early": *Boston Globe*, April 9, 1922.

262     "I am reminded": Will H. Hays to Frank Munsey, January 21, 1922, WHH.

262     "To attain and maintain": Will Hays to W. V. Robb, January 24, 1922, WHH.

262     "clean-up campaign": *Madison (WI) State Journal*, March 4, 1922.

263     "developing economies": *Madison State Journal*, March 4, 1922.

263     "sanity and conservatism": *New York Times*, July 23, 1922.

263     "If the public does indeed": *New York Times*, July 23, 1922.

263     "never have to turn red": *New York Times*, March 17, 1922.

264     A friend at the New York: James G. Blaine to Will Hays, January 17, 1922, WHH.

265     "The motion picture industry": *New York Times*, March 17, 1922.

## CHAPTER 46: THE MORBIDLY CURIOUS

266     "a cozy little place": *Hartford (CT) Times*, March 13, 1922. See *Los Angeles Times*, March 9, 1922, for Patterson's death.

267     "She giggled all afternoon": *Captain Billy's Whiz Bang*, June 1922.

267     In Lynn, Massachusetts: *Boston Globe*, February 14, 1922; see also *Variety*, February 17, 1922.

267     "Mabel knows enough": *New York Globe*, February 13, 1922.

268     "to talk above": *Los Angeles Examiner*, February 15, 1922.

268     "I talked with Mabel": *Boston Advertiser*, February 20, 1922.

268     "a typically Mabel Normand": *Chicago American*, February 11, 1922.

268     "Following this theory": *Chicago American*, February 11, 1922.

268     "a large roll of bills": *Los Angeles Record*, February 17, 1922.

269     in a sudden burst of determination: *Film Daily*, March 29, 1922.

## CHAPTER 47: HER OWN BOSS

270     Boasting connections: A thorough digital search of the *Los Angeles Times*, *New York Times*, *Film Daily*, *Exhibitors Trade Review*, and *Exhibitors Herald* revealed no "Independent Producers Distributing Syndicate," which was the way the company was referenced in newspaper notices of Gibby's new production concern. But a new "Independent Producers Syndicate," formed by James Calnay, was mentioned in *Film Daily*, June 19, 1922, at the same time Gibby's notices were appearing in newspapers. At the time, Calnay was gathering many investors for various start-up companies, as subsequent court fights would detail. Gibby's distributor was not the longer-established Independent Producers and Distributors

Association, which was a trade organization, not a distributing company.

270    "a series of six five-reel": *Variety*, May 24, 1922; *Oakland Tribune*, June 18, 1922.

271    she was planning to roust Don Osborn: I am speculating about this, given Gibby's statement to the FBI: "When I was to produce my own pictures, I offered him a job." November 1, 1923.

## CHAPTER 48: NO TIME TO TALK

272    Charlotte Shelby had known: Exactly when detectives first tried to interview Shelby is unclear, but Jesse Winn said that it was "immediately after the discovery of Taylor's body"; *Los Angeles Daily News*, September 9, 1937. Although it doesn't appear to have been "immediately," the attempted interview probably occurred within the first few weeks of the investigation.

272    "for the purpose": King, "I Know Who."

273    "whoever killed Taylor": Interview with Nicole Westwood, granddaughter of Thomas Woolwine.

274    She was heading back: Mrs. Miles's trip and her disposal of the gun were revealed in her granddaughter Margaret's testimony. See, for example, the *Los Angeles News*, September 13, 1938.

## CHAPTER 49: A GREAT INJUSTICE HAS BEEN DONE

275    "Every inch of his huge frame": *Washington Herald*, April 13, 1922.

275    "Acquittal is not enough": *New York Times*, April 13, 1922.

276    "very pleased": *Los Angeles Times*, April 13, 1922.

276    "for the purpose of gauging": Associated Press, as in the *Ogden (UT) Standard-Examiner*, April 13, 1922.

276    On the announcement: *Variety*, April 21, 1922.

276    "If [audiences] flock": *Alton (IL) Evening Telegraph*, April 14, 1922.

277    "the fans who have waited": *Los Angeles Times*, April 17, 1922.

277    "without any reference": *Film Daily*, April 18, 1922.

278    Liberty Theatre polled: *Film Daily*, April 21, 1922.

278    "the privilege to be the first": *Helena (MT) Daily Independent*, April 18, 1922.

278    "The public knows full": *Kokomo (IN) Tribune*, April 13, 1922.

278    "to intervene and prevent": *San Antonio Express*, April 16, 1922.

278    In Hartford, Connecticut: *Hartford Courant*, April 16, 1922.

279    reformers made sure: These two examples were reported in *Film Daily*, April 22, 1922.

279    Hays was summoned: Although some news reports implied the meeting took place at Hays's office, it seems more likely, given the Famous Players memo that the agreement was written upon, that the principals all gathered in Zukor's office.

280    "well-nigh bankrupt": *Memoirs of Will H. Hays*.

281    Hays who had "prevailed upon": *Variety*, April 21, 1922.

281    "After consultation at length": The draft and the typed release are both in Hays's

files, WHH.

281    "hat and coat in hand": *New York Times*, April 19, 1922.

282    "I thought I was well-started": *New York Times*, April 20, 1922.

282    "very homesick for you all": Will Hays to Mrs. S. D. Puett, April 18, 1922, WHH.

282    "The action is regarded": *New York Times*, April 20, 1922.

## CHAPTER 50: A QUESTION OF MOTIVES

283    Connette had implied: *Honolulu Advertiser*, April 26, 1922.

283    "first society man": See, for example, the *Salt Lake Tribune*, February 2, 1913; *Washington Post*, October 28, 1913; *Indianapolis Sunday Star*, January 11, 1914; and *San Antonio Light*, January 17, 1915. Other biographical detail on Connette comes from the US Census, his passport application, ship passenger lists, and his World War I registration file.

284    he wrote articles: See, for example, *Hilo Tribune*, March 14, 1922.

284    7000 HOLLYWOOD RUMORS: *Variety*, February 10, 1922.

284    received a police report: *Oakland Tribune*, February 11, 1922.

285    "a moment of levity": *Honolulu Star-Bulletin*, April 26, 1922.

## CHAPTER 51: A COMPANY OF OUTLAWS

286    "not cooperating with the studio": This comes from "Twisted by Knaves," an unpublished, incomplete manuscript, generally accepted to have been Charlotte Shelby's attempt at a roman à clef. Located at the Margaret Herrick Library, AMPAS, it was also briefly available in a synopsis form online. That Shelby was with the company in Wyoming was confirmed by an item in *Variety*, August 11, 1922.

287    her costar, a spitfire: I am speculating that Mary and Gibby developed a close relationship on this film, but it is based on some reasoning. If we accept "Twisted by Knaves" as an accurate description of Shelby's feelings, then her concern over Mary's friendship with the "least desirable" of the company is quite telling. Tom Moore, the leading man, was pretty upstanding, and I've found no negative reports about others on the film. But Gibby, Leonard Clapham, and Viora Daniel, who'd later be called a gold digger by her wealthy husband's family in divorce court (*Galveston Daily News*, September 11, 1932), had somewhat unsavory connections. It seems likely this trio were the ones Shelby described as a "motley crew."

287    Mary had known Palmer: *Indianapolis Star*, March 1, March 4, 1916.

287    "more beautiful than the Swiss Alps": *Salt Lake Tribune*, August 8, 1922.

287    "I've stood in the stillness": A page from Mary's diary, dated February 25, 1922, apparently taken from her estate before her death, was posted on an auction site online.

288    "Many of those letters": *Los Angeles Herald*, August 14, 1923.

288    later that year a warrant: *Los Angeles Times*, January 24, 1923; September 6, 1923; May 2, 1924; May 3, 1924; September 7, 1924; US Penitentiary Records, 1895–1936. Calnay had been charged with embezzlement by Olympian Productions, a minor production company, though the charges were dropped (*Los Angeles Times*, November 5 and 9, 1921). *Film Daily* had written skeptically of his plans to start a new company on June 19, 1922.

289     They boarded the Oregon Short Line: Details of the train accident come from the *Salt Lake Tribune*, August 7 and 8, 1922; and the *Ogden (UT) Standard-Examiner*, August 7, 1922.

## CHAPTER 52: THE SAVIOR

291     Thirty thousand people: *Los Angeles Times*, July 30, 1922.

291     "the Caesar of the Cinema": *Los Angeles Times*, July 21, 1922.

292     From the roof of every studio: *Los Angeles Times*, July 22, 1922.

292     "I wish you would let me": Will Hays to Adolph Zukor, June 22, 1922, WHH.

292     "Unquenchable enthusiasm": *Los Angeles Times*, July 30, 1922.

293     "For the life of me": *Los Angeles Times*, July 28, 1922.

293     ""little Napoleon of the Movies"": *Los Angeles Times*, July 25, 1922.

294     "an active young Republican": *Los Angeles Times*, March 25, 1921. Other issues of the *Times* attesting to Herron's involvement in the party include September 14, 1920, and August 5, 1921, among others.

294     was declared obscene: Associated Press, as in *Hutchinson (KS) News*, May 23, 1922; *Variety*, June 1, 1922.

295     a cross-section of decent, law-abiding America: The list of the Committee of Public Relations, dated June 1, 1922, is found in the archives, MPPDA.

295     "If we can preserve": Will Hays to Adolph Zukor, September 5, 1922, Zukor Collection.

296     former comedian had written to Hays: Although Arbuckle's letter to Hays does not survive, some of its contents can be deduced from Hays's response.

296     "In this whole matter": Will Hays to Roscoe Arbuckle, June 5, 1922, WHH.

296     "What is the matter": W. D. McGuire to Charles Pettijohn, May 24, 1922, NBR.

297     "a vast load": *Los Angeles Times*, June 25, 1922.

297     recent brouhaha in Seattle: *Film Daily*, May 9, 1922.

297     "very grateful": Minta Arbuckle to Will Hays, June 20, 1922, WHH.

## CHAPTER 53: THE SKY'S THE LIMIT

299     The gross national product: US Census, Historical Statistics of the United States, 1976.

299     "A beehive is a slow": *Los Angeles Times*, June 29, 1922.

299     Although earnings were actually: *Wall Street Journal*, March 23, 1923.

299     "We believe the depth": *Motion Picture Classic*, April 1922.

299     Zukor's customary whisper: Unsourced article, September 1, 1922, Adolph Zukor file, NYPL.

299     That would make the Paramount larger: News reports of Zukor's plans, however, said that the Paramount would be the "second largest" theater, apparently due to square footage. See *New York Times*, June 3, 1922.

299     "sit up to all hours": Zukor, *Public Is Never Wrong*.

300     "to create the perception": Stephen Vaughn, "The Devil's Advocate: Will H. Hays and the Campaign to Make Movies Respectable," *Indiana Magazine of History* 101 (June 2005).

300    "Your attitude in this matter": Carl Laemmle to Adolph Zukor, January 10, 1923; Adolph Zukor to Carl Laemmle, January 11, 1923, Zukor Collection.

302    "laid a bet on who": Zukor, *Public Is Never Wrong.*

## CHAPTER 54: THE SPIRITS SPEAK

304    "As a matter of fact": *Los Angeles Examiner*, February 18, 1922.

305    "a funny thing": King, "I Know Who."

306    "Wasn't that person": *Joplin (MI) Globe*, May 23, 1922.

307    "Yesterday afternoon an unknown": *Los Angeles Times*, October 4, 1922.

307    "E. C. King, on the district attorney's staff": *Los Angeles Record*, October 4, 1922.

307    "the name of the woman": King, "I Know Who."

## CHAPTER 55: LAST CHANCE

309    They'd found a creditor: Los Angeles chattel mortgage deeds, February 23, 1923, date entered into agreement "four months ago."

310    spent some time in the slammer: FBI file, August 11, 1923. Madsen's detailed arrest record stretched back to 1916. He was arrested on July 11, 1922, and sentenced on July 20. By early August, according to FBI reports, he was back in Los Angeles.

311    "a series of petty bunco jobs": FBI file, November 13, 1923.

311    "feeling very confident": Court depositions, Southern District of Ohio, 1923.

311    Back in her hometown of Brattleboro: Biographical details of Rose Putnam come from the US Census, 1900, 1910, 1920; *Vermont Phoenix*, November 22, 1907; May 13, 1910; February 24, 1911; May 9, 1911, January 5, 1912; Vermont marriage records, Walter O. Cooley and Rose Putnam, January 2, 1912.

311    wealthy Beatty Balestier: Divorce suit of Walter Cooley and Rose Putnam Cooley, November 26, 1919, Vermont State Archives. Cooley was apparently content to simply live apart from his wife, but Rose filed suit against him on September 9 charging "intolerable severity and desertion." Cooley then filed his own suit against Rose on October 20, charging desertion. He also filed an alienation-of-affection case against Balestier. The court dismissed Rose's suit and gave the divorce to Walter. *Brattleboro Weekly Free Press*, September 11, 1919, and October 23, 1919. For more on Cooley, see *Brattleboro Weekly Free Press*, March 5, 1914, January 30, 1919, and May 8, 1919; clipping, June 20, 1947, Brattleboro Historical Society.

311    John L. Bushnell of Springfield, Ohio: Biographical details from the US Census 1880, 1900, 1910, 1920; *20th Century History of Springfield and Clark County, Ohio, and Representative Citizens*, 1908; *Standard History of Springfield and Clark County*, 1922; Springfield, Ohio, city directories; *Springfield News*, September 16, 1910; *Boston Globe*, June 10, 1919; *New York Tribune*, November 20, 1920; passport application, July 23, 1923.

311    Bushnell wrote asking her: Rose Putnam Cooley, statement, July 11, 1923, FBI files.

312    "Bushnell had sexual relations": FBI report, July 16, 1923.

312    Remarkably, Lasky agreed: At first glance, it's tempting to speculate that Gibby had been given a three-picture contract by Lasky in spring 1922. But it's highly

unlikely that Lasky (and Zukor) would allow a contract player in the midst of her contract with them to go out and produce independent pictures.

312     *Mr. Billings Spends His Dime*: Reid's drug-related illness would soon force him out of the picture; he would be replaced with Walter Hiers.

## CHAPTER 57: TRIGGER HAPPY

317     "unhappily situated": FBI report, July 16, 1923.

318     Blackie Madsen was fifty years old: My description of Blackie Madsen comes from FBI reports, census records, and his military records. Although his death certificate gives his year of birth as 1864, and indeed the FBI believed him in 1923 to be between fifty-five and sixty years of age, the 1870 and 1880 censuses as well as his military records (1898) agree that he was born in 1872.

319     "His early youth": *Wichita (KS) Daily Eagle*, October 29, 1901.

319     eighteen-year-old Ross took a job: Independence city directories; *Indicator: A National Journal of Insurance* 9 (1890).

319     "highly respected" in her field: *Wichita Daily Eagle*, October 29, 1901.

319     When the United States declared: Returns from Military Posts, National Personnel Records Center. Sheridan enlisted on May 12, 1898, in St. Louis, and was discharged on February 24, 1899, at Puerto Principe, Cuba.

319     Sheridan at least got: *Wichita Daily Eagle*, October 29, 1901. That Madsen still carried a wartime revolver was referenced when his weapon was described as "Spanish war vintage" (*Osborn*, 1923).

319     "the two men were jealous": Details of Sheridan's involvement with Clara Williams and his attack on William Arista "Writ" Berkey come from the *Kansas City Star*, October 28, 1901; *Wichita Daily Eagle*, October 29, 1901; *Jackson (MO) Examiner*, November 1, 1901.

320     But finally he realized: *Kansas City Star*, April 19, 1902.

320     "one of a bunch": San Diego police report, included in FBI report, August 11, 1923.

321     The five-story Beaux Arts: *20th Century History of Springfield and Clark County, Ohio, and Representative Citizens*, 1908. Background on the Bushnells and the Bushnell Building comes from various materials compiled by Clark County Historical Society.

321     The banker's appearance: My description comes primarily from Bushnell's passport application, which also included a photo.

322     He'd just gotten back: *New York Tribune*, November 16, 1922.

322     "put up something": FBI report, July 16, 1923.

323     "a special agent and inspector": *Osborn*, 1923.

## CHAPTER 58: A COLD-BLOODED BUSINESS

325     expected at the Sennett: *Variety*, December 1, 1922.

325     No one thought to look: *Indianapolis Star*, November 5, 1922.

326     "turned into gold": *Los Angeles Times*, September 13, 1922.

326     "You all made me so": Mabel Normand to Rose, December 10, 1922, in the Mabel Normand Sourcebook.

326     "give parties and plan dinners": *Los Angeles Times*, December 28, 1922.

327     "Tragedy and scandal": *Los Angeles Herald*, January 13, 1923.

327     "spread from coast to coast": *Los Angeles Times*, December 16, 1922.

328     "With some dailies": *Variety*, December 22, 1922.

329     "Actors are no longer heralded": Unsourced article, n.d. [1922], Ellen Terry file, NYPL.

329     At the eleventh hour: A Sennett representative confirmed that Mabel had sailed on the *Majestic* and that her decision to spend Christmas in London was made "somewhat unexpectedly." He denied, however, that her departure had anything to do with Wallace Reid's breakdown. *Los Angeles Times*, December 22, 1922.

329     The *Majestic* was the last ship: *New York Times*, December 16, 1922.

## CHAPTER 59: NO HAPPY ENDINGS

330     "silver-tongued orating": *Washington Times*, December 15, 1922.

331     "his sympathy, his hopes": *Los Angeles Times*, December 20, 1922.

331     The Methodist Preachers Association: *Los Angeles Times*, December 18, 1922.

331     "those in authority": *Los Angeles Times*, December 20, 1922.

331     "If Reid's condition": *New York Times*, December 19, 1922.

331     Hays was hoping: There were press reports that Hays planned to meet with Arbuckle. Associated Press, as in the *Twin Falls (ID) Daily Times*, December 11, 1922.

332     "neutral channels": Memo, July 8, 1922, WHH.

332     "very formidable": Memo, September 6, 1922, WHH.

333     "long deliberation": *Memoirs of Will H. Hays*.

333     "I believe that every fair thinking man": *Variety*, October 27, 1922.

333     "unlimited amounts of capital": *Variety*, October 13, 1922.

333     "going stronger than any": *Film Daily*, July 10, 1922.

334     "Roscoe Arbuckle is to have another chance": *Los Angeles Times*, December 21, 1922.

335     "With a membership": *New York Times*, December 21, 1922.

335     "who are helping to pay": *Film Daily*, December 23, 1922.

335     "Arbuckle was acquitted": *New York Times*, December 26, 1922.

337     "This organization": *Olean (NY) Evening Herald*, December 27, 1922.

337     "The wild eyed reformers": *Film Daily*, January 3, 1923.

337     "the Anvil Chorus": *Memoirs of Will H. Hays*.

337     "in any form among the humbler people": *New York Times*, July 23, 1922.

338     "I am sorry if my decision": Minutes of meeting of the Public Relations Committee, January 4, 1923, MPPDA.

339     "a complete loss": *Film Daily*, January 15, 1923.

339     Theatrical producer Arthur Hammerstein: Hammerstein to Zukor, December 26, 1922, Zukor Collection.

## CHAPTER 60: RAISING CAPITAL

340 Slowing her car down: The accounts of Gibby's escapade with Lasher in Tijuana and their attempts to retrieve the check are documented in FBI records, October 25, 1923, November 2, 1923, and are based on the testimonies of Gibby, Lasher, and Jim Dallas, with Dallas's account seeming the most accurate and Gibby's the least. Additional information on Dallas and Edward Rucker from the census and World War I registrations. Rose Putnam's buying spree was also described in the FBI records.

340 "Why, sure I fell": *Los Angeles Record*, November 5, 1923.

341 "rounded out": *Oakland Tribune*, July 1, 1922. For more on Miller, see *Oakland Tribune*, February 8, 1920; *Film Daily*, July 2, July 26, 1923.

343 also paid her $585: According to the FBI report of November 2, 1923, the equity was assigned to Osborn on March 9, 1923. However, there is no record of this in Los Angeles property records.

343 "The girl's ma": *Los Angeles Record*, November 5, 1923.

344 "I am a stranger to you": FBI records, July 16, 1923; October 25, 1923.

## CHAPTER 61: A NEW MAN ON THE JOB

345 "I know I am a sick man": *Los Angeles Times*, March 9, 1923.

346 "People on the inside of the game": *Movie Weekly*, March 24, 1923.

346 "wrought-iron constitution": *Los Angeles Times*, June 7, 1923.

346 The two women obtained passports: Passports were issued for both Mary and Shelby on May 17, 1923, with a trip to Japan, China, Hong Kong, and Korea scheduled for June. The trip was never taken.

## CHAPTER 62: UNFAIR COMPETITION

348 a tall, rangy Oklahoman: *Variety*, April 26, 1923.

348 He sailed off for Europe: *New York Times*, February 20, 1923.

349 Independent producer Al Lichtman: *New York Evening World*, April 27, 1923.

349 "weekly receipts as large": *New York Times*, April 28, 1923.

349 "The same day we put Zukor on the stand": *Film Daily*, May 26, 1923.

350 "take over Metro": *Film Daily*, June 17, 1923.

350 "When the Sioux started": Ramsaye, *Million and One Nights*.

351 "it countenances government commissions": *New York Times*, June 9, 1923.

## CHAPTER 63: TRAPPED LIKE RATS

352 On the hot, humid morning: My account of the shakedown and arrest comes from FBI records, July 16, July 18, 1923; *Springfield (OH) Daily News*, July 13, July 14, July 15, July 16, July 17, 1923; *Sandusky (OH) Register*, July 14, 1923; *Mansfield (OH) News*, July 14, 1923; *Sandusky Star Journal*, July 14, 1923.

354 John A. Ryan: Ryan's gambling den is described in an FBI report of January 2, 1924.

356 "numerous prominent motion picture people": *Los Angeles Times*, July 16, 1923; *Springfield Daily News*, July 17, 1923.

## CHAPTER 64: COMING OUT OF HIDING

358 "as happy as Easter morning": Sennett, *King of Comedy*.

359     Mabel even attended: *Photoplay*, September 1923.

360     "It is too bad": *Los Angeles Examiner*, August 16, 1923.

361     With the help of her friend: I am surmising that McPherson was involved in this scheme as Charlotte Shelby, in "Twisted by Knaves," blamed her for trying to take over Mary's career at this point.

361     McPherson's story: *Los Angeles Times*, August 13, 1923.

361     "Police do not take the matter seriously": *Variety*, August 16, 1923.

361     "as if our love": *Los Angeles Record*, August 14, 1923.

361     "Mother liked William": *Los Angeles Record*, August 15, 1923.

362     "vials of dope": Florence Atherton Dickey, oral history, Bancroft Library, University of California, Berkeley. Mary's hosts were the screenwriter Philip Dutton Hurne and his wife.

362     "Please leave me alone": *Los Angeles Examiner*, August 15, 1923.

362     The thought had never occurred to her: *Oakland Tribune*, August 14, 1923.

## CHAPTER 65: THE END OF THE ROAD

363     Larry Outlaw: FBI report, March 14, 1924. Although MacLean reported that he had visited Madsen at the St. Catherine Hotel, there was no hotel by that name in Venice. The only "Saint" hotel in Venice was St. Mark, a well-known landmark. I have concluded that seven months after his visit, MacLean, unfamiliar with Los Angeles, confused the St. Mark with the St. Catherine Hotel on Catalina Island.

364     "undaunted by the fact": *Springfield Daily News*, July 16, 1923.

364     "You can imagine": FBI records, August 11, 1923.

365     "a former Paramount star": *Oakland Tribune*, June 5, 1923.

365     "I intend to expose": George Lasher to John L. Bushnell, August 28, 1923, in FBI report, October 25, 1923.

366     Gibby went back to Jesse Lasky: The timing can be determined fairly precisely. In June, Gibby called herself a "former Paramount star," so she was clearly not on an ongoing contract. Lasher wrote to Bushnell on August 28; he had already given Gibby the ultimatum for September 4. The *Film Daily* reported on August 29 that Lasky had decided to move ahead with *To the Ladies*; on September 9, it was reported that Cruze would begin shooting on September 17. So Gibby likely got the assignment during the first week of September.

366     Lawrence MacLean took the letters: *Springfield Daily News*, October 10, 1923.

## CHAPTER 66: READJUSTMENTS

367     Hays had decided on a legal separation: Not until 1929 would the facts become known. See, for example, the *Moberly (MO) Monitor-Index and Democrat*, June 21, 1929.

367     sailing off for England: *Variety*, September 20, 1923.

368     "wined and dined": *Film Daily*, September 24, 1923.

368     contemplating a return to politics: *Variety*, September 13, 1923.

369     "Motion picture people": *Film Daily*, December 2, 1923.

369     discussing a "readjustment" of the industry: *Film Daily*, November 6, 1923.

369     "to discuss his recent trip": *New York Daily News*, October 27, 1923.

## CHAPTER 67: UNEXPECTED DEVELOPMENTS

370     officially a married woman: Marriage certificate, Arthur McGinness and Patricia Palmer, October 27, 1923, Orange County Courthouse.

371     "blackmail ring": *Los Angeles Examiner*, November 3, 1923. The FBI had interviewed George Weh on October 25, two days before Gibby's marriage.

371     "these gentlemen are officers": *Los Angeles Herald*, November 3, 1923. The account of Gibby's arrest and court appearances are taken from this source as well as the *Los Angeles Times* and *Los Angeles Examiner*.

371     "became very busy": *Springfield Daily News*, November 3, 1923.

372     "a put-up job": *Los Angeles Examiner*, November 3, 1923.

373     "She gained the limelight": *Los Angeles Times*, November 3, 1923.

373     "never attained stardom": *Los Angeles Examiner*, November 3, 1923.

373     "insufficient evidence": FBI case file, November 13, 1923.

373     "violated the Mann Act": Mark L. Herron to L. C. Wheeler, November 10, 1923, reproduced in FBI case file, November 13, 1923.

374     "This poor girl has lost her job": *Los Angeles Examiner*, November 9, 1923.

374     "the federal brigade": *Los Angeles Times*, August 19, 1922.

## CHAPTER 68: MANHUNT

380     Rose Putnam was released from jail: *Springfield Daily News*, March 31, 1924; *Sandusky (OH) Star Journal*, April 1, 1924.

380     "throw away the key": *Zanesville (OH) Star Signal*, April 6, 1924.

380     For the first shakedown: Final Commitment, US District Court, Southern District of Ohio, Indictments 2608 and 2610, April 5, 1924.

## CHAPTER 69: THREE DAMES NO LONGER SO DESPERATE

383     CHAUFFEUR SHOOTS MAN: *Los Angeles Times*, January 2, 1924.

384     "An unvoiced, passionate": *Chicago Tribune*, January 3, 1924.

384     "Dear Mabel may be very sweet": *Ogdensburg (NY) Advance and St. Lawrence Weekly Democrat*, January 10, 1924.

384     NORMAND CASE UPROAR: *Variety*, January 10, 1924. Bans were reported through January 17.

384     "the Normand temper": *Los Angeles Examiner*, June 17, 1924.

384     "The majority of Illinois club women": *Los Angeles Times*, March 20, 1924; *New York Morning Telegraph*, March 23, 1924.

385     "There is a limit": *Los Angeles Times*, October 12, 1924.

385     MABEL IS CLEARED: *Syracuse Herald*, January 13, 1925; *Hammond (IN) Times*, January 14, 1925.

386     play wasn't as bad as all that: I've based my reassessment on the actual newspapers that reviewed it. There were some pans, but the show was not the disaster many have described. See *Washington Times*, September 8, 1925; *Variety*, September 9, 1925; *Charleston Gazette*, September 16, 1925; *Providence Evening Bulletin*, September 23, 1925.

386    "magic at the box offices": *New York Times*, September 13, 1925.

386    her otherwise sympathetic biographer: Fussell, *Mabel*.

386    fashion columnist Betsy Schuyler: *Cumberland (MD) Evening Times*, October 9, 1925.

387    "looking well and happy": *Photoplay*, February 1926.

387    "Don't get too big": An anecdote told several times by Dwan. See *Milwaukee Journal*, January 21, 1982.

## CHAPTER 70: END OF AN ERA

389    Out at the windswept corner: Details of the construction of the Paramount Building come from the *New York Times*, May 24, 1925, August 2, 1925, January 7, 1926; *New York Evening World*, May 26, 1925; and various unsourced clips in the Zukor file, NYPL.

390    "surpass in capitalization": *New York Times*, March 24, 1924; *Los Angeles Times*, April 8, 1924.

390    FILM WAR LOOMS: *Elyria (OH) Chronicle Telegram*, April 23, 1924.

391    "they get eaten first": Unsourced clipping, circa 1920, Zukor file, NYPL.

391    "the most beautiful home": *New York Times*, October 16, 1924.

391    "Zukor is about the wisest manipulator": *Variety*, March 26, 1925.

392    "conspired to seize": *New York Times*, August 25, 1925.

392    Neither a merger nor a sale: *Wall Street Journal*, September 25, 1925. Also see Douglas Gomery, *The Hollywood Studio System* (New York: St. Martin's Press, 1986).

393    On August 2, 1926: *New York Times*, August 3, 1926.

393    theater's official premiere: The opening of the Paramount Theatre was described in the *New York Times*, November 14 and November 20, 1926.

394    "All I can say now": *New York Times*, September 6, 1927.

394    "a heritage of reputation": *Film Daily*, September 6, 1927.

394    "like a beacon": *Photoplay*, November 1927.

395    "A man is great": *Film Daily*, September 6, 1927.

395    "I can't find words": *Film Daily*, September 6, 1927.

## CHAPTER 71: "WE ARE MAKING REAL PROGRESS"

396    "My God, the next thing": J. M. Berger, statement, March 11, 1926.

397    TAYLOR MYSTERY: *Hartford Times*, March 11, 1926.

397    "We are making real progress": *Los Angeles Express*, March 23, 1926.

397    "Mr. Taylor was the most": Charlotte Shelby, statement, April 9, 1926.

397    "prominent Los Angeles society woman": *Los Angeles Herald*, March 27, 1926.

398    "I know that he loved me": Minter, statement, March 4, 1926.

399    "willful and corrupt": *Los Angeles Times*, November 1, 1928; February 9, 1929.

399    Margaret did reveal how afraid: The 1937 testimony of Margaret Shelby, Charlotte Whitney, and Chauncey Eaton was described by Leroy Sanderson in his overview of the Taylor case, reproduced in Long, *Taylor: A Dossier*.

400    They handed down: *Los Angeles Examiner*, May 7, 1937.

401    "I demand a complete": *Los Angeles Examiner*, May 11, 1937.

## EPILOGUE: A CONFESSION

405    At a little past four: Ray Long wrote about Mrs. Lewis for Taylorology. He slightly amended his recollections in personal correspondence with me.

406    she died at 5:20: Death certificate, Ella Margaret Arce, aka Palmer, aka Lewis, October 22, 1964, Los Angeles County Archives.

406    named Mrs. Long as her executor: Ella Margaret Lewis, Last Will and Testament, March 12, 1964, courtesy Ray Long.

410    "She was frightened": *Los Angeles News*, September 13, 1937.

410    "The image was too cinematic": Fussell, *Mabel*.

410    Other facts debunk the theory: I am indebted here to Bruce Long's essay "Did Charlotte Shelby Kill Taylor?" in his *William Desmond Taylor: A Dossier*.

412    "one pistol in thousands": *Los Angeles Examiner*, February 18, 1922. As for claims that "soft-nosed" bullets did not date back as far as the Spanish American War, it is true that such bullets were not marketed as such until about 1907–1908. But they definitely were being made and used a decade earlier, when they were more frequently called "hollow-point." See the *NYT*, September 2, 1900, which references "captured Mauser rifles" from the war "loaded with cartridges containing soft-nosed bullets." So Blackie Madsen's gun could well have fired this old, hollow-point ammunition.

416    Madsen fit perfectly: That is, he fit her original description, of the rough-looking man with the prominent nose who reminded her of a movie burglar. In her original description she did not give an age. That came only later, after detectives prodded her to admit things she didn't really see.

418    Elbert E. Lewis: Born in Michigan, Lewis was living in Los Angeles in both 1920 and 1930, though he traveled a great deal, marrying his first wife in Ohio. Biographical detail from the US Census and World War I registration. His devotion to her is revealed in his letters to her, provided courtesy of Ray Long.

418    marrying Elbert Lewis: Consular Reports of Marriage, Singapore, Straits Settlements, February 9, 1935.

418    sailed back to the United States: Ella Margaret Lewis arrived on the SS *Chichibu Maru* from Shanghai into Los Angeles on February 28, 1937. Elbert Edgar Lewis arrived on the SS *President Jackson* from Hong Kong into Seattle on October 14, 1937. His death record was located in Reports of Deaths of American Citizens Abroad, April 18, 1942. He did not die in a bombing raid, as has been reported. Lewis referred to himself as "Daddy" in a very sentimental letter to Gibby dated February 8, 1942, courtesy of Ray Long.

## WHAT HAPPENED TO EVERYONE ELSE

420    Don Osborn served out his sentence: US Census; Leo Maloney file, NYPL; Los Angeles telephone directories; death certificate, May 16, 1950, Los Angeles County Archive.

420    Rose Putnam moved back: US Census; index to California death records.

420    Blackie Madsen got out of the clink: Washington marriage records, 1865–2004; *El Paso Herald-Post*, December 3, 1935; Ross Garnet Sheridan, death certificate, March 19, 1938, Los Angeles County Archives.

421 Minter never made another movie: *Los Angeles Times*, March 23, 1957, August 24, 1965, June 11, 1981; *Hartford Courant*, January 9, 1981; Higham manuscript; Brownlow interview; Don Bachardy, interview with author.

424 "an apostle of progress": For Hays's legacy, I am indebted to Stephen Vaughn's perceptive article "The Devil's Advocate: Will H. Hays and the Campaign to Make Movies Respectable," *Indiana Magazine of History* 101 (June 2005).

425 "would change only": Gomery, *The Hollywood Studio System*.

425 "Rather than lose the public": *New York Times*, June 11, 1976.

425 "never had such a time": Gabler, *Empire of Their Own*.

# INDEX